C000318590

Bath

PEVSNER ARCHITECTURAL GUIDES

Founding Editor: Nikolaus Pevsner

PEVSNER ARCHITECTURAL GUIDES

The Buildings of England series was created and largly written
by Sir Nikolaus Pevsner (1902–1983). First editions of the county
volumes were published by Penguin Books between 1951 and 1974.
The continuing programme of revisions and new volumes has
been supported by research financed through the Buildings Books
Trust since 1994.

The Buildings Books Trust gratefully acknowledges
Grants towards the cost of research, writing and illustrations
for this volume from:

BATH PRESERVATION TRUST
FEILDEN CLEGG BRADLEY ARCHITECTS
STACKS
MICHAEL BRIGGS

Assistance with photographs from:
ENGLISH HERITAGE
(photographer: James O. Davies)

Bath

MICHAEL FORSYTH

with contributions by
STEPHEN BIRD

PEVSNER ARCHITECTURAL GUIDES

YALE UNIVERSITY PRESS

NEW HAVEN & LONDON

For James, Antonia and Henrietta

YALE UNIVERSITY PRESS
NEW HAVEN AND LONDON
302 Temple Street, New Haven CT 06511
47 Bedford Square, London WC1B 3DP

Published 2003; reprinted with corrections 2007
10 9 8 7 6 5 4 3 2 1

Copyright © Michael Forsyth, Stephen Bird

Set in Adobe Minion by SNP Best-set Typesetter Ltd., Hong Kong
Printed in Italy by Conti Tipocolor

Library of Congress Cataloging-in-Publication Data

Forsyth, Michael.
Bath / Michael Forsyth.
 p. cm. – (Pevsner architectural guides)
 Includes index.
 ISBN 0-300-10177-5 (pbk. : alk. paper)
 1. Architecture – England – Bath – Guidebooks.
 2. Bath (England) – Buildings, structures, etc. – Guidebooks. I. Title. II.
Pevsner architectural guides (New Haven, Conn.)
 NA971.B2F67 2003
 720′.9423′98 – dc21
 2003011393

Contents

How to use this book

This book is designed as a practical guide for exploring the buildings of Bath and its outskirts. The divisions between the centre and the outer (Excursions) sections are shown on the map on pp. x–xi. Eight Major Buildings or groups of buildings have entries of their own, indicated by the map on p. 52. Of these, all but Prior Park lie in the central area. The rest of the centre is covered by a series of eleven Walks, each of which has its own street map showing the route followed. The Georgian set pieces of Queen Square, The Circus and the Royal Crescent will be found in Walk 3. Buildings in the excursions are not arranged into walks in the same way, but have been grouped with ease of visiting in mind. In addition, certain topics are singled out for attention and presented in separate boxes, they are listed on p. 329.

1. Woodhill Place, Bathwick Hill, Apollo the sun god

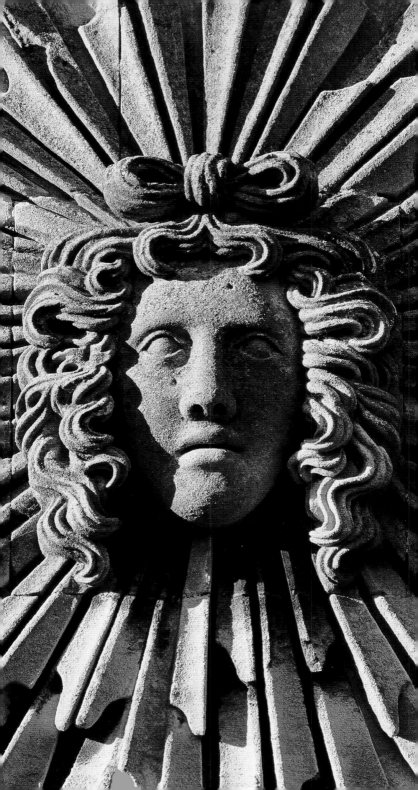

Acknowledgements

My first debt is to Sir Nikolaus Pevsner, whose original entry on Bath in *North Somerset and Bristol* (The Buildings of England), 1958, highlighted the city's architectural importance at a time when its buildings were soot-blackened and the Assembly Rooms were still a bombed shell. I am especially grateful to James O. Davies of English Heritage for photography, and to Stephen Bird, Head of Heritage Services at Bath and North East Somerset Council, for contributing the Roman material in the Introduction, the Grand Pump Room and Roman Baths entry, and the Further Reading section. Special thanks are due to Marion Harney for carrying out the research and working tirelessly with me as a team on all aspects of the book.

I am indebted to Elizabeth Holland and Mike Chapman of the Survey of Old Bath for reading the text, generously giving time and expertise, and freely sharing their formidable local knowledge - as also did Peter Davenport and Marek Lewcun of Bath Archaeological Trust, John Hawkes, Alistair Durie, Alan Rome, and Warwick Rodwell. The help and patience of Colin Johnston and his team at Bath Record Office were endless. At the University of Bath, Howard Nicholson, Librarian, Katy Jordan, Faculty Librarian, Lizzie Richmond, Archivist, and Patrick Finch, Director of Property Services, were of constant assistance. I am grateful to Douglas Bernhardt who made available his research on George Phillips Manners and his successors for his unpublished Ph.D. thesis at the University of Bath, 2003. I received much kind help from Derek Jones, Surveyor to St John's Hospital Trust and Quentin Elston, Clerk to the Trustees there; from Michael Rowe; from Sheila Edwards and Terry Hardick of Bathwick Local History Society; from James Elliott, former Listed Buildings Architect to Bath City Council; from the Built Heritage team and other members of Bath and North East Somerset Council, in particular David McLaughlin, Eunice Bletso, Helen Friel and Robert Sutcliffe; from Roger Bowdler, Elain Harwood and Rory O'Donnell of English Heritage; from Lucy Rutherford, Bath Abbey Archivist; from Jon Bennington and his team at the Victoria Art Gallery; from Cathryn Spence of the Building of Bath Museum; from Gillian Sladen and from Michael Briggs, Chairman of the Bath Preservation Trust; from the staff at Bath Reference Library; from Jane Coates of the Bath Royal Literary and Scientific Institution; from

Theresa Ford, librarian at the *Bath Chronicle*; from David Odgers of Nimbus Conservation Ltd; and from James Ayres, Michael Bussell, Sue Sloman, Martin Robertson, the late Tony Symons, Andrew Ellis, Peter Howell and Frank Arneil Walker.

Amongst the architectural profession, Peter Clegg, Stephanie Laslett and Linton Ross of Feilden Clegg Bradley gave their time freely, as did many other practices, companies and individuals, including William Bertram of William Bertram & Fell, Chris Bocci, Mike Rawlins of David Brain Partnership, Raj Malik and Stephen Newbold of De Brandt Joyce, Rob Denning of Denning Male Polisano, Geoff Wallace of Dorothea Restoration, Aaron Evans of Aaron Evans Associates, Sir Nicholas Grimshaw of Nicholas Grimshaw & Partners, Peter Carey of Donald Insall Associates, Chris Balme of Ferguson Mann, David Lewis of David Morley Architects, Edward Nash of the Edward Nash Partnership, Daphne Bunker of NVB Architects, Peter Salter, and Rob Ward of Wilson, Mason & Partners. The late Gus Astley's paper on window joinery was valuable.

Many allowed me generous access to their buildings and supplied valuable information, and I would especially like to thank David Brown, archivist to Kingswood School; the Bursar and his staff at Prior Park College; Melanie Heath of the Royal Crescent Hotel; Caroline Stanford of the Landmark Trust; Anne Sedding of the Theatre Royal; Roger Hornshaw, Deputy Director of the American Museum in Britain; Lisa White of the Holburne Museum; Paul Simons and Rhodri Samuel, in connection with the New Royal Bath; James Dalley of Bath Spa Station; Michael Briggs and Isabel Colgate of Midford Castle; and Della and Michael Father of Lodge Style. I hope that those whom I have omitted will forgive me.

The editorial team at Yale University Press have been immensely supportive, especially Simon Bradley for editorial help and guidance; Sally Salvesen for design, assisted by Emily Winter; and Emily Rawlinson for co-ordinating illustrations. Bridget Cherry gave early encouragement back in the days when the Pevsner series was with Penguin. Touchmedia designed the maps, Alan Fagan the plans of Bath Abbey and St John's Hospital. Pat Taylor Chalmers was the copy editor, and the index was compiled by Susan Vaughan.

Finally, by long tradition in the Pevsner volumes, an appeal to all readers for any corrections or significant omissions.

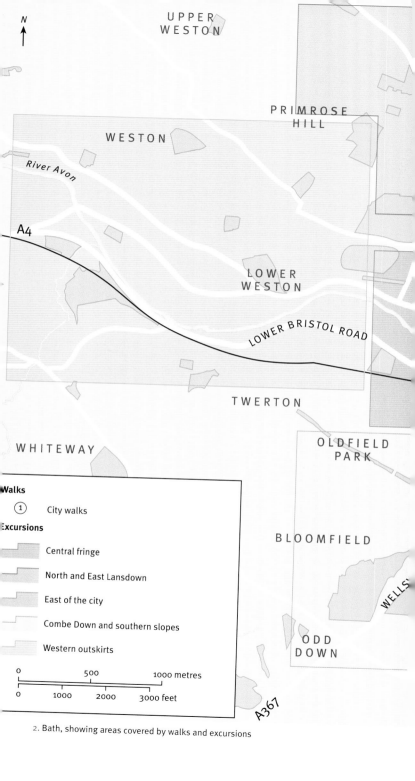

N

UPPER
WESTON

PRIMROSE
HILL

WESTON

River Avon

A4

LOWER
WESTON

LOWER BRISTOL ROAD

TWERTON

OLDFIELD
PARK

WHITEWAY

Walks

①　　City walks

Excursions

　　　Central fringe

　　　North and East Lansdown

　　　East of the city

　　　Combe Down and southern slopes

　　　Western outskirts

BLOOMFIELD

WELLS

ODD
DOWN

| 0 | 500 | 1000 metres |

| 0 | 1000 | 2000 | 3000 feet |

A367

2. Bath, showing areas covered by walks and excursions

FAIRFIELD
PARK

ROAD

BAILBROOK

A46

A4

River Avon

LAMBRIDGE

LONDON ROAD

Kennet and Avon Canal

BATHAMPTON

WARMINSTER ROAD

A3c

⑨

⑤

⑩

③

④

②

ATH

①

①

⑥

BATHWICK

BATHAMPTON
DOWN

⑦

⑧

WIDCOMBE

LYNCOMBE

Prior
Park

CLAVERTON
DOWN

PERRY MEAD

COMBE DOWN

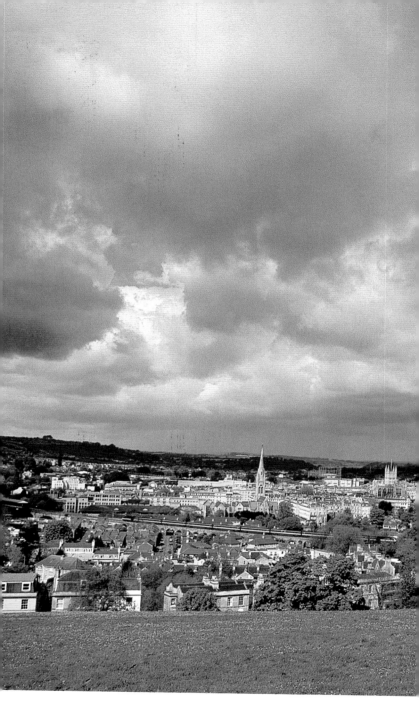

Bath from the East

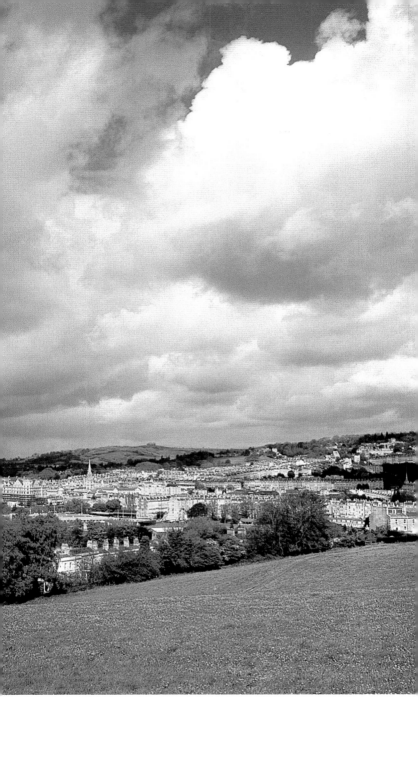

Introduction

Introduction

That Bath was one of the centres of Roman life in Britain, with its hot springs, warm climate and appealing situation, is easily seen by any visitor to the town. But it is often forgotten how flourishing a town Bath was in the Middle Ages and that the prosperity of her citizens, rooted in the cloth trade, went on, with some setbacks, through Tudor and Stuart times, and in fact to the very moment when Bath leapt to fame a third time. It is this Bath that the traveller comes to visit and admire now, the Bath of Ralph Allen and Beau Nash, of Bath stone and polite manners, the Bath of Smollett and Jane Austen, the spa *par excellence* of Britain.

The city lies in a loop of the River Avon, comfortably sheltered by land that rises steeply at once, a first step in the direction of the Mendips to the s, the more open country of Lansdown to the N, and the slopes of Combe Down and beyond to the SE. This last hilly margin yields some of the finest building stone in the country, pale cream oolitic limestone of the Middle Jurassic – warm, honey-coloured, dappled with lichen when weathered – of which Bath is almost entirely built. And it is this local material that makes it the most coherent of English cities, for in other respects it is by no means a unified, planned whole, like say Edinburgh's New Town. The expansion that took place in a relatively short time span in the C18 and C19 by builders-cum-architects created a collage of separate, largely unconnected, individual and often incomplete pieces of speculative development, each shaped by accidents of land purchase and constraints of topography, often curtailed by over-ambition, bankruptcy or demise.

Architecturally speaking much of Georgian Bath remains, despite post-Second World War demolition. Of the Bath before 1725 little remains above ground, though the medieval city and its suburbs, overlaid by the Georgian, remain like a palimpsest through the persistence of boundaries and streets.

Roman Bath
by Stephen Bird

The Roman invasion of AD 43 under Aulus Plautius quickly occupied southern England as far W as the Bristol Channel and river Severn. Control over the Iron Age population was exerted by a network of strategically sited timber-built forts and military roads. The Fosse Way,

running down the western extremity of the new province from the Humber to Lyme Bay, may have crossed the river Avon w of Bath city centre where the valley is wider and its slopes less steep. The location of the **fort** that must have been sited in the Bath valley is uncertain, although a possibility is the Bathwick area in which early Samian pottery has been found. This is complemented by considerable evidence of an early settlement across the river in Walcot, and the case for a ford here is supported by roads converging on this point from the Cotswold ridge to the N and Poole Harbour to the s. This location for the earliest Roman occupation of Bath lies several hundred metres N of Bath's unique natural phenomenon, the three geothermal springs.

The units that garrisoned the fort are unknown and may have changed during the early years of occupation. Two incomplete cavalry tombstones in the Roman Baths Museum [4, 5], one of Lucius Vitellius Tancinus of the *ala Vettonum* from Spain and the uninscribed upper section of another, point to an auxiliary unit, while early tombstones of soldiers of *Legio XX* suggest a detachment of regular troops may also have been stationed here. Both would have attracted the interest of traders amongst the local population leading to the development of the Walcot *vicus* close to the ford. The roads and trackways along and across the valley bypassed the marshy bend in the river containing the springs, although the lure of the natural phenomenon and its importance as a focus for the identity and beliefs of the local population doubtless aroused Roman curiosity. Timber buildings with painted lath-and-plaster walls were soon erected nearby and a substantial metalled road built to improve access to the two smaller springs. However, for the first twenty years of military rule no redevelopment of the Celtic sanctuary appears to have taken place.

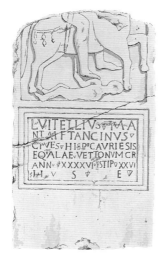

4, 5. Roman cavalry tombstone fragments
(Lysons S, 1810)

The Boudican Revolt of AD 60 and its suppression were followed by a period of reconciliation and regeneration in the province. Resources were poured into public building projects as new cantonal capitals were built and equipped with all the institutions and facilities of urban life. It is around this time that construction of the great sanctuary of **Baths** and **Temple** around the principal hot spring (the King's Spring) began. The presiding Celtic deity Sulis was identified with her nearest classical equivalent Minerva and the two conflated into a single Romano-British cult of Sulis–Minerva. In deference to the site's Celtic origins, the name *Aquae Sulis* was adopted, although in the C2 the geographer Ptolemy, perhaps more interested in its physical properties, referred to it as *Aquae Calidae* – 'hot waters'.

The Roman army would have undertaken the considerable logistical exercise of bringing timber, Mendip lead and building stone from the downs s of the river to be fashioned and finished on site. Skilful engineering work captured the largest of the springs in a polygonal lead-lined stone reservoir, allowing the surrounding marshy ground to dry out in preparation for the construction of the Baths and Temple. Initially open to the skies but later covered by a brick vault, this Sacred Spring (as it is now known) became the pivot around which the complex functioned, serving both as a supply of hot water for the Baths to the s and as a focus for votive worship to the N where the Temple stood.

In its earliest form the bath-house was simple in arrangement but massive in construction. A spacious entrance hall stood directly s of and overlooking the Sacred Spring; from here bathers could turn w into a suite of steam rooms heated from beneath by hypocausts; or they could turn E to the main swimming bath, known today as the Great Bath [44], fed with warm water directly from the Sacred Spring, probably covered by a pitched timber roof and illuminated by a clerestory above the pool. The water was fed on to two smaller pools, both of which were filled in and replaced by another suite of artificially heated rooms in the early C2, and during the next two centuries the Baths underwent numerous further extensions and refinements.

North of the Sacred Spring the Temple of Sulis Minerva stood on a podium centrally positioned in a rectangular colonnaded precinct that incorporated the Sacred Spring in its SE corner. Although not as vast as the Temple of Claudius at Colchester it was, nevertheless, an imposing classical building whose E-facing Corinthian portico supported a pediment sporting an ornate array of motifs in relief with, at the centre of the tympanum, the fearsome so-called Gorgon's Head [45] dominating the entrance and forecourt of the precinct. In the *cella*, accessible only to priests tending the perpetual flames, stood a life-size gilded bronze cult statue of Minerva adorned by a high Corinthian helmet [6]. Public ceremonies, led by priests like Gaius Calpurnius Receptus whose tombstone is exhibited in the Roman Baths Museum, took place outside on

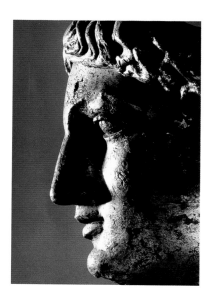

6. Gilded bronze head of the goddess Minerva

the temple steps or in procession around the courtyard and may have involved ritual use of the 'temple plate', mostly pewter vessels which eventually found their way into the Sacred Spring. In front of the Temple augurs conducted animal sacrifices at a great altar. One such priest, Lucius Marcius Memor, *haruspex*, made a donation to the temple; the inscribed block recording his gift was excavated in 1965 and returned to its original position beside the altar in 1983. Visitors with particular vows to fulfil might erect their own altars in outer courtyard around the base of the Temple; for example, the freedmen Eutuches and Lemnus fulfilled their vows by petitioning Sulis for the welfare and safety of their patron Marcus Aufidius Maximus, a centurion of the Sixth Legion.

Although they could work perfectly well separately it is clear that the Baths and Temple were intended to function together. Pilgrims seeking a cure might first petition the deity for help at the Sacred Spring, perhaps by throwing offerings into the water. These included coins, jewellery or other valuable or symbolic items, and messages to the goddess scratched on pewter tablets seeking help or retribution on others, often for trivial offences. They might also attend ceremonies in the Temple precinct before turning to the Baths to seek their cure in the healing waters. The case for the importance of healing is supported by a medicine stamp found in or near the Temple precinct and Aesculapian images of dogs and snakes both on a carved stone block from the Cross Bath Spring and on smaller objects found close by.

The Baths and Temple were functioning by about AD 75 although the colonnade around the Temple was not added for at least another fifty

years. It is possible that the complex started life as a military spa for soldiers serving in the military zones of the province. By the late C1, however, civilians including women were visiting it and thereafter the epigraphy records a wide range of individuals. The youngest known, eighteen-month-old Mercatilla, was doubtless brought by her foster parents in the hope of a cure, while the oldest, an eighty-six-year-old former town councillor from Gloucester, probably retired to *Aquae Sulis* to be close to the spa. Some travelled long distances to erect their altars, such as Peregrinus from Trier in Germany, while others lived closer to home; Sulinus son of Brucetus was a local sculptor who also had a workshop in Cirencester.

Where these pilgrims stayed is a matter of conjecture. In the C1 and C2 *Aquae Sulis* had two distinct nuclei that performed very different roles. The Baths and Temple complex did not include residential accommodation; unlike the monumental public buildings of the period in the new cantonal capitals, they were not part of a planned town involving other public buildings, shops and dwellings, although these were to come later. Unusually, the complex stood in semi-rural isolation with only timber buildings and metalled yards nearby that were needed for maintenance purposes. Some 870 yd. (800 metres) to the N in Walcot the other nucleus continued to flourish with well-built artisan and residential premises alongside the main road leading to the sanctuary. Doubtless it served both as a market for local people and the surrounding countryside as well as a source of labour and goods for the religious spa and its clientele. By the third century it had spread s along the road and merged with the nucleus around the springs. To the N on the out-of-town side the town's cemetery lay astride the London Road.

There is little evidence to indicate that the Romans developed the Cross Bath Spring and Hetling Spring at the same time as they built the sanctuary around the King's Spring. At some point, however, the Cross Bath Spring was enclosed by a large oval wall and the Aesculapius block and a dedication to Sulis Minerva suggest that it may have served as some kind of shrine. The Hetling Spring has yielded dedications to Sulis

Minerva and Diana as well as a quantity of Roman coins and so may have had religious significance, while hypocausts and a lead-lined plunge bath immediately to the s indicate the presence of another thermal establishment. To the E of the two smaller springs, traces of another huge public building have been found on the same alignment as the Baths, prompting speculation that it may represent another component of the spa linking the principal spring with the two smaller ones.

Other monumental **public buildings** were constructed adjacent to the Baths and Temple. To the E of the Temple and N of the Baths lay a level terrace supported on its s side by massive foundation blocks. Large column shafts and curved blocks with relief decoration on both sides found nearby suggest that an elaborate open circular temple or *tholos* of unknown dedication may have stood here in another sacred enclosure. It is tempting to associate the construction of this Greek-style building with Hadrian's visit to Britain in AD 122 when it might also have coincided with the early C2 redevelopment of the eastern range of baths. Regrettably there is no evidence that Hadrian visited Bath. An alternative interpretation would be that the architectural fragments came from a great basilica, hitherto unknown in Bath, although a building like this with administrative and judicial functions would have afforded *Aquae Sulis* a status which its other characteristics tend not to support.

Theatres were often closely associated with temples, as at St Albans and Canterbury, and one must surely have existed in Bath. A monumental block decorated with gargoyles found under Westgate Street, combined with monumental foundations observed under its junction with Union Street, suggest an attractive location for a theatre carved into the rising ground immediately N of the Temple.

Antiquarian observations and periodic excavations conducted during the C20 have recorded numerous other masonry buildings in the city centre. Some were shops and industrial premises, others well-appointed buildings with window glass, painted wall plaster, hypocausts and mosaics. Whether these related to the life of the religious spa or belonged to the owners of estates in the surrounding countryside is unknown. In the late C2, possibly during the succession crisis of AD 192–6, a rampart and ditch were constructed on the line of the later N medieval wall and then strengthened in the C3 with a masonry facing. This pattern was repeated over a similar period at many Romano-British towns, although in Bath there is as yet no evidence for a full circuit of defences. Nevertheless all of the major public buildings recorded and all of the known mosaics – at least eight in all – lie within the medieval town wall, which may support the case for a Roman precursor.

The question of the status of *Aquae Sulis* is interesting. Romano–British towns ranged in size from 45 to 240 acres (18 to 97 ha.). The presumed walled area of Bath enclosed just 24 acres (10 ha.), half the

size of Caerwent in South Wales, one of the more modest cantonal capitals, and less than one-tenth the size of Cirencester. Even when combined with the undefended Walcot settlement Bath was only 60 acres (24 ha.) in size. Bath lay towards the western end of a new canton created after the invasion which extended from the Solent to the Severn with its capital at Winchester, although Cirencester, much larger and twice as close, probably had greater economic influence. Although an important spa town and thriving market centre, Bath itself lacked the critical mass and institutions to have been a cantonal capital.

Roads converging on Bath from all directions allowed easy access for pilgrims and enabled the import of luxury goods and the export of agricultural and industrial products from Bath's rural hinterland. An unusual characteristic of the countryside around Bath was the absence of villas prior to c. AD 270; rural sites seem to be confined to farms and villages, some specializing in industrial activities such as the pewter-making settlement at Little Down Field on Lansdown. After the initial occupation period certain particularly productive areas were requisitioned and administered as imperial estates. Later in the C3 the flight of wealthy landowners from political turmoil in Gaul may have coincided with the sale of imperial estate lands to raise cash, which could explain the sudden and dramatic appearance of so many new **villas** in the fertile and attractive countryside around Bath.

By the C4 the concentration of villas in the area was as dense as anywhere else in the province, prominent amongst them great courtyard residences like Keynsham, Box, North Wraxall, Atworth and Wellow appointed with intricate geometric and figures mosaics, painted wall plaster and window glass. Many continued to generate agricultural wealth while others were simply the country retreats of wealthy town-based bureaucrats. This surge of economic activity and the retention of a greater proportion of locally generated wealth, combined with political changes that saw Britain divided into two and then four provinces, may have seen *Aquae Sulis* take on a new administrative role for the western Belgae, although the institutions needed to support it have yet to appear in the archaeological record.

Combe Down in Roman Times

An Imperial Estate centre may have stood at Combe Down where a lead seal of the procurator's office and an inscription recording the early C3 rebuilding of a *principia*, an official headquarters building, have been found. Gaius Severius Emeritus, 'centurion of the region' who restored the temple after an act of vandalism, may have worked there. The station was later converted into a villa; at some point the inscription referred to above was reused as a coffin cover.

Some villas were surprisingly close to the city centre; those at Marlborough Lane and Sion Hill, built on native farmstead sites, and others below Wells Road and at Norfolk Crescent and Bathwick, all stood within sight of the Baths and Temple. The Marlborough Lane and Wells Road villas were aligned to face directly towards the hot springs and this may have been true of all villas in this stretch of the valley.

Between AD 350 and AD 370 many villas in the countryside around Bath were sacked and torched by Irish raiders. Some were abandoned, their owners perhaps seeking refuge in the comparative safety of Bath. Whether Bath itself was attacked is unknown. In the later C4 the outer Temple colonnade was demolished and buildings with hypocausts and mosaics erected over the precinct. The inner precinct went into decline as mud and debris started to accumulate, and in the Baths flooding from the river Avon up the Roman drain made maintenance of the eastern range increasingly difficult. It may have been during these events that the statue of Minerva was toppled and desecrated. At some point resistance to the elements became futile and the complex was abandoned, but when is impossible to tell. Although a house nearby in Abbey Gate Street remained in use well into the C5, domestic occupation of the city centre area appears to cease.

The Walcot nucleus, however, the heart of the resident population and away from the flood-prone area of the hot springs, was better placed to adapt and survive. A high-status C5 burial near St Swithin's church sums up the moment in time. A man of Middle-Eastern origin, the deceased reflects better times when *Aquae Sulis* had attracted travellers and traders from distant parts of the Empire; his burial, aligned E–W, announces the emergence of the sub-Roman village clustered around its church. Its population was to form the nucleus of a new order which, however indistinct its status, was at the heart of a community led by a 'king' that finally fell to the Saxons in AD 577.

Saxon, Medieval and Post-Medieval Bath

The first phase of post-Roman Bath was its Saxon reconstruction under King Alfred in the late C9. Alfred probably rebuilt the defences based on the Roman walls, and the former S, W and N gates are almost certainly on the Roman gate sites. He replanned the town also, almost completely replacing the Roman street pattern. Within the old walled enclosure and S of it in the Southgate area, no Roman roads survive into the present day. As with Saxon town plans elsewhere, its chief features would have been a road running around its circuit just inside the defensive walls, main thoroughfares linking the gates, and a grid of lanes in between. The commercial heart was the market place, now the High Street, a wide space (which retains its original wedge shape) just inside the N gate, running N–S and connecting at its S end with the main E–W axis. The latter exists as Westgate Street and Cheap Street, and would

have continued further E until the Cathedral precinct was extended N after 1091, and the E gate relocated to the N. The area N of Westgate Street and Cheap Street and W of the market place was probably laid out in blocks divided by small parallel lanes or 'twichens'. In the S sector existing features – the Abbey, the Cross, Hot and King's Bath springs and various Roman remains either standing or ruined – would have caused the grid pattern to be modified. At least one interconnecting street survives in part as Bilbury Lane, running N from Lower Borough Walls. It is the only one so far to have been archaeologically proven. Bath's main present day N–S thoroughfare, Stall Street, is thought to date from the creation of the Cathedral Priory close after 1091 (*see* below).

Although little other physical evidence of the **medieval** period survives above ground, documentary research, topographical studies and archaeological evidence have helped build a picture of the pre-Georgian city. Early maps are helpful in giving a visual impression. Speed's map, inset in his map of Somerset, is a reliable bird's-eye view, probably of *c.* 1575, although the most widely used edition was published in 1672. Gilmore's map of 1694 is similarly a bird's-eye view but presents a measured survey of the streets, though the conventionalized houses do not match the individual touches of Speed. This map nicely characterizes different parts of the city, for example planks of sawn timber in the Saw Close indicate the function of this area [67], and small illustrations of individual buildings around the border of the map graphically show what the early houses looked like. The Kingston Estate map dated 1725 is considered to be the first truly reliable map of the city with the street patterns and properties that existed before the later Georgian improvements and redevelopment. Early deeds, leases and wills also help the understanding of Bath's topography by providing information about the relationships between buildings, if not their precise locations. Using a combination of early maps and legal documents, historians and groups such as the Survey of Old Bath have determined the precise location of some early properties, such as the original St Catherine's almshouses in Beau Street. Investigation by Bath Archaeological Trust meanwhile has revealed much evidence on the ground. Early maps also provide a topographical context and show how the walls and surrounding natural features contained the old city, situated within an arc of the river. Between the wall and river to the E was the Abbey orchard, on what is now Parade Gardens. To the S was the Ham, a low-lying flood-plain meadow. W of Southgate Street lay further grazing land, the Ambry Mead and, beyond the city limit, Kingsmead. The land N of the city is crossed by routes that became principal streets in the C18. Milsom Street, George Street, the Paragon and Julian Road are all farm and village tracks on Gilmore's map of 1694, and undoubtedly of medieval origin (Julian Road E of Crescent

Lane broadly following the line of the Roman Fosse Way). Snow Hill, through the c20 council housing development, is an ancient route up to Claremont (Camden Road, by contrast, is a new route determined by Camden Crescent's final form).

At 24 acres (10 ha.) Bath is one of the smallest walled medieval cities. The **walls**, 10 ft (3 metres) wide at their base and over 20 ft (6 metres) high, were seen as essential to the defence of the city until after the Civil War. They were largely demolished in the c18 because of their hindrance to planning; only a few fragments remain. A short crenellated length, quite accurately restored (contrary to popular belief) in the later c19, is in Upper Borough Walls. This survived because the Mineral Water Hospital burial ground lay just outside it. The upper part of another section can be seen in the car park on the corner of Old Orchard Street and Henry Street. The lower, finer masonry is probably Roman. A large section here was demolished in 1959 when the adjacent store was built. Further lengths survive in basements. Two were discovered in 1995 beneath the Empire Hotel and the markets. The latter example survives, in its late medieval and c17 form, up to battlement height. s of here the wall lies buried beneath Terrace Walk, but its alignment can be seen at No. 1 North Parade, which has a canted front area wall built off the medieval wall's foundations, and this continues into the basement. North Parade (Gallaway's) Buildings, built just inside the walls, also follow the same orientation, as does Old Orchard Street, built just outside. The line of the walls is also marked by the names Westgate Buildings, and Lower and Upper Borough Walls. Little is known of the city **gates**, which are illustrated on the Speed and Gilmore maps [73]. They are however known to have been narrow and restrictive to traffic, hence their demolition in the c18, though the names remain as Northgate, Westgate and Southgate Streets. The only gate to survive is the very narrow 6.5 ft (2 metre) E gate that led only to Monks Mill and the Bathwick ferry. It was probably moved to its present position after 1091, and rebuilt in the c13 or c14. Other small gates provided access from the priory grounds. The ground level of the city rose over time because of deposits of debris and there were substantial differences of level either side of the walls. When *John Wood the Elder* built the Parades on the Ham in the c18, enormous vaults had to be built to bridge the difference.

In 1091 the King granted John of Tours, Bishop of Wells the whole city of Bath along with the Abbey (*see* Bath Abbey, p. 53) and for the remainder of the Middle Ages the Abbey was a cathedral priory. John of Tours initiated, probably in the mid–late 1090s, a new large-scale monastic precinct, redeveloping the entire SE quarter of the city within the walls. The works included the construction of enclosing walls, a vast cathedral (the present Abbey sits on the site of just the nave), a cloister to its s, monastic quarters, chapter house and, on the w side of the present Abbey Green, a bishop's palace. John also rebuilt the main

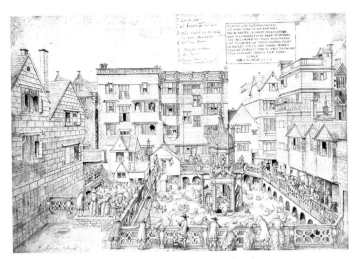

7. The King's and Queen's Baths. Drawing by T. Johnson (1675)

hot spring building, which became the King's Bath [7]. Stall Street was also built as the main N–S route to replace a former route to the E, and the E gate was moved to its present position because of additional expansion N. The works were mostly completed during the incumbency of Bishop Robert of Lewes, 1136–66. Virtually all of this has completely vanished.

Many tenants must have been evicted during the enlargement of the abbey precinct and this probably encouraged the growth of **suburbs** beyond the walls. C13 deeds exist for properties in Slippery Lane just outside the N gate. Others mention Broad Street, probably the cloth-working centre of the town. Its fork, Walcot Street, running N (an entirely Roman road connecting Fosse Way, now London Road, with the city) developed as an area of trades, and it had shops in the C14. Early deeds and the Poll Tax of 1379 – as well as surnames – indicate the trades of tailor, shoemaker, weaver, dyer, tiler, tailor, glover, tucker and others, especially grouped near the N gate. Southgate Street s of the city, inhabited as a linear suburb, led to a bridge over the river, referred to from the early C13. The bridge survived until 1755 and its replacement was demolished in 1966. Beyond, in the Holloway (the original Wells road, a well-used route), was a lepers' isolation hospital, established soon after the Norman Conquest, and as part of it, the small church of St Mary Magdalen, built at the end of the C15. No development seems to have taken place outside the W gate.

The present street system within the walls is largely the medieval one, modified by alterations following the Improvement Act of 1789. Early maps – as well as C13–C16 leases – show the commercial centre to be the High Street, Cheap Street and Stall Street, with densely built-up

8. The Saracen's Head, Broad Street (*c.* 1700)

frontages and references to shops rather than mere stalls from the C14. Union Passage (designated 'Cockes Lane' on Speed's map), connecting Cheap Street with Upper Borough Walls, still gives an impression of a medieval street. Steps at the top end reflect the build-up of refuse against the city wall, and this narrow part may retain the medieval street line (the lower section was widened post-1790). Descriptions make it clear that living quarters were at the rear or set over commercial properties, entered from the side or between stalls and later shops. Gardens, for growing vegetables and herbs, both for food and medicine, and for keeping small animals, were more common in the less commercially important streets, such as Westgate Street and Bridewell Lane. s of Westgate Street and w of the Abbey precinct, the area originally known as Bimbery contained two of the three springs, the Hot Bath and Cross Bath springs. It may have served the Abbey as a secular village, but became associated with healing and medicine, and with the establishment of almshouses for the poor.

The present **Abbey** itself is a Tudor-Perp rebuilding from 1502 [38], substantially completed by the time of its dissolution in 1539. It was re-edified by and for the citizens of Bath in the late C16 and early C17, though most of this work, including a nave roof, went in C19 restoration. Of the other **buildings**, one would like to know what kind of a house Chaucer's Wife of Bath might have possessed, and what kind of houses had the manufacturer-merchants who could do better than

Ypres and Ghent in cloth-making and selling. Most would have been timber-framed; documentary evidence makes it clear that in medieval Bath stone buildings were unusual. But of houses actually visible and datable only two are currently known from before the Reformation. Abbey Church House, called 'Mrs Savils Lodgings Nere the hott Bath' [64] (the only building depicted on Gilmore's map of 1694 that still remains, apart from the Abbey) contains a stone undercroft to a house that was extended *c.* 1400, whose upper parts could still have been timber. No. 21 High Street has the N side wall and gables of a medieval timber-framed building with wattle-and-daub infill (discovered in 2000) embedded in an early C18 recasting, which itself was much altered in the C19 and C20. Just two storeys high (with a timber storey added probably in the C17), it was little more than 16 ft (5 metres) square. The first floor jettied over the street and the timber structure would have rested on a masonry ground floor.

The normal construction was timber framing until the C17; No. 3 Broad Street has a section of C17 timber framing at the rear. However, by the Stuart period houses were being built in Bath with rubble stone walls and gables towards the street, two-, three-, and even four-storeyed [8]. No. 4 North Parade Passage (Sally Lunn's House) of 1622 and its neighbour to the E are rare survivals of this period. Gabled houses of this type continued to be built after the introduction of sash windows, which Wood in his *Essay Towards a Description of Bath*, 1742–3, dates 1695–6. Of these some can be seen in Broad Street and Green Street, as will be found in Walk 2. Others, such as in Broad Quay and Holloway, mentioned in Pevsner's original entry of 1958 in *North Somerset and Bristol*, have since been demolished.

The Georgian Resort

The introduction of sash windows by the early C18 (*see* p. 30), together with classical decoration in the form of pilasters or columns in superimposed orders flanking the doorways and central windows above, and of pediments and balustrades, signalled the introduction of **classicism** to Bath. The Palladian formula of podium, *piano nobile* and attic storey then unified the transitions of style in Bath's housing developments for the next hundred years. Early examples, transitional from Baroque to Palladian, omit the *piano nobile*, with ground- and first- or first- and second-floor windows equally sized. Dated or datable examples are the House of General Wolfe in Trim Street (a street begun in 1707), No. 14 Green Street (a street which was built up in 1716), Beau Nash's first house in Saw Close of 1720, and General Wade's house in Abbey Church Yard [60], which has giant fluted pilasters, of *c.* 1720. With the 1720s and Beau Nash as well as General Wade we have arrived at the crucial moment of the great change in Bath's architectural importance. Up to 1725 the buildings of Bath had been an imitation of Bristol fashion. Now they began to set fashions for the whole of England. As a piece of

town planning, Georgian Bath was to become unique in England and indeed in Europe. And Bath was to become both a pleasure resort as well as a health resort, a city very rare as cities go, devoted almost entirely to leisure. The change is due to three men: Beau Nash, Ralph Allen, and the elder John Wood.

Beau Nash was the oldest. He was born in 1674, failed at Cambridge, failed at the Inns of Court, failed in the Army, then succeeded in making a living out of gambling. He went to Bath in connection with opportunities which he thought Queen Anne's visit to the baths might offer. It is usual to say that Queen Anne's visits of 1702 and 1703 are the beginning of a new era in Bath. Yet nothing might have ensued if Beau Nash (who was a big man of harsh features and not at all a beau) had not stayed on, become assistant to the Master of Ceremonies and in 1704 Master of Ceremonies himself. That year is the turning point. Bath was a place visited for reasons of health only; he made it into a social centre and with the help of dictatorially enforced rules taught it elegance. The lesson was necessary; for Defoe's *Tour* of 1724–6 still tells of raffling shops in the churchyard, walks of the visitors up and down the church, gaming, levity, and mean theatrical plays. Beau Nash's was a slow job, and it might not have had such spectacular architectural reflections, if it had not been for Ralph Allen.

Ralph Allen was born in 1694, and proved his worth first in the postal services in Cornwall. He then became postmaster of Bath, where he remedied the deficiencies of the national postal system by devising cross-posts which he formed himself and which brought him in about £12,000 a year. Allen was one of those instrumental in the improvements which made the River Avon navigable as high up as Bath. Work on this started in 1727. The same year Allen bought the quarries at

Bath's Population Growth

1700	2–3,000	The rate of Bath's development can be seen by its
1750	6–8,000	population growth, from being a small walled city in
1770	15,000	1700, doubling in size by 1750, again by 1770 and again
1800	33,000	by 1800. The early C19 increase reflects the city's
1830	50,000	changing function away from seasonal resort to
1850	54,000	residential town, while that of the late C19 is largely
1900	67,000	due to the inclusion of the villages of Twerton and
1938	68,000	Weston, which strictly lay beyond the city boundary.
1970	84,000	The figures are rounded and approximate anyway
2000	80,000	until the first census of 1801, being based until this time on the number of houses multiplied by occupancy rates.[*]

[*]Source: R. S. Neale, P. Borsay and Bird & Fawcett (*see* Further Reading)

Transporting Building Materials

Adjacent to Prior Park, Allen employed the Bristol engineer *John Padmore* to construct a wooden railway (an idea, used in England from the C17 e.g. in the North-East, mine railways), down the slope of Prior Park Road, connecting his quarries with the yard and wharf where he shipped his stone to Bath, Bristol and beyond. The trucks had flanged iron wheels and a mechanical brake. Horses hauled back up the empty trucks. The railway cut the price of the stone, and was in itself a tourist attraction along with Allen's house. At the yard the stone was dressed into ashlar blocks, then loaded onto barges at the wharf, using a crane that Padmore also built. The improvements to the Avon Navigation also enabled Scandinavian deal timber to be more readily imported, together with Cornish and later Welsh slate for roofing. (Until the mid C18 most Bath roofs had stone tiling, which was quarried E of Bath.)

Combe Down which, by his ability in promoting their product, made Bath stone first acceptable and then famous. He used it for the new N wing of his town house [62] in North Parade Passage (then Lilliput Alley) and then Prior Park [58], his mansion at Widcombe above Bath, which he used as an advertisement for the material. It was designed by the elder *John Wood* and begun *c.* 1734.

John Wood was born in Bath in 1704, the son of a small builder. He was apprenticed as a carpenter, then worked in London in the early 1720s where he knew Edward Shepherd and his development at Grosvenor Square. In the summer of 1725 he was in Yorkshire, and began to turn his thoughts to Bath and possibilities of planned developments there. He settled at Bath in 1727, in which year his son, the younger John Wood, was born. The father's first actual job was for the Duke of Chandos in Chapel Court, and as Edward Shepherd was one of those who worked for the Duke in London and at Canons in Middlesex, it is quite possible that Chandos and not Allen brought Wood to Bath. To appreciate the novelty and the daring of his plans one ought to look at Gilmore's map of Bath in 1694. It is still, with its two suburban ribbons, the medieval town within its walls. (The Corporation tried to thwart building developments and other economic activity outside the city, for example by surcharging on sedan chairs if going beyond the walls.) A Cold Bath had been built (by *Thomas Greenway*) on the river at the suggestion of Dr Oliver in 1704, a modest Assembly House in 1708. A ballroom was added to this in 1720 by *William Killigrew*. What new houses and streets looked like at that time has already been described. There is nothing in all this to prepare one for the scale and style of **Wood's scheme** of 1725. He suggested building in two areas, to

the NW of the walls and to the SE of the Abbey. The former land belonged to Mr Gay, a surgeon of London, the latter to the Duke of Kingston (who had inherited part of the old Priory precinct). 'In each design,' Wood writes in his *Essay Towards a Description of Bath*, 'I proposed to make a grand Place of Assembly, to be called the Royal Forum of Bath; another place, no less magnificent, for the Exhibition of Sports, to be called the Grand Circus; and a third Place, of equal state with either of the former, for the Practice of Medicinal Exercises, to be called the Imperial Gymnasium.'

Wood's wish to revive the splendour of a Roman city is accompanied in the *Essay* by a mythical glorification of British antiquity based around a legendary Druidic civilization. According to Wood, Bath and its hot springs originated as part of a great pre-Roman city comparable with Babylon and ruled by King Bladud, mythical founder of Bath. The Druids were said to have built the megalithic stone circles of Britain to a divine proportional system as revealed by God to Solomon for the building of his temple. This, Wood said, was disseminated to all ancient people by the Jews and used by the Druids before both the Greeks and the Romans. Wood thus invented a British – and specifically Bathonian – antiquity that surpassed classical antiquity.

The theory was not to find architectural expression until the very end of Wood's life, in the shape of the Circus, where the idea of a Druid circle of houses is overlaid with allusions to classical theatre, themes that were united as an interpretation of a single divinely-revealed architecture. But his firm faith in Rome – as seen through the eyes of Palladio – appears at once in his first buildings: the houses of Chapel Court, with their great simplicity, and of Queen Square, begun in 1728. The style must have been felt as a self-denial after Greenway and Killigrew. The **square** as such had by then become the typical centre of planned improvements in England. The first London square had been Inigo Jones's Covent Garden piazza of the 1630s. It had been followed from the 1660s by Bloomsbury Square and St James's Square, and several others. Bristol joined in early with her Queen Square of 1699. But what distinguishes John Wood's from all these save Inigo Jones's is that each of its frontages was planned to one consistent scheme. Simple, utilitarian schemes on the E and S, and on the W a composite scheme with two separate ranges to left and right, a recessed detached range further back in the middle (at the behest of the sub-leaseholder), and a proprietory chapel inspired by Inigo's St Paul Covent Garden. The N side finally, facing S, was treated more grandly as a palace front with attached columns as its principal accent and a middle pediment of five bays' width. Shepherd may have had a similar idea for Grosvenor Square a little before, but it remained fragmentary there, and Wood's is the first palatial treatment of the square in the English C18. All the larger terraces at Bath subsequently follow this model. London did not catch up until the second half of the C18, though squares were much more common there.

Gay leased the land to Wood, and so Wood was speculator as well as architect. He was not the only one to believe in the financial possibilities of new housing at Bath. Concurrently with the Queen Square scheme, to s the riverside area of Kingsmead was built over by *John Strahan* of Bristol, substantially extending the city in that direction. The centres are Kingsmead Square, no more than a junction of streets, the small Beauford Square, and Kingsmead, Monmouth and Avon Streets, the latter streets now much demolished. There is no overall plan here nor an architecture of distinction. The most conspicuous house, Rosewell House of 1735, probably by *Nathaniel Ireson* of Wincanton, Somerset, is indeed in a wild provincial Baroque which must have been as distasteful to Beau Nash as it was to Wood.

For Wood and Nash were, in their respective fields, working for exactly the same ideals, order and discipline as against the homely and showy. The danger for a spa which is inherent in this ideal is dullness. But one neither gets the impression that Nash's assemblies were dull, nor was Wood a dull architect. Queen Square was complete in 1736. The Parades, again a speculation of *Wood*'s, were begun in 1740. The scheme was for a big block of houses with the Grand Parade on the N and the Royal Forum on the Ham to the s. The latter never took shape. After this Wood built very little in Bath for many years, working in Liverpool and elsewhere instead. Then at last, in 1753 he purchased the land for the Circus, and the foundation stone was laid in 1754, twenty-nine years after Wood had conceived such a composition as part of his vision for Bath. He died in the same year. Superimposed orders had been a fashion about 1720–30 in Bath and Bristol. Wood showed in the Circus that their treatment could be as correct and elegant as that of giant pilasters and columns [3]. The **Circus** [9] is the earliest circus in England and Wood's most successful achievement. Even if his original conception for a place for 'the exhibition of sports' seems a ludicrous notion, considered in the context of c18 Bath, it does bear witness to Wood's romanticism, to his infatuation with the grandeur of a Rome which he never visited.

At the time when the elder Wood died, Queen Square and the Circus were isolated showpieces. It was left to his son to complete this great sequence, with Gay Street, completed after 1755 to connect Queen Square and the Circus, Brock Street in the 1760s and at its end, in 1767–75, the supreme Royal Crescent [11]. The Circus is intensely inward-looking, originally paved and with an underground water cistern in the middle – the trees are a later, picturesque contribution – and the middle of Queen Square had a polite formal garden with low planting. The Royal Crescent however was left open to the s – it was not 'landscaped' in any way at the time – and the later crescents higher up were also designed in such a way as to allow communication between the urban building and 'nature unadorned'. For the first time it created *rus in urbe*, providing rural views for every resident – like the prospect from a

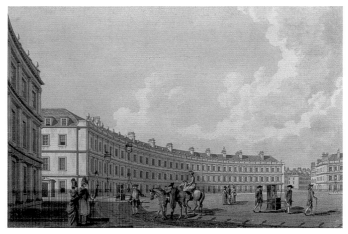

9. *The Circus at Bath*. Watercolour by T. Malton, Jun (1784)

10. *Royal Crescent, as the building works near completion*. Watercolour by T. Malton, Jun (1769)

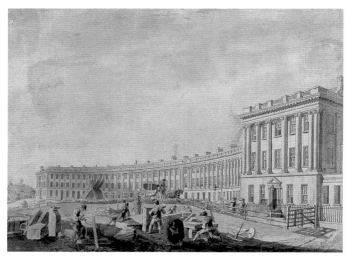

country house but with the advantages of living in town. The sequence Queen Square, Circus, Royal Crescent demonstrates the transition from Bath as an urban conception to Bath as rural, a theme that continued into the C19 with the development of the suburban villa (*see* p. 33).

The Royal Crescent [10] set a precedent for **crescents** elsewhere, though their prevalence outside Bath has been exaggerated and few appear until the 1790s. John Carr's Buxton, Derbyshire, is a close and

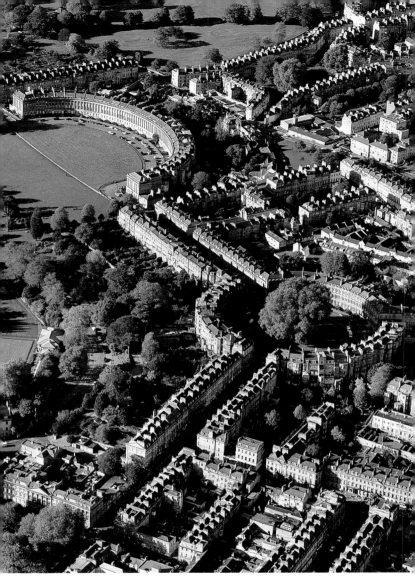

11. Aerial view of Queen Square, the Circus and Royal Crescent

early parallel, also for a spa (begun 1780), but Brighton's Royal Crescent (1798–1807) is only just C18. In London, Dance the Younger's little Crescent in the City (contemporary with Bath's, but which of course did not face an open view) is not picked up on until the mid-1780s (Michael Novosielski's lost crescent at Brompton). The Paragon at Blackheath, begun 1794, is the only London crescent facing an open view – which of course the steepness of Bath makes rather easier, as does that of Clifton,

Bristol (e.g. Royal York Crescent, 1791–1820, and the Paragon, 1809–14, interesting because it turns its convex not its concave side to the valley). But more typical in terms of later C18 development in Bath is *Thomas Baldwin*'s Bathwick in its rigidity (*see* p. 23), like the New Town of Edinburgh. In other words, the lasting legacy of Bath is more the palace frontage rather than the fluid, contour-related crescent.

A whole quarter now grew around the Woods' great achievements, including the younger *Wood*'s Upper Assembly Rooms of 1769–71 and the grid of streets around them, Alfred Street, Bennett Street and Russel Street, built from 1769 to Wood's overall plan. They mostly have standard Palladian elevations of the period and it is difficult to differentiate between the work of the various speculative **builder-architects** who were busy with these developments. *Thomas Jelly*, who worked with *John Palmer*, was involved with Milsom Street, begun 1761; George Street was begun 1762–3. Bladud Buildings, 1755–62, is probably by *Thomas Jelly* or *Thomas Warr Atwood*; the latter certainly built the Paragon of 1768–75 [141]. By *c.* 1800, Bath had grown beyond the Paragon along the London Road as far E as Grosvenor Place (by *John Eveleigh*, started 1791), that is another mile, and also up the steep hillside to the N, where one by one Camden Crescent (*Eveleigh*, *c.* 1787–8), Lansdown Crescent (*Palmer*, 1789–93), Somerset Place (*Eveleigh*, started 1790) and finally Sion Hill Place [96] (*Pinch*, *c.* 1817–20) appeared. Lower down, above St James's Square (*Palmer*, 1790–3), are *Pinch*'s Cavendish Place (1808–16) and Cavendish Crescent [94] (1815–30). That was the end of the Georgian development of Bath on the N side, and Pinch's death in 1827 marks the end of elegant terrace building in Bath. But it should not be forgotten that large areas of artisan housing were also built at this time in conjunction with the grand set pieces, and that these 'poor quarters' have now been all but swept away (*see* p. 44–45), except for fragments such as *Pinch*'s Northampton Street of the 1790s and the early C19 Brunswick street [12].

These later terraces of *Pinch*, as with his terraces in Bathwick – Sydney Place [106] (*c.* 1804–8) and Raby Place [110] (1818–25) – mark the culmination of a development of architectural style away from the purity of Wood. About the middle of the C18 Wood's Palladian style reigned supreme. Then – just as in England in general – a desire appeared for something lighter, more elegant and more lively. Robert Adam satisfied it in London, *Thomas Baldwin* at Bath. But there were also those who dared to abandon the classical style altogether and turn to a playful **Gothicism**, a fashion led by Horace Walpole, even if he had not made it. The associative qualities and affinities for landscape of Neo-Gothic anticipated the Picturesque, as at *Richard Jones's* Priory, Prior Park (*c.* 1740), then at Ralph Allen's Sham Castle ([159]; 1762), a folly on the hill to the E. After this comes the Countess of Huntingdon's Chapel of 1765 [142], stylistically related to Bathwick Villa (1777–9, demolished 1897) and perhaps by the same hand, and Midford Castle, [168] *c.* 1775.

12. Artisan housing, Brunswick Street (early C19)

These, though, are quirky exceptions to the general mood. When Atwood, architect to the city estates, died falling through the floor of an old building in 1775, Baldwin, Atwood's clerk, took over the design and supervision of the Guildhall, High Street (1775–8). The exterior is in the, by now, slightly tired Palladian tradition, but with contemporary details, but the fine Adamish interior was the height of **Neoclassical** fashion [47]. Following the Bath Improvement Act of 1789 Baldwin introduced his new light-hearted style to the rest of the medieval town, cutting swathes through the tangle of streets and lanes, most notably at the delightful colonnaded Bath Street.

The next big **expansion** was *Baldwin*'s layout of the Bathwick Estate from 1788, the land across the river to the SE owned by the Pulteney family. The rural 600-acre (240 ha.) estate was inherited by Frances Pulteney on the death in 1764 of her cousin, William Pulteney, first and last Earl of Bath. The key to its development was to bridge the river. For this her husband, William Johnstone Pulteney* obtained permission in 1768 by a private Act of Parliament, subject to the consent of Bath Corporation. The bridge (Pulteney Bridge) [50] was built to *Robert Adam*'s design in 1769–74, and Frances' daughter Henrietta Laura Pulteney granted ninety-nine-year leases to build from 1787. Baldwin planned a great square to the N and large riverside crescents to the S, and the central spine of Great Pulteney Street [100], which divides around the hexagon of Sydney Gardens [106], was to rejoin and continue on its straight course. But for its curtailment after 1793, when the outbreak of war with France, together with a general rise in interest rates, precipitated the Bath Bank crash, the vast geometric scheme of streets would have rivalled Edinburgh's New Town and dwarfed the scale of Wood's Bath.

Most **house-building** work at Bath was speculative and based on the

*He had his name changed from William Johnstone when they married in 1760.

system first used by Wood at Queen Square, itself based on that normally used in London. Typically, a landowner (for example, the Corporation) and a developer would agree a ninety-nine-year lease on a plot of land. In return, the developer and his heirs made a fixed annual payment, and when the lease expired the property including the houses upon it reverted to the landowner. To minimize his financial exposure the developer in turn sub-let individual plots, frequently to tradesmen who would agree to build a house, at a peppercorn rent and normally within two years. Builders usually required borrowed money, and, besides the bank, wealthy tradesmen such as brewers and victuallers were an important source of loan capital. The façade would be to a specified uniform design, and the construction to a specified standard, and this would be inspected by the developer's surveyor. The builder then advertised the house for sale, and its purchaser would then pay the developer a fixed annual rent for the remainder of the lease. In the case of Queen Square and adjacent streets, the yearly rents from seventy-five houses yielded £305 income to Wood, who paid a ground rent of £137 for the land to the freehold owner, making an annual profit of £168. The market was buoyant for most of the c18, but with the failure of the Bath Bank in 1793 many builders, developers and architects, including Baldwin and Eveleigh, became bankrupt.

The developers were either architect-builders, or professionals such as physicians and lawyers, businessmen, or sometimes the landowners themselves. Architecture had not yet become established as a profession in the present sense, and **architects** were generally builders or trained craftsmen. For example, beside John Wood the Elder, himself a carpenter, Timothy Lightoler was a wood-carver and joiner, Thomas Warr Atwood a plumber and glazier, and John Eveleigh a builder and supplier of materials. The many available pattern books by Batty Langley and others contained design and technical guidance, from practical matters such as staircase and roof construction and fireplace-opening size, to the proportioning of façade and windows and correct detailing of classical decoration. Armed with this knowledge, a

carpenter or mason undertaking the construction of individual houses would produce competent results but also would be confident to design and work intuitively rather than adhere rigidly to rules and patterns. This has resulted in a wealth of subtly individual details in the buildings of Bath. The pattern books also contain valuable advice on surveying and setting out. For example, Batty Langley's *The London Prices of Bricklayers' Materials . . .* (1748) explains how to construct an ellipse using templates. The semi-elliptical Royal Crescent was probably laid out in a similar way.

The **houses** are usually of rubble stone construction faced with ashlar on the street façade, or of single-leaf 6-in.- (150 mm-) thick ashlar without rubble backing for simple houses, and the rear façades are rubble stone, often originally rendered with lime stucco to resemble ashlar. They usually have three storeys, and, where economy ruled out using an actual order, the front elevation is proportioned to imply an order of columns. In addition there is a basement below street level and in the better houses an attic protruding into the roof space. The roof itself is a double mansard for height, M-shaped, behind parapets, with a central valley drained by a hidden gutter to the front or rear parapet. The basement is usually built from ground level so as to be dry and to avoid excavation. Sometimes there is a sub-basement as well, to take up differences of level, as in Great Pulteney Street [13]. In front of the house is an area at basement level, separating the house from the street and

Advertising for Architectural Commissions

The following notice appeared in the *Bath Chronicle* on 28 August 1788:

NOBLEMEN, GENTLEMEN, BUILDERS &c

EVELEIGH, from Eminent Surveyors and Builders in London (late with Mr Baldwin, Architect, Bath) thanks his friends for the encouragement already received and hopes by the probity, accuracy and dispatch of business entrusted to his care, he shall merit their lasting favours, which ever shall be most gratefully acknowledged.

At his Office, No. 11 Bridge-street, Bath will be executed all kinds of Plans, Elevations and Designs in the Gothic and Modern taste, either for New Buildings or Alterations which he will superintend – Also the different Branches Measured for gentlemen and workmen in town or country, Estates Surveyed and Mapp'd, Rents collected, &c. And as he intends Building in the New Town, Bath any gentleman wishing to treat for a House or Houses may see the intended Designs at his Office, or may have them built after their own taste on the most reasonable terms.

N.B. Youth instructed in that noble Science of Architecture.

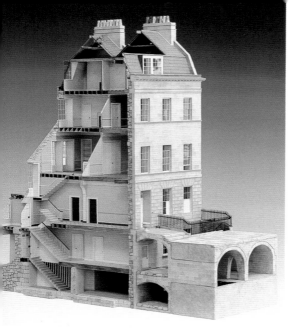

13. Section model of a
Great Pulteney Street
house showing the
layout

bridged across to the entrance. The street itself is formed on a combination of made-up ground and of vaults that belong to the individual houses and contain coal cellars. Many original stone coal-hole covers remain, e.g. in Trim Street, Duke Street and Gay Street. Down the middle of the street is the vaulted 'Grand Common Sewer' to carry rainwater and, in some cases, foul sewage, as with the main drain built under the Upper Walks in 1718 to receive the discharge from the 'house of ease' or public lavatory. In the back garden was a privy (though first-rate London town houses had flushing water closets by the late C18 and it would be reasonable to assume that Bath was not many years behind). Effluent emptied into a cesspit, which was periodically emptied by 'night soil men' with carts.

Bath's houses were unusually well served with water. The city has an abundance of springs that issue in the surrounding hillsides when water, percolating through the limestone, meets impermeable Lias clay. The supply, which had been channelled and collected since Roman times, became especially crucial to the city's later expansion. The basis of the Corporation's agreement to open up Bridge Street for Pulteney Bridge was that water would be piped across the bridge to supply the city. Pulteney estimated that there was sufficient to feed in addition up to 5,000 houses on his own estate, should these be built. The mains pipes were hollowed-out elm trunks, which supplied a cistern in the kitchen of individual houses via lead branch-pipes.

As for **layout**, the basement contains the kitchen and servants' quarters, the ground floor an outer hall lit by a fanlight [19] and an inner hall

Building on Sloping Sites

14. Ramped string course, Sydney Place, by John Pinch the Elder (1804–8)

15. Building along the contour: aerial view of Lansdown Crescent and adjacent terraces

Architects had various ways of dealing with Bath's hilly sites, which were often selected for the views they offered rather than for ease of construction. One solution was to build horizontally along the contour, as with the snaking upper crescents on Lansdown [15]. At the Parades and at the Paragon enormous changes of level were overcome with vaulted basements to create a horizontal surface. Raised pavements are another feature of Bath, where the houses are elevated above the road, as at Walcot Parade. The elder *Wood*'s approach at the Circus was to flatten the entire site by earth moving. He earlier intended this at Queen Square, which slopes gently N to S, but this proved too expensive. Instead, the houses on the E side, and their continuation, Gay Street, simply step uphill, breaking the platband and cornice. A more elegant and unifying method used by *John Pinch* at Sydney Place, Cavendish Place and elsewhere, is the ramped cornice and string course [14], presumably derived from ramped staircase balustrades and dados. The younger *Wood* had first used the device at Barton Buildings in the 1760s. Another solution is that of *John Eveleigh*, who at Somerset Place and Camden Crescent, simply tilts the cornice and band course to follow the slope.

separated by an arch. Off this is the eating room at the front, a parlour at the rear. Very occasionally, as at No. 15 Queen Square and Nos. 7–8 the Circus, the hall occupies the whole ground-floor front with no reception room to one side. The first, principal floor, the *piano nobile*, has a drawing room overlooking the street, usually three bays wide and often

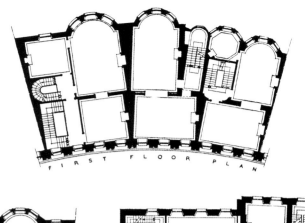

First-floor house plans (Walter Ison):
16. The Circus
17. Royal Crescent
18. Nos. 20 & 19 Lansdown Crescent

interconnected with large double doors to a back room. Sometimes when the view and orientation demand, the layout is reversed with the principal rooms to the rear and the staircase at the front, as at the Paragon and Grosvenor Place. The second floor contains bedrooms, and the attic, low-ceilinged and lit by small dormer windows, contains further bedrooms for children and servants. In the Circus and Royal Crescent, variations in wall thickness accommodate the slightly wedge-shaped plan, so that rooms are rectangular [16, 17].

In all but the simplest houses the interior wall surfaces in the main rooms were divided so as to imply the parts of a classical order, using simple joinery mouldings. The dado, including skirting and dado rail, represents the pedestal, the wall surface the column shaft, and the cornice the entablature. Up to the mid C18 rooms were generally panelled in wainscot to full height, with timber cornices, but they were later plastered, at least above the dado. By the late C18 many standard components were available such as ornamental plasterwork [20], metalwork to half-landing balustrades, cast-iron hob grates and composition

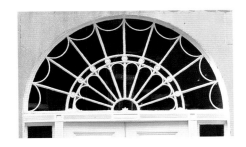

decoration to pine chimneypieces [21]. The latter often reflect the usage of the room, such as Bacchanalian features or wheatsheaves for the dining room and musical depictions for the parlour. The interior fittings were frequently updated and many houses now have later plasterwork and joinery. To the rear is a garden, in major streets backed by a mews house, sometimes with an ornamental façade. Town gardens were rather more intended to be looked down upon from the house than much used, and they generally have simple geometric layouts.

Some individual **public buildings** have already been described above. Others, apart from churches and chapels, and *Thomas Atwood*'s New Prison, Grove Street (1772–3) [103], are mostly associated with the spa, i.e. the younger *Wood*'s Hot Bath (1775–7) [52], *Baldwin*'s Cross Bath (1783–4) [51], altered by *Palmer* in 1798, and the Grand Pump Room, by *Baldwin*, completed by *Palmer* (1790–5) [43]. The city's earliest classical chapel is *William Killigrew*'s St Michael at St John's Hospital, rebuilt in 1723 to replace a C12 predecessor. *Jelly & Palmer*'s St James church (1768–9, demolished), replaced one from the C13. Several

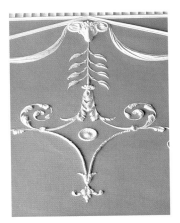
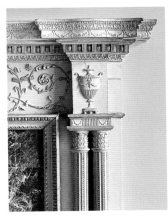

20. Detail of ceiling plasterwork, 39 Milsom Street
21. Detail of pine and composition chimneypiece, Great Pulteney Street

Sash Windows

22. No. 20 Beauford Square, ground-floor window (*c.* 1730)
23. No. 26 Rivers Street, first-floor window (*c.* 1770)
24. No. 40 Gay Street, first-floor window (*c.* 1755, altered c19)

The early c18 windows at Bath have two sashes, each three panes wide and high, known as 'nine over nine', with almost square panes and ovolo glazing bars and meeting rails [22]. By the 1730s, however, the sash became divided with the more normal three-pane width and two-pane height – the more vertical 'six over six' – with increasingly large overall window size and thinner glazing bars giving more illumination and a better view [23]. To increase the sense of contact with the exterior still further, by the mid c19 first-floor window sills were commonly lowered, often cutting through the string band, sometimes tooling it off completely. Meanwhile, the abolition of weight-based duty on glass in 1845 encouraged the replacement of glazing bars with single large sheets of plate glass, and the stonework reveals were often chamfered [24]. At the Paragon, carrying out this work was a condition of renewing the leases in 1870. At the Royal Crescent too what started as a fashion became a condition. In the present day this creates a conservation dilemma: on one hand the lowered sills are incorrect and spoil the façade; on the other, they are uniform (except for No. 1 Royal Crescent, where the sills were raised on conservation grounds well before a debate on the matter raged in the 1990s) and much damage to later interiors would incur. The less invasive and much adopted compromise of inserting glazing bars into the Victorian sashes, however, results in awkward proportions.

churches were built to serve the expanding town, including the elder *Wood*'s St Mary, Chapel Row (1732–4) and *Timothy Lightoler*'s Octagon, 1766–7 [90], both proprietary chapels. St Swithin, Paragon by *Jelly & Palmer* (1777–80) [130] is Bath's only remaining classical parish church. The Countess of Huntingdon's Chapel (1765) [142], which is Gothick, was built for Selina Hastings, Countess of Huntingdon, a prominent member of the Evangelical movement.

Of the **daily activities** of Bath's visitors descriptions abound else-

Glazing Bars

For glazing bars, four patterns of moulding profiles were used in Bath. The earliest and most popular was the **ovolo**, initially as in Queen Square about 1 ½ in. (38 mm) thick, but becoming thinner throughout the c18. The post-1755 houses of Gay Street have 1 ⅛ in. (29 mm) bars and by the 1760s–70s (e.g. Brock Street, Royal Crescent and Rivers Street) they are ¾ in. (19 mm). The most elegant bars, with their delicate reflection of light off their curved surfaces, are **astragal and hollow**, used in the 1790s and early 1800s, just ⅝ in. (16 mm) thick with meeting rails of ¾ in. (19 mm). The **keel mould** (so named after the moulding on medieval vault-ribs that resembles the keel of a ship) is common on shopfronts in the city and later houses on the Bathwick Estate. Finally, the **lamb's tongue** moulding is of the mid to late c19. At this period also, 'horns' appear on sashes, the extension of the styles beyond the mortice and tenon of the meeting rail, to strengthen the frame to take heavy sheets of plate glass. A feature of Bath's sash windows is that they never have timber sills – the lower sash always meets the stone sill directly.

25. Glazing bar sections: Queen Square, Royal Crescent, Sydney Place; keel mould, lamb's tongue

where, of coffee houses (men's and women's), pump rooms, assembly rooms, theatres, pleasure gardens, parades, luxury shops, visits to artists' studios, of beaux, rakes and gamblers, and of the indulgent lifestyle that caused Charles Wesley to say that preaching there was 'attacking the Devil in his own headquarters'. So much is known of Bath society, for men of letters fell in love with Bath, among them Addison, Pope, Smollett, Sheridan, and c18 literature provides many insights. Many also are the contemporary guidebooks and directories, including those by Egan (1819) and Tunstall (1845). They provide information on lodging houses, hotels and banks, sedan chair rates, and names of physicians, surgeons, dentists, apothecaries, chemists, tradesmen, wine merchants, tea merchants, grocers, print and booksellers, dancing masters and artists. The social life and attractions are depicted also in the aquatints, paintings and engravings of artists such as Malton, Rowlandson, Nattes and Shepherd. And the city became an increasingly fashionable destination as journey times from the capital decreased. Before 1680 it took sixty hours and by 1750, thirty-six, but by the 1790s, John Palmer's mail coaches – 'flying machines' – took just ten hours before the visitors' arrival could be announced (for a payment) with a peal of bells from the Abbey.

Spa Water and the Pump Room

Bath spa water contains forty-three minerals, most importantly calcium and sulphate, with sodium and chloride. Dissolved iron gives the rusty staining around the baths and contributes to its flavour. The attraction of Bath grew from the medieval practice of bathing in the water as a cure for diseases such as paralysis, colic, gout and palsy. Late c17 medical ideas introduced the fashion for drinking the water, and the first Pump Room (1704–6), by *John Harvey*, next to the King's Bath, provided shelter for invalids while drinking the prescribed quantity. By the time that this was replaced by *Baldwin*'s Grand Pump Room (1790–5), completed by *Palmer*, it was a favourite morning meeting place of the sick and healthy in equal measure. Open at 6 a.m. (7 a.m. in the low summer season), it was most popular between 8 and 10 but did not close until 4 p.m. to enable patients to drink the prescribed number of glasses at regular intervals. It was more informal than the assembly rooms. There were six to ten musicians, and the entertainment included watching the bathers, and there was a subscription book to signal the arrival of new visitors. The usual practice was for the sick to arrive from their lodgings by sedan chair, obtain a glass of water from the attendant, and consume it whilst moving and conversing, reading notices and perusing the Subscription Book.

The **pleasure gardens**, once an important component of the entertainment, deserve a general note, as all are now vanished except for Sydney Gardens. They were based on those of London and were loosely called Vauxhalls, after the famous garden which Pepys and John Evelyn frequented, which was also known as Spring Garden until 1786. The earliest was Harrison's Gardens, opened in 1708 near the Lower Assembly Rooms. Spring Gardens (1730s–1798) were across the river from South Parade, served by ferry until the construction of Pulteney Bridge. Mrs Willis in *Humphrey Clinker* describes them as 'a sweet retreat, laid out in walks and parks and parterres of flowers; and there is a long room for breakfasting and dancing'. In the quiet Picturesque retreat of Lyncombe and Widcombe there were Bagatelle (*c.* 1770–8; situated between what is now Prior Park Road, Lyncombe Vale and Rosemount Lane), King James's Palace (*c.* 1777–93; now Lyncombe Court), and Lyncombe Spa (now the Paragon School), developed after 1737 with the potential to become a pleasure garden (but it never wholly did). The Gothick-style Bathwick Villa was a pleasure garden between 1783 and 1793. Grosvenor and Sydney Gardens were the last to be established, in 1792 and 1795. Grosvenor, behind Eveleigh's Grosvenor Place, contained archery butts, bowling greens and a maze,

and there were rowing boats on the river. At Sydney Gardens music played an important part in the entertainment and, as at London's Vauxhall, there were covered boxes, open at the front, beside the orchestra so that listeners could sup during the music.

The Nineteenth Century

As Brighton and Cheltenham eclipsed Bath in the early c19 as fashionable resorts, visitors to the city declined in number and society became more sedate. There was a shift away from the public amusements that previously characterized town living, and the idea of a rural retreat in the hills beyond had its attractions. The major c18 terraces and squares were essentially urban conceptions, providing accommodation around the entertainment that was offered in the town. Following the precedent of the Royal Crescent, the later terraces provided Picturesque rural views, as from the rear of *Harcourt Masters*' Widcombe Crescent, *c.* 1805 [124], which turns its back to the street with a plain entrance façade that reflected the suburban and domestic priorities that were then in the ascendancy. *Henry Edmund Goodridge*'s Woodland Place (1826) is also a terrace, but now clearly separated into individual houses with gate piers and porches.

The city's decline as a resort coincided with the outbreak of the French Wars in the 1790s, when building almost stopped, and most terraces begun after 1800 stood unfinished and unoccupied for several years. Speculators turned instead to building **villas** on the fringes, which also had the advantage that the plots could be sold and developed one by one, as at *John Pinch*'s work of the 1820s at Cambridge Place and Bathwick Hill. The Italophile poet Walter Savage Landor described Bath's surrounding hills and 'romantic precipices' as the English Florence, and this 'Italian' landscape provided a Picturesque setting for the villas, each with a borrowed prospect over someone else's land. Several are on the upper slopes of Bathwick Hill – *Edward Davis*'s Oakwood (1833) [114], and *Goodridge's* Montebello – now Bathwick Grange – (1829), Casa Bianca [111] and La Casetta (*c.* 1846) and Fiesole (1846–8) [112]. Others are on Lansdown, including *James Wilson*'s Heathfield (*c.* 1845) and his own residence, Glen Avon (1858–60). They are influenced by, or even anticipate, contemporary pattern books such as John Buonarotti Papworth's *Rural Residences* (1818) and Charles Parker's *Villa Rustica*, (1833–41, 2nd edn 1848). They are early examples of the Italianate style and typically have projecting eaves (except Montebello), asymmetrical planning, and a tower with a room at the top. This, Francis Goodwin says in *Rural Architecture* (1835), may be a 'snuggery, aerial boudoir or a belvedere to guard for the approach of bores from town'.

The informality, asymmetry and contact with raw nature that the villas provided belong to the cult of the **Picturesque**, that movement fostered in the 1790s by Richard Payne Knight, Humphry Repton and

Uvedale Price in reaction to the contrived landscapes of the previous generation. In Price's *Essay on the Picturesque* (1794), he remembers his disappointment in seeing on his visit to Bath 'how little the buildings are made to yield to the ground, and how few trees are mixed with them'. Yet feelings changed from the 1820s, when William Beckford created between 1825 and 1838, beyond the 'embattled gateway' behind his house at Lansdown Crescent, his rambling landscaped progression, a succession of plantations and shrubbery that led from the formal and the urban to the wild and the Picturesque. The sequence culminates with Beckford's Tower by *Goodridge* [156], a severely Greek building, set, like William Wilkins's The Grange, Hampshire (1809), within a natural landscape. Contemporary with Beckford's private, intimate landscape, *Edward Davis* placed an even severer triumphal entrance [137], derived from Soane's latest and most abstracted Grecian Classicism, at the start of his Royal Victoria Park (1829–30), one of the earliest great public parks of the C19.

Beckford's Tower and the park entrance belong to a handful of Classical Revival buildings in Bath designed or influenced by stylistically advanced **London architects**. Davis, who also built a Soanian tollhouse at Bailbrook in 1830, had worked for Soane in 1824–6. But already *George Dance the Younger* had designed the spare Theatre Royal (1802–5) [148], *Joseph Michael Gandy*, Doric House, Cavendish Road (*c.* 1805) and *Wilkins* had added (1809–10) to the Lower Assembly Rooms a powerful Doric portico based on the Temple of Concord at Agrigento in Sicily. The portico was as important as that at The Grange, pure Greek, conspicuously placed, and exhibited at the Royal Academy (which Wilkins' country house porticoes were not).[*] When the building was badly damaged by fire in 1820, *George Allen Underwood*, another Soane pupil and surveyor to the County of Somerset, incorporated Wilkins' Doric portico in his rebuilding of 1824–5 to house the Bath Royal Literary and Scientific Institution. It was demolished in 1933. *Wilkins* in addition designed the Friends' Meeting House, York Street (1817–19), built as a Freemasons' Hall, and – quite likely – the nearly contemporary terrace, Nos. 11–15 York Street opposite. *Samuel & Philip Flood Page* of London designed Partis College, Newbridge Hill, almshouses of 1825–7. *Goodridge* was also receptive to the Greek Revival, and himself built the Argyle Chapel (1821), probably the Bazaar (1824–5) [87] and certainly the Corridor (1825) [74], the Cleveland Bridge tollhouses (1827), Cleveland Place East and West (*c.* 1827–30), and the Eastern Dispensary (1845) [131].[†] The (originally) Royal and Argyle Hotels, Manvers Street (late 1840s) are likely his too. *J. J. Scoles*,

[*] The Greek Revival's origins lay especially with Stuart and Revett's *The Antiquities of Athens*, published as long ago as 1762, with subsequent volumes appearing in 1789, 1794, 1816 and 1830.
[†] Goodridge's assistant at this time was Harvey Lonsdale Elmes, who signed leases on his behalf, until he won the competition to build St George's Hall, Liverpool.

Grecian Ironwork

There is much enjoyment to be had from noticing Goodridge's bold use of ironwork – cast by this time, no longer wrought – derived from L. N. Cottingham's *Ornamental Metalworkers' Directory* of 1823, with anthemia, rosettes and other Grecian decoration: balconies at Woodland Place [26] and Nos. 6 and 9 Cleveland Place West, stair balusters at Fiesole [113], and heavier railings at Lansdown Cemetery (restored) and Cleveland Bridge [134]. Goodridge's name cast in iron on the bridge, as distinct from the contractor's, is also an eloquent indication of the growing professional status of architects, in contrast to the blurred architect/builder role of the c18.

26. Woodland Place, rear balcony detail

27. Norfolk Crescent, balcony detail

at the basilican church of St Paul, Prior Park (started in 1844), turned, not to Greece, but Imperial Rome, or rather c18 Paris, to Chalgrin's Saint-Philippe-du-Roule and Gabriel's chapel at the Ecole Militaire.

At the same time that in such buildings classicism turned Grecian, it is interesting to observe how in the course of the first half of the c19 the **Gothic Revival** gradually turned serious and respectable. To see this progression one must step back – just – into the c18 with Christ Church, Julian Road (1798) by *John Palmer*, the first larger Gothic Revival church in Bath, but really more like a Georgian classical church dressed up. After the insouciant Gothic of the c18 there is then a tendency towards greater archaeological correctness. The first example of this in Bath is the elder *Pinch*'s St Mary the Virgin, Raby Place (designed 1810, built 1817–20) [108], rare as a full-blown Perp Gothic Revival church with a pre-1818 date. That year, the first Church Building Act provided countrywide a million pounds towards a programme of church building overseen by the Church Commissioners, and in 1824 the second Act gave a further half-million. Three Commissioners' churches were built at Bath: Holy Trinity, James Street (1819–22, demolished 1957) by *John Lowder*, Surveyor to the city of Bath; St Mark, Lyncombe, 1830–2, by his successor, *George Phillips Manners*, now with the title City

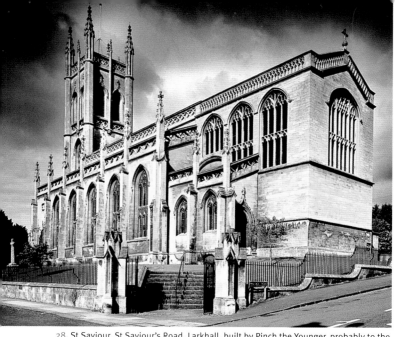

28. St Saviour, St Saviour's Road, Larkhall, built by Pinch the Younger, probably to the elder Pinch's design (1829–32), the chancel by C.E. Davis (1882)

Architect; and St Saviour, St Saviour's Road (1829–32) [28], probably to the elder *Pinch*'s design and built by *Pinch the Younger*. This derives from St Mary the Virgin, and displays some scholarly handling in the details. The same cannot be said of *Goodridge*'s Holy Trinity, Church Road, Combe Down (1832–5) with its absurd polygonal spires. *Manners*' fine St Michael with St Paul, Broad Street, (1834–7) [76] and *James Wilson*'s St Stephen, Lansdown Road (1840–5) represent a further step towards greater awareness of actual medieval examples. It is not until the Roman Catholic St John the Evangelist, South Parade (1861–3) [122] by *Charles Francis Hansom*, that we reach the confident Gothic advocated by Pugin in his *True Principles of Pointed or Christian Architecture* (1841) as being the only appropriate Christian style. Other, mostly less fervent, examples include *George Gilbert Scott*'s High Victorian chapel interior at Partis College; St John the Baptist, St John's Road by *C. E. Giles* (1861–2), enlarged by *Sir Arthur Blomfield* (1869–71); and the distinctly less Puginian, 'lower'-looking Our Lady Help of Christians (St Mary's Roman Catholic) church, Julian Road by *Dunn & Hansom* (1879–81). Bath was a formidably devout city, and the C19 was an era of fervent church building of almost every denomination. Nonconformist examples include the attractive little Temperance Hall (now First Church of Christ Scientist), Claverton Street, 1847, *Wilson & Willcox*'s Hay Hill Baptist Church (1869–70), and Manvers Street Baptist Church, 1871–2. It was also at this time that *Manners* (from 1833) then *George Gilbert Scott*

(1860–73) restored Bath Abbey. Part of Scott's work was to reverse some of Manners' alterations, but his most significant contribution was the completion of the nave vaulting. Scott's pupil *T. G. Jackson* continued his work into the 1920s, building onto the s side of the nave a closed cloister – really a choir vestry – the city's final Gothic gesture.

It was not only the committed Gothicists who revealed distinct anti-classical tendencies during the C19 'Battle of the Styles'. *Edward Davis* experimented with Neo-Tudor for a group of villas at Entry Hill Drive (1829–36), a style with which *Manners* was much at ease, as his villas at Weston Lane and Weston Park (*c.* 1840) illustrate. Tudor-Gothic with its Oxford and Cambridge overtones was considered especially appropriate for institutional or collegiate application, as at *James Wilson*'s St Stephen's Villas, St Stephen's Place (1843) and Kingswood School (1850–2) [155] and *Isambard Kingdom Brunel*'s Railway Station (1840; *see* p. 92). Tudor and 'Jacobethan' remained the favoured styles of *Manners* and his successors, from St Catherine's Hospital, Bilbury Lane (1829) onwards. The practice could equally turn its hand to domestic Georgian (Northampton Buildings, 1820–6), secular Gothic (La Sainte Union Convent, Pulteney Road by *J. Elkington Gill*, 1866–7), or fashionable

Architect 'Dynasties'

Several architects formed father-and-son practices – the elder and younger John Wood, the elder and younger John Pinch, Henry Edmund Goodridge (son of James Goodridge, builder) and Alfred S. Goodridge. The well-known City Architect, Major Charles Edward Davis, who discovered the Roman Baths, was nephew of Edward Davis though they did not work together. George Phillips Manners' practice, however, continued a unique architectural, if not wholly family, dynasty, tabulated below (Wallace Gill was John Elkington Gill's son). The practice office was No. 1 Fountain Buildings between 1846 and 1909. On his retirement, Wallace Gill transferred the practice to Mowbray A. Green, who partnered J. H. Hollier in 1914 and practised as Mowbray Green & Hollier. Frank W. Beresford-Smith acquired the practice in 1947, eventually taken over by his son.

George Phillips Manners	1820–45
Manners & Gill	1845–66
John Elkington Gill	1866–74
Gill & Browne (Thomas Browne)*	1874–9
Browne & Gill	1879–99
Gill & Morris	1899–1903
Wallace Gill	1903–9

*Gill set up the practice Gill & Browne before he died, and it was effectively the practice of Thomas Browne.

Neo-Norman (the unbuilt 1830s Queen's College, Claverton Down, and the former Catholic Apostolic (Irvingite) Church, Guinea Lane, 1841). Romanesque also, but Italianate, are *Goodridge*'s screen wall and gateway to Lansdown Cemetery and the slacker Elim Pentecostal (formerly Percy) Chapel, Charlotte Street (1854) by *Goodridge & Son*. The Italian Palazzo style (unlike Palladian with no *piano nobile*) at *George Alexander*'s Bath Savings Bank, Charlotte Street (1841) [147] and *Charles Edward Davis*'s Police Station and Lock-Up, Orange Grove (1865) [72] provided the opportunity for richness of detail and historical reference within a classical context. *Manners & Gill*'s Palladian extension block to the Royal National Hospital for Rheumatic Diseases (1859–60) and *Major Charles Edward Davis*'s contextually sympathetic side elevation to No. 2 Gay Street (1870) signal the rediscovery of Bath's Georgian architecture by the Victorians. Finally, *Brydon*'s remarkably successful contributions to the public architecture of Bath, the additions to the Guildhall (1893–7), the Victoria Art Gallery, Bridge Street (1897–1900) [48], and the Concert Room, Abbey Church Yard, are not so much Neo-Georgian as Neo-Baroque, a national style looking back to a period not well represented in Bath.

Signs of renewed interest in the Georgian architecture of Bath coincide with its brief **renaissance as a spa** in the later C19. A tentative effort had been made when *Manners* added the Tepid Bath in 1829–30. But by the 1860s hotels were closing, the post of Master of Ceremonies was made redundant and the Corporation tried unsuccessfully to let the Baths on lease. The City Fathers accordingly decided to make a vigorous attempt to revive the spa. Behind Bath Street, they built the New Royal Baths, by *Wilson & Willcox*, opened 1867, and, opposite the Grand Pump Room, a private company built the French Renaissance-style Grand Pump Room Hotel, 1866–9 by *Wilson & Willcox* (demolished 1959), which was linked to the new baths by lift. Meanwhile, the Midland Railway was sufficiently confident to build Green Park (originally Queen Square) Station (1868–9, by *J. H. Sanders*, architect and *J. S. Crossley*, chief engineer) [29] as a branch terminus of the Birmingham–Bristol line. In 1874 it was linked to the Somerset & Dorset Railway which gave access to the s coast. By the 1880s the resort was picking up to the extent that C. E. Davis and Dr Henry Freeman, surgeon to the Royal United Hospital, were sent on a tour of foreign spas to study new treatments. As a result, *Davis* built in 1889 the Douche and Massage Baths for the latest 'Continental' treatments (demolished 1971). Meanwhile, in 1878–9, Davis had discovered and excavated the Roman reservoir around the original spring head beneath the King's Bath, and in 1880–1 he uncovered the Great Bath itself. He carefully preserved the baths and his intention was to protect them with a vaulted roof. However, the commission for an open colonnade instead went to *Brydon* [44], together with a concert room (1895–7) to alleviate the crowded Grand Pump Room, following a competition from which Davis was disqualified by his enemies in the Corporation.

29. Green Park Station, roof structure, by J.S. Crossley, chief engineer, Midland Railway (1868–9)

The final surge of Bath's confidence in its future as a spa town was the Empire Hotel [119], an enormous and eccentric Queen Anne Revival building, with the accompanying Grand Parade, by *Davis* (1899–1901). It is contemporary and comparable with such great addresses as the Midland Hotel, Manchester, by Charles Trubshaw (1898), C. Fitzroy Doll's Russell Hotel (1898) and Imperial Hotel (1898, demolished 1966), both Russell Square, London, and the Ritz Hotel, Piccadilly, London, by Mewès & Davis (1906). Remarkably few hotels in Bath were purpose built and, since the Grand Pump Room Hotel was demolished, it is the only major survivor. It is the last monument to the Victorian city, and marks the end of an era, the brief flowering of the spa already over.

As the city became a place of residence and retirement, the **town houses** changed function from seasonal lodgings to comfortable year-round residences, sustained by large numbers of servants – the 1841 census records 6108 domestic workers, the great majority women. The guidebooks emphasize the city's respectability, religiosity, charity and order (along with modern aspects such as its street lighting and bridges), though the impression is one of dullness, sliding into shabby gentility. Yet today's visitor who comes to see the Georgian city may be surprised to discover the extent of c19 Bath, for as the century progressed it became a place of **commerce and industry**, and steadily

expanded its suburbs – Oldfield Park, Twerton, Weston, Larkhall – to house a working population. As Bath went through its own industrial revolution, the city clung relentlessly to its old image as a genteel spa town. To this day C19 Bath's primary role as a manufacturing centre is little known, and the strength of its economy often underestimated. By the end of the C19 the city produced its own gas, electricity and beer, transported across the country numerous products including cloth, flour, building materials and mass-produced architectural mouldings, and exported manufactures from giant dockland cranes to shorthand manuals to every corner of the world.

The development of a **transport network** gave much impetus to the new industrial prosperity. *John Rennie* completed the Kennet & Avon Canal in 1810, which enabled the shipment of coal and other materials to and from the city, but it was *Brunel*'s Great Western Railway that revolutionized trade and travel. The Bath–Bristol line opened in 1840 and, with the completion of the Box Tunnel the following year, the line connected to London. Brunel built the railway station [57] and goods yard on the SE edge of the Ham near the river across from Broad Quay. The Great Western Railway Act specified laying out Manvers Street, running N into the city centre, for passengers and their luggage (on foot or by carriers with horses), but wagons or carts 'hauling articles of trade' were specifically forbidden. Industry therefore developed around here, but spreading to the w. The Broad Quay area had stone yards, coach builders, maltsters, corn factories, the Pickwick Iron Works, Marshall & Banks' Steam Dye Works, carriers, cranes, weighing machines and a marine store dealer. Larger industries set up along the Lower Bristol Road [149] and the river bank towards Twerton. The famous ironfounding engineers and heavy-duty crane builders, Stothert & Pitt (who in 1851 employed 540 people) moved in 1857 from a foundry in Southgate Street to *Thomas Fuller*'s Newark Works, where they remained until closure in 1987. Isaac Pitman (inventor in 1837 of 'stenographic sound hand') moved the Pitman Press (having printed at home from 1845) to the Lower Bristol Road in 1859, where the firm still is (now called LIBERfabrica [sic]). Further w, Charles Wilkins (and later the Carr dynasty) in the 1830s and 40s employed 800 people at Twerton Mills, with sixty-seven power looms operated by two steam engines; he also employed up to 300 workers who wove cloth at home.

Rubbing shoulders with the noise and dirt of this industrial activity at the beginning of the Victorian era was very considerable poverty, and the Avon Street area, including Milk Street and Corn Street w of Southgate (around the present Bath City College) was a most unpleasant slum. It was home to more than 10,000 people, one fifth of the population, many of whom lived by begging, theft and prostitution, a fact

*To protect the interests of the health resort, the disease was not reported in the newspapers and the Corporation voted against notifying the authorities in London.

again carefully concealed in the guidebooks. In a cholera outbreak in 1832, one third of seventy-two deaths were in this area.* A second outbreak in 1848 resulted in ninety deaths. Only gradually did Bath City Corporation take steps to improve the citizens' wellbeing and education. Bath Union Workhouse, by *Manners* to *Sampson Kempthorne*'s model plan, opened in 1838 to house six-hundred impoverished men, women and children but by 1845 there were 758 adults and 374 children there.* The elder *Pinch*'s United Hospital (1824–6) was extended by *Manners & Gill* in 1861–4 (Queen Victoria conferred the royal title in 1868), and in 1866 the city appointed its first Medical Officer. In 1882 it had 105 beds and treated 1,213 inpatients and 10,379 outpatients. The poor could also obtain medical help at *Goodridge*'s Dispensary, Cleveland Place East (1845) [131], with its ingenious plan, advocated by *The Builder* as a nationwide model for dispensaries [132]. As for education, a number of parochial **schools** were built before the national Education Acts of 1870 and 1880, early ones being *Manners*' Jacobethan-style St Stephen's School (originally Beacon Hill Schools), 1839, and the younger *Pinch*'s Tudoresque Bathwick St Mary School, 1841. In 1848 a factory school was set up for children employed at Twerton Mills. On the grand scale are *James Wilson*'s Kingswood School (built for the sons of Wesleyan ministers, 1850–2) [155] and the Royal High School, Bath (built as the Bath and Lansdown Proprietary College, 1856) [154], Lansdown Road. Of charity schools, the Blue Coat (1859–60) by *Manners & Gill*, replacing a schoolhouse of 1728 by *William Killigrew*, is notable. Educational, instructive and cultural too were the additions to Royal Victoria Park, the Botanical Gardens of 1887 and *C. E. Davis*'s Shakespeare Monument, 1864.

If the poor were bit-by-bit better off, the rich could reflect that Bath had at this time, too, recovered as a polite **shopping centre**. *Goodridge*'s Corridor underwent a major refurbishment in 1870, the year that Colmer's department store opened in Union Street, while many elegant shopfronts of the late Victorian and Edwardian periods, such as *C. E. Davis*'s at Jolly's department store, Milsom Street (1879), recall the very formal shopping in Bath that survived into the mid c20.

The Twentieth Century and Beyond

If the start of the c20 saw the continued waning of the spa – even as the Empire Hotel was under construction – the c21 began with its revival, with the opening in 2006 of the New Royal Bath [35, 53] and the associated refurbished Cross and Hot Baths. In the first four decades of the intervening century the city sank into a somnambulant state from which it was woken by the deafening blast of the Baedeker raids of 1942. The destruction included the recently restored Assembly Rooms, recorded by the Ministry of Works' booklet *Chief Cultural Losses*

*Between 1838 and 1899, 4,289 paupers were committed to unmarked graves in the nearby burial grounds.

through Enemy Action (1949). A brief period of gentle patching and repair followed, and then a period of far greater destruction, this time in a fervour of renewal and redevelopment, before, finally, the will returned to cherish the Georgian city of Beau Nash, Allen and Wood.

After 1900 the Assembly Rooms, barometer of the spa's prosperity, fell on hard times. To postpone bankruptcy, Gainsborough's portrait of Captain Wade, Master of Ceremonies 1769–77, was sold in 1903 (bought back by the council in 1988), and the last Master of Ceremonies, Major Simpson, tried to revive the Rooms with balls in period costume. The Royal Flying Corps occupied the building in the First World War, and then in 1921 the ballroom became a cinema.

New buildings often conceded nothing to the Georgians, but their Arts and Crafts refinement no longer displayed the bombast of the Victorians. *F. W. Gardiner*'s Bayntun's Bookshop and Bindery, Manvers Street (1901), originally the postal sorting office, with gables and ironwork, is a fine example. Millbrook School by *C. B. Oliver*, 1902, now residential, also has attractive Arts and Crafts detail, as do *Wallace Gill*'s St Michael's Church House, Walcot Street (1904, gabled Jacobean) and No. 108 Walcot Street by *Silcock & Reay* [129]. Even *Charles Voysey*, one of the leaders in the style, built a charming, if somewhat uncharacteristic late work, a house now called Lodge Style (1909) [166]. *W. A. Forsyth*'s Domestic Revival-style Posnett Library at Kingswood School (1924–6), with a finely crafted roof structure, is a late derivative of Arts and Crafts. Also at Kingswood School is the War Memorial Chapel, by *Gunton & Gunton* of London (1920–2), Neo-Perp but with good oak joinery in the Arts and Crafts tradition. Also belonging to this tail end of the Gothic Revival is *H. S. Goodhart-Rendel*'s Chapel at the Royal High School, Lansdown Road (1939–50). By far the most delightful – and least-known – of the c20 historicist churches is the Church of Our Lady and St Alphege, Oldfield Road (1927–9) [169], by *Sir Giles Gilbert Scott* (grandson of Sir George Gilbert Scott). It is an Early Christian basilica based on Santa Maria in Cosmedin, Rome. The interior is as perfectly managed as the exterior, and Scott considered it one of his best works.

If propriety dictated historicism for institutional and church buildings, hints of fashionable Art Deco were popular for retail and entertainment premises [92]. Even so, politeness and understated elegance are bywords for 1920s Bath shopfronts, as at No. 19 New Bond Street (1922). The jazzy style is similarly low key with cinemas – see the very inoffensive sort of Art Deco of the Egyptian-style Beau Nash Picture House (later Canon Cinema) in Westgate Street by *A. J. Taylor*, 1926 – or is concealed behind well-mannered façades that match the Georgian. Such is the case with *W. H. Watkins & E. Morgan Willmott*'s Forum cinema at the junction of St James's Parade and Somerset Street (1933–4), with its wonderfully outrageous Art Deco interior [123], which is deferentially Bath stone clad and classical where it meets the street.

As for the Modern Movement, Bath was untouched, save for *Mollie Taylor*'s reinforced concrete Kilowatt House, now Woodside House (1935–8), built for a highly individual, not to say eccentric, client. In early C20 Bath it is only **industrial buildings** that make expressive use of new building materials and techniques, and in this respect the city, with its C19 industrial background, was up to the minute. The reinforced concrete pyramidal roof to a barley-drying kiln in the Malthouse, Lower Bristol Road, is an early British example of the *Hennebique* system (*c.* 1900), and *Hayward & Wooster*'s reinforced concrete grain silo on Lower Bristol Road (1913) followed the latest model.

Art Deco caprice and industrial functionalism apart, most large buildings of this period in Bath are contextually classical: the beginning of a re-evaluation of the Georgian city that is a world away from the eclectic late C19 interventions of Major Davis. Early examples are *Dunn, Watson & Curtis Green*'s Old Bank (now NatWest) at Nos. 15–17 High Street (1913–14) and *Sir Reginald Blomfield*'s freely classical remodelling of the Holburne Museum (opened 1916). The Post Office [75], on the NE corner of New Bond Street, by the *Office of Works* (1923–7), is a most accomplished building and a telling stylistic contrast to its previous headquarters. From the thirties are *W. A. Williams*' Electric Light Station offices and showrooms (1931; scheduled for demolition), *L. G. Ekins*' Co-operative Wholesale Society Building, Westgate Buildings (1932–4) and – domestic this time – *Axford & Smith*'s competent South Lodge, Sion Hill (1932) with a superb entrance screen and railings.

Along with this new recognition of the Georgian, we find a first glimmer of the **conservation movement**. As long ago as 1908, *Herbert W. Matthews*, architect for Capital and Counties Bank, restored Baldwin's rusticated ground floor to No. 47 Milsom Street. This was probably an individual decision rather than City policy, but a more sure sign came in 1937, when, on behalf of the Corporation, *Mowbray A. Green* advised *G. A. Coombe* and *F. N. Waller* of the *Prudential Insurance Estate Department* to restore the first floor of No. 42 Milsom Street. Earlier, in 1931, Ernest Cook (*see* p. 88) anonymously bought the Assembly Rooms for £31,000 and donated them to the Society for the Protection of Ancient Buildings. They were then passed on to the National Trust, in turn leased to the Corporation, and restored by *Mowbray Green* with *Oliver Messel* (1936–8). The Assembly Rooms became a symbol of rediscovered Georgian Bath, having attracted the attention of national bodies like the SPAB, the National Trust, and the Georgian Group (formed in 1937).

Most significant, however, was the passing of the **Bath Corporation Act** in 1937, which required a list of protected buildings to be drawn up. In consultation with the Bath Preservation Trust, established in 1934, 1,251 buildings were included, though only the façades were protected. This pioneering scheme predated by a decade the principle of listing at a national level, embodied in the 1944 Town and Country Planning

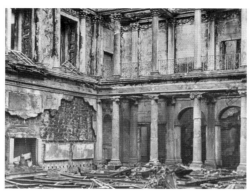

30. Bomb damage of 1942, the Assembly Rooms

31. Royal Crescent, Patrick Abercrombie's proposal for a Centre of Civic Administration (1945)

32. 'The Sack of Bath'. Demolition work in progress

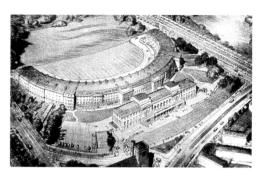

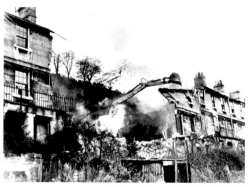

Act. At this time, urban planning and 'civic design' were generally seen as the route to solving urban problems of sub-standard housing and traffic flow. This emphasis stimulated considerable interest in c18 Bath, which was regarded as a pioneer – even though, in reality, the layouts that planners admired were not particularly well co-ordinated with each other.

Then came the attacks of 25–26 April 1942, part of the so-called Baedeker offensive following the allied bombing of the historic

German city of Lübeck. Over 400 people died, 329 houses and shops were totally destroyed, a further 732 were demolished, and 19,147 buildings were recorded by the City Engineer as receiving some damage. Among the architectural victims were the s side of Queen Square (the Francis Hotel, then Queen Square Hotel receiving a direct hit), some houses in the Circus, Royal Crescent and Norfolk Crescent, Abbey Church House, the churches of St Andrew and St James, and – most important – the iconic Assembly Rooms [30]. (It was ironic that the decision to rebuild the last took twelve years – until 1954 – as the National Trust and Bath City Council debated for and against.)

The year after the bombing, the influential architect and town planner *Patrick Abercrombie* was commissioned to advise on Bath's **reconstruction**, and in 1945 he published *A Plan for Bath*, a radical framework for the city's development. Abercrombie was nationally known for his promotion of free-flowing traffic and the replacement of sub-standard housing. The key to this was zoning. In the case of Bath, the centre was to be divided into ten 'precincts', each with a different function, and separated by traffic circulation including an inner ring road with roundabouts round zone No. 1, roughly following the line of the walls. In line with thinking at the time, there was an emphasis on preserving and isolating the most important buildings, at the expense of much demolition, including most of the s part of the centre. The scheme included converting the middle of the Royal Crescent into a Centre of Civic Administration, linked to a new council chamber and committee room at the rear, after demolition of the mews [31]. Another proposal was for a concert hall s of the Abbey, involving the demolition of Abbey Green. The scheme was never carried through, but its influence remained for many years, in particular the principle of retaining the architectural set pieces and 'clearing' much of the remainder [32]. The lack of mention of lesser buildings in Walter Ison's *The Georgian Buildings of Bath* (1948) and in Nikolaus Pevsner's original entry in *The Buildings of England: North Somerset and Bristol* (1958) helped create a rationale for this apparent ambivalence towards the Georgian architecture, in the effort to create a new and better world.

As for **new buildings**, the Moorlands Housing Estate, by *J. Owens*, City Engineer, and *P. Kennerell Pope*, Chief Assistant Architect, was the first completely new City Council development after the war, completed by 1950. Its semi-detached and terraced houses in Bath stone, with gardens and sheltered play areas, were seen as a model of respect for the Georgian tradition while being unashamedly modern. Other postwar council housing includes the higher density Phoenix House, Julian Road by *Hugh D. Roberts* (1951–3), Snow Hill, by *Terence Snailum* of *Snailum, Huggins & Le Fevre* (1954–61), and Ballance Street Flats, by the City Architect and Planning Officer *Dr Howard Stutchbury* (1969–73). The southern half of the commercial centre was comprehensively redeveloped from the early 1960s. The insipid Arlington

33. City of Bath College, by Sir Frederick Gibberd (1957–63)

House, by *K. Wakeford, Jerram & Harris* replaced the Grand Pump Room Hotel; *Monro & Partners'* Marks & Spencer building and *W. B. Brown's* (former) Woolworth block replaced several pre-Wood listed houses in St James Street South, while *E. Norman-Bailey & Partners'* Northwick House dominates New Orchard Street. The whole E side of Southgate Street and Philip Street was demolished for *Owen Luder Partnership's* Southgate Shopping Centre (1969–72) and the adjoining multi-storey car park. The other area that suffered was Kingsmead. Developments in James Street West included the City of Bath College by *Sir Frederick Gibberd* (1957–63) [33], Rosewell Court by *Hugh Roberts* (1961), and the social security office, Kingsmead House (1964–5) by *W. S. Frost* for the *Ministry of Public Building and Works*, who also designed the former Telephone Exchange in Monmouth Street (1966–7). The last major demolition was the Holloway area to the s, for Calton Gardens, private housing by *Marshman Warren Taylor* (1969–70).

Abercrombie had emphasized the need for traffic control back in 1945, and the council by the sixties considered the problem to be acute. In 1963 it sought the advice of *Colin Buchanan & Partners*, engineers and planners, who published *Bath: A Planning and Transport Study* in 1965. This proposed solving E–w traffic congestion by constructing a 560-yd. (510-metre) tunnel under the centre from Walcot Street to New King Street. Part of the scheme was the proposed redevelopment of the s end of Walcot Street, including a multi-storey car park, hotel, offices and law courts, with raised pedestrian circulation. Of these, the car park and Hilton (formerly Beaufort) Hotel were actually built, by

34. Incised street
names, c18 (above)
and c20 (below)

SUNDERLAND STREET

SUNDERLAND STREET

Snailum, Le Fevre & Quick (1972). After nearly 15 years of debate the Buchanan scheme was then abandoned, the Walcot Street area having remained blighted as a result.

About 1,000 Georgian buildings, of which some 350 were listed, were demolished between 1950 and 1973. By the sixties, **preservation groups** and the council were increasingly at odds. The Bath Preservation Trust was strengthened in 1967, when Major Bernard Cayzer presented it with No. 1 Royal Crescent [85] (restored as a museum by *Philip Jebb*, 1970). Slowly, the tide of demolition began to turn, and it is significant that in 1968 *Colin Buchanan & Partners* produced *Bath: A Study in Conservation.** Another sign was the refusal of permission to demolish the s side of Kingsmead Square in 1969, and instead the houses were restored, by *David Brain & Stollar* (1974–6). In 1973 Adam Fergusson's *The Sack of Bath: A Record and an Indictment* drew nationwide attention to this *cause célèbre*. It swiftly resulted in a strengthening of the law, notably Conservation Area legislation, and in a general sense helped to bring about the increasing appreciation of historic buildings that took place in the seventies.† Later still, in 1983, the National Trust purchased woodland and farmland around the city, to preserve its green setting.

The city authority had nevertheless acted to conserve the most important monuments, and from 1955 grants were also made available under the Bath Terraces Scheme (extended in 1979 as the Town Scheme). The first project was to restore the badly eroded façade of the Circus. An immense amount of carving was replaced, the rest cleaned, black paint to door and window reveals removed (perhaps applied to match soot-blackened façades), and glazing bars inserted (a decision made by a committee that included Sir John Summerson). The repair of General Wade's House [60] for the Landmark Trust in 1976 by *Brain & Stollar*, consultant *Professor Robert W. Baker*, made early use of lime-based conservation techniques.

Earlier measures to improve the **streetscape**, such as the 1970s restoration of overthrows and lamps in Lansdown Crescent, continued into the 1980s and 90s and beyond. Council policy for shopfronts was towards Victorian–Edwardian Revival, such as No. 6 Princes Buildings by *Graham Finch*. Projects by residents' associations, the City and others included the restoration of railings in St James's Square,

*One of four reports, together with Chester, Chichester and York, jointly commissioned by the Government and the councils.
†The City of Bath's powers were anyway capped when local government reorganization in 1974 created a new Avon County Council that was also the highway authority.

Catharine Place and the Holburne Museum, and much re-carving of street names by *Peter McLennan* [34]. Notable 'urban repair' schemes at this time included the rebuilt Plummer Roddis Block, between Upper Borough Walls and New Bond Street, by the *Alec French Partnership* (1980–3). Smaller restoration projects meanwhile demonstrated the viability of lesser Georgian houses for present-day living, such as St Ann's Place, New King Street, by *Aaron Evans Associates* (1987) and Circus Mews, by *MWT Architects* (1986–95).

The latter part of the C20 saw various examples of imaginative **adaptive reuse**. A museum, now the Museum of Bath at Work, opened in 1969 within a former royal tennis court of 1777 on Julian Road. *Stride Treglown Partnership* regenerated Green Park Station in 1982–4 as shops and other facilities. *Aaron Evans Associates* restored the Countess of Huntingdon's Chapel [142] and *Michael Brawne & Associates* converted it to the Building of Bath Museum for the Bath Preservation Trust (1984–8), and a brewery of 1810 in Parsonage Lane behind No. 33 Westgate Street became flats, as part of a larger mixed-use project of 1996–9 by *Aaron Evans Associates. C. E. Davis*'s Police Station and Lock-up, Orange Grove, of 1865 meanwhile became a restaurant in 1998, and *BBA Architects* constructed apartments within the shell of Bath Electric Tramways Depot off Walcot Place (2000–2).

As for good **new architecture**, we are getting ahead of ourselves and must step back. By far the biggest grouping is the **University of Bath**, built on open fields at Claverton Down, the last major area of the city to be developed [162]. The entirely new campus is the only successful and fully realized example of Bath's various postwar plans. It was born of the technological optimism and social invention of the 1960s, but had historical roots in immense proposals 130 years earlier for Queen's College. The University received its charter in 1966 and completed the core campus 1967–80 [162]. It became Bath's biggest employer, the size of a small town, with some 10,000 staff and students (cf. Bath's population of about 80,000). Yet the campus is remarkably non-Bath in character, on the face of it even alien. Its own community with its own architecture, of its time and set in an exposed landscape that is more Scandinavian than indigenous, in a location that is both discrete and discreet, it is little known by the majority of the population. Further, whilst Bath's *raison d'être* was the pursuit of leisure and culture, the University's Development Plan of 1965, by *Robert Matthew, Johnson-Marshall & Partners* (*RMJM*), was specifically for a technological university, formed out of Bristol College of Science and Technology. This transferred here by an accident of events – a chance conversation at a formal dinner – to become one of the country's leading universities. *RMJM*'s core campus is a megastructure ordered around a central spine and with a raised main level that separates pedestrian and vehicular movement. Contained yet expandable, the original campus now has many additions, notably a series of buildings by *Alison & Peter*

Smithson, their major works after the early 1970s. These were conceived as 'tassels' to the fringe of the campus fabric, and include One West North (1978–81; originally the Second Arts Building), the Department of Architecture and Civil Engineering (1982–8) [164], and the Arts Theatre (1989–90, completed later).

Apart from the university, other significant buildings of this time were based on **industry**. *Yorke, Rosenberg & Mardall*'s Bath Cabinet Makers' Factory (now part of Herman Miller), Lower Bristol Road, has an innovative space-frame roof structure of 1966–7. The Herman Miller Factory, Locksbrook Road (1975) [171], by the *Farrell Grimshaw Partnership*, was designed to foster a pleasant work environment and to be adaptable, with a large-span structure and demountable cladding. Of worthy infill buildings within the city at this time there is relatively little to report, despite the City Council having, since 1965, engaged eminent consultants to advise on design – *Sir Hugh Casson, Roy Worskett* (following his departure as City Architect and Planning Officer) and *John Darbourne*. *Alan Crozier-Cole* in 1965–9 completely rebuilt the s side of Chapel Court at the Hospital of St John the Baptist, in a style which echoed buildings that used to stand on the site. *Gerrard, Taylor & Partners* in 1971–2 replaced *Davis*'s Douche and Massage Baths in Stall Street with a persuasive building in Baldwin's style, while the *Oxford Architects' Partnership*, with advice from *Worskett* as City Architect, extended the Francis Hotel, Queen Square into Barton Street (1977–80), with a rigorously C20 design. A crop of indifferent shopping malls followed, on significant sites. The vaguely classical Podium, by *Atkins Sheppard Fidler & Associates* (1987–9), stands on the site of the intended law courts in Northgate Street. *Rolfe Judd Partnership* in 1988–9 built a shopping mall behind the N façade of Bath Street, now a department store, with a crude pedimented extension overlooking the Cross Bath. Shires Yard, by *Bristol Team Practice* (1988), in rustic 'heritage' style, links Milsom Street with Broad Street. The contextual classicism of *Aaron Evans Associates*' Seven Dials in the Saw Close (1991) is altogether more successful, holding its own against the Theatre Royal next door. New residential buildings from this 'heritage' era were generally Georgian pastiche, e.g. Cavendish Lodge, Cavendish Road, by *William Bertram & Fell* (1996) and Combe Royal Crescent, Bathwick Hill by *David Brain Partnership* (2001–2).

Contextual also are the Magistrates' Courts, North Parade Road by *Chris Bocci* (1987–9) their steeply pitched roofs relating to *J. Elkington Gill*'s former La Sainte Union Convent to which they are attached. The public waiting area on the first floor is a striking space. Also conceived as a 'public' space is the wedge-shaped double-height hall and conservatory at the Bridgemead Nursing Home, St John's Road [107], by *Feilden Clegg Design* (1989–92), one of a hierarchy of spaces that vary in scale and degrees of privacy. King Edward's Junior School, North Road, by *Alec French Partnership* (1989–90) is also arranged around a wedge-shaped central space, an open library to which all the other spaces relate.

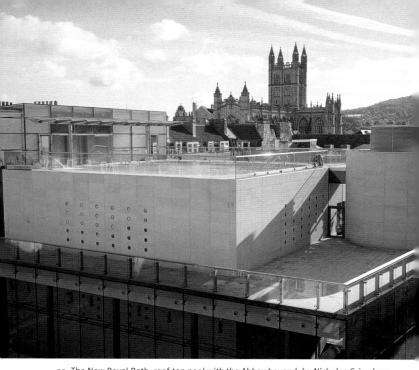

35. The New Royal Bath, roof-top pool with the Abbey beyond, by Nicholas Grimshaw & Partners (1999–2006)

Feilden Clegg Design's Kingswood Day Preparatory School (1991–5) [97] on the other hand is organized along a toplit linear 'street', for it is set inside an old kitchen garden wall and enjoys its sunny, protected enclosure. *Nealon Tanner Partnership*'s St Andrew's School, Julian Road (1991) and Widcombe School, Pulteney Road (1995–6) each creates its own protection against the road, with heavy rubble walls and small openings to the street. Light, colourful indoor classroom spaces [140] nestle behind and open on to sheltered outdoor play spaces.

The c20 closed with the completion of the Wessex Water Building, North Road [161] by *Bennetts Associates* (1999–2000), a model office headquarters on Bath's rural periphery designed for environmental sustainability and in a careful relationship to the site. The building is finely detailed in Bath stone and glass with large metal sunshades. The c21 opened with the completion of the New Royal Bath [35, 53] and the associated renovation of the Hot Bath, Cross Bath and Hetling Pump Room, by *Nicholas Grimshaw & Partners* with conservation architects *Donald Insall Associates* (1999–2003). The new building is unmistakably of its date, not of the past, sensitive to its site and forming a discreet backdrop to the Hot Bath. Bringing together themes of conservation, contemporary design, and adaptive reuse, the complex once more celebrates the hot springs that were Bath's making.

Major Buildings

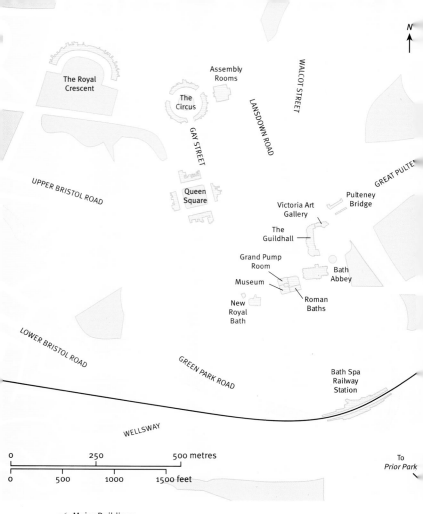

N

The Royal
Crescent

Assembly
Rooms

WALCOT STREET

The
Circus

LANSDOWN ROAD

GAY STREET

UPPER BRISTOL ROAD

GREAT PULTE

Queen
Square

Victoria Art
Gallery

Pulteney
Bridge

The
Guildhall

Grand Pump
Room

Bath
Abbey

Museum

New
Royal
Bath

Roman
Baths

LOWER BRISTOL ROAD

GREEN PARK ROAD

Bath Spa
Railway
Station

WELLSWAY

0 250 500 metres

0 500 1000 1500 feet

To
Prior Park

36. Major Buildings

Bath Abbey

Abbey Church Yard

This is an ex-monastic Benedictine church now in an urban setting, having lost its associated buildings, much like Selby or Southwark. It is also a very consistently designed C16 monastery church, one of the last to be built on such a scale. Traces of the (larger) Norman church remain within. To this day, the Bishop is called Bishop of Bath and Wells, as the two churches retain a joint title as equal seats of the Bishop following a papal decree of 1244.

History and Introduction

A 'convent of holy virgins' received land at Bath from King Osric of the Hwicce in 675. Nothing is known of the convent but it could have been built from Roman buildings demolished for salvage, for which ample archaeological evidence exists. Perhaps, as at Gloucester, the community was originally a double house, i.e. for monks and nuns together, for in 757 a charter granted land s of the Avon to the 'brethren of the monastery of St Peter at Bath'.* In 959 Edgar reunited the kingdoms of Wessex and Mercia, and in 973 he was crowned here by Archbishop Dunstan of Canterbury as the first king of all England.

In 1088 John de Villula of Tours, previously William Rufus' physician, became Bishop of Wells, and following a decree of 1075 that bishops' sees ought to be in populous towns, obtained licence to remove from Wells to Bath. In 1091 the King granted him the whole city of Bath along with the abbey, which were both royal possessions. Here he resided, nominally as abbot; the former abbot became a prior, and the bishop's *cathedra* or throne was in the priory church. It was sustained resentment by the canons of Wells at the loss of their *cathedra* that led to the joint bishopric title as a means of resolving the conflict.

The Saxon church is entirely unknown to us. In 957 its 'marvellous workmanship' is referred to. It was probably located under the present church: excavation has made clear that it was not s of the medieval abbey, and Cheap Street was an early route running E–w just to the N.

The **Norman church** was begun by John of Tours, together with associated buildings including a cloister on the s side, monastic

*The dedication became St Peter and Paul from around the time the name of the diocese reverted to Bath and Wells.

quarters, and a palace for himself in the sw corner of the close. He also rebuilt the main hot spring, which became known as the King's Bath, and brought it within the close. Work began in the mid to late 1090s and the church was up to the lower vaulting at John's death in 1122. The church was damaged when a fire destroyed much of the city in 1137.* It was consecrated some time between 1148 and 1161 during the incumbency of Bishop Robert of Lewes.

The Norman church was immense. The entire present church is built on the foundations of just the nave, and the E front incorporates part of the w wall of the Norman crossing and transepts. These were broad, with both E and W aisles (cf. Old Sarum, Wiltshire), and the E end was apsidal with an ambulatory and radiating apsidioles. The floor level of the nave was some 6.5 ft (2 metres) below the present floor; the area in between is filled with post-medieval burial vaults. Fragments are exposed below gratings in the floor; the best survival is on the N side of the choir. The composite nave piers were apparently of the type of Norwich, Ely and Peterborough, as was the W end, with a giant niche flanked by turrets. Norman C12 fragments of zigzag and other decoration as well as sculpture are preserved in the Heritage Vaults Museum (*see* p. 58) and in the Choir Vestry s of the s aisle.

When Bishop Oliver King (formerly secretary to Henry VII) first came to Bath in 1499 he found the Norman church to be seriously delapidated. King had a dream in which angels were ascending and descending a ladder from heaven and a voice said: 'Let an olive establish the crown and a king restore the church.' Following demolition of the old nave, work began on the **present church** in 1502, and the new E end was ready for roofing in 1503. William Birde, in 1499 elected prior, effectively the bishop's deputy, carried on the project, outliving King by twenty-two years (King's successor never visited Bath – *see* p. 62). The church was substantially completed under Birde's successor, Prior Holloway (1525–33). The old E end beyond, still standing in the 1540s, was probably used while the new church was built. Bishop King's master masons were *Robert* and *William Vertue*, who were also the king's masons. (Robert Vertue appointed *Thomas Lynne*, mason, to carry out the work on site.) William may have built the vaults at Henry VII's Chapel at Westminster Abbey, and also the vault of St George's Chapel at Windsor. They promised Bishop King the finest vault in England. They said that 'there shall be none so goodely neither in England nor France' – though when this promise was made, neither the vault of Henry VII's Chapel nor that of King's College Chapel at Cambridge had yet been begun.

Much of the existing Norman crossing wall was possibly incorporated. The crossing arches stood on piers with strong coupled shafts

*Evident from a study of Romanesque mouldings; exposed faces are fire-reddened and whitewashed.

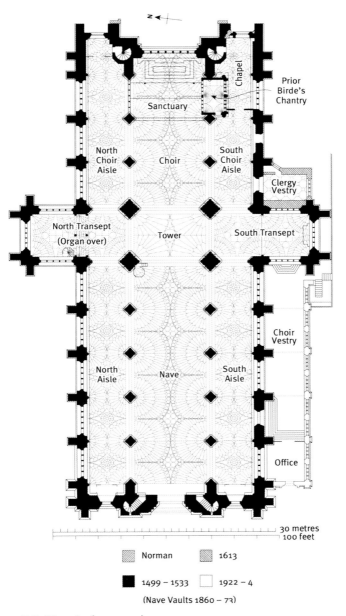

N

Chapel

Prior
Birde's
Chantry

Sanctuary

North
Choir
Aisle

Choir

South
Choir
Aisle

Clergy
Vestry

North Transept
(Organ over)

Tower

South Transept

Choir
Vestry

North
Aisle

Nave

South
Aisle

Office

30 metres
100 feet

Norman

1613

1499 – 1533

1922 – 4

(Nave Vaults 1860 – 73)

37. Bath Abbey, plan (begun, 1502)

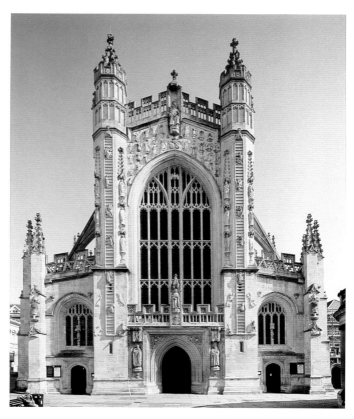

38. Bath Abbey, the west front

to each main side and thinner shafts in the angles. The bases of two of these are exposed on the exterior of the present E front. Blocked-up Norman arches survive internally in the E wall at the end of the present choir aisles. These were the original access from the nave aisles to the transepts. Only the voussoirs of the N arch are visible, but the s arch has roll mouldings and, on its left side, a column with a block capital and a plainly chamfered abacus. This was revealed in excavations of 1863–71. Above the choir vaulting the E wall has slots for horizontal timbers, perhaps for an intended flat ceiling before the decision to build vaulting.

After its dissolution in 1539 the monastery was sold to Humphry Colles of Taunton. He passed it on in 1543, by now stripped of its lead and other materials and the nave roof demolished, to Matthew Colthurst of Wardour Castle, Wiltshire, the M.P. for Bath. His son Edmund Colthurst gave the building to the city in 1572 to become the parish church. Queen Elizabeth I visited Bath in 1574 and authorized a

Manners' Restoration

This began with the clearance of the congested Wade's Passage to the N side, 1825–35. (The N wall retains scars of the houses' pitched roofs, built against the Abbey.) Lord Manvers also demolished buildings to the s side in 1833. In 1833–4 Manners replaced the missing pinnacles along the nave and choir, and to the turrets of the tower and the w and E ends. Those on turrets replaced short openwork ones that had disappeared by 1816. To receive these the E turrets were converted from rectangular to octagonal (the head mason *Vaughan* priced the pinnacles at £4 10s. and £2 10s. each for large and small respectively). He also added flying buttresses (at £55 each) to the nave to match the originals of the choir, and replaced triangular-pattern parapets to the aisles with battle-mented ones of upright design to match those of the w front. Such was the public controversy that the alteration caused, dubbed by the news-papers 'War of the Pinnacles', the Corporation sought the opinion of Edward Garbett, who vindicated Manners' scheme.

national collection for repairs and reconstruction. Subsequent work included the crossing vault (late C16, paid for by the city) and s transept vault (early C17). Finally, Bishop Montague (1612–16) gave the nave a timber roof with a ceiling of Tudor-Perp ribs with plaster infill, giving the effect of a flattened vault. A small clergy vestry of this date E of the s transept is interesting for its ceiling, as it shows what Bishop Montague's nave roof was like. In the C17 and C18 'much company' walked in the church in wet weather (Celia Fiennes). The church served from this time as a kind of covered cemetery; the nave piers had clus-ters of monuments, later removed to the side walls. Structurally the church remained substantially unaltered until the C19, but many changes were made to the fittings (*see* p. 62).

There were two major **restorations**, first from 1833 by *G. P. Manners* and then in 1860–73 by *Sir George Gilbert Scott* for the rector, Charles Kemble, who paid for half the work. Scott's scholarly work was the most comprehensive and included the reversal or replacement of Manners' alterations. Commissioned in 1860, he prepared a three-phase scheme for which estimates were approved in 1864; annual reports monitored the work, 1865–72. Scott made two substantial internal alterations. He replaced Bishop Montague's Jacobean timber and plaster ceiling over the nave with the originally intended fan vaulting to match the choir; and he opened the interior from end to end to enable it to be used for very large congregations. *T. G. Jackson* (Scott's pupil) carried out further restoration work in 1899–1901 and later, on the w front and con-tinuing Scott's programme of renewal and replacement of Manners'

work. A further programme in the 1990s included conservation of the w front and exterior, cleaning of the interior, and making a museum in the c18 secular storage vaults on the s side (architect *Alan Rome*, succeeded in 2001 by *Chris Romain*).

The **measurements** of the church are: length 201 ft (61.3 metres), width 123 ft (37.5 metres), height of vaults 78 ft (24.8 metres), height of tower 162 ft (49.4 metres).

Exterior

The church is throughout quite exceptionally uniform in design. The system, once it had been established, was not altered in any major way. The outer walls sit on the Norman foundations and much stone was reused in other foundations and in the structure behind the new facing. The detail – and the uniformity – owe much to *Scott* and to some extent *Jackson*. Scott restored the E, W and large transept windows, and returned the pinnacles and parapets to their original appearance, changing Manners' solid pinnacles to lower, pierced ones. He also replaced Manners' flying buttresses to the nave (which were hollow) with structural ones, because he was also vaulting the nave. By 1904 Jackson had repaired and rebuilt flying buttresses on the SE aisle, and built two new flying buttresses at the W end of the nave to correspond with those at the E end of the choir. In 1906 Jackson replaced Manners' six remaining pinnacles to the E end and those of the tower to match Scott's, and two of Scott's that had deteriorated (because of this Jackson used Clipsham stone from Rutland).

The choir is three bays long. The aisles have broad five-light windows, buttresses, battlements, and a parapet with pierced arcading. The clerestory windows, also of five lights, are higher and have steeper arches. Flying buttresses between them, also pinnacles, battlements, and a similar pierced parapet. At the E end is a very tall seven-light window with three transoms and tracery below them. The window has three-light sub-arches and elaborate panel tracery. It is square-framed at the top with tracery in the spandrels. Plain three-light aisle windows, rising pierced parapets. Low-pitched parapet over the main E window and turrets flanking the choir. The turrets are polygonal but were originally rectangular (altered 1833). The transepts have no aisles and strike one as somewhat narrow in comparison with the spaciousness of nave and choir. They have in their end walls five-light windows with three transoms much as the E window. Battlements, parapet and pinnacles also are as at the E end. The **clock** in the N transept is to *Edward William Garbett*'s design, maker *Lautier*, 1834. Of the nave not much can be said that would be new. It is five bays long.

However, the **w front** [38] deserves attention as an original and poetical version of the E end theme. Basically it is the same, except that the design of the big window is different. It has only two transoms. The window has clearly visible stonework in the springing of the arch that

39. Bath Abbey, Jacob's Ladder, detail of the west front

is set to form a lower head than was finally built. The tracery was completely renewed *c.* 1865 by *Scott*. The aisle windows do not appear to be original either, but it is unclear when they were restored. Of the carved figures, those noted below as original date from 1500–40. Others date from restorations of: *c.* 1900 by *Jackson*, sculpture of this date by *Sir George Frampton*; 1959–60 by *Lord Mottistone* and *Paul Paget*; and 1991–2 as part of the overall conservation of the w Front by *Nimbus Conservation Ltd.** The main w doorway has a four-centred head, richly moulded jambs and arch, and in the spandrels good carvings of the emblems of the Passion, with considerable evidence of polychrome. The side entrances are insignificant, and altogether the appearance of the relatively low aisles in section, as it were, is not an advantage. The w **door** was given by Bishop Montague's kinsman, Sir Henry Montague, in 1617, conserved in 2001–2 by *Hugh Harrison*. It is splendidly carved with arms, drapery and cartouches, with some recarving as part of Manners' restoration. Either side of the main doorway are two figures, of cruder, provincial quality and almost certainly later than the original carving, not too badly preserved as external C16 sculpture in England goes. The left figure, St Peter, is carved lower than the right figure, St Paul, probably to take a mitre (leading people to think that the head was lost, and the face re-carved into the beard). The buttresses between nave

*Plaster casts of the statues made in the 1860s, when they were considerably less eroded, aided the 1990s conservation work.

and aisle fronts are decorated by the unique motif of ladders on which little angels ascend and descend [39]. This commemorates Bishop King's dream. The lower angels are original, retained to illustrate their poor condition. The next pair up are of 1959–60 and the remainder were carved in 1900 in Clipsham stone. The descending angels are iconographically incorrect. In its upper part the buttresses are polygonal, and here they are flanked by three tiers of figures, original except where noted, some of which have been identified. The sequence is left to right. On the lower tier are St John the Evangelist, the Virgin Mary, St Andrew and St John the Baptist. The middle tier right-hand figures are St James and, by *Peter Watts*, 1959–60, St Matthew; this is unlikely to refer to the original it replaced. The top tier outer figures are St Philip by *Laurence Tindall*, 1991–2, and St Bartholomew and the canopy of *c.* 1900 are by *Frampton*. Above the main doorway are battlements, and in the middle is the statue of Henry VII by *Frampton*. Above the main window is the Heavenly Host (original and heavily decayed) gathered round a statue of Christ in Majesty and a cardinal's hat showing that the work was completed under either de Castello or his successor Wolsey. This in its present form is also by *Frampton*. In the aisle windows are small figures in niches, of uncertain date, perhaps C18. The rebus on each angle buttress, the olive tree and the crown with a mitre, a pun on the name 'Oliver King', was completely renewed by *Peter Watts*, 1959–60.

Now the **crossing tower**. It is much broader than it is long, being built on existing foundations of a bay of the Norman nave, and the surprising thing is that this has no seriously upsetting effect visually.* It has polygonal angle buttresses – not a Somerset, rather a Berkshire to Wiltshire motif – ending in polygonal turret pinnacles, and the same pierced arcaded parapet as the rest of the church. The tower is of two stages; the upper holds the two bell-openings on each side, of two lights with two-centred arches to the N and S, of four lights with four-centred arches to the E and W. The openings are set in a square framing. On the stage below the same composition and motifs are repeated blank and much larger. Attached to the S side of the nave is a choir vestry in the form of a covered cloister built in 1922–4 by *Jackson* as a war memorial, and dedicated 1927.

Interior

The interior [40] is impressive for its even lightness, with no break at all from W end to E end. The High Altar is placed against the E wall, without an ambulatory behind. The arcade is not high. The piers are not specially slender. They have four shafts and in each diagonal two

*An oblong crossing tower was also intended for St George's Chapel, Windsor, and St Mary Redcliffe, Bristol.

40. Bath Abbey, the nave looking east

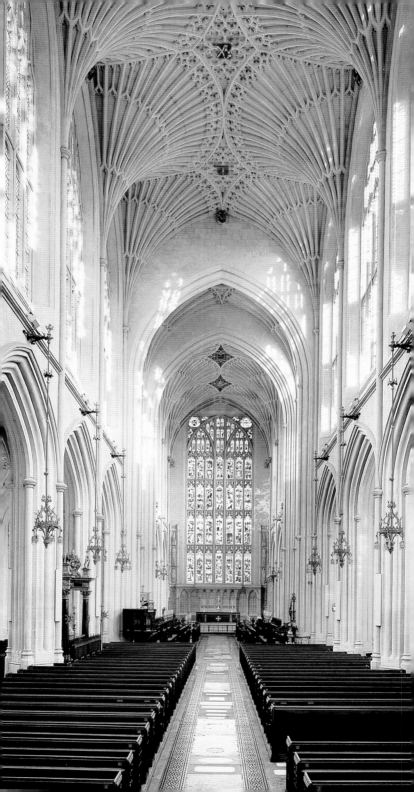

broad waves. The arches are four-centred and depressed. Tall clerestory – that is a tendency to even proportion between lower and upper stage. The finest piece of architecture is the **fan-vault** extending throughout aisles, choir and nave. The square inner framing of the E window indicates that those of the choir were not planned at once. Bishop King died in 1503, and on the vaults both in choir and aisles are the arms of his successor Cardinal Adriano de Castello (1504–18) (who never came to England) and of Prior Birde. The fans are constructed in ribs and panels. The smaller aisle vaults have pendants. The tower vault dates from the time of Elizabeth I, and the S transept vault from that of James I. The nave received its fan-vaults only in the C19 as part of Scott's restoration, at a cost of £37,000. The Priory cloisters were demolished in the C16 but two entrance doorways remain. One is E of the transept in the S choir aisle (now leading to the clergy vestry, built in 1613), the other, from the nave, now the bookshop entrance in Jackson's choir vestry. W of this is the former entrance to the prior's lodging. In the 1990s, the interior was cleaned for the first time, including the memorials, by *Nimbus Conservation Ltd. Tempus* with *Ivor Heal Design Group* created a Heritage Vaults Museum (opened 1994) on the S side in empty vaults. It contains Romanesque architectural remains and an archaeological *in situ* dig.*

Furnishings

George Vertue's print of 1750 illustrates a splendid Georgian choir screen surmounted by an organ, together with Bishop Montague's pulpit. C18 services took place in the choir. Double galleries in the choir were added in the second half of the century, for the numerous visitors to Bath who lodged nearby, as well as residents. *Manners* later made further alterations, removing the screen and organ and constructing a new screen to the design of *Edward Blore* further E. Nothing remains of Manners' work except his arrangement of monuments (*see* below). *Scott* removed the screen, relocated the organ to the N transept, took out the galleries and renewed many fittings.

Reredos. By *Scott*, 1875 (Decalogue removed, 1930s). – **Statues** either side of the E window, 1929–39, by *F. Brook Hitch* from designs by *A. G. Walker*, architect *Sir Harold Brakspear*, representing St Alphege, St Dunstan, John de Villula and Bishop King. – **Sword rest** (crossing pier). 1916. – **Statue** (N transept). King David, *c.* 1700. One of three wood figures attributed to *Caius Cibber* from *Abraham Jordan*'s organ of 1708. (The organ was transferred to Wells in 1838 and sold to Yatton, Bristol in 1872, when the figures were disposed of; they were found in a furniture shop in 1925, presented to Yatton, then the figure was returned, 1952). – Five-light **gasoliers** by *Scott*, made by *Skidmore* of Coventry,

*Outside the entrance is a sculpture of the Risen Christ, carved *in situ* by Laurence Tindall in 2000. It depicts the moment when Christ rends the funeral cloths that bind his body.

Monuments

There are plenty of monuments in Bath Abbey – some 640 of them – but the majority are minor late C18 and early C19 tablets. Urns are ubiquitous. Signatures abound. The most widely patronized sculptors were *Thomas King* and *Reeves & Sons*. Major monuments are almost entirely absent. They nonetheless provide rich social documentary on those from across the kingdom and overseas who retired to Bath, or who came to take the waters and failed to find a cure. There are many minor Bath names of social interest, too. Examples include: (s aisle) William Oliver M.D., d. 1716, illegitimate father of the more famous eponymous physician, inventor of the Bath Oliver Biscuit; Robert Brooke, d.1843, of the Royal Crescent, 'late of the Bengal Civil Service'; W. B. Farnele, d.1829, 'Apothecary for nearly 44 years to the General Hospital in this City'; (NW vestibule) Sarah Fielding, d.1768, sister of Henry Fielding; (N aisle) Sir Isaac Pitman, d.1897, inventor of Pitman's shorthand. Abbey registers show that 3,879 bodies were interred under the Abbey floor, buried within the walls up until 1845, though many memorials refer to those buried in other churchyards, or in the Abbey cemetery outside the city centre (*see* Walk 8, p. 221). Many more were lost when Manners cleared the nave pillars of monuments in the 1830s and fixed them to the walls. The chief monuments are described from the E end to the w on the s side, returning E on the N side.

1870s; converted to electricity in 1978. – **Triptych screen**. E end of the N choir aisle in the St Alphege Chapel, 1997. St Alphege is surrounded by the bones and boulders that were used to martyr him. Designed by *Jane Lemon* and embroidered by the *Sarum Group*. – Wrought-iron **rail** (St Alphege Chapel). Originally the altar rail, probably by the Bristol smith *William Edney*. Given by General Wade 1725, sold to William Beckford in 1833 who installed it at Lansdown Crescent. Restored to the Abbey in 1959. – **Fonts**. E end of the N choir aisle, 1710. Moulded polygonal bowl with band of inscription; the underside deeply and Baroquely fluted.* In Prior Birde's Chantry (E end of s choir aisle), a portable oak font of *c.* 1770. On a slender quatrefoil cluster column. Acorn finial. – w end of s nave aisle, carved stone font, by *Scott*, 1874. – **Pulpit**, by *Farmer & Brindley*, *c.* 1870. – **Organ.** The carved case and console are by *Jackson* from a *Hill, Norman & Beard* organ of 1912–14. The positive organ case of 1972, cantilevered from the organ gallery, is the design of *Alan Rome*. The present *Klais* organ of 1997–9, consultant *Nicolas Kynaston*, com-

*Cover. Polygonal, like a spire; given by Thomas Bellot in 1604, now in the Heritage Vaults Museum.

bines entirely new work with reused components from all periods. These include the original by *Smith* of Bristol (1837–8), and *William Hill*'s rebuild of 1868 (when the instrument was re-positioned in the N transept), which in turn underwent several reconstructions.

Stained glass. There is a very large Victorian display here. Some windows were damaged or destroyed during air raids in 1942; postwar work replaces bomb-damaged windows. Those that are now plain glass are not mentioned. Clockwise from the W end, N aisle, nave. N wall, windows 1–3 and 5 by *Clayton & Bell*, 1872, 1866, pre-1889 and 1870 respectively. No. 2 incorporates much glass from the original window of 1614, depicting the Lamb of God, symbols of the Evangelists, and seven shields of the St Barbe family. Window 4, *Bell* of Bristol, 1951, depicts the arms of C17 benefactors, salvaged from the clerestory windows of *c.* 1604–20 damaged in 1942. One heraldic panel was retained in the clerestory to show their original position. N transept, N and E walls, *Powells* of Whitefriars, 1922 and 1924. N aisle, choir, window 2, *Powells*, 1947–56 (replacing a C19 window by *Bell* of Bristol). NE window, *Bell* of Bristol, 1949, designed by *Edward Woore*. E window, by *Clayton & Bell*, 1873, severely damaged in 1942, was restored by the great-grandson of the designer, *Michael Farrar Bell*, 1955, at a cost of about £17,000. The original E window glass was probably destroyed after the Dissolution. Thomas Bellot paid for its reglazing with a gift of £60 in the early 1600s; fragments are preserved in the clerestory windows. SE window by *Bell* of Bristol, 1952, showing the supposed interior of the Norman cathedral. Progressing E–W, S choir aisle, windows 1–2 by *Burlison & Grylls*, 1914 and 1870, 3, *Ward & Hughes*, after

1872, formerly in the N aisle where the armorial window now is. S transept, E, by *Burlison & Grylls*, installed 1953 (replacing a *Ward & Hughes* window), S transept, S, by *Clayton & Bell*, 1873, restored. S transept, W, *Burlison & Grylls*, 1914. Nave s aisle, E–W, 1–4, *Clayton & Bell*, 1868, 1873, 1862, after 1868, and *Ward & Hughes*, 1869. S aisle, W wall, by *Bell* of Bristol, 1869 (presented by the contractors engaged in the restoration, 1864). W window, *Clayton & Bell*, completed in stages, 1865–94. N aisle, W wall, by *Chance Bros*, 1862 (the earliest extant window other than the C17 armorials).

Monuments. Chantry Chapel of Prior Birde, begun in 1515: choir, S side, E end. Two bays with four-light four-centred openings on the long sides. Crested transoms, thickly foliated spandrels and frieze. Inside an exceedingly pretty vault, fans, but over the altar a closely panelled coving instead. Birde's rebus, a bird, is over the doorway and in the frieze, very characteristic of the early C16 (cf. e.g. Alcock's Chantry Chapel at Ely Cathedral, Cambridgeshire, with its many representations of cockerels). *Edward Davis* restored it in 1833 and finished Prior Birde's incompleted carving. – **Wall cross** of bronze, a wall altar and a wrought-iron gate by *Sir Harold Brakspear*, 1930.

Other monuments. On the 'exterior' N wall of Prior Birde's Chantry, right of the altar, Sir George Ivy, d. 1639 and wife; brass with kneeling figures. – Bartholomew Barnes, d. 1605 and wife. Large hanging monument of alabaster and touchstone with the usual two kneeling figures facing each other across a prayer-desk. But the sculptural quality is uncommonly high, best seen in the small figures of children kneeling in the 'predella'. – Opposite, to the left of the altar, Lady Miller d. 1781, by *John Bacon Sen.* A usual Bacon composition. Two female figures lean over a pedestal with an urn. On the pedestal portrait medallion in profile. Obelisk background.

In the S chapel: S wall; Granville Pyper, d. 1717. Good, of reredos type, with well-carved cherubs. – Mary Frampton d. 1698. Bust on the top; inscription by Dryden. – Dorothy Hobart, d. 1722, also with bust on top. Signed by *John Harvey* of Bath. – Elizabeth Winckley, d. 1756. No more than a small oval tablet with a portrait in profile. – N wall: the painter William Hoare, d. 1792. Very classical. A kneeling angel holds a portrait medallion. By *Chantrey*, 1828.

South Choir Aisle. Sir Philip Frowde, d. 1674; excellent, a little swaggering bust in front of a trophy. Among the weaponry and armour is a small grotesque. Probably by *John Bushnell.* – Admiral Bickerton, d. 1832 by *Chantrey*, 1834. In the Grecian taste. Kneeling woman by an urn. – Dr Sibthorp (Professor of Botany at Oxford, author of *Flora Graeca*). By *Flaxman*, 1796. A small monument. He walks in profile from the Styx towards a Greek temple, in a short cloak with a Hermes hat hanging down from his neck and holding flowers in his hands. A delightful vignette even if a little funny.

South Transept. Several relatively inexpensive versions of compositions familiar from village churches, e.g. Elizabeth Moffat d. 1791 by

Reeves, Mary Boyd d. 1763. – Joseph Sill, d. 1824. Still the standing woman by an urn, but now in a Gothic surround. – Jacob Bosanquet, d. 1767, by *W. Carter;* no portrait, but a very fine relief of the Good Samaritan. – Archdeacon Thomas, d. 1820. By *Gahagan.* Faith stands by a column with a Greek inscription. – Lady Waller, d. 1633. One of the few earlier monuments. Alabaster and touchstone. By *Epiphanius Evesham.* She lies; in a half-seated position behind, her husband, Sir William, commander of the Parliamentarian troops at the battle of Lansdown (1643), who erected the monument. His effigy is defaced, as Pepys noted in his diary, 16 June 1668. Two children seated frontally at head and foot, behind big black Corinthian columns which carry a pediment. – Lady Wentworth, d. 1706. Two putti hold a medallion with a portrait bust.

South Aisle. Beau Nash, d.1761. Plain tablet with inscription in a Siena marble surround, 'Bathonie Elegantiae Arbiter'. – William Baker, d.1770, a merchant. By *J. F. Moore.* Allegorical relief with Justice, an anchor, a figure of Plenty and a Turk with a camel. – Anne Finch, d.1713, pretty cartouche with cherubs. By *Joseph Catterns.* – Caleb Hillier Parry, d.1822, eminent physician. Sarcophagus surmounted by books and a serpent. – Mrs Reeve, d.1664 and sons. Brass plate. Probably engraved by *George Reeve.* – William Bingham, an American senator, d.1804. By *Flaxman,* 1806. Inscription flanked by female genii holding wreaths. – John Hay Balfour, d.1791. By *Reeves,* with an awkwardly flying cherub at the top. – Leonard Coward, a lace merchant, d.1764. Weeping cherub at the foot between an urn and a skull. Against the s wall of sw porch. – Venanzio Rauzzini, d.1810. Swagged theatrical curtain engraved with a musical score. sw porch. – Lt-Col. John Mervyn Nooth, d.1821, with Fame blowing a trumpet.

Nave w wall. Herman Katencamp, His Majesty's Consul General in the Two Sicilies and in Spain. By *John Bacon Jun.,* 1808. Large female figure, by an urn nicely wreathed with flowers. – Col. Alexander Champion, d.1793. By *Nollekens.* Obelisk background, and standing angel with portrait in an oval medallion.

North Aisle (from w). Jonathan Henshaw, d.1764 [41]. Amply draped woman by an urn. – Lt-Col. Robert Walsh, d.1788, the last in a family line. A broken column in an oval surround. – James Tamesz Grieve of Moscow, physician of the Empress Elizabeth of Russia, d.1787. Simple sarcophagus. – Below, his wife, Elizabeth d.1757, with charming relief of a reading man, an allegorical female figure flying to ward off Death (a skeleton), and Father Time (by *Harris,* according to Wright's *Historic Guide,* though several monumental masons bore that name). – Brigadier-General William Steuart, d.1736. Telling portrait relief in profile in a circular medallion against an obelisk background. – Towards the nave: the largest monument in the church: Bishop Montague, d.1618. By *William Cure,* mason (who also provided the *plat,* i.e. the design) and *Nicholas Johnson,* carver. Perhaps not entirely in its origi-

nal state. Recumbent effigy on tall tomb-chest. At the head two black Corinthian columns carrying a piece of entablature. The same motif at the feet – that is, not a four-poster.

North Choir Aisle. Henry Harington, M.D., d.1816. Relief with organ and music. – Fletcher Partis, d.1820. Relief of the Good Samaritan. – Andrew Barkley, d.1790. Two standing women with urn and portrait medallion. – Richard Chapman, d.1572 and William Chapman, d.1627. Flanked by skulls. The Abbey's oldest monument. – The actor James Quin, d.1766. By *Thomas King*. Just an eloquent portrait relief in an oval medallion. Inscription by Garrick.

The Grand Pump Room and Roman Baths

Abbey Church Yard and Stall Street

The **Grand Pump Room** and associated baths played a pivotal role in the life of Georgian Bath, as a combined social and medicinal centre. The principal surviving baths in the complex are the mostly post-Roman King's Bath and Roman Great Bath; a third, the Queen's Bath, was removed in the late C19. The description is ordered: exterior of the main blocks; interiors; the Roman Baths and Temple of Sulis Minerva. The Roman remains are comprehensively described elsewhere (*see* Further Reading) and this account does not attempt to repeat that work but describes the component parts the visitor can discover today.

The Grand Pump Room, 1790–5, by *Thomas Baldwin*, completed by *John Palmer* after Baldwin's dismissal in 1793, replaced John Harvey's Pump Room of 1704–6 (enlarged in 1751 by the addition of a fifth bay to the w). Baldwin's side elevation to Stall Street, designed as a screen wall just three bays wide flanked by colonnades N and s, is particularly successful and one of the best displays of masonry in Bath. The composition forms part of his masterpiece of urban planning that includes Bath Street to the w, a result of the Bath Improvement Act of 1789 (*see* Walk 1, p. 109). The **colonnades** (the N is open and the s, blank) each have nine bays of unfluted Ionic columns and a three-bay pediment containing sphinxes facing a wreathed oval with a relief of Hygieia. The s colonnade, built 1788–90 (Baldwin's plans having been approved the year before the Act to build the whole), formed the frontage to the first phase of the development, the New Private Baths. These had dressing rooms with en-suite baths; the building is now the exit from the Roman Baths. *C.E. Davis* added a corner block to the s in 1889, the Douche and Massage Baths, which was demolished and replaced by a convincing building in Baldwin's style, 1971–2, by *Gerrard, Taylor & Partners*. This contains the Roman Baths shop and offices above. Baldwin's open colonnade to the N, completed in 1791, screens Stall Street from the Abbey Church Yard. Between the twin colonnades the w front of the Grand Pump Room proper is completely windowless, but made interesting by vermiculated rustication and four strongly modelled roundels on the ground floor. Above are four pairs of coupled unfluted Corinthian columns. In the three bays are

slender arched niches with balustraded aprons and pediments on consoles with swagged friezes.

The seven-bay N **front** facing the Abbey Church Yard is less satisfactory, with a portico that relates uncomfortably to the colonnade. Baldwin intended a detached portico (excavations in the 1980s revealed the footings for this aborted scheme) and Palmer's main alteration was to attach the portico to the N façade, presumably for economy. This gave it a stuck-on afterthought appearance, further weakening the effect. The façade is wide with a three-bay portico of giant Corinthian columns rising from the ground and carrying a pediment, which remains below the main intermittently balustraded parapet. The pediment contains an oak-and-acorn-wreathed concave panel and the entablature, a raised and gilded inscription, 'Water is Best' in Greek. Only the architrave of the entablature and first-floor sill band carry across the façade to tie the composition together. In between are five oval windows (more appropriate to an attic than a first floor) set in rectangular panels. The angle bays break boldly forward with large arched upper windows in the bays, the left side with an elegant doorcase, double Ionic columns and a pediment, balancing the entrance with the colonnade on the right-hand side. The window joinery is all C20 restoration.

To the E is a successful continuation by *John McKean Brydon*, 1895–7, won in competition in 1894 and subsequently redesigned. Built following the discovery of the Roman Baths in the 1880s, it contains a concert room with a domed centre, with a Palladian pedimented front. A one-storey wall links this with the Grand Pump Room on the right and continues to the left with a curved corner to enclose, as a screen wall, the Great Bath on the S side (*see* below).

42. Bath chairs lined up outside the Grand Pump Room (photograph *c.* 1900)

The **interior** of the Grand Pump Room [43] is no disappointment after the façades. It is one large saloon, 60 ft (18 metres) by 46 ft (14 metres) by 34 ft (10 metres) high, with attached giant fluted Corinthian columns, a coved ceiling and broad semicircular apses under semi-elliptical arches at the E and W ends. The columns divide the long walls into five bays, each of those on the N wall with a window and a clerestory. On the opposite wall each second bay contains a fireplace and panel above, and the centre, a small glazed apse holding the fountain by *C. E. Davis*, 1888, now rebuilt in a plainer form. The W apse has a serpentine-fronted musicians' gallery with a wrought-iron balustrade and, below, an orchestra platform. The E apse has a niche containing a **statue** of Beau Nash, the Master of Ceremonies, probably by *Joseph Plura*, 1752, working in the studio of Prince Hoare. Below is a fine long-case **clock** by *Thomas Tompion*. Both are from the old Pump Room. The clock, together with C18 triple-backed rout **benches** (the centre-back reflecting the oval windows) in the SE ante-room are important pieces of architectural furniture. *Ian Bristow* redecorated the interior in the 1980s. The room is remarkably festive, especially when the musicians play. From the windows to the S can be seen the King's Bath (*see* below), the open-air bath of Bath before Ralph Allen and Nash made the city into a spa of polite manners. Here men and women splashed about, as can be seen from a C17 drawing [7]. This explains why Nash in his Rules of 1742 had to preach to the gentlemen and lady patrons of Bath the most elementary rules of good behaviour and to embroider on his theme with such forced jocularity.

The **Concert Room** by *Brydon* is of course thicker and richer in its decoration than the Grand Pump Room. It has a coffered dome with a glazed lantern and apses with half-domes either end. Attached marble composite columns support the main entablature. A Venetian window at the N end and a Diocletian window at the S end light the apses. The planning and decoration derive from Wren's St Stephen Walbrook, London. Vaulted corridors on the N and E sides have porphyry Tuscan columns, paired pilasters and black and white marble floors. Impractical for music performance, the Concert Room now serves as a splendid reception hall to the Roman Baths complex, which continues under this building and under the Grand Pump Room. The museum was laid out in 1897 around *in situ* Roman remains immediately N of the Great Bath. In 1983, the museum was extended under the Pump Room following the excavation of the Temple Precinct.

To the S, Brydon's Tuscan colonnade and terrace enclose the Great Bath (*see* below), with a pierced balustrade at high level. Statues by *G. A. Lawson* on the parapet depict the eight Roman emperors and generals especially connected with Britain. Emperors: Julius Caesar (a replacement by *Laurence Tindall*, 1989–90, following vandalism), Claudius, Hadrian, Constantine the Great, Vespasian. Generals: Ostorius Scapula (defeater of Caractacus), Suetonius Paulinus

43. The Grand Pump Room, interior, by Thomas Baldwin, completed by John Palmer (1790–5)

(defeater of Boudicca), and Agricola. The N side has a glazed loggia of five Diocletian windows with triple keystones, under a pent Roman-tiled roof (originally open; permanently glazed only in the 1920s). A doorway with a Gibbs surround opens on to the terrace at either end; these doorways are reflected by corner pavilions opposite. On the w side are further remains of *Davis*'s Douche and Massage Baths of 1889. The Roman levels are described below in the order in which they are encountered.

The **Temple Precinct** lies directly beneath the Pump Room. Excavations in 1981–3 revealed part of the inner Temple forecourt N of the Sacred Spring. The area visible is restricted by the Pump Room foundations. Interpretation is further complicated by the subterranean nature of what was, in Roman times, an open courtyard paved with large Blue Lias slabs. The visitor must imagine the pavement continuing under the Pump Room foundations to the N and around the Temple podium to the w. Areas of later re-paving in Pennant stone are visible. To the w several heavily worn steps of the flight ascending the Temple podium can be seen through a gap in the Pump Room foundations. The podium under Stall Street beyond is inaccessible. To the N the Pump Room foundations stand on the Roman precinct and the plinth where the sacrificial altar stood. Sufficient of this plinth has survived to enable its southern half to be reconstructed. Only the s side of the Temple Precinct bears any relation to its Roman form. A wall that formed the long outer N face of the **Sacred Spring** survives 3 ft 3 in. (1 metre) high and is penetrated at mid-point by the entrance. Its worn steps are still clearly visible. At the E and w ends of this wall are foundations of massive oolite buttresses added to take the

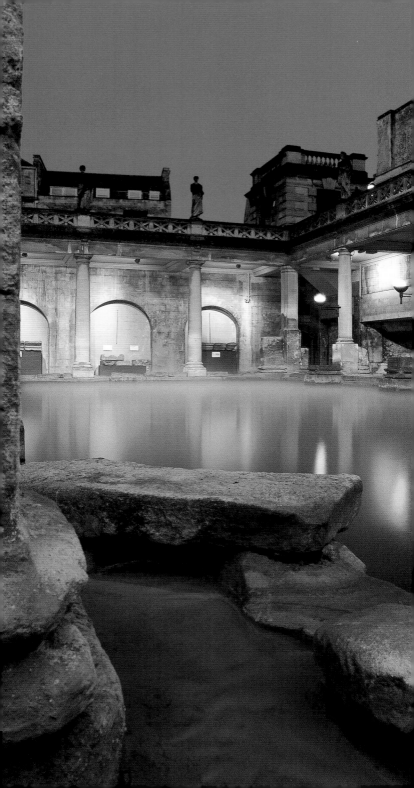

outward thrust of the heavy vault covering the Sacred Spring and, centrally positioned, the four pier-bases of the *quadrifrons* framing its entrance. To the E the main precinct entrance can be seen with difficulty beneath an electrical sub-station. The Roman Sacred Spring can be viewed from the N through windows at basement level. An open polygonal lead-lined reservoir was built in the C1, incorporated in the C2 within the SE corner of the colonnaded precinct around the Temple of Sulis Minerva. By the C3 it had been enclosed within an E-W rectangular stone building with a vaulted tile roof. The water level is now at the Roman level. Two square pillars, possibly statue bases, can be seen below the surface on the S side. Votive offerings excavated from it are exhibited nearby.

The **Outfall Drain** can be seen in two places in the Museum. The first is a dramatic iron-stained arch that served as an overflow from the reservoir in the outer E wall of the Sacred Spring. On the N side a flight of steps descends into the water. The drain passes beneath the Museum but can be seen again 80 ft (25 metres) further E where the outflow from the Great Bath joins it. The drain continues unseen from here to the River Avon 650 ft (200 metres) away. On either side of the drain substantial Roman masonry is visible. To the S the outer wall of the Great Bath stands up to 6 ft 6 in. (2 metres) high. To the N massive blocks bearing masons' marks prevented another great structure, either the precinct containing the *tholos* or possibly a basilican building, from collapsing the Drain.

The **Great Bath** [44] is the centrepiece of the bathing establishment. Despite the misleading nature of the C19 superstructure it remains one of the most dramatic monuments of Roman Britain. The chamber, aligned E–W, is 110 ft by 70 ft (34 by 21 metres) and contains a pool 60 ft by 30 ft (19 by 9 metres) and 5 ft (1.5 metres) deep. Steps on all four sides descend to a flat base still lined with forty-five sheets of Mendip lead. In the NW corner a shallow channel feeds the bath from the King's Spring. The outfall sluice is in the N side near the E end. The pavements around the bath consist of rectangular oolite slabs, most of which survive, worn to a smooth but uneven surface. In the centre of the N side a small area of inferior repaving overlies the original. Three *exedrae*, or alcoves, are set back in the N and S walls, the central ones rectangular, the outer ones apsidal. The chamber is enclosed by a wall surviving 3 ft 3 in.–10 ft (1–3 metres) high which bears traces of impermeable crushed tile lime mortar. On the N and S sides of the bath stand six piers, originally to support the roof but which now support the C19 galleries. In the C2 the piers were greatly strengthened by the addition of blocks encroaching into the ambulatory on one side and over the top step of the pool of the other. The enlarged piers supported a heavy tile vault over the bath, fragments of which are exhibited around the bath. This

44. The Roman Baths, the Great Bath, with superstructure by John McKean Brydon (1895–7)

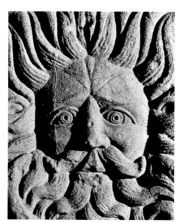

basilican superstructure would have included a clerestory to admit light and allow ventilation.

The **Eastern Range** included a variety of facilities. The principal component was another rectangular bath, the 'Lucas Bath', 80 ft by 35 ft (26 by 10.5 metres), N–S aligned with steps at its N end. Steps at the s end are presumed but missing. It too was surrounded by a paved walkway. In Roman times it was fed from the Great Bath. Its floor was raised at a later date and traces of this are visible. The C1 establishment was completed by a third pool further E again. Its base slabs are still visible, although in the C2 it was filled in, possibly to avoid flooding from the Avon. A drain from the Lucas Bath was left through the infill and is still visible. The end pool was replaced by a suite of steam rooms with hypocausts. This range underwent several stages of development between the C2 and C4. These rooms were heated from furnaces on the N and E sides. The only surviving mosaic fragment in the Baths is visible in the far NE corner. In the C4 the steps at the N end of the Lucas Bath were blocked off and an apsidal immersion pool with a bench seat was installed immediately inside the doorway from the Great Bath. It was fed with water from a lead pipe along the N side of the Great Bath. This facility was walled off from the East Baths, accessible only from the NE corner of the Great Bath.

Of Bath's three hot springs, the largest rises in the **King's Bath** to the w. It is the most rewarding of the baths, as it is the only place where one can look back through two thousand years of history and architecture from the C20 to the C1, and admire the same bubbling hot water that fascinated Mesolithic hunter-gatherers seven thousand years ago.

The shape of the C1 Roman reservoir is preserved on the E, s and w sides. The floor of the later King's Bath was cut back to this line in 1979. The N side of the reservoir lies under the Pump Room which was extended over part of the King's Bath in 1790–5. The rectangular

vaulted chamber that enclosed the Sacred Spring in the C2 still gives the King's Bath its form today. The s wall below the C17 balustrade is mostly Roman and contains two dramatic apertures, both partly infilled with later blockwork. A third Roman aperture was used to connect to the Queen's Bath in the C16 but was blocked up when that bath was removed in the late C19.

The four recesses on the E wall are all that remain of many more built on the inner E, N and W faces of the Roman chamber, probably in the late C11 or early C12, by the monks of Bath Abbey. There were at least two steps down to the floor of the bath from the arched seated recesses. These have remains of Jacobean strapwork around the top on the E and s sides, gratefully donated by Sir Francis Stonor in 1624. The bronze rings in the walls are further C17 donations for other hopeful bathers to clasp. The orange staining on the walls indicates a higher water level in which bathers sat neck-deep in mineral water. The water was lowered to its present level in the 1970s for archaeological assessment. The statue of Prince Bladud, the legendary founder of Bath, was also added in the early C17. The figure is possibly a composite from different medieval statues. The buildings above are the remains of *Davis*'s Douche and Massage Baths of 1889, built over Roman remains on the site of the demolished Queen's Bath of 1576. The N side of the King's Bath is occupied by the Pump Room, below which bathers descended flights of steps, or 'slips', into the bath. The cupola over the Pump Room fountain and the balcony on the w side were both added in the early C20.

To the s lies the **frigidarium**. In the C1 it took the form of a large unheated hall whose original grandeur and simplicity are difficult to appreciate due to many subsequent changes. Screen arcades aligned with the piers beside the Great Bath were matched at the N end by three large apertures overlooking the Sacred Spring. The hall served as a vestibule from which bathers would either turn E to the warm water of the Great Bath, or w to the West Baths. Later, the *frigidarium* was divided up. The area between the arcades was walled off and the 30 ft (9 metre) wide cold Circular Bath, fed by a fountain on its N side, was inserted in the floor of the hall. Outside the arcades, E–W passages connected the Great Bath with the West Baths. The N passage was raised to overlook the Sacred Spring. The s passage is well preserved with pillars standing over 6 ft 6 in. (2 metres) high.

The **West Baths** started as a simple suite of warm (*tepidarium*) and hot (*caldarium*) steam rooms typical of any town bath-house. The range underwent extensive changes between the C2 and C4. A circular *laconicum* (dry heat sauna) was added and the *caldarium* was replaced by a round-ended cold water bath. Central to the West Baths is the *tepidarium* whose entire form is visible. It includes the best-preserved hypocaust on the site, flues from the furnaces, and doorways to adjoining areas. To the w, a rectangular cold bath, also complete in layout and with two sets of steps into it, can be seen beneath Stall Street.

The Guildhall and
The Victoria Art Gallery

High Street and Bridge Street

The Guildhall is by *Thomas Baldwin*, 1775–8. The elevation to the High Street is the best in Bath, and the Banqueting Hall within is the best interior. *John McKean Brydon* added large wings in 1893–7 and the Victoria Art Gallery in Bridge Street in 1897–1900, forming a significant Victorian civic complex.

Externally Baldwin's building is in the Palladian country-house tradition with some fashionable Adamish detail; but internally the Banqueting Hall and staircase are a masterpiece of up-to-the-minute late C18 decoration. It derives from the tradition of hospitality that grew with medieval guildhalls. This immensely extravagant building may also be regarded as a riposte to the Upper Assembly Rooms (*see* Major Buildings, p. 88), from which many civic dignitaries, mainly tradespeople, were socially excluded. Formal mayors' dinners, glittering affairs with numerous toasts to monarchs and naval and military victories, took place in the Hall, which was also used until 1829 for private functions.

A complex set of circumstances surrounds the building's commissioning, including an abortive start to another design. Timothy Lightoler produced an initial design in 1763, then in 1766 he won a limited competition (against *John Wood the Younger* and *Richard Jones*) and the following year the design was revised yet again. In 1768, the foundation stone was laid but still there was no action. In 1775 the wealthy plumber and glazier *Thomas Warr Atwood*, architect to the city estates and waterworks and member of the Corporation's building committee, produced a scheme, probably to the design of his clerk *Thomas Baldwin*. Work started, amid accusations that it was an inside job and acrimony over a rival scheme produced by *Jelly* and *Palmer*, when Atwood was accidentally killed when he fell through the floor of an old building in the market place. Baldwin, who was already supervising work, took his place, producing new designs in stages over the following months for approval by the Corporation committee.

Exterior. Baldwin's ground floor is rusticated with vermiculation where it projects in the centre. Above is a three-bay giant portico of attached three-quarter Ionic columns on pedestals. The entablature has a fluted frieze with paterae in the centre part and is carried across the

46. *The Town Hall at Bath*. Watercolour by T. Malton, Jun (1779)

wings. The pediment has the city arms flanked by festoons in the tympanum. Each of the broad wings has a single pedimented window set within an arched recess at first floor. Above the window, rectangular panels interrupt the architrave and frieze of the entablature. The parapet has pedestal balustrading with stone vases and the pediment, a lead statue of Justice, not blindfolded. *Brydon* added the dome (*see* below). On each side there was a low screen to the market with end pavilions, demolished when Brydon's extensions were built. Around the front areas are good original wrought-iron railings with fleur-de-lys heads with vases on the main stanchions, and four fine lanterns.

To the rear, the Council in the 1980s removed an accretion of later additions to reveal a splendid and original E elevation, very different from the front. Here the emphasis is on the end pavilions, each two windows wide with a pediment. The centre is slightly recessed and three windows wide. This refusal of a central emphasis, unusual until the later C18, was presumably used to show that there was no entrance in this front. Rusticated ground-floor façade; the long first-floor windows sit on blind balustrading. *Œil de bœuf* attic windows set within rectangular panels form a clerestory to the Banqueting Hall, and in the centre is a panel with a patera and festoon of husks. The centre first-floor window is blind, to accommodate a fireplace inside, and the chimney is disguised as a classical Roman altar, crowning the balustraded parapet together with four urns.

Interior. In the SW corner is a grand staircase of Dutch oak, square in plan, with fine Neoclassical wrought-iron balustrading and stuccowork with oval paterae and festoons of husks. This leads to the sumptuous Banqueting Hall [47], a double square in plan, 40 ft (12.5 metres) by 80 ft (25 metres), by 30 ft (9 metres) high. Engaged columns, with pedestals, fluted shafts and Corinthian capitals, divide the long E and W walls into seven bays. The second, fourth and sixth bays have arched shallow recesses with mahogany double doors on the W wall. The remaining bays have plain panels with large portraits by *William Hoare* and others, and, in the attic above, the *œil de bœuf* windows on the E wall and oval plaster panels opposite on the W wall. The entablature has

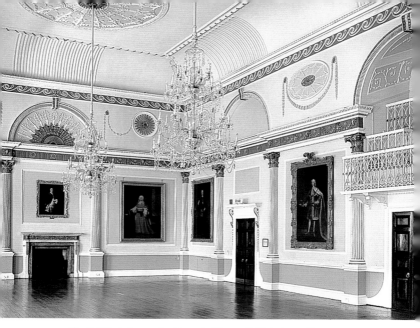

47. The Guildhall, Banqueting Room, by Thomas Baldwin (1775–8)

a frieze enriched with festoons of husks, bucrania, vases and anthemia and, in the recesses, fluting and paterae. In the centre of the w wall is an orchestra gallery and opposite on the E wall a fireplace with a fine composition-moulded chimneypiece with a panel of arabesque moulding surrounding the city arms above and an ornamented lunette. The N and s end walls similarly divide into three bays with an arched recess with a fireplace in the centre and plain panels either side, and paterae instead of ovals. A coved ceiling springs from a second frieze with Vitruvian scrolling. The flat ceiling has three large stucco circular panels with elaborate radiating plaster decoration, each connected by small circular ventilation grilles. Three magnificent four-tier crystal chandeliers by *Lovell* of Bristol. The centre front room, w side, was the Common Council Room. On the N side is a service stair and, originally, 'water-closets for the ladies'.

On the ground floor, beyond a public hall, is a large centre rear room, E side, which was a sessions court, now the Brunswick Room. Either side were the jury room and prison cells, s side and, N side, the Town Clerk's office and a weighing house accessible from the market outside. The basement contained a kitchen, bakehouse, scullery, housekeeper's room, cold larder, pastry room, wine and beer cellar, and coal cellar.

In 1891, *Brydon* won a competition for extensive **additions**, a wing to the s to house municipal offices and, to the N, a technical school (relocated 1935, now also municipal offices). The scheme extends to twenty-six bays, of which the central five of the present w façade are Baldwin

and rest are Brydon. The general effect resembles Adam's Register House, Edinburgh (1774) and Brydon may have had this in mind when he added the dome to Baldwin's Guildhall. Work started in 1893; the s wing was completed in 1895, the N wing 1896.

Brydon's wings are essentially in the same style as Baldwin's centre, set slightly back and continuing the rusticated base and pedimented windows, but with some exuberant Baroque added. The curved corners to N and s repeat Baldwin's giant columns, but in Corinthian with friezes of classical figures by *G. A. Lawson*, derived from John Belcher and Beresford Pite's Institute of Chartered Accountants, London (1888). That to the s symbolizes Justice and Administration and, to the N, Arts, Science and Learning. Either side of the curved corners a single bay is set forward to mirror Baldwin's flanking wings. To the corners, Brydon adds two-stage belvederes in the style of Wren or Vanbrugh, similar to those designed a little later by Brydon for his Government Offices in Whitehall. The first stage is square with rusticated arched openings framed by blocked Ionic half-columns and supported by consoles; the second stage, octagonal with round openings, crowned by a lead dome and vase. They make a fine addition to Bath's skyline. This is Brydon at his most Baroque. The s wing is attached to the old Police Station (*see* Walk 2, p. 124) by an arched screen, also Baroque [72].

The interiors of the former technical school in the N wing are predictably utilitarian but the s wing has some fine municipal rooms. The ground floor contained a courtroom (used as such until 1986, now the Alkmaar Room) and solicitors' and treasurers' offices, the basement housed a police waiting room and the Inspector of Weights and Measures. On the first floor a stone vaulted corridor interconnects the council chamber, committee room and mayor's parlour. The council chamber is square with red scagliola Ionic columns and pilasters around all four sides. Beyond are apses to N and s. The groin-vaulted ceiling has Neoclassical-style emblematic figures representing the arts, sciences, commerce and justice, by *Frederick Schenck*. The mahogany woodwork is richly carved and distinctly Baroque. – Chandelier. By *Spence*. – The City of Bath arms, wood-carving. By *William Aumonier*. – Circular window, depicting the city arms. By *C. E. Kempe & Co.*, 1895.

Victoria Art Gallery, Bridge Street, by *John McKean Brydon*, 1897–1900 – that is, begun in the Queen's Diamond Jubilee year. The plan has a main rectangular room on two floors parallel with the street, an exhibition gallery (formerly a library) on the ground floor, the main art gallery on the first. The façade is a Baroque-Revival two-storeyed continuation E of Brydon's N wing to the Guildhall. It picks up the balustrading and ground-floor rustication, but the Corinthian order has changed to Doric. The first-floor façade is blind and has nine coved niches with alternate triangular and segmental pediments on consoles with balustraded aprons. Only the central one, larger with flanking

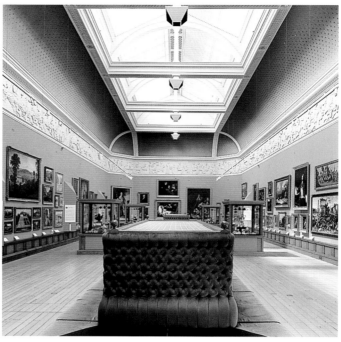

48. The Victoria Art Gallery, first-floor interior, by John McKean Brydon (1897–1900)

Ionic columns and pilasters, has a marble statue of Queen Victoria, 1897, by *Andrea Lucchesi*, presented by the women of Bath. A single bay returns to the s into Grand Parade, and set into the NE corner between the two blocks is a three-bay semicircular entrance with a canted ground floor. The doorway, breaking forward with an open pediment on blocked Roman Doric half-columns, is set within an arched recess with the head of Minerva carved in the keystone. Paired Ionic columns at first floor support the entablature and parapet. Above is a dome, with meticulously restored leadwork, oculi in the base.

On the ground floor, a lending library opened in 1912. This was swept away to form an exhibition gallery in 1990–1. Off the circular entrance vestibule through an arch is a fine C17-revival staircase of Hopton Wood stone with mahogany square-section newels, bulbous balusters and handrail, with a barrel vault above. On the upper floor over the entrance vestibule is a rotunda with six Bassae-order Ionic columns of Devonshire marble supporting a coffered dome with the signs of the zodiac in relief. This leads through a pedimented oak doorcase to the toplit picture gallery containing the permanent collection [48]. It has a panelled dado of American walnut, a coved ceiling, a rectangular pitched skylight, and a cast of the Parthenon frieze paid for by the architect.

Pulteney Bridge

The bridge, 1769–74, built by William Johnstone Pulteney to *Robert Adam*'s design, has shops on both sides. It connects to Bathwick and was key to the development of Pulteney's Bathwick Estate (*see* Introduction, p. 23 and Walk 6, p. 176). Three segmental arches span from two midstream triangular piers. Adam's design is very original, with few precedents for a coherent bridge design with shops (save for Palladio's unbuilt proposal for the Rialto Bridge, Venice, illustrated in *Il Terzo Libro dell'Architettura*).

Adam's structure as depicted by Malton [49] (Adam's drawings are in Sir John Soane's Museum) is now much altered but the s, downstream elevation retains a strong flavour of the original [50]. A central pavilion has an open pediment and a great Venetian window, and the wings have pavilion features over each pier. Square end pavilions sit on the abutments, with domes and pediments and, originally, porticoes facing outward. The street elevations are broadly similar but the flanking wings each have three arched openings to form shopfronts with doorways between. All this sounds monumental. In fact, it is a surprisingly small

49. *The New Bridge at Bath*. Watercolour view from Bridge Street by T. Malton Jun (1779) of Pulteney Bridge

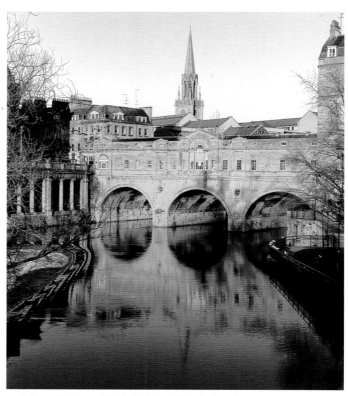

50. Pulteney Bridge, south side, by Robert Adam (1769–74)

bridge, friendly in its dimensions. In 1792 *Thomas Baldwin* added a
storey, removed the porticoes and altered the shopfronts. After the NW
mid-stream pier collapsed in 1800, *John Pinch the Elder*, now surveyor
to the Bathwick Estate, appears to have reconstructed the N side in
1802–4 to a plainer design and a deeper plan. The voussoirs to Adam's
tripartite centre are evident on the street elevation, and are all that
remain of the original. Many C19 alterations and cantilevered timber
extensions like those at the Ponte Vecchio in Florence radically altered
the N elevation to the river. In 1902–3 *Gill & Morris* demolished the SW
pavilion, which protruded into the street after Grand Parade was con-
structed, and rebuilt it to an Adam-style design in place of the three end
shops. Adam's Palladian S façade to the river was well restored, except
for the asymmetrical Gill & Morris alterations, by *J. F. Bevan Jones*
(drawings of 1937, completed 1951). The timber shopfronts with thin
mullions and arched heads mostly date from a restoration of 1975 by
Vivian & Mathieson, based on the 1880s model of Nos. 1–2, NW side.

The Cross Bath, Hot Bath and New Royal Bath

The Cross Bath, Hot Bath and New Royal Bath form a coherent adjacent group in the sw sector of the medieval walled city, an area, with its therapeutic hot springs, associated since the Middle Ages with hospitals, baths and healing (*see* Introduction, p. 14, and Walk 1, p. 111). The waters, for drinking and bathing, were enjoyed up to the 1970s, but then fell into disuse. Restored and revived in the early c21 they continue Bath's function as a spa town.

The history of the **Cross Bath** is complicated. Originally an irregular pool of Roman origin situated slightly to the w, it is mentioned in deeds to adjacent properties from the late c13 and first described by Leland in 1540. It is named after a medieval marble cross which was once set in the middle but which had disappeared by 1586. Owned by the Church until the Dissolution, then for a few years in private hands, it came under city control in 1555. *Thomas Baldwin* as City Architect rebuilt it in 1783–4 [51], before the construction of Bath Street under the Bath Improvement Act of 1789 (*see* Walk 1, p. 109). Fitted within an almost triangular site constrained by narrow medieval lanes, it had a narrow apex to the s and a remarkably Baroque n façade, with a central bow, but with charming Adamish detail. Behind this was an oval pump

51. *The Cross Bath, from Bath Street*, by Thomas Baldwin (1783–4), reconstructed by John Palmer (1798). Engraving from a drawing by T. H. Shepherd (1829)

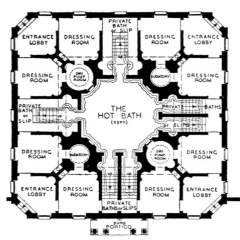

52. The Hot Bath, by
John Wood the Younger
(1775–7). Plan
(Walter Ison)

room. The bath itself to the s was oblong, bowed to the e and w sides.
When Bath Street cut through the irregular medieval city fabric
Baldwin's building was a misfit with a blank façade skewed to the splen-
did e–w axis. In 1798, *John Palmer*, having replaced Baldwin as City
Architect in 1792, took down his building, except for the w wall and
bath. Using the existing stone and precisely to the same plan, he recon-
structed Baldwin's serpentine n façade to face e towards Bath Street
[51]. He rebuilt the n elevation to his own design with straight side parts
canted back towards the middle, where a segmental projection with a
portico of four Corinthian columns forms the main accent. Inside,
Palmer rebuilt the dressing rooms and pump room. Unable to compete
with the enlarged Hot Bath and Tepid Bath (*see* below), the bath was
converted in 1829–30 by *George Phillips Manners* to provide vestibule
and dressing rooms with reclining baths and the colonnaded portico
was infilled to increase the floor area. *Manners & Gill* carried out a still
more drastic conversion in 1854, lengthening the bath by two feet, pro-
viding thirteen private dressing rooms and removing Manners' earlier
conversion and the remainder of the original internal structure. *Charles
Edward Davis* further vandalized this beautiful building in 1885–8, con-
siderably enlarging the bath to become a rectangular swimming pool
and roofing it over. The roof was removed in 1952. All that remains of
Baldwin's interior is an elegant relief carving of a vase and one patera.

In 1999–2006 *Nicholas Grimshaw & Partners* with conservation
architects *Donald Insall Associates* renovated and brought back to life
the Cross Bath. A new elliptical lead roof, expressing Baldwin's original
pump room, forms an entrance vestibule and cantilevered canopy with
a glass apron. A new bath of similar size and shape intersects on plan
with the canopy. At the point of intersection the hot spring rises under
natural artesian pressure through a water sculpture of stainless steel by
William Pye.

Diagonally opposite to the SE is the **Hot Bath**, built in 1775–7 for Bath Corporation by *John Wood the Younger* (who was 'paid 100 guineas for his services, trouble, and attending as architect'). It was his only civic commission. It replaced a medieval bath to the w that was demolished. It is one-storeyed with a portico of two pairs of Tuscan columns with a pediment. The original, clever and completely symmetrical interior layout [52] was radically altered by *A. J. Taylor* in 1925–7. The plan was square with an entrance at each of its splayed corners. Inside, a wall niche faced each entrance across the diagonal. To left and right were pairs of changing rooms with fireplaces that backed on to each other. 'Slips' or steps descended between the rooms into a centre octagon, originally open, which contains the bath. Externally, this inner space appears rising above the outer accommodation, with a balustrade sitting on the enclosing walls and linked to the dwarf parapet of the outer façade by a shallow-pitched lead roof.

Now forming part of, and accessible from, the New Royal Bath (*see* below), the Hot Bath was converted into a medical treatment centre by *Nicholas Grimshaw & Partners* and *Donald Insall Associates* in 1999–2006. They restored the basic square-within-a-square plan together with the inner pool – the hottest in the complex – now with a structural glass roof instead of open-air. Twelve surrounding rooms provide treatments that include hot and cold soaking, Vichy douches and mechanical manipulation. Opaque glass shutters in the portico retract at night to provide glimpses from the street of the pool staircase with underwater recessed lighting.

To the E, *G. P. Manners* added the Tepid Bath in 1829–30;* it was demolished in 1922. The entrance remains, as an extension to the N side of the Hot Bath. This has a serpentine façade enclosing a gentle ramp for the invalids. The doorway survives as a window. The Tepid Bath was replaced by *A. J. Taylor*'s Beau Street swimming baths, opened 1923, demolished and replaced by the **New Royal Bath**, by *Nicholas Grimshaw & Partners*, 1999–2006 [35, 53]. This incorporates, besides the Hot Bath, No. 7 Bath Street (*see* also Walk 1, p. 110). Now with a glazed ground-floor façade by *Grimshaw* to its sw frontage, No. 7 provides the entrance to the complex, a restaurant at first floor and, above, consulting and meeting rooms.

The **New Royal Bath** is a very high quality building of its time, discreetly holding its own, tucked behind historic neighbours, knitting together the elements of the site. It is an unexpected commission for a firm associated so much with steel and glass and with non-contextual buildings. The plan reflects the square form of the neighbouring Hot Bath, but here forms a three-storey Bath stone-clad cube raised one storey above the ground on pillars. The levels are interconnected in the

*An alternative design, by *Decimus Burton*, was unexecuted.

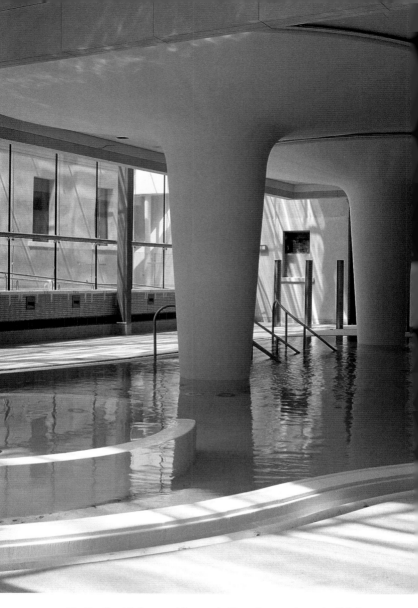

53. The New Royal Bath, ground-floor pool with mushroom columns, by Nicholas Grimshaw & Partners (1999–2006)

SE corner by a cylindrical service riser and staircase, similarly clad, and by a staircase, lift and service tower to the N. The cube and cylinder are set within a glass enclosure which follows the line of the street. There are pools for bathing on both ground and roof levels.

The ground-floor pool occupies the full area of the glass enclosure, that is, spreading beyond the footprint of the cube above. It has a curving, free form – no straight edges or corners. Out of the pool rise four powerful reinforced-concrete mushroom columns that support the cube, each capital spreading out to occupy a full quadrant of the square soffit (cf. Frank Lloyd Wright's Johnson Wax Building, Illinois). The lowest level of the cube contains changing rooms with an in–out system of cubicles and lockers of etched glass. The middle level contains massage rooms in four segmental enclosures of curved etched glass that carry up the building the memory of the mushroom capitals. In the centre, is an 'inner space' that echoes the square-within-a-square plan of the Hot Bath. This has a suspended wood floor for yoga and meditation, and rehabilitative exercise. The top level is a steam floor based on traditional Turkish baths, alternating between hot-steam and cold-water finishes and showers. Four free-standing circular steam rooms, again informed by the columns, have glass walls and continuous curved Bath stone perimeter benches with steam generators beneath. A central cold-water shower feature with fibre-optic lighting graduates from a water mist to a deluge in the centre. On the N perimeter wall are hot and cold footbaths, on the other three stone slabs for lounging that snake around the circular steam pods. The glass building enclosure finishes at this level, forming a glass-balustraded roof terrace, with down-lighting in the handrail. Finally, the cylindrical staircase leads upwards into fresh air and the hot-water open-air roof-top pool with views across the city and to the surrounding hills. Square with curved corners, this occupies all but a narrow perimeter of the cube. Circular corner enclosures – the leitmotif again – contain whirlpool baths and Jacuzzis. Between these are profiled stone surfaces like just-submerged Corbusian *chaises longues*.

The architecture is finely crafted and contemporary. Although rubbing shoulders with its neighbours, it is entirely articulated from the historic buildings which it incorporates, detached by glazed links and slots that introduce light into deep-plan spaces and provide orientat-ing views of rooftops and the Abbey. Small, circular porthole windows pepper the solid façades, giving further glimpses of location. Unlike traditional ashlar work, the stone (cut on the curve for the cylinder) has grooved joints to express its character as panels, and the pool surrounds are of flame-treated Kashmir granite. The laminated glass cladding hangs from steel section columns with spider-like sprockets, and opaque sections of the lightweight outer enclosure have a cherry-coloured laminate. The water glows softly with coloured and fibre-optic lighting (cf. Grimshaw's UK Pavilion, Expo 92, Seville) and, utilizing the natural heat of the water, the building makes use of recycled heat energy.

Assembly Rooms

This is a large and noble block [54], tucked away behind the Circus in an unimaginative urban arrangement by the younger *Wood*, built in 1769–71, between Bennett and Alfred Streets, with Saville Row to the E (*see* Walk 4, p. 162). Initially *Robert Adam* submitted a very ambitious design of Augustan majesty, but this was rejected as too expensive. Originally called the New or Upper Rooms to rival the earlier ('Lower') Assembly Rooms, they were built by tontine subscription to serve the fast-expanding upper town. Opened in 1771 with a 'Grand Ridotto' they quickly became the centre of Bath society (*see* Introduction, p. 20). They are one of the most splendid of all Georgian civic buildings and, severely damaged in the Second World War, are also a triumph of restoration.

Following Bath's brief late C19 revival as a spa resort, the Assembly Rooms declined; the Ballroom became a cinema in 1921 and the Tea Room, a saleroom and market. Through the generosity of Ernest Cook (*see* Walk 5, p. 169) the Society for the Protection of Ancient Buildings

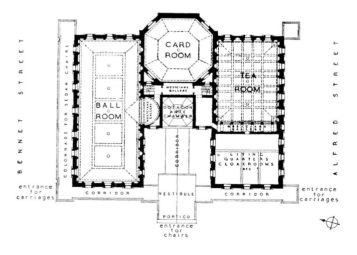

54. The Assembly Rooms, by Wood the Younger (1769–71). Plan (Walter Ison)

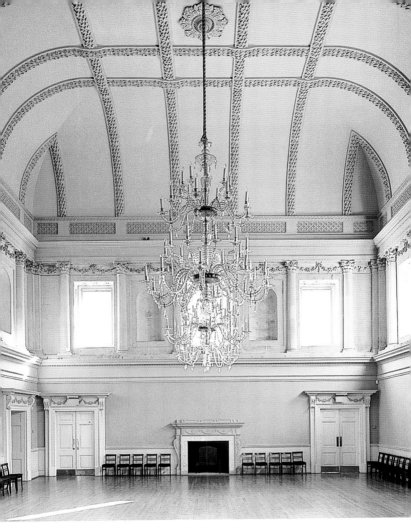

55. The Assembly Rooms, the Tea Room, looking east

(SPAB) rescued the building and gave it to the National Trust in 1931. They in turn let it to Bath City Council on condition that it was restored to its original state. With *Mowbray Green* as architect and *Oliver Messel* as interior designer, they reopened in 1938. Gutted by incendiary bombs in 1942 and reduced to a roofless shell, the building was again restored in 1956–63, by *Sir Albert Richardson* with *E. A. S. Houfe*, and interiors once more by *Oliver Messel*. *David Mlinaric* redecorated the principal rooms in the 1970s for the National Trust and, after collapse of plaster in the ballroom, the *David Brain Partnership* carried out major restoration and redecoration, 1987–91, basing colours largely on *Mlinaric*'s scheme.

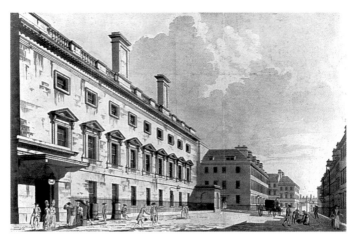

56. *The New Rooms at Bath*. Watercolour by T. Malton Jun (1779) of the Alfred Street
front from the west

The building consists of a U-shape of tall oblong blocks, with a sin-
gle-storey centre to the w, the N side in Bennett Street with seven upper
windows with pediments, the s with nine more closely spaced windows
[56]. Above them on the s side are square windows, but the façade gains
strength elsewhere from much plain walling between the windows and
entablature. The Ballroom runs the entire length of the N block, and the
shorter Tea or Concert Room, the s block, both going through two
storeys. On the s side there were also smaller public rooms, now the
shop and kitchen. On the E side is a large Octagon (originally Card
Room) with a full-height central canted bay, the Ballroom and Tea
Room forming three-bay flanks. In the centre of the E elevation is an
addition of 1777 containing a Card Room, architect unknown. This is
lower, with pediments on the N and s ends. Along the N, Ballroom front
runs a one-storeyed Doric colonnade for sedan chairs. This returns
along the w side as a plain corridor (rebuilt 1963) and forms in the mid-
dle between the open arms of the U the main, projecting entrance por-
tico, Roman Doric with a pediment. Inside, a covered, single-storey
corridor leads straight ahead to a small octagonal hall in the centre of
the building, toplit with four chimneypieces. This opens into the three
main spaces, which also interconnect elsewhere for ease of movement
between activities.

The 105-ft (32-metre) double-height **Ballroom** has the simple arith-
metic proportions, 1:1:2.5, i.e. a double cube and half-cube. The lower
walls, plain with a dado punctuated by door surrounds and chimney-
pieces, terminate in a Greek key frieze. At high level, a colonnade of
forty attached Corinthian columns and pilasters, 12 ft (3.6 metres) high
– garlands between the capitals – frames clerestory windows and niches.

Above the entablature, a coved ceiling, 12 ft (3.6 metres) high, springs from a Vitruvian scroll frieze. Five ceiling panels contain elaborate plaster roses with garlands, palm and laurel branches. In the middle of its s side is a wide apsidal orchestra gallery, the ironwork balustrade with lyre decoration.

The **Tea Room** [55], 60 ft by 40 ft (18 by 12 metres), has a splendid two-storeyed six-column screen at its w end, Ionic to the ground floor, Corinthian to the upper storey, in natural stone creating a magnificent antique effect. The wall is set back forming an entrance vestibule below and a musicians' gallery above. The other walls are treated like the ballroom, the upper columns continued around the room. Here however the narrower spacing between the bays of windows and niches creates a double rhythm. Above the entablature is a continuous plasterwork pedestal with trellis decoration, from which spring foliated bands in line with the columns. These rise up a coved ceiling and cross over one another on the flat ceiling, creating square and rectangular panels. The *New Bath Guide*, 1772, described these as embellished with 'garlands, laurels, palm branches, festoons and wreaths of flowers'.

The gorgeous **chandeliers** are among the most important to have survived from the C18. The three in the Tea Room and five in the Ballroom are by *William Parker* of Fleet Street. *Jonathan Collett* made an earlier set for the Ballroom but one month after the opening in 1771 an arm collapsed; they were dismantled and salvaged to form a single chandelier, now in the Octagon.

The **Octagon**, 48 ft (15 metres) in diameter, is more simply treated with dado, frieze and entablature, and relies on its shape for impact. The round-headed windows have Gothick glazing bars.

The basement houses the **Museum of Costume** (collection of Doris Langley Moore, designer, collector, historian). This opened at the Assembly Rooms in 1963. It is one of the largest and finest collections of fashionable dress in the country.

Bath Spa Railway Station

The station is part of *Isambard Kingdom Brunel*'s broad-gauge Great Western Railway connecting Bristol with London. The Bristol to Bath section opened in 1840 and Bath–London in 1841 on completion of the Box Tunnel. Some of the greatest engineering feats of the railway were in and around Bath. Brunel ensured that the route would be practical and accessible without cutting through the city. The line skirts the city to the s in a long curve, crossing the river in two places, the station set between the two river bridges just 270 yd. (250 metres) apart (*see* Walk 8, p. 213). On the approach from the ε, Brunel constructed, ¾ mile (1 km.) to the ɴ, a massive but elegant retaining wall through Sydney Gardens to retain the Kennet & Avon Canal (*see* Walk 6, p. 185).

The station, designed by *Brunel* and built under the superintendence of *Mr Frere*, is a twenty-arch viaduct with the station buildings constructed on each side. The platforms are now much extended. A great glazed roof originally spanned the platform and lines [57], similar to the one at Brunel's Bristol Temple Meads. The present glass canopy replaced the roof in 1897. From at least 1885 there were hydraulic

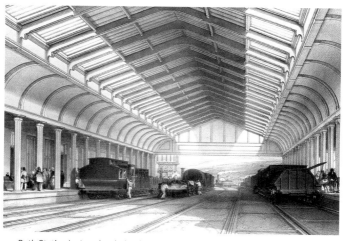

57. *Bath Station* by Isambard Kingdom Brunel (1840–1). Lithograph by J. C. Bourne (1846)

Trains to Bath in Victorian Times

The first passenger train with eight coaches, pulled by the engine *Fireball*, arrived from Bristol at 8.33 a.m. on 31 August 1840. In addition to passenger facilities, there was an engine shed and goods depot at right angles to the main line, with access provided by a turntable. The first, second and third class passengers had their own sets of stairs and the platforms had separate pens. (The third class carriages themselves were open and one man died of exposure.) A slender footbridge at platform level connected the station with the Royal Hotel to the N (removed 1936). When the Italian patriot Garibaldi passed through, after his triumphal tour in 1864, he was to address the crowd from the bridge but was unable to alight because of crowds joining the mayor on the platform.

Smoking was prohibited on both platforms and trains, but passengers throughout Bath could have their luggage delivered to their homes by station employees, and also their coal when the coal train arrived.

lifts to each platform, powered from a riverside pump house at the E end of the station, elegant ones for passengers and others for luggage. Only the w-bound survive.

Originally, there was an entrance on the s side as well as the N. The railway line sets the station at an angle relative to the 'grid' of the town. The station front is rotated to face N along the approach road and an asymmetrical shallow-curved wing to the E, parallel to the railway line, resolves the two alignments. The N front is two storeys with three curved Flemish gables. The ground floor has eight arched openings with radial fanlights and the first floor, Jacobethan ovolo-moulded mullions, otherwise quite plain. The glazed porte cochère across the centre, supported on cast-iron columns, dates from the 1880s. The clock was added in 1931.

Lord Manvers intended the N, Manvers Street, approach to be a grand avenue but prevailing economic decline led to *ad hoc* development.

Prior Park

Widcombe

Built *c*. 1733–*c*. 1750 for Ralph Allen in Bath stone. The architect was *John Wood the Elder*. It was meant to be Allen's proof of the suitability of the product of his Combe Down quarry for work of the highest order. Prior Park certainly is a composition in the grand manner, the most ambitious and the most complete re-creation of Palladio's villas on English soil. It has a breathtaking view over the city of Bath, situated as it is at the head of landscaped grounds that extend down a green combe towards the old village of Widcombe [58]. The house is now a Roman Catholic school and the garden belongs to the National Trust.

Exterior

The house was to consist of a main central mansion flanked each side by a square pavilion and a long wing beyond, all connected by galleries. Building started *c*. 1733 with the w wing to house cattle, poultry and the stables. But *Wood* was dismissed when he quarrelled with Allen over alterations to his design for the w wing made by Allen's clerk of works *Richard Jones* (*see* below). Jones completed the mansion and designed the E wing, which was built by 1750. Ralph Allen moved into the completed mansion in 1741.

 Wood's design for the mansion itself is based on the unbuilt, first design of Colen Campbell for Wanstead House, Essex, published in *Vitruvius Britannicus* in 1715. Wood's version, though, has a different, bolder character, shorter by two bays with taller proportions and a more projecting portico. With both rural and urban links, it belongs more firmly to the original Palladian villa tradition (essentially belonging to the outskirts of the town) than its country-house contemporaries that also derive from the first Wanstead design: Wentworth Woodhouse, Nostell Priory, and Harewood House, Yorkshire. Like the Circus and Royal Crescent, however, Prior Park may represent an overlay of more than one idea. Unlike any Palladian villa, the wings are canted inwards and although at first reading this appears simply to follow the contour, in his *Essay Towards a Description of Bath* Wood illustrates the plan as forming three sides of a duodecagon, a quarter of a mile in diameter. This may derive from Palladio's illustration of a Roman theatre based on a circle inscribed within a twelve-sided figure, which Wood must have known from Perrault's translation of Vitruvius

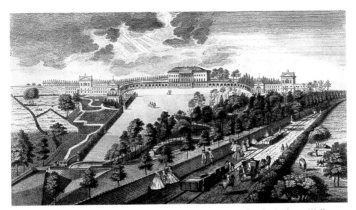

58. *Prior Park the Seat of Ralph Allen Esqr near Bath.* Engraving by Anthony Walker (1752)

or one of the English editions. Sitting as it does on one of the natural terraces of the hillside, 'rising above one another, like the Stages between the Seats of a Roman Theatre' as Wood in his *Essay* puts it, the house may thus be perceived as a theatrical analogy, with the city as a spectacular stage set. Inigo Jones had earlier used the same geometric figure in his reconstruction of Stonehenge, published by John Webb in 1653, and this may relate Prior Park also to Wood's interest in imagining Bath as 'the Metropolitan Seat of the British Druids'. (*See* also Introduction, p. 18 and Walk 3, pp. 136–7.)

Mansion Exterior

The mansion itself is large for a villa (at least in appearance, for the internal accommodation is relatively modest) – fifteen bays wide with a giant six-column pedimented portico on the N side. The columns are Corinthian and the portico is two columns deep. The ground-floor windows have alternating pediments. The whole composition rests on a rusticated ground floor treated as a basement and vaulted inside. The elaborate outer staircase leading to the doorway is a rather Baroque alteration of 1834 (*see* also below). The best preserved elevation of Prior Park is that to the E – five bays wide; the ground-floor windows in aedicules with Ionic pilasters, on the upper floor just one central Venetian window. The S side is very plain, merely provided with an attached portico of six giant Ionic demi-columns and a pediment. It appears of one storey fewer than the N side due to the falling ground. The house is connected with the pavilions or side ranges by a splendid sweep of curved one-storeyed arcades.

East Wing Exterior

That is where the original work ends. For the E **wing**, *Jones* threw Wood's intended pair of pavilions into one. It was again completely

altered (together with the W wing – *see* below) after Bishop Baines, Roman Catholic Vicar Apostolic of the Western District, bought Prior Park in 1829. He converted the E wing into a school, St Peter's, and the W wing into a seminary, St Paul's. The E wing now consists, W side, of a square pavilion (a 'brew house' when Bishop Baines arrived) with a Venetian window to each elevation, and continuing it a range of sixteen bays. The ground floor projects (extended *c.* 1834) and above it the main floor, originally a half-storey, raised *c.* 1830 to a full storey, has a central Venetian window. In 1831 *John Peniston* of Salisbury and his son *George* added a pedimented three-bay floor over the middle of the sixteen bays (6+3+7), with sculpture in the tympanum transferred from Huntstrete House (*see* below). Set back on the roof is a small clock tower with a cupola removed from the W pavilion of the E wing. (The Penistons may also have made internal alterations including a semicircular amphitheatrical lecture room.)

West Wing Exterior

In the W **wing** yet more drastic changes were made. *Wood* had intended this range as an allusion to a Palladian agricultural building, one and a half storeys in height, using the Tuscan order, with projecting eaves and a pigeon loft above. The executed version was gentrified with the roof concealed behind a parapet, and with a raised banqueting room in the centre. A detached square pavilion set in a colonnade between this and the main block (demolished for the church, *see* below) functioned as a porte cochère for carriages. In 1834 *H. E. Goodridge* remodelled it, inserting a theatre (bombed in 1942), an entrance hall and a staircase to the S and raising the one and a half storeys by a further storey and a half. The sixteen bays still match the remodelled E range except that it has a continuous roofline with no raised centre. Then in 1844 to its E, *Scoles* built the **church of St Paul**, which his son, *A. J. Scoles*, completed, and a very large church indeed. It has a severely closed ground floor with a heavily vermiculated and rusticated doorway with icicle-man keystone. Above it are giant attached Corinthian columns and pilasters, the capitals mostly uncarved, and clerestory pedimented windows with blind attic panels There is an apse towards the house. Architecturally speaking these changes are regrettable, as the total weight of the W wing is now greater than that of the centre of the composition.

Apart from an unbuilt project for a vast domed cathedral, lying S behind the mansion, Goodridge is not known to have carried out any other work at Prior Park. Other building of this period is probably by the Bishop and his nephew the *Rev. James Baines*, including the mansion steps, usually attributed to Goodridge.

Mansion Interior

In 1836, fire destroyed most of the mansion's interior. It was rebuilt largely with fittings salvaged from the late C18 Huntstrete House, near

Marksbury, Somerset. These include garden sculpture, chimneypieces, plasterwork, joinery, mahogany doors, pilasters, the main staircase and the windows with timber sills (not a Bath feature – *see* Introduction, p. 31). To accommodate the windows, the sills were cut back, giving the now odd reverse-slope with drainage holes. Only the E elevation retains the original windows with thick glazing bars. In 1991 Prior Park was again ravaged by fire – the entire roof and third floor were lost, most of the second floor, half of the first and a third of the ground floor. *Ferguson Mann* reconstructed the building to the post-1836 scheme, including elaborate plasterwork by the conservation contractor *St Blaise*. The work was completed in 1995.

The impressive Entrance Hall, three bays wide with its tall Corinthian columns, interconnects the N and S fronts. A central passage leads to the **chapel** at the E end. This interior is the best preserved from both fires (save for the ceiling, lost 1991) and is the most impressive interior of *John Wood the Elder*. Occupying one fifth of the volume of the building, it runs through two storeys and is articulated by pilasters and columns in two orders, unfluted Roman Ionic to the ground floor, Corinthian to the first. It ends in a full-height coffered apse with a large reredos below. The opposite end has a two-storeyed gallery of coupled columns, vaulted with three small groin-vaults above.

Before the 1830s alterations the chapel gallery was connected with a great Gallery that occupied the middle nine bays of the first floor. This was an unusual remnant of the long gallery tradition (cf. Colen Campbell's galleries at Newby Hall, Yorkshire, Pembroke House, Whitehall and Mereworth Castle, Kent). It was subdivided and walls to the S were demolished in the post-1836 rebuilding to form the **Academy Hall**, a room spanning the depth of the building corresponding with the entrance hall below. Pairs of unfluted Corinthian pilasters support a coved ceiling containing delicate restored plasterwork panels with trophies of military arms, musical instruments, and hunting and rural themes. The doorcases have fluted Corinthian columns supporting an elaborate enriched entablature. W of the entrance hall, the Huntstrete staircase, by *John Stephenson* and *William Toms*, has fluted balusters with cable moulds. Three stone reliefs from a monument erected in the grounds by Allen commemorate General Wade's public works in Scotland, the roads and the forty bridges built from 1726 onwards. The other main rooms have coved ceilings also, including the Drawing Room, now the Library in the NW corner, with its fluted Corinthian pilasters, Siena marble Ionic chimneypiece with a Greek key frieze and plasterwork above with garlands and cornucopia.

Bishop Baines died in 1843 and his successors commissioned Scoles to build the ambitious **church** in the W wing. Financial problems forced the college to close in 1856 and it reopened as a Roman Catholic grammar school in 1867. Work on the chapel recommenced in 1872, and it opened in 1882. It is without any doubt one of the most impressive

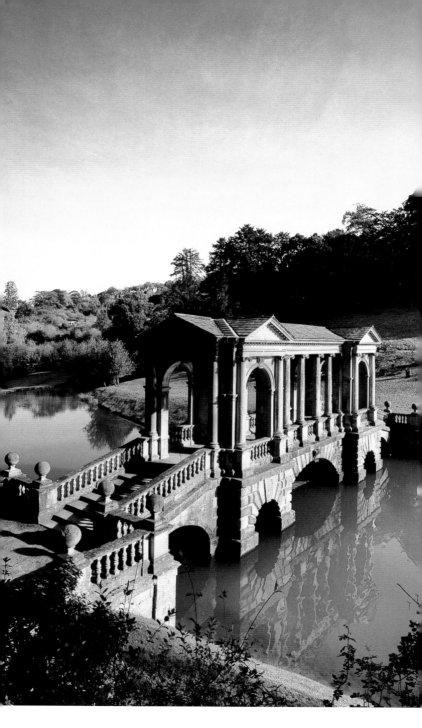

church interiors of its date in the county. Eight fluted Corinthian giant columns on each side separating nave and aisles carry not arches but a straight entablature, which runs from w to e without any break or projections and recessions. Some capitals remain uncarved. The ceiling is a coffered tunnel vault with penetrations from almost invisible clerestory windows; the tall apse has attached columns. The type comes from France and the later C18 (e.g. Chalgrin's Saint-Philippe-du-Roule in Paris, begun in 1774). *Charles Hansom & Son* of Clifton completed the vaulted corridor on s side of the chapel in 1867.

The Grounds

The **gardens** (to the n of the mansion and now National Trust) were landscaped in three phases. The first, *c.* 1734–44, a Rococo scheme executed with advice from the poet Alexander Pope, is shown in Anthony Walker's engraving of 1752. A sloping lawn is flanked to the e by a formal straight hedge screening a kitchen garden with a bathhouse (now probably relocated; *see* below) and to the w a wooded wilderness with a serpentine path. At the top are the remains of **Mrs Allen's Grotto** (sw corner), lined with Cornish minerals, and, a little e, a **serpentine lake** and a small vermiculated and pedimented **sham bridge**. Next, following Allen's purchase of lower slopes in 1743 and Pope's death in 1744, the garden was extended downhill, a cascade was formed halfway down, and the lakes and **Palladian Bridge** [59] were constructed and informal planting was introduced at the fringes. The bridge was built by *Richard Jones* in 1755 and follows Palladio's famous bridge design in the Burlington-Devonshire Collection now at the RIBA. The drawing had been copied before at Wilton, Wiltshire (1736–7) and Stowe, Buckinghamshire (1738). The bridge is roofed and has two pedimented end pavilions with arched openings and an open colonnade of four Ionic columns between. Finally, shortly before Allen died in 1764, *Capability Brown* removed the cascade to unite the garden in one great sweep and further naturalized the planting.

School grounds to the s. Several buildings remain to be mentioned. n of the e wing is a re-erected, pedimented archway that used to form a pedestrian entrance from the road. Heavily vermiculated, it has exaggerated, blocky keystone and imposts and, like the massive gateposts to the estate on Ralph Allen Drive to the w, is intended to greet the visitor with a showy advertisement for Allen's product. Beyond the archway is the **Priory**, a very early Gothic Revival cottage by *Richard Jones*, built *c.* 1740 for Dodsley, Ralph Allen's gardener. The s front, originally the main façade, has a battlemented projecting square bay, originally with a doorway, now with tripartite Gothic

59. Prior Park, the Palladian Bridge, by Richard Jones (1755)

mullioned windows with hoodmoulds, and a bay of similar windows either side. The roof was originally hipped. It was extended in the C19 on the E and N sides. The entrance is now on the short, now gabled w front. To the N, in 1988 *Ferguson Mann* built a girls' dormitory extension, gabled, rendered with stone surrounds (Prior Park became a co-educational public school in 1981). Adjacent to the w, the Priory Day House by *Ferguson Mann*, 1996, is a grass-roofed, rubble-stone lean-to with a timber loggia.

E of the mansion uphill, the **Old Gymnasium**, a recreational facility for the schoolboys and an arena for ball games, existed by 1839 and is by the *Rev. James Baines* (earlier attributed to Goodridge). This curious building reuses salvage from Goodridge's alterations to the w wing. It is long and narrow, enclosing on one side the sunken arena, perhaps over the quarry used to extract ashlar for the building. The N elevation is plain with a central Venetian window and a widely spaced window either side. The s, arena elevation has a primitive ground-floor colonnade of baseless Tuscan columns (probably purpose made) and corresponding round-arched windows above. A gladiatorial entrance to the arena on the E side has an impressive stepped keystone. w of this, i.e. s of the mansion, is a relocated rectangular **garden building**, plain with a cornice, shouldered openings and a vaulted interior with niches, now a cricket pavilion. This is probably the bath-house in Walker's engraving (*see* above) relocated. Further w (s of Scoles's chapel) is the **Julian Slade Theatre** and Sixth Form Study Centre by *Ferguson Mann*, built 1995. In ashlar and render, it has a simple rectangular enclosure which makes reference to classical details. A distinctive staircase tower projects above the parapet, open at the top with a small pyramidal roof. A single rake of retractable seating makes use of the steeply sloping site.

Walks

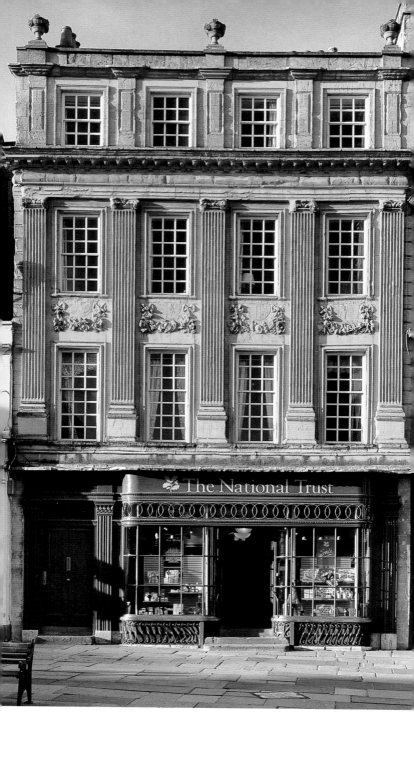

Old Bath: The South and West

The Walk explores the old city, including the former Abbey precinct, Bimbery – an area associated since the Middle Ages with healing and the mineral waters – and the Saw Close – originally containing timber yards and, later, places of entertainment. It also includes a brief excursion beyond the medieval wall to the N.

We start in **Abbey Church Yard**, before the w façade of the Abbey (*see* Major Buildings, p. 53) at the heart of the Roman city, on the site of the altar of Sulis Minerva and the lay churchyard to the Priory. Here, Bath's collage quality, its layers of history superimposed, is supremely evident. To the s is the Pump Room (*see* Major Buildings, p. 68); opposite to the N, Nos. 6–9 are a late 1790s terrace by *Palmer*, with a small centre pediment and Vitruvian scroll platband, and E of these, a pleasant row of individual houses. Nos. 11 and 12, three-storey, three and four bays wide respectively, are early C18, and No. 13, four-storey, is early C18, refronted and heightened, early C19. No. 14 was **General Wade's House** [60]. Tradition links Wade with the house though the freehold belonged to the Corporation until 1840 and he never held the lease. We may assume that he lodged there. The house is of *c.* 1720, that is pre-Wood. The architect is not recorded; it is possibly *Thomas Greenway* – or it may be Wade's own design. Above its ground floor the façade is a glorious architectural showpiece. A fine display of five giant fluted Ionic pilasters divides the upper part of the front into four equal bays. This is probably the first use in Bath of the Palladian giant order set over a basement storey. However, the details indicate distinctly provincial design – the even number of bays, window sills that come below the base of the order and curiously undersized Ionic volutes. Also, the proportions of the first- and second-floor windows, with old-fashioned bolection-moulded architraves, are similar enough in size to fall short of a Palladian *piano nobile*. Handsomely carved garlands in the spaces between have vestiges of French Baroque. The entablature has a pulvinated frieze and modillioned cornice. An attic storey with panelled pilasters, although original, has a clumsy 'added-on' feel. The house was acquired by the Landmark Trust in 1975 and repaired by *Brain & Stollar*

60. General Wade's House, Abbey Church Yard (*c.*1720)

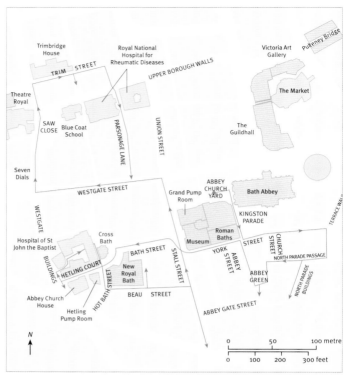

61. Walk 1

in 1976. Under the consultancy of *Professor Robert W. Baker*, early use was made of lime-based conservation techniques: lime watering consolidation, poulticing and revival of lime mortars. His controversial refusal on purist grounds to restore the Ionic volutes led to the City's withholding grant aid. The restored sash windows have small square panes and heavy ovolo bars. Internally, the first floor was refitted in the early C19; the second floor has restored panelling throughout. No. 15, attributed to *Thomas Greenway*, is also of *c.* 1720 and has above the ground floor an arrangement similar to No. 15 Westgate Street and General Wolfe's house in Trim Street, i.e. superimposed orders of pilasters flanking the (arched) central windows and superimposed angle pilasters. The first floor is Ionic with a straight pediment and the second floor Corinthian with a segmental pediment.

The **shopfronts** here are worth special notice, added when the address ceased being a fashionable one and declined into commercial use. No. 15 is *c.* 1850 with pilasters and four-centred arches, No. 14 is an exceptionally fine, large-scale and well-restored example of *c.* 1830 with double flat-fronted quadrant-ended bays with a continuous fanlight

General (later Field Marshall) Wade (1673–1748)

One of the founders of the city's good fortune, Wade served under Marlborough, was promoted general aged thirty-five, was sent to Bath to quell Jacobite plots, and uprisings, and later served four times as the city's M.P. He gave many grants and gifts to the city, including money towards the clearance of houses around the N of the Abbey to stop the public using the transept as a thoroughfare, the rebuilding of St Michael's church and a butchers' market. He is buried in Westminster Abbey.

over. The soffit has elegant composition mouldings. It was depicted on an advertisement for Woodford's 'Irish linen and muslin warehouse . . . Crapes, Bombazeens, Funerals Furnish'd'. No. 13, c. 1830, attributed to *Edward Davis*, is Soanish and has pilasters with incised decoration and acroteria, and a Greek key frieze. Nos. 11–12 have a High Victorian front with thickly carved cartouches in the spandrels. No. 10, of 1875 by *Price & Titley*, is smaller but confident with elaborate console brackets and a full-sheet plate-glass window with quadrant corners. No. 8, of c. 1830–40, standing in front of earlier arched openings, is designed for large square panes of either cylinder or plate glass.

In **Kingston Parade**, the open space s of the Abbey, stood the cloister and, along the w side, the long range of Abbey House (demolished 1755), residence of the Colthurst family who bought the Priory grounds in 1543. This joined the Abbey and extended to about the third buttress E. Turning left into **York Street** is an oblique view to the s of Ralph Allen's Town House extension (*see* below) and, immediately E, the **Friends' Meeting House**, 1817–19, built as a Freemasons' Hall. The design is by *William Wilkins* and proves him to be a more severe Greek than any of the Bath architects. A portico, with four fluted Ionic giant columns and pediment, based on the Erechtheum, projects from flanking wings decorated with single windows, originally blind. Within the portico is a symbolically blind doorway with a pylon architrave, which formerly bore the Masonic date, 5819, across the lintel. Hopper heads to the sides retain Masonic devices. The interior Great Room was lit solely by the two circular glazed lanterns. From the start, the building was rented out for functions; Thomas and Benjamin Barker, the Bath painters, both held exhibitions there. Opposite, Nos. 11–15 are a terrace of equally severe design, here Grecian tempered by Renaissance influence, built on a lease of 1819. With eleven bays and giant pilasters rising from the ground, the capitals, entablature and three-bay pediment reflect the Masonic Hall and may be attributed also to *Wilkins*.

Turning s into Terrace Walk (*see* Walk 8, p. 206), pausing to see again Ralph Allen's Town House at the end of a narrow alley right of the Huntsman public house, at once w again is **North Parade Passage**

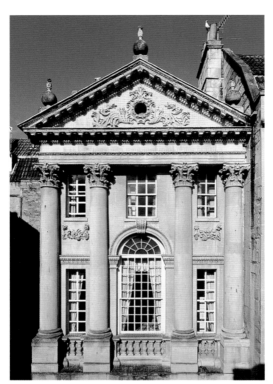

(formerly Lilliput Alley). Off North Parade Passage to the s are **North Parade Buildings** (formerly Gallaway's Buildings, as the incised lettering indicates) completed in 1750, a handsome paved blind alley set at an angle against the medieval wall (*see* Introduction, p. 12). Probably designed by *Thomas Jelly*, they are built to one plan instigated by an apothecary, William Gallaway. The corner of each range has long and short quoins, and the first-floor windows have alternately pediments and straight cornices. Most have fine pedimented doorcases with Corinthian columns or pilasters, unusual for speculative lodging houses (rather than houses for private individuals) because of cost. Some front and rear windows retain original glazing bars, still at this date with heavy ovolo bars. Most interiors retain panelling of varying quality and several have fine staircases, notably No. 7, of oak and mahogany with a full-height open well. Beyond to the s stood the National School, 1816–17, by *John Lowder*, a circular building with wedge-shaped classrooms for 1,000 pupils, demolished in 1896.

No. 4 North Parade Passage, **Sally Lunn's House** is a rare example in Bath of an early Stuart house (as is the almost identical house next E,

now part of the Huntsman). Four-storeyed with gables and inserted sash windows, it was built by a lease of 1622 to *George Parker*, a carpenter (not 1485 as the plaque suggests). The façade is keyed to take lime plaster. The shopfront is mid-C18, bow fronted with an integral doorway and geometrical fanlight. No. 3, originally Blanchard's Tenement, is also of 1622 but the façade is C18 with an ashlar ground storey, a rubble stone first storey, and a later C18 ashlar second storey. The first floor has early C18 panelling and the wooden staircase is spiral. No. 2, **Ralph Allen's Townhouse**, is of the same C17 type, but to the street has an C18 façade of five bays with quoins of even length. The interior contains full-height C17 and early C18 panelling. Allen was a sub-tenant from 1718 and when he acquired the lease in 1727 he built a detached wing in the garden to the rear, at right angles to the house [62]. He also added a matching but less elaborate façade to the rear of the existing house. The extension faces E towards the downs and the (later) Sham Castle, built by Allen to improve his view. When Allen moved to Prior Park in 1745 the building became his offices. The design is traditionally attributed to *John Wood the Elder*. However, there are no comparable works (but he had no other clients of comparable wealth), and in his *Description of Bath* (1765) Wood is ambiguous: 'the Designs, as well as a Model for this Addition, were made while I was in London'. Oddly tall and narrow, it is like a miniature Roman temple, with a rusticated ground floor with a wide arched centre, and giant engaged three-quarter Corinthian columns above forming three bays. The middle one has a large arched window with a carved keystone that breaks into the second-floor centre window sill. Below the windows in the side bays are richly carved garlands with fruits and flowers. Three ball finials and torches surmount a richly decorated steep pediment. The façade to the older house is simpler with the order omitted but with matching garlands and cornice. The forecourt, sunken by more than a metre, reflects changes in the surrounding ground level that occurred shortly after the house was built. Internally, the extension's second floor has remnants of early panelling of two phases, one portion with vertical emphasis and another three sections high.

At the w end of North Parade Passage is **Abbey Green**, an irregularly shaped, delightful little square of late C17 or early C18 houses with original stone setts and a large plane tree. The w side of the Green is along the E boundary of the Bishop's precinct, in which stood the Bishop's Palace. On the corner of North Parade Passage, No. 2, built by an agreement of 1698, has mullioned windows in the s façade and gables to the rear. There are probably areas of timber framing behind render. The front is mid- to late C18 with a timber lintel over the ground-floor windows to spread the loading, which traditionally would have been painted to resemble stone. It was restored and refaced for Bath Preservation Trust by *David Brain*, 1971. A right of ancient light of 17 ft (5 metres) to the E creates the sunken **Lilliput Court**, which

retains the early C18 ground level. No. 3 Abbey Green, to the s, is a late C17 house, with the remains of a double gable in the top floor and a bolection-moulded doorcase. The window surrounds too would have been bolection moulded, now tooled flat. Originally five-bay, the house is now only four except for the attic; the voussoirs of the original long narrow window openings remain. Mullioned windows to the sides are visible. Keyed to take lime plaster, the ranged stonework, typical of the late C17–early C18, is scored into blocks to form poor-man's ashlar. During repairs in the 1980s the rear (E) wall was revealed to be timber framing, which is almost certainly contemporary with the main structure and was merely an economy measure. To the s, No. 8 **Abbey Gate Street** was in the C18 the site of the Raven Inn, and the s gatehouse of the Abbey, which had two chambers over, stood opposite facing w. The Abbey gate was demolished in the mid C18. St Michael's Arch of 1973, by the *City Architect*, an elliptical rusticated archway with accommodation above, now forms the s entrance to Abbey Green. On the w side, No. 10 Abbey Green, the **Crystal Palace Tavern**, *c.* 1780, probably by *Thomas Baldwin*, originally had another storey. The doorcase architrave is now truncated, but the delicately carved scrolled brackets with sprouting acanthus buds are notable. In Bath these are usually simplified.

On the N side of Abbey Green several houses share uniform elevations, No. 1 (now misleadingly called Abbey House) and to right and left, in **Church Street** and **Abbey Street**. These were built by agreement of 1762 by *Jelly* in partnership with a mason, *Henry Fisher*. No. 1 Abbey Green and No. 2 Church Street have nice wooden staircases with carved ends to the treads, two twisted balusters per tread and broad handrails ramped to the half-landings. The former is elegantly curved. No. 2 Church Street backs on to, and now interconnects with, Ralph Allen's Townhouse. No. 5 has a late C18 shopfront. No. 2 Abbey Street, **Elton House**, of various periods and remarkably preserved, represents a microcosm of the changes undergone by the city itself from Roman times to the present. Excavations in 1981 revealed a Roman tessellated pavement, extending N from beneath the adjacent public house, and a medieval burial site. The ground plan is irregular and follows earlier boundaries, probably relating to the late Saxon church of St James, which was incorporated into the Bishop's Close in the C12. (This became the bishop's private chapel when a new church was built from 1279 outside the Close, the site later occupied by the C18 St James's church.) The house was built by a contract of 1699 for Edward Marchant. In the basement front s room is a stone range with a fine Baroque stone buffet with a shell hood set into raised and fielded panelling. An elaborate external doorcase in the front basement suggests a ground-level rise to Abbey Green in the mid C18. At the back are gabled wings N and S. The N wing has good bolection-moulded stone fire surrounds. In 1749 Bristol residents Jacob and Elizabeth Elton bought the lease from the Duke of Kingston, presumably as lodgings for visitors.

63. Bath Street, colonnades providing shelter for sedan chairs, by Thomas Baldwin (started 1791)

Soon after, the recess between the wings was infilled with a staircase, simple but broad, rounded at the half-landing for a sedan chair, but without a protruding rear bay. The heavy glazing bars are original. The street frontage was given an ashlar façade with plain surrounds. Around 1800, a double-bowed shopfront was added to the NE frontage and some further alterations and extensions were made to the stairwell and N and S wings. In the C19 the area ceased to be fashionable and major alterations ceased. Donated to the Landmark Trust in 1982, the house was sensitively repaired with minimal intervention by *Peter Bird* of *Caroe & Partners*. The façade was deliberately left uncleaned. No. 4 is a fine Palladian house of 1756, probably by *Thomas Jelly* (the design closely resembles North Parade Buildings). The first-floor windows have two straight cornices and one pediment in the middle and the corners have long and short quoins. Fine Corinthian columns and a pediment frame the big doorway, which has the earliest wooden fanlight in Bath. Original heavy ovolo glazing bars remain at first-floor level. Inside, the main rooms are panelled and there is an excellent staircase.

w along **York Street**, on the left is **Bath City Laundry**, 1887–8, by *C. E. Davis*, adapted from a Dissenting chapel. The ground floor has unfluted Ionic pilasters and above is a fanciful Baroque attic storey with pilasters supported on animal head consoles. This returns to form an elliptical-arched 'bridge' over York Street, linking with the Queen's Bath (*see* Major Buildings, p. 75), through which hot water was piped from the spring into the laundry. A Neo-Baroque doorway opens on to Swallow Street, and, behind, a massive ornate fluted ashlar chimney rises through an arcaded and pedimented square base.

w into Stall Street and a little to the N, and the finest piece of formal planning at Bath is reached, part of the Bath Improvement Act of 1789 which replaced the medieval street pattern. It is a perfect piece of design made especially attractive by its modest, easily manageable size. At the E end of the chief E–w axis is the front of the King's Bath, at the w is the Cross Bath. Between the two **Bath Street** (originally Cross Bath Street),

designed by *Thomas Baldwin* and started in 1791, runs with colonnades of twenty-one bays of unfluted Ionic columns on both sides, varying in height to accommodate the slope of the street [63]. These gave shelter for sedan chairs carrying sick occupants between baths. They open into a semicircle to embrace the King's Bath (the NE segment lost its two N end bays in 1869) and into another at the w end. Each façade above the colonnades has a platband with Vitruvian scrolls, and the principal windows have pediments and friezes with swags and paterae, supported on long, thin consoles typical of Baldwin. On the s side, E to w, Nos. 3–4 were restored and converted to shops and flats by *C. H. Beazer & Son* in 1963 and Nos. 5–6 to banks and flats by *David Brain Partnership* in 1990–2. Nos. 6–7 have original and sophisticated **shopfronts** of 1791 by *Baldwin*, designed integrally with the buildings. They have elegant console brackets, astragal and hollow glazing bars and wooden fanlights. Panels were added over the lower panes at an early date. The panes to No. 7 are elegantly proportioned to the golden section. The painter Thomas Beach (a pupil of Reynolds) resided at No. 6. In 1963 *J. F. Bevan Jones* rebuilt the N side of Bath Street to form Corporation offices, and in 1988–9 *Rolfe Judd Partnership* again rebuilt the N side behind the façade as a shopping mall; it was later converted into a department store. The replaced shopfronts are unfortunately without doorways and are spoilt by not stepping down with the fall of the street. The development has an extension beyond the semicircular NW segment with a weak and incorrect pedimented classical façade, forming an unwelcome intrusion into this important space. The street surface was restored with setts, though regrettably in granite not Pennant stone and in a radiating pattern of interlocking fans unknown in Bath. The sw segment now forms part of the **New Royal Bath** complex (*see* Major Buildings, p. 85). At the end, No. 8 Bath Street is the **House of Antiquities**, a small, early purpose-built museum constructed in 1797 by the Corporation to deposit the antiquities of the city previously displayed in the Stuart Guildhall (*see* Walk 2, p. 126). Niches in the façade contain statues from the Stuart Guildhall of the mythical King Coel and King Edgar, the first king crowned in Bath Abbey. The Council Minute Books for 1797 record that the architect was *Palmer*.

Closing the w end of Bath Street is the **Cross Bath** and, diagonally opposite to the SE, the **Hot Bath** (*see* Major Buildings, pp. 83). This is the heart of the sw sector of the walled city, a district once known as Bimbery. Although in the Middle Ages the area was sparsely populated and the residents poor, the improvement of the baths from the late C16 attracted both prominent invalids and fashionable doctors. Facing the Hot Bath is that delightful oasis Hetling Court and Chapel Court. At the entrance from **Hetling Court** on the left, s side, is the four-column Tuscan portico of the **Hetling Pump Room**, 1805; there is some evidence that suggests the design may be that of *Harcourt Masters*. It is now a visitor centre related to the New Royal Bath.

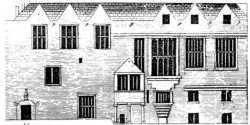

64. Abbey Church House, detail from Gilmore's map of 'Mrs Savils Lodgings Nere the hott Bath' (1692–4)

M[rs] Savils Lodgings Nere the hott Bath

Attached, to the w, is **Abbey Church House** (formerly Hetling House) [64]. Apart from the Abbey, it is the only surviving building illustrated on Gilmore's map of 1694. The core at basement level is medieval and is approached by later steps through an arch in the s wall. It may well be originally at or near ground level. At the e end two blocked openings are probably an original window and door. One has a pointed arch. These remains are post-1150 but otherwise undatable and are possibly part remains of the medieval buildings of St John's Hospital. The rest of the house, fronting w on to Westgate Buildings, was built around 1550 by Bath M.P. John Clerke. Dr Robert Baker acquired it in 1591 and extended the house e as a grand mansion to treat and lodge his noble patients, conveniently adjacent to the Hot Bath. The extension butts against the quoins of the original w block and is now partly Hetling House (No. 2 Hetling Court). Big and gabled, Abbey Church House has a few original windows, a good staircase, and a great c16 chimneypiece in the Great Chamber with fluted Ionic columns, an overmantel with seven tapering termini-pilasters, and also some strapwork. The house underwent a major rebuild and refurbishment in 1888 and most other internal features are Victorian. Abbey Church House was bombed in 1942 and restored in phases in 1949 by *Mowbray Green & Partners* and 1951 by *Carpenter & Beresford Smith*. The whole of the w front and most of the block s of the Great Hall are completely rebuilt.

On the n side of Hetling Court is the **Hospital of St John the Baptist**, its buildings arranged around Chapel Court with a main w entrance in Westgate Buildings [65]. The hospital was founded about 1180 by Reginald Fitzjocelyn, a protégé of Thomas Becket who, after Becket's murder, was sent to Rome to plead the King's innocence. The See of Bath was his reward. The hospital was located by the Cross Bath with its constant supply of hot water. At the start, it provided homes for poor men and one priest or master and was placed in the charge of the Prior of Bath. The existing buildings in this intricate group will be explained here in chronological sequence. The earliest, in the se corner behind the Cross Bath, is the chapel, **St Michael**, rebuilt in 1723 by *William Killigrew*. It replaced a c12 predecessor and was the first classical chapel in the city. The apse-ended interior is single height (the organ

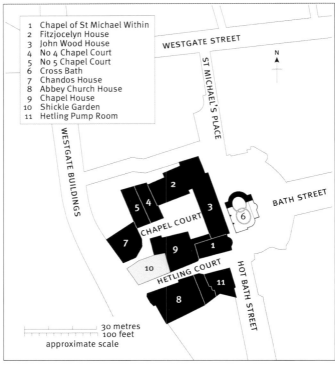

1 Chapel of St Michael Within
2 Fitzjocelyn House
3 John Wood House
4 No 4 Chapel Court
5 No 5 Chapel Court
6 Cross Bath
7 Chandos House
8 Abbey Church House
9 Chapel House
10 Shickle Garden
11 Hetling Pump Room

WESTGATE STREET

ST MICHAEL'S PLACE

N

WESTGATE BUILDINGS

BATH STREET

CHAPEL COURT

HETLING COURT

HOT BATH STREET

30 metres
100 feet
approximate scale

65. Plan of St John's Hospital, Chapel Court

gallery was added in 1971) but has two-storeyed windows, segment-headed and circular above. It was altered in 1879 by *Browne & Gill* with deplorable Venetian tracery, and stained glass by *Ward & Hughes*. This survives in the E windows and in the round windows with the symbols of the Evangelists. James Brydges, Duke of Chandos, built most of the other buildings as a venture, as lodging houses for persons of fashion visiting to take the waters. Properties near the Cross Bath and Hot Bath were always in demand. He leased blocks of property from St John's Hospital – which eventually reverted to the hospital – and employed as his architect the twenty-two-year-old *John Wood the Elder*, who had returned after gaining experience in London. First, in 1726–7, he rebuilt a lodging house on the N side of the hospital courtyard, later known as Chapel Court House. The ground storey is plain except that the windows have keystones which merge with a band course, the first-floor surrounds have architraves, a continuous sill and cornices with pulvinated friezes. The second-floor surrounds have eared architraves. The cornice is modillioned with a pulvinated frieze. The building was rebuilt behind the façade in 1953–6 by *Alan Crozier-Cole* and renamed

Fitzjocelyn House. Inside is a fine stone Baroque buffet with a shell hood for the display of china, removed from No. 15 Westgate Street (*see* below, p. 115). Then followed in 1727 the principal building along the E side, now known as **John Wood House**. This incorporated some structure of the Elizabethan hospital of 1580, which was two storeyed, with almshouses and a colonnade below and – to create income – lodgings with gallery access above. The Duke was only interested in upgrading the revenue-producing lodgings on the upper floors, but at Wood's behest it was given new front and back façades. It is a fine sober and dignified design. The main front has a heavy ground-floor arcade on pillars; above, the architecture matches Fitzjocelyn House. The rear façade, facing the Cross Bath, was restored in 1991, though without the lime render that would have covered the rubble stonework to resemble ashlar. Next, in 1728, was a range of lodging houses to the N, Chandos Buildings, now demolished. In 1729–30 **Chandos House** was built to the W, facing N and backing on to Chapel Court (renovated 1982–4 by *William Bertram*). It has a good plain five-bay front, three storeys, without any decoration. Inside is a good balustraded wooden staircase. The original workmanship, however, was said to be poor and the tenants complained of thin partitions, loose tiles and smelly drains. On 29 August 1730 the Duke wrote to Wood: 'It is the opinion of almost every one who has seen them [Chandos Buildings and Chandos House] & especially who have lodged in them that no two houses have been worse finished and in a less workmanlike manner by anyone who pretended to be an Architect'. In 1776 it became a public house, the Chandos Arms, which thrived until the First World War. Nos. 4 and 5 adjacent to Chandos House to the E were built in the 1760s by a carpenter, *William Sainsbury*, in a provincial, earlier style. No. 5 has a curious serpentine stair-rail, a showpiece of carpentry. The S side of Chapel Court was completely rebuilt in 1965–9 by *Alan Crozier-Cole* in a style echoing the buildings they replaced, 1760s Georgian but with aluminium windows and replica pre-Georgian with gables. A lift-shaft behind has a big Doric entablature. The accommodation includes almshouse flats and the Master's Lodge.

Leaving Chapel Court through the colonnade of John Wood House by the rear archway, with Roman Doric columns and pediment, **Hot Bath Street** to the S leads into **Beau Street**, running E–W. At the W end, the **Gainsborough Building**, originally the **United Hospital**, 1824–6, is by *John Pinch the Elder*. *Manners & Gill* added a heavy attic storey and the Albert Wing in 1861–4 and *Browne & Gill* added a third-floor attic storey to the W wing in 1890. Pinch's composition is bold and severe, unlike his delicate domestic work. The original building is like the elder Wood's General Hospital (*see* Walk 2, p. 122), of eleven bays with a four-column attached Ionic portico and pediment, except that here the columns start only on the first floor. *Manners & Gill* added a chapel in 1849, rebuilt by *Wallace Gill* in 1864; *Browne & Gill* an additional chapel

in 1897–8. This hospital resulted from the merger of two small infirmaries and served the local community, unlike the General Hospital. The bold, balustraded disabled access ramp is by *King Sturge*, 1995.

Next to the E is Bellots, founded at the beginning of the C17 for the reception of poor people coming to the city to take treatment by the waters, rebuilt to a bad design by *Cotterell & Spackman* in 1859. The small façade, two-storeyed with a slightly projecting centre, is ashlar with unpleasant black mortar and odd, splay-cut surrounds. Against the Bath stone in sandstone are mock eyebrow-like relieving arches and a rusticated plinth. The coat of arms is that of Lord Burghley of 1609, removed from the original building (the founder Thomas Bellot was his steward). Opposite to the N in Bilbury Lane, **St Catherine's Hospital**, 1829, by *George Phillips Manners* in Tudor style, is arranged around an intimate courtyard. It is an early C15 foundation that was originally administered by the City, once situated to the s, and known as the Black Alms after the colour of the uniform. *Richard Le Fevre* of *Snailum, Huggins & Le Fevre* converted it into ten flats in 1986.

E along Beau Street, Stall Street is rejoined. Little of interest remains s of here. To the SE stood until 1957 St James's church, rebuilt by *Jelly & Palmer* 1768–9, altered and with a new Italianate tower by *Manners & Gill*, 1848 (gutted in air raids 1942). Behind, St James Street South had several pre-Wood listed houses. These were demolished to make way for the **Marks & Spencer** building, 1961 (additional storey, 1970) by *Monro & Partners* and the (former) **Woolworth Block** by *W. B. Brown*, 1961, both fronting on to the E side of Stall Street. The former is one of the better postwar commercial buildings in this part of town. The first-floor windows to Stall Street have segmental pediments with

Tuscan surrounds, and there is a cornice with metopes. The latter is Neoclassical too, plain, with architrave surrounds. Returning N across Bath Street, the Grand Pump Room Hotel by *Wilson & Willcox* stood on the left, described by Pevsner in 1958 as 'large with Frenchy pavilion roofs . . . an intrusion of 1870'. Demolished in 1959, it was replaced by **Arlington House**, 1959–61, a bland colonnaded Baldwin-style building, contextually related to the architecture of Bath Street, by *K. Wakeford, Jerram & Harris.*

Now to the N and at once w, **Westgate Street** is the principal medieval E–w thoroughfare, formerly an area concerned with the reception of travellers, goods and animals. Many tradesmen lived here, and although it lacks large-scale industry or business the tax records do not portray it as a poor district. Westgate Street began to be developed from the Tudor period when the city grew as a health resort, with town houses and lodgings, many with malthouses to the rear. No. 11 has an early C18 hanging wooden staircase with twisted balusters and fluted newels. No. 14, **The Grapes Hotel**, contains in the first-floor drawing room the oldest remaining plasterwork of Bath, a fine ceiling with heavy strapwork and escutcheons with heraldic devices [66]. The heavy raised and fielded dado panelling with bolection moulding and bold bolection-moulded door surround are early C18. The second floor has a section of C17 panelling and a fireplace with a bolection mould. The third floor has a C17 mullioned window facing E and there are two further early windows on the same façade, now blocked. The house itself is one of a larger composition, and the street façade looks *c.* 1720. It has seven bays and four storeys. The centre bay is framed by Roman Doric three-quarter columns below (restored *c.* 1985), Ionic columns above and Corinthian at the top and carries a broken pediment. The Grapes was the family business of the architect George Phillips Manners. (At the rear of No. 15 was a stone buffet, found behind panelling in 1906 and removed to Fitzjocelyn House, St John's Hospital in 1956 – *see* above, p. 113.) Opposite, Nos. 27–29 are a single composition, late C18. Further w, the Egyptian-style former cinema at Nos. 22–23 was, from 1911–12, the Electric Theatre. *A. J. Taylor* extended it in 1920 to become the Beau Nash Picture House and refitted the interior in 1926. The façade is ashlar, three storey, five bay, with rusticated pilasters with stepped Art Deco drops; the parapet, raised in the centre, bears the city arms. The rectangular auditorium is classical; the shallow-vaulted ceiling is ribbed with brackets that disguise the end of steel roof trusses; the side walls are panelled. *The Builder* in 1924 thought it a good example of cinema design. No. 21, formerly the County Wine Vaults, is in confident 1870s Italian palazzo style. At the end of Westgate Street is the site of the medieval West Gate which, unlike the N and s gates, had direct access into the surrounding countryside without suburbs. The West Gate itself was rebuilt (in 1572, according to the elder John Wood) with lodging apartments above.

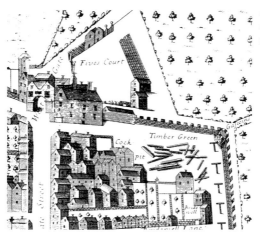

67. The Saw Close,
detail from Gilmore's
map (1692–94)

Turning N, the **Saw Close** [67], formerly also called Timber Green,
was originally an open grassy space bounded by the city wall on the N
and w, used in the C16 and C17 as a timber yard with saw pits. It devel-
oped as a space of general utility, of tradesmen and, later, entertain-
ment. The area remained untouched by the grand set pieces for which
Bath is famous. By the mid C18 it was an area for haulage, for in 1763 the
Corporation decided to erect a machine there 'for weighing hay, straw,
coals and other things'. Soon after, the city walls were demolished in this
area, and light industries developed, including a soap and candle
factory in 1815. By the mid C19 workshops operated from the rear of the
Westgate Street premises: No. 21 was a plate-glass warehouse, No. 23 a
brass foundry, and Nos. 24–26 a carrier's business. By the 1850s there
were public houses and wine merchants.

On the sw side, the **Seven Dials** development (named after an inn
that stood nearby) by *Aaron Evans Associates*, 1991, is a successful essay
in contextual classicism enclosing a courtyard, a piece of urban repair
on a triangular site cleared in the 1930s for a road scheme. The façade to
the Saw Close follows the line of the medieval wall, which stood 7–10 ft
(2–3 metres) to the E. The curved façade of the s extremity has a lead
dome and canopied balcony and a Doric colonnade at the ground floor.
The w elevation to Monmouth Street is especially fitting, with ramped
Pinch-the-Elder-style cornices to accommodate the slope. The stepping
downhill of the colonnade on the E is a little heavy handed and lacks the
lightness of touch of its C18 counterpart.

Still on the w side and continuing N across St John's Place, off to the
left, are some of the most interesting pre-Wood houses of Bath. The
present foyer to the Theatre Royal (*see* Walk 11, p. 257) is the principal
house of a group of four built by *Thomas Greenway* in 1720 that extend
into St John's Place. Beau Nash lived there from 1743. It has three storeys;

the E façade is six windows wide and the S, five. Late Baroque, the mouldings of window frames and frieze are characteristically overdone, as are the volutes of the brackets of the door-hood. Wood the Elder criticizes it as 'so profuse in Ornament, that none but a Mason, to shew his Art, would have gone to the expense of those Enrichments'. *C. J. Phipps* added the brash *Rundbogenstil* ticket office and entrance vestibule in 1862–3. The Garrick's Head public house occupies part of the ground floor and has over the entrance a bust of Garrick of 1831 by *Lucius Gahagan*. The house lay just outside the medieval western wall. Its northern neighbour was **Beau Nash's second house**, where he lived until his death in 1761. It too was outside the wall, on the site of the city's former refuse pit, separated only by a few feet from a corner bastion known as Gascoyn's Tower, which stood at the return of the wall along the N city boundary. The western rampart and Gascoyn's Tower were not demolished until the 1770s, so that the house finally opened on to the Saw Close. This is a later and more refined example of *Greenway*'s building. The house is well preserved, with nine-over-nine sash windows with heavy ovolo glazing bars and good interiors. Three bays wide on the entrance façade and five on the return, it has a fine and elaborate Corinthian doorcase, with a rusticated surround to the arched opening with a lion's head keystone and an excellently carved cornice. Two eagles on pedestals stand on the door-hood. The internal plan is simple but effective. The impressive eight-panelled entrance door gives access to a hall with a small room to the right and an arch to the left and, beyond, a fine staircase with winders. Ahead, the main room has three windows on the long E side, originally almost abutting the city wall, and tall painted deal panelling. Opposite the entrance is the fireplace, with a carved wood frieze of foliate design and a good later hob grate with urns, *c.* 1780. The first-floor layout is similar, but windows light the principal chamber on both long sides, three to the E and two to the W. The room is lined throughout with raised and fielded panelling.

Opposite, on the E side of the Saw Close is the **Pavilion Music Hall**, built into an older structure in 1886 with licences for music and dancing. This was formerly a large carrier's yard and stables, established in the C18 and extended in the C19. Substantially remodelled in 1894–6 by *Wylson & Long* as the Lyric Theatre of Varieties, it became an 812-seat theatre with stalls and pit, dress circle and gallery. The existing building was given a new entrance frontage, of ashlar with a pyramidal roof and a segmental arch over a two-storey loggia with heavy giant flanking pilasters. Known as the Palace Theatre by the 1930s, then altered in 1956–7 by *W. A. Williams* as the Regency Ballrooms, it is now a bingo hall. The adjoining random rubble building to the S is a house of 1636; a mullioned and transomed window survives in the S elevation. *F. W. Gardiner* added a fluted Corinthian pilastered shopfront in 1903; it became the theatre bar.

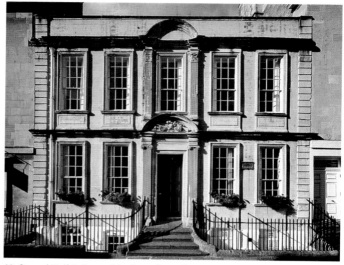

68. General Wolfe's House, Trim Street (c.1720)

Adjacent, to the N, on the corner of Upper Borough Walls is the **Blue Coat School** of 1859–60, by *Manners & Gill*, built for sixty boys and sixty girls at a cost of £3,000 and so called after the colour of the children's uniform. The school was founded on the site in 1711, and had a schoolhouse of 1728 by *William Killigrew*. Both John Wood the Elder and Manners went to the school. The style of the replacement is Jacobean but with an eclectic Flemish flavour, with curved gables, mullioned windows and ornate strapwork. The extravagant five-stage corner bell-tower, with clock, engaged columns and steeple, is a witty reference to that of the original school. A Roman tessellated pavement, discovered during the construction, is preserved in the building.

Further N, the **Unitarian Church** (formerly Trim Street Chapel) of 1795 attributed to *Palmer* (right) cost £2,500. The ground floor is rusticated and in the upper part are tall arched windows. The apse was added and the interior altered in the *Rundbogenstil* style in 1859–60 by *W. J. Green*. It ceased to function as a chapel in 1972 and is now a public house. **Trim Street** off to the E, begun in 1707, was the first extramural C18 development, and is named after George Trim, a wealthy clothier and city councillor who breached the N wall to give access. In the C19 the houses in this once fashionable street became warehouses, a rope yard and a mason's workshop. The street's charm is now spoilt by **Trimbridge House** (the City Planning Office) on the NW corner, by *John Bull & Associates* of 1970. With a three-storey ashlar elevation, aluminium sashes and a false mansard roof, the building at least conforms to the general scale of the street. Incised moulding links the

windows and an abstracted reference to giant order pilasters marks the entrance. Opposite, a uniform group of three houses dated 1724, converted to offices in 1982, with characteristically framed windows and keystones. One retains a fine stone shell hood. E of these, on the corner of Trim Bridge, is an early house with twin gable-ends; the valley is now infilled. On the N side of Trim Street the arch, also known as **Trim Bridge** (originally and more correctly St John's Gate), was formed after 1728 as a public passage for carriages to Queen Square at the NW corner of the city. No. 5, of *c.* 1720, in florid provincial Baroque style, is known as **General Wolfe's House** [68], though he occupied what was actually his parents' house only for a short period in 1759. That year he left to fight the French in Quebec, where he died in action. It has only two storeys, with five narrow bays, rusticated angle pilasters, a doorway with fluted Ionic pilasters and a segmental pediment; the window above it has fluted Corinthian pilasters and again a segmental pediment. The windows have bolection mouldings, but the sashes are later, as are the military trophies in the tympanum over the door. The rear elevation is gabled and with indications of fenestration (now blocked in) to the staircase. The panelling in the hall is, unusually, stone. The staircase has twisted balusters, the ground-floor front room an early arched sideboard recess with foliate plaster decoration.

Original setts (boasted on the slope) and Bath stone coalholes remain at this end of the street and in the return to **Upper Borough Walls**. Here, a stretch of the medieval battlemented **wall** of Bath survives, much repaired. On its N side was an extramural burial ground to the General Hospital on the other side of the street (*see* Walk 2, p. 122). It was opened in 1736 and closed in 1849 'from regard of the health of the living'. Opposite, Parsonage Lane, and the parallel Bridewell Lane to the w, are two of the city's grid-pattern streets thought to have been laid out in Saxon times. In 1997 remnants of medieval tenements were excavated in Bridewell Lane, called Plumtreotwichene (Plum Tree Lane) in C13 documents. Down **Parsonage Lane**, on the w side behind No. 33 Westgate Street, is a rare early, large-scale **brewery** with a side dray entrance. A lease for the property, sold by the Corporation in 1810 to Thomas Pickford of Islington (a 'Gentleman') describes a 'newly built house and brewhouse'. All of this, except for the stable block, survived conversion for the *Bath Chronicle* newspaper printing works in the 1920s and then into flats and retail in 1996–9 by *Aaron Evans Associates*. The latter forms part of a larger mixed-use project, which includes another Georgian building at the NE corner of Parsonage Lane and new, discreet infill building on Bridewell Lane to the w.

From here we are a few steps from Abbey Church Yard.

Old Bath: The North-East and its Suburb

The Walk explores the NE medieval city, including the Guildhall area and the E and N gates, one of its suburbs, and the impact of the Bath Improvement Scheme of 1789.

From Abbey Church Yard, W through Baldwin's Pump Room colonnade [69] into **Stall Street** and heading N, we meet the main E–W thoroughfare: Cheap Street running E (*see* below) and Westgate Street (*see* Walk 1, p. 115) running W. On the SE corner, No. 21 Cheap Street, a pub (formerly Abbey Wine Vaults), 1897 by *C. E. Davis*, curves around the corner, with three C19 splayed bar windows and front with a decorative frieze. The first-floor windows have segmental pediments. Diagonally opposite, No. 1 Union Street is a large, boldly ornate classical block, French in character, with giant Corinthian pilasters, of 1885 by *Willcox & Ames*. A refronting and additional storey to an existing house for a Mr S. J. Andrews, forming shops at ground level, offices at first floor and domestic accommodation above; the architects justified the proposed embellishment on the grounds that 'the far greater and dominant

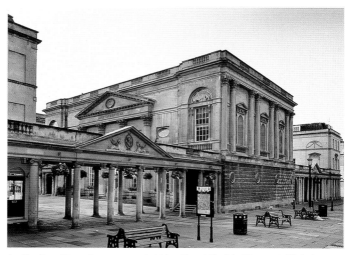

69. The Grand Pump Room, screen to Abbey Church Yard, by Thomas Baldwin (completed 1791)

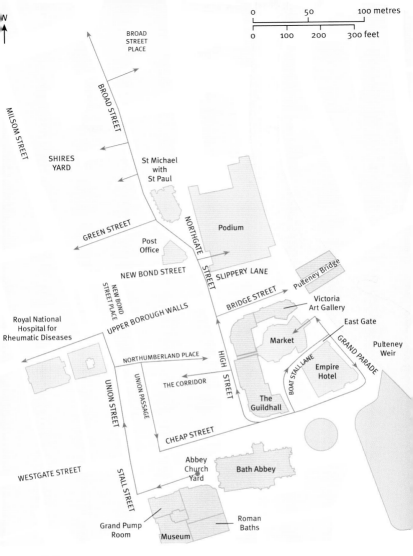

70. Walk 2

height of the Grand Pump Room Hotel (*see* Walk 1, p. 113) dwarfs these premises'. Over the first-floor windows are profusely carved scrolled pediments and birds of prey, over the second-floor, carved human heads. Above, lions' heads hold in their mouths large carved laurel swags. Attic windows in the mansard roof have tapered pilasters and segmental and triangular pediments, each with a shell in the tympanum.

N is **Union Street**, laid out by *Baldwin* as part of the Bath Improvement Act of 1789 (*see* Introduction, p. 23) and built 1805–10. This significantly improved the route N between the old city and the

upper town. Before, this involved passing through the yard of the Bear Inn or one of three narrow alleys running N from Westgate Street and Cheap Street to Upper Borough Walls. Nos. 6–8 on the w side formed the centrepiece of the whole, otherwise plainer, elevation. It is a typical Baldwin composition with paired fluted Corinthian pilasters and garlands and rosettes. The central window is pedimented. It was occupied in the C19 by a department store, Colmers, the business expanding N into Nos. 9–11. In 1892 *Browne & Gill* completely rebuilt the façade of Nos. 9–11 to match the elaborate Nos. 6–8. This unified the store but lost the street its symmetry. On the E side, Nos. 23–25 are modern facsimiles. No. 20 has a C19 façade with a four-bay engaged Ionic colonnade at first floor. Just to the N is the w entrance to The Corridor (*see* below). Continuing N, Upper Borough Walls, running E–W, indicates the N boundary of medieval Bath.

In Upper Borough Walls, s side, is the **Royal National Hospital for Rheumatic Diseases** (originally the General Hospital, then the Mineral Water Hospital). Primarily set up for the visiting poor to receive mineral water treatment, as did Bellot's Hospital from the C17 (*see* Walk 1, p. 113), it was built by the elder *Wood* in 1738–42 who gave his services gratuitously. It was sited to be near the baths. His initial design was for a circular building but this was dropped after insistence that there should be room for future expansion. Ralph Allen donated the stone and Beau Nash organized subscriptions: an interesting parallel to the hospital-founding philanthropy of contemporary London. Originally two-storeyed over a basement, the main block is eleven bays long, with a three-bay attached portico. The unfluted Ionic columns rise from the ground floor and carry a pediment. *John Palmer* added an attic storey *c.* 1793, until which time it accommodated about seventy patients. The building reflects the standard C18 'country house' approach to hospital design. The patients occupied wards on the upper storey, and the principal storey was shared between two more wards, the medical staff including the resident apothecary, the matron and the Committee. Resident staff lived and ate in the basement, which also housed the privies. Until 1764, sewage and all hospital waste was swilled along a drain to a ditch beyond the city wall. In 1830 water was piped direct from springs. Locals were not admitted – on the basis that they would not require accommodation – and 'cripples and other indigent strangers' had to provide credentials proving their poverty. The building was severely damaged in 1942, and the internal layout is now altered. An extension block, also eleven bays, in similar style – remarkably for that time – was put up to the w in 1859–60 by *Manners & Gill*. The tympanum has a carving by *H. Ezard Jun.* of the Good Samaritan with the inscription 'Go thou and do likewise'. An apsidal chapel on the E side has stained glass by *Wailes* of Newcastle. The addition contains a large open wooden staircase in Palladian Revival style within a central hall. In the C20 the hospital became the world leader in

the treatment of arthritic and rheumatic diseases. The extension has a
fragment of a **mosaic** measuring 9 ft 2 in. by 6 ft 10 in. (2.8 metres by 2.1
metres) and 13 ft (4 metres) below street level. The scale of its blue and
white swastika-meander design suggests that it formed part of a much
larger pavement, perhaps a corridor, in a C4 dwelling close to the
assumed line of the N wall.

Turning E and straightaway S, **Union Passage**, parallel to Union
Street, is an intimate little thoroughfare rebuilt also by *Baldwin* under
the Bath Improvement Act. Paved, about 12 ft (4 metres) wide, and
with uniform plain three-storey frontages with attics above and shops
below. Before the rebuilding, the jettied façades were said to be set so
close that it was possible to shake hands with opposite neighbours.
Northumberland Place, extending E from Union Passage, is a charm-
ing narrow paved street with C18 buildings, built on land owned by the
Duke of Northumberland [71]. The small-scale shopfront of No. 7, *c.*
1820, is the best preserved of what was once a matching group of four,
perfect for this narrow street. Reeded pilasters, with square margins and
lions' head capitals, flank the fascia, which retains its shutter slot. The
glazing bars are tapered in section, but every second bar has been
removed. A good collection of traditional-style late C20 hanging shop
signs contributes much interest. The local authority encourages these
in appropriate streets or groups provided they accord with advertising
policies. Ahead, above the archway connecting with High Street, is a
pediment and, in *Coade* stone, the arms of Frederick Augustus, Duke of
York and Albany (1763–1827), who attended the opening of the new
Pump Room in 1795 and was presented with the Freedom of the City.
Continuing S, No. 25 Union Passage, E side, is a narrow early C19 build-
ing with its original bowed shopfront, filling a former entrance to
Shum's Court (originally a stableyard to the former Hind Inn at Nos.
5–6 Cheap Street, taken over in 1800 by the Shum family, butchers and
confectioners of Nos. 7–8 there).

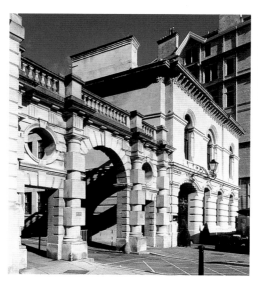

72. Baroque screen, by John McKean Brydon (1893–7) and the old Police Station and Lock-Up, by Charles Edward Davis (1865), Orange Grove

Union Passage now meets **Cheap Street** (in Old English, Market Street), known until 1399 as Sutor (Shoemakers') Street. It was widened and refronted *c.* 1790, under the 1789 Improvement Act. Nos. 15–19, s side, are by *Baldwin*, with Doric columns at street level to take **shopfronts**. Several are noteworthy. Nos. 20–22 are by *C. E. Davis*, 1895. No. 16 was originally a butcher's shop with a sash window for ventilation. No. 14, by *A. J. Taylor*, dates from 1925, with a continuous wide stone surround with a stepped top of Art Deco flavour, bronze framing and a black and gold marble stall-riser. On the n side, Nos. 5–6, known from deeds to have been occupied in the c15 by cloth workers, were totally rebuilt by *A. J. Taylor* in 1925–9, along with the façades of the other Georgian houses in this part of the street.

Continuing e into Orange Grove (*see* Walk 8, p. 204), opposite on the n side is the old **Police Station and Lock-up** of 1865 by *Charles Edward Davis* [72]. It functioned as such until 1966 when the new one opened in Manvers Street. The building is in the Italian palazzo style and, despite its comparatively small size, has a suitably bold appearance with a heavily rusticated ground floor and three deeply recessed round-headed windows on the *piano nobile*. It became a restaurant in 1998. The cells are now the lavatories.

To the left through *Brydon*'s Baroque screen [72] we reach a court-yard dominated by the beautiful e façade of *Baldwin*'s Guildhall (*see* Major Buildings, p. 76). This area was once the site of the medieval Guildhall, which would have been timber-framed and was perhaps originally thatched. It was superseded in 1626–7 (*see* below), when it became a butchers' shambles. On the e side is the slipway to the **East Gate** [73], a c14 gate of the medieval city, the last survivor of four (the

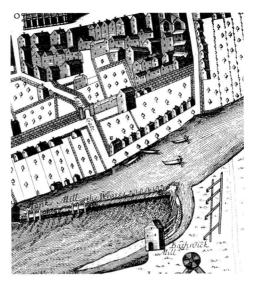

others were demolished 1754–76). Originally leading to the city mill and
the ferry to Bathwick, it is a narrow postern barely adequate for a cart,
with a shallow pointed arch externally and a segmental arch internally.
The city wall to the N survives in C18 undercrofts; the wall to the S, 6 ft 6
in. (2 metres) broad at its base, was largely demolished for the Empire
Hotel (*see* Walk 8, p. 206). The short alleyway to the E, **Boat Stall Lane**
(named after a former passage from the High Street to the East Gate),
leads to the River Avon. The group of buildings to the left, Newmarket
Row, includes the **Market**, a building of shallow depth forming the river
frontage to Baldwin's design for the Guildhall and market of 1775. The
modest façade is of two storeys and eleven bays, the one-bay centre with
a pediment and arched entrance. The area behind, for the actual mar-
ket stalls, was rebuilt in 1861–3 to a design won in competition by *Hickes
& Isaac*. A concentric arcade surrounds a twelve-sided domed centre, lit
by a drum with lunettes. Further arcades give access from E and W.
Stone Roman Doric columns support the cast- and wrought-iron roof
structure. Inside, W, is an C18 'nail' pillar with a slate top for counting
money (hence the expression 'pay on the nail', meaning without delay).

Returning E out of the market on to **Grand Parade**, before us is the
principal view of the river. Pulteney Bridge (*see* Major Buildings,
p. 81 and Walk 6, p. 176) is to the left and beyond are fine views across
green slopes around the city that were purchased by the National Trust in
1983 to prevent development. **Pulteney Weir** was rebuilt 1968–72, architect
Neville Conder of *Casson & Conder*, as part of Bath's flood control
measures. This was once the site of fulling and corn mills on either side of
the river. Newmarket Row was widened in 1890–5 to create Grand Parade
and its long Tuscan colonnade of thirteen bays below, next to the weir.

Early Photographic Studios in Bath

The Corridor was much associated with early Bath photographers. At the rear of No. 7 William Whaite's by 1854 had a 'Photographic Portrait Establishment', one of the first in the centre of the city. Half a dozen successive photographers took the studio (a term not used in this context until the 1870s), until the portrait photographer William Friese Greene, pioneer of the moving picture camera and holder of the cinematograph patent of 1889, occupied it in the 1880s. (He also had studios at 34 Gay Street – *see* Walk 3, p. 141 – and others in Bristol, Plymouth and London.) Following Friese Greene's departure in 1889 improvements were made and the photographic studio continued in use until the end of the C20. By the 1850s–60s there were several early photographic studios in Milsom Street, at Nos. 42, 38 and 35 (where Mrs Williams specialized in portraits of children 'from the age of ONE MONTH'. Roebuck Rudge, scientific instrument maker and inventor of the biophantascope – demonstrated in 1892, precursor of the kinematograph – had premises at No. 1 New Bond Street Place, to the s off New Bond Street.

Walking clockwise around the block past the Empire Hotel, and turning N into **High Street**, the N side of the Abbey and the Guildhall make a splendid ensemble. The Guildhall fills the whole of the E side and the description is therefore of the w side. High Street, probably one of the Saxon grid of streets laid out within the city wall, functioned historically as the civic heart of Bath, and the marketplace. In front of the present Guildhall stood the medieval Guildhall's successor, built in 1626–7 on the site, and possibly on the foundations, of a Tudor market house. As the administrative and judicial centre for 150 years, and the venue for Corporation celebrations, plays and other events, surprisingly little is known about it, apart from the illustration on Gilmore's map. This shows it raised over an open storey for the market, with six bays of tripartite mullioned windows separated by piers and an **M**-shaped roof. Various alterations were subsequently made, including partial rebuilding with a new s front in 1724–5, apparently by *William Killigrew*, to provide more space. The fabric subsequently deteriorated and by 1766 seemed near to collapse. Of the building, only two weatherworn statues remain in the niches in the wall of No. 8 Bath Street (*see* Walk 1, p. 110). The house at the s corner of Cheap Street (No. 13), earlier C18, conforms to the pre-Palladian practice of equal-size windows in the upper storeys. Nos. 9–10 on the N corner of Cheap Street, by *C. E. Davis*, 1895, are curved with large arcaded first-floor windows.

74. The Corridor, High Street, by Henry Edmund Goodridge (1825, shopfronts and roof glazing altered, 1870)

Nos. 11–12, the **Christopher Hotel** were originally two or three C17 tenements running back from the High Street. The building had a Georgianized, jettied timber-framed façade. It was probably Bath's oldest surviving inn, and contained part of a C17 staircase, several parts of Georgian staircases and an early C18 panelled room. It was de-listed in the 1970s because the façade had been rebuilt in bland Neo-Georgian in 1955; the interiors were gutted and the rear C17 part demolished in 1997–8. Nos. 15–17, **The Old Bank** (now NatWest), have been bank premises since 1787, but were rebuilt above the basement by *Dunn, Watson & Curtis Green* in 1913–14. Their façade is Neo-Georgian, rusticated at ground floor, five bays wide, with architrave surrounds at first and second floors, and with alternating pediments and straight cornices at first floor and a partly balustraded parapet. The banking hall to the rear has a shallow domed coffered ceiling and clerestory lighting.

Nos. 18–19 are the façade of a shopping arcade, **The Corridor**, built in 1825 as a speculation by the young *Henry Edmund Goodridge*; it was one of the earliest outside London of this new building type and fashionably Grecian in style (cf. Samuel Ware's Burlington Arcade, 1815–19, and Nash's Royal Opera Arcade, 1816–18). Originally of twenty-six units, now much altered, it is some 200 ft (65 metres) in length. Slightly recessed between narrow pavilions, the central portion is three windows wide, with a pediment supported on consoles at first floor. Above the entablature the attic storey has three lunette windows and a central pedestal with wreath decoration. Intersecting Union Passage and connecting with Union Street, the arcade has entrances at each end with Doric columns and pilasters of polished red Aberdeen granite of 1870, replacing the originals of Bath stone. The High Street entrance has a glazed canopy of 1927 by *A. J. Taylor*. Until 1965 gates at each end were locked at 10.00 p.m. by a 'constable'; it was declared a public highway in 1977. The arcade has a tunnel-vaulted glazed iron roof, also of 1870 (originally wood-framed and pitched with coloured glazing) either side of a double-height centre with an iron-balustraded gallery. Originally a band played here in the afternoon to accompany the pleasant promenade. The frieze has nice wreath decoration (cf. the Choragic

Monument of Thrasyllus, Athens). Several **shopfronts** of 1870 have tall sheets of plate glass with quadrant heads [74]. In the late C19 there were wide brass stall plates from end to end. That at No. 18 remains, engraved with ornamental lettering; 'Bussey' was a firm of stationers. No. 10 was Mrs Mary Ann Flukes' fringe, gimp and tassel manufacturer, 1841–52, and Nos. 8–10 from the 1860s were notable for the celebrated Hatt's Hair-dressing and Perfumery Establishment. In 1833 *Goodridge* built the Corridor Rooms (later Victoria Rooms) in Shum's Court, miniature assembly rooms, entered between Nos. 7–8 (and originally also from Cheap Street). The arcade was lit by electricity in 1894 (electric incandescent lighting was first introduced into a Bath store in 1882 and into the main thoroughfares in 1890, about the time that telephone lines were laid in the region).

Next on High Street, the **Harvey Building**, 1964–6 by *North & Partners* under the guidance of *Sir Hugh Casson*, is a dreary block designed to a formula considered contextual at the time. The stepped plan and false mansard roof (something relatively new then, and influential) are intended to reduce the scale, while modern aluminium frames are set within windows of Georgian proportions, a perpetuation of 1930s techniques, e.g. in Charles Holden's buildings for the University of London.

To the right is **Bridge Street**, with the Victoria Art Gallery on its s side (*see* Major Buildings, p. 79). The mixed commercial street was built with the Corporation's agreement in 1769 to connect High Street with Pulteney Bridge. On the N side, the shopfronts to Nos. 1–2, by *A. J. Taylor*, 1922, incorporate in the fanlight a clock in a gilded wreath frame. No. 7 has an excellent shopfront of *c.* 1830 with wide, curved stall plates engraved with ornamental lettering and four fluted Corinthian columns. *W. J. Willcox* elaborately rebuilt No. 9 in 1903 for the music shop, Duck, Son and Pinker, with Corinthian pilasters through the first and second floors, urns on the parapet and a shopfront with segmental heads.

Following directly from High Street, **Northgate Street** lies almost entirely to the N of the medieval North Gate (demolished 1754) and therefore outside the city wall. This was the principal entrance to the city, probably from the Saxon period, and a prime trading site with market stalls. In 1776 there were four licensed alehouses along its short length. On the corner of Bridge Street, No. 17 has a jeweller's shopfront by *Browne & Gill*, 1881, curved around the street corner with composite pilasters and an ornate entablature with consoles and garlands. On part of this site stood the church of St Mary by the Northgate. After it became disused, King Edward's School, founded in 1552 in Frog Lane, later New Bond Street (*see* Walk 4, p.153), occupied it from the 1580s, before moving to Broad Street in 1754 (*see* below). The tower served as the prison at the same time, the prisoners shouting insults to travellers as they made their way through the North Gate. The church was demol-

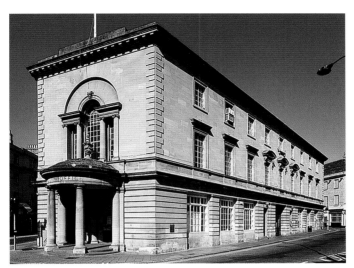

75. Post Office, New Bond Street, by the Office of Works (1923–7)

ished when Bridge Street was built. A little to the N, the narrow **Slippery Lane** off to the E was immediately outside the North Gate. It is one of the few remaining medieval lanes and linked Northgate Street with the ferry that preceded Pulteney Bridge. Next, No. 12 was rebuilt in 1927–8 by *A. J. Taylor*, incorporating an Art Deco shopfront, which has a continuous stone surround with acanthus leaf carving, a granite base and bronze framing and lettering.

Opposite on the W side, between Upper Borough Walls and New Bond Street, the rebuilt **Plummer Roddis Block** is by *Alec French Partnership*, 1980–3. The infill to Upper Borough Walls, with double-height openings and cast-iron window frames and spandrels, is a contemporary, well-mannered intervention which avoids pastiche. The façade is a faithful replica of its late C18 predecessor with the exception of the Tuscan colonnade, an alteration to widen the pavement at the behest of the Highways Department. A less rustic choice of order would have been preferable. Four C18 corner buildings, renovated by *Atkins & Walters* as part of the same project, incorporate at Nos. 2–3 **Upper Borough Walls** a pair of Neo-Victorian shopfronts with Greek Revival anthemia and plate-glass windows.

On the N corner of New Bond Street, the **Post Office** [75], 1923–7 by the *Office of Works*, is a distinguished and competent Neo-Georgian design produced at a time when classicism still formed the basis of an architect's education. A self-confident building, it fits in well with its period neighbours without copying them. It replaced the Castle Hotel, rebuilt after the Improvement Act of 1789; its carriage entrance was perpetuated as service access. The site is wedge-shaped and the

entrance at the narrow end has a Roman Doric rotunda vestibule with a Venetian window above (cf. Gibbs's St Mary-le-Strand, Westminster).

Opposite, E side, the **Podium**, 1987–9 by *Atkins Sheppard Fidler & Associates*, a complex containing a shopping mall, supermarket and the city library, is an unconvincing essay in half-hearted classicism using an architectural language that is foreign to its Georgian context. It replaces streets of C18 houses, demolished originally to provide a site for new law courts. It does therefore have the merit of filling a gap in the streetscape and turning the much reviled Hilton Hotel (*see* Walk 9, p. 223) from a free-standing block, visually unconnected with its setting, into part of a quasi-terrace. Behind the façade, a crudely designed glazed atrium leads to the river.

St Michael with St Paul, Broad Street [76], at the sharp corner with Walcot Street and in the *point-de-vue* up Northgate Street, 1834–7, is by *George Phillips Manners*. The church is of medieval origin and lay at first outside the walls. The present church is Manners' most notable work. Its predecessor, dating from 1734–42, was by the stonemason *John Harvey*, probably son of the mason of the same name who built the first Pump Room. The design was in a handsome if outdated classical style influenced by Wren. Manners' church was built to increase the pew accommodation from 500 to 1,200. The splendid tower is tall and narrow with a huge group of three stepped lancets, buttresses and corbel tables based on the E end of Salisbury Cathedral. At the top, the tall octagonal open lantern with a spire resembles German Gothic (cf. Freiburg Cathedral). Polygonal porches flank the tower. The sides have the same buttresses and the same groups of lancets. Inside, the aisles are the same height as the nave, i.e. a 'hall church' (cf. Bristol Cathedral) to accommodate galleries – removed, with Manners' pulpit and pews, in a reordering by *Browne & Gill* in 1889. The circular piers are tall and thin with four attached shafts. The ceiling has quadripartite plaster rib-vaulting, the polygonal apse blank arcading. In the church is a detailed architect's model and some curious fittings, a top hat stand under a pew and a rest for the mayor's sword set into the column next to the pulpit.– **Organ**, 1847, by *Sweetland*.

To the w side of the church we now enter **Broad Street** and the main medieval suburb, with substantial remains of the early C18. It was an area of cloth weavers. First **Green Street** off to the w provides a rewarding miscellany of houses and shops. So called from having been laid out in 1717 on the site of a bowling green, it never formed part of the city's later planned interventions. Of transitional type, the surviving original houses are markedly old-fashioned in relation to the surrounding late C18 streets. Most of the houses became shops by the early 1800s, originally with projecting bow windows but now with plate-glass **shopfronts**. On the s side that to No. 10 is designed for a butcher, retaining a canopy above the fascia to protect displayed produce. The congenial **Old Green Tree**, No. 12, is one of the city's oldest public

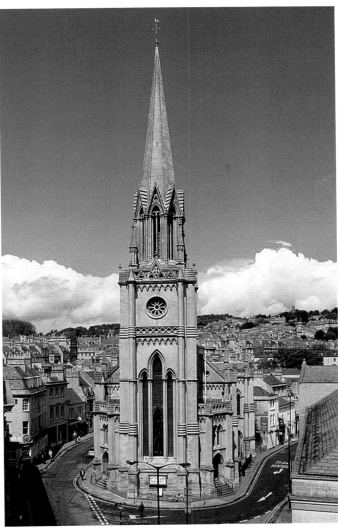

76. St Michael with St Paul, Broad Street, by George Phillips Manners (1834–7)

houses having existed since the 1770s. Originally just one room deep, with a brewery, it had a rear extension added by *W. A. Williams* in 1926, including a 'smoke room' and a toplit bar, a pilastered front and oak-panelled interior. No. 13 is believed to be where Bath Oliver biscuits were first sold in the C18. No. 14 is a good three-bay four-storeyed gabled house with closely set sash windows and broken seg-mental pediments over the first and third windows on the first and second floors. A shopfront of *c.* 1850–60, narrow with elliptical-arched

mullions, originally full height, has exquisite and unusual undercut carved wood consoles of free-flowing naturalistic floral design. No. 15 too is gabled. The shopfront to No. 19, *c.* 1850–60, was originally arcaded; it has double console brackets and the cornice has turned pendant drops, presumably by the same carver as at No. 14. Opposite and set back on the N side, No. 3 is of vernacular style, three-storeyed with three gables, hoodmoulds and a good shell hood over the doorway. Five windows wide on the first floor. Nine-over-nine sash windows in bolection-moulded surrounds. Inside, the first floor has fielded panelling. Returning to the E, Nos. 4–6 were rebuilt in 1769 as a single block on the site of a malthouse owned by the Dallimores, landlords and probably builders of the Saracen's Head, Broad Street. Nos. 7, 8 and 8a are a parade of single-storey lock-up shops of 1908 with decorative toplights, by *J. Foster & Sons,* builders.

Broad Street retains its medieval character with variations in height, width and style. Many pre-Georgian buildings survive behind Georgian façades. On the w side, No. 3 has a C17 timber roof structure suspended inside the present one, and visible at the rear is a complete and rare section of C17 timber framing. A Bath-chair works was at No. 4. The Post Office occupied No. 8 in 1821–54, when the London mail started from the Royal York Hotel (*see* Walk 4, p. 162). From here, the first adhesive postage stamps in the world were franked and sent in 1840. No. 7a has a rear outshut of *c.* 1680 [77] (a 1640 date stone, formerly external, is probably from an earlier building). In the N wall there is a long four-light ovolo-mullioned window and a chamfered former doorway all under one dripmould (seen from Shires Yard – *see* below). Stone-mullioned window to the s side, which survives behind a late Georgian front block. On the E side, from s to N, No. 42, the small-scale **Saracen's Head** [8], *c.* 1700, dated 1713, has two storeys with quoins and a double-gabled attic. The windows have bolection moulding with later sashes, the entrance doorway a wide bolection surround. Charles Dickens stayed here in 1835 when he was a Parliamentary reporter. No. 41 of *c.* 1720 has a quaintly asymmetrical façade, four windows wide with stone architraves and keystones. Superimposed orders with a

pediment above emphasize the bay containing the door. This early attempt at classical design may be attributed to *William Killigrew*. An attic storey, probably with twin gables, was replaced by a mansard roof in 1973. The shopfront is Victorian with an arcaded window head and fanlight. The interior retains fragments of early C18 joinery including a shell alcove. No. 38 had a date stone of 1709 (removed) and is an excellent example of the period despite the ground floor having been cut away. It is four-storeyed and twin-gabled, with quoins and heavy bolection surrounds and string courses at each floor level. The shopfront is of 1883; No. 37's, too, is characteristically Victorian with beautifully carved but conventional classical consoles. No. 35 is older than its late C18 facade. It has a C19 shop door with a glazed sash fixed from the inside forming a recess at the front for the door shutter. Through a gap on the w side, **Shires Yard** is a retail development by *Bristol Team Practice*, 1988, in a folksy neo-Cotswold vernacular. Two awkward levels of shopping arcades inserted between old gutted buildings link a pleasant courtyard café space to Milsom Street. In the C18 Walter Wiltshire built stables here for his carting and carrying business. Every Wednesday and Sunday evening, Wiltshire's Flying Wagons rolled out of the yard on the start of their two-and-a-half days' journey to Holborn Bridge, London. Wiltshire was a friend of Gainsborough and regularly transported his paintings, apparently without payment.

Further up on the w side, **King Edward's School** is a distinguished Palladian building of 1752–4 by *Thomas Jelly*, erected by the city council on the site of the Black Swan inn and another property, which the council purchased in 1744. Two storeys. The centre is three windows wide and breaks slightly forward to leave small wings, each one window wide. The windows have eared architraves, on the ground floor with pulvinated friezes and segmental pediments. Engaged three-quarter Ionic columns supporting a pediment form the doorcase. The main cornice is modillioned and each wing has a balustraded parapet running into a large central pediment with the city arms in the tympanum. Finials in the form of busts, carved according to the official minutes by 'Mr *Plura*, the statuary', who received 41 guineas, disappeared in the late C20. The piers to the shallow forecourt are contemporary but the connecting stone balustrading is early C20, replacing railings. More than 100 boys were taught in one large classroom by a master, usher and two assistant masters, occasionally assisted by a senior boy awaiting university. Boarders slept in dormitories upstairs and ate in the dining room. Remaining King Edward's Junior School until 1991 (*see* Excursions, p. 274), the building is vacant at the time of writing.

Next, Nos. 10–11, by *C. E. Davis*, 1884, have a late Victorian Baroque flavour; the design incorporates shops. Further N on the w side is the arched entrance to the stables for the Royal York Hotel. Opposite, on the E side, Nos. 22–22a seem to have been originally gabled and now have late C18 ashlar façades. The rear can be inspected from Broad

Street Place, through the alley to the s side of the houses. Finally, on the E side further N, the former **Young Men's Christian Association (YMCA)**, of 1887–8 by *T. B. Silcock* (twice Mayor of Bath), has heavy but good classical detail. Giant fluted Ionic pilasters articulate the upper floor and there is a small pediment and dentil cornice. (The present YMCA Hostel and Club bound the N side of Broad Street Place – *see* Walk 9, p. 223).

78. Walk 3

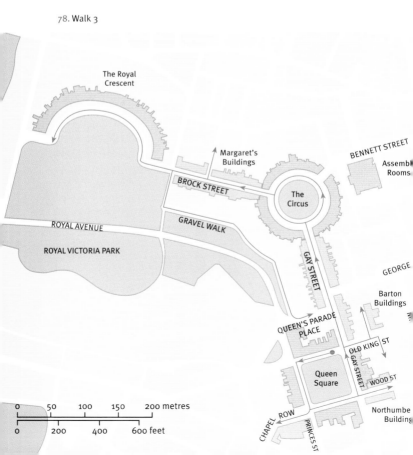

Queen Square, the Circus and the Royal Crescent

We start in **Queen Square**. The walk follows the most important architectural sequence in Bath, enabling us to study the style and mind of *John Wood the Elder* at their best. After gaining experience in the building trades in London, including contact with very large architectural developments, Wood had settled at Bath in 1727. Queen Square, his first venture, marked the start of the new upper town in earnest. It was begun in 1728 and completed in 1736. The new buildings set fresh standards for urban development in scale, boldness and social consequence.

The great innovation of Queen Square is its treatment of a whole side of a square as one palace-like façade. This Wood did on the N side, a composition of seven houses with a central emphasis. The E and W sides were conceived like wings enclosing a forecourt, though practicalities caused Wood to modify his initial plan here. The concept of individual dwellings as a single, unified architectural composition was partly inspired by Inigo Jones's Covent Garden piazza (1631–7), while the

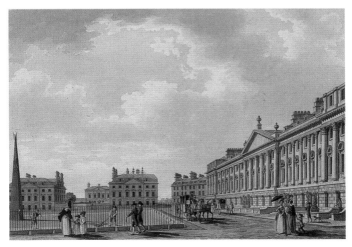

79. *Queens Square at Bath.* Watercolour by T. Malton Jun (1784) of the north and west sides of Queen Square

square plan form perhaps echoed Wood's reconstruction in his *Description of Bath* of the Roman camp which he believed formed the basis of the present city. A more direct influence can be traced to London, where he knew the work of the builder-architect Edward Shepherd (d. 1747) and was thus intimately familiar with Shepherd's design for the N side of Grosvenor Square (*c*. 1720–5). This he intended as one palatial composition, itself influenced by Colen Campbell's first, unexecuted design for Wanstead House, Essex, published in his *Vitruvius Britannicus* in 1715. Shepherd however failed to acquire all the leases simultaneously and the result was hesitant and asymmetrical. Wood's N side of Queen Square fulfils Shepherd's thwarted design and is architecturally more assured and robust. Completed earlier too was Dean Aldrich's Peckwater Quadrangle at Christ Church, Oxford of 1706–10, and this scholarly work may have especially influenced the very muscular buildings that Wood created at Bath.

The important selling point of the Palladian palace façade, of podium, *piano nobile* and attic storey, is that the tenants of the individual dwellings could enjoy a sense of domestic grandeur that no one individual could afford. Having been exposed in London to the financing of urban development, the method that Wood now imported set the terms of all his future ventures. His system was to lease a site from a landowner and then sublet individual plots to builders, stipulating the overall design while minimizing his own financial exposure. Proceeding with caution, additional land was leased at intervals as work progressed. The first of a series of 99-year leases was obtained from the ground landlord, Robert Gay, an eminent London surgeon, late in 1728 and the last, in 1734. When in London, Wood had already sent Gay his initial plans for transforming Bath which he had drawn while working in Yorkshire in 1725 (*see* Introduction, p. 17). Building began in 1729 for four houses, three of which faced Wood Street. The square was to have been levelled but the extra cost of £4,000 was risky for a speculative development.

We start on the N side and walk anti-clockwise around the square. The symmetrical palace-fronted N **side**, a group of seven large houses (Nos. 21–27), is the grandest. And with its twenty-three bays, its attached giant columns with a pediment on a rusticated ground floor for the middle five bays, and its matching columns without pediments for the three angle bays it is indeed one of the grandest Palladian compositions in England designed before 1730. It has in addition significant variations from the precedents of Peckwater and Wanstead (first design). Wanstead has no end emphases, and the equivalent pavilions at Peckwater come forward as wings and so read very differently. Uniquely too, a very distinctive impost moulding marks the door and window heads in the rusticated ground floor, and above this is a plain band course. The giant order of engaged three-quarter columns uniting the first and second floors in the central and end bays is, like at

Wanstead, Corinthian, and the wings have corresponding pilasters (like at Peckwater, but unlike Wanstead). These support a richly decorated entablature with a modillioned cornice. Unlike Peckwater and Wanstead, the parapet is plain, and never had balustrading. The great central pediment has three floriated vase finials and the end bays have attic storeys. Originally rising from projecting balustraded aprons, the tall first-floor windows have plain pilaster strips with consoles supporting alternately triangular and segmental pediments. Originally the areas that separate the houses from the street had stone balustrading. The double-width centre house, No. 24, is the grandest in the square, and has to the rear sedan chair attendants' lodges (*see* p. 141). All first-floor window sills were lowered and the sashes replaced with plate glass in the C19; most now have restored glazing bars. Internally, nearly all the houses here – and throughout the square – have original and typical dog-leg oak staircases with turned balusters, three to a tread; twisted balusters occur, but are relatively rare (e.g. No. 27).

Circumstances prevented Wood from building the w **side** of Queen Square as a wing to match the E, and the centre part on this side was originally set back. In his *Description of Bath* he says, 'I found myself under a necessity of dispensing with a uniform building.' Instead, he chose another equally monumental treatment: two broad villa-like blocks of similar design form the N and s corners (the s block is two houses, and the N, three). In between, a third house, the property of a strong-willed sub-leaseholder, Sir John Buckworth, sat well back behind a forecourt. The centre building had in the middle giant pilasters carrying a pediment. *Wood*'s two corner blocks are identical, of seven bays and two and a half storeys with a slightly projecting pedimented centre and a rusticated ground floor. The centre ground-floor openings are set in blind arches and the flanking window frames are of the Gibbs type, their alternating pediments interrupted by massive keystones somewhat complicated and mannered in detail. On the first floor the three centre openings have pilasters carrying alternating pediments. The end elevations are also pedimented and the N corner block, Nos. 18a–20, has a pedimented rear façade with heavy dentils. No. 20 has a side doorway with attached Ionic columns and a pediment, a favourite motif which continues at Bath right through the C18. Nos. 14–15, the s pair, retain three vases on the pediment. No. 15 has the grandest staircase hall in Bath. Like Nos. 7–8 the Circus (*see* below), this is situated at the front, with no reception room to its side. The staircase here connects just the ground and first floors; a lesser, domestic staircase in an inner hall beyond serves every floor. The magnificent main staircase was unfortunately removed to Norcott Hill House, Berkhamsted, Herts., in the 1920s, and the present one is a faithful re-creation, 1984–6 by the designer-joiner *Donal Channer*. It ascends around three walls to a gallery landing and has carved tread ends with three balusters per tread, the outer turned and fluted, the centre ones

twisted, and fluted Corinthian column newels with corresponding pilasters in the ramped dado. Lively stucco decoration with musical scenes adorns the upper floor. The work is attributed to the *Lafrancini* brothers who later worked in Ireland. The s wall has St Cecilia at the organ, framed by a moulded and scrolled *trompe l'œil* archway. Niches at each side contain statues of female musicians and on the E wall stands a mythical figure with cymbals. Framed panels on the w and N walls depict the musical contest of Apollo and Marsyas and the latter's consequent gruesome punishment. The ceiling cove has acanthus scrolls and putti, modelled in the round in parts.

The composition of the w side was altered when in 1830 the central space was filled in. The new building, originally three three-bay houses, is Neo-Grecian, by the *younger Pinch*, and has giant fluted engaged Ionic columns, whereas Wood's giant columns are always unfluted. The centre projects and is raised above the entablature to form an attic. Above the first-floor windows is a crisp frieze of anthemia and honeysuckle. In 1931–2 *Mowbray Green & Hollier* converted it to house the Bath Royal Literary and Scientific Institution, forming ground-floor meeting rooms and a library, and a museum upstairs displaying birds, insects and minerals. Requisitioned by the Admiralty, 1940–59, it then housed the public reference library until it reverted to the BRLSI from 1993. The ground-floor front rooms retain segmental niches with pairs of Ionic columns, and the two staircases of the outer houses, cast-iron balusters decorated with Greek motifs.

Before visiting the s side, a moment's excursion w into **Chapel Row** – nine houses stepped up twice – illustrates a lower and socially modest terrace also by *Wood* and of mid-1730s date; all now have late C19 and later shopfronts. No. 1 at the E end in **Princes Street** has an ele-

Chapel of St Mary, Chapel Row

Set back and accessible from Chapel Row was the Chapel of St Mary, the earliest proprietary chapel in Bath, built for £2,000 in 1732–4 by a consortium of *John Wood* and eleven other residents. Modelled on Inigo Jones's St Paul Covent Garden, it was a fine classical temple with a portico, distyle *in antis*, though Doric not Tuscan. Like Jones's chapel, the altar was at the E end and entry was through E vestibules, the central doorway being blind. It was demolished in 1875 to improve access to Green Park Station (*see* Walk 11, p. 251). Fragments are now at No. 4 Cleveland Place (*see* Walk 9, p. 229). The aedicular monument on the N side of Chapel Row, placed on the present site in 1976, is said to be constructed from further relics. It is square, with Tuscan columns, a tent roof and ball finial.

gant late C18 doorcase, its pediment supported by three-quarter columns with waterleaf capitals.

The s side of Queen Square (Nos. 6–13) is much less palatial than the N. The middle pediment is no more than three bays wide, and the only other accent is the setting of the ground-floor windows in blank arches in the outer three and the middle nine bays. Jane Austen lodged briefly at No. 13 in 1779, with her mother, sister Elizabeth and brother Edward. The doorways of Nos. 11 and 12 are more richly carved, no doubt commissioned by the occupiers. Wood lived in the centre at No. 9 until his death in 1754 (not No. 24 on the N side as the plaque states). The house is modest and barely ornamented, save for carved moulded surrounds, but from here he could look across to the palatial N elevation. Solomon Francis opened the **Francis Hotel** at No. 10 in 1858, expanding into Nos. 6–9 and 11 by 1884. The E section was bombed in 1942. *J. Hopwood* rebuilt it in 1952–3, with dropped Victorian-style window sills and plate glass, matching the adjacent houses. A twenty-five-bedroom extension was added facing E to Barton Street, 1977–80, by *Oxford Architects' Partnership* with much input by *Roy Worskett*, Bath's last City Architect, after two previous designs had been rejected. The design is uncompromisingly C20, yet tasteful in appropriate materials and in scale – three-storey, three-bays wide with bronze-anodized oriel windows with pre-cast concrete sills and aprons, set in a vertically articulated ashlar façade.

The s side extends E into **Wood Street**. The N side, Nos. 1–6, together with No. 1 Queen Square, formed the first phase of the Queen Square development. They are all three storey with a band course and cornice, otherwise plain. Nos. 1–6 now have a formal composition of shopfronts, 1871–4 by *J. Elkington Gill*, modulated by Corinthian columns and with cast-iron undersill railings. The street allows one to assess the difference between *c.* 1730 and *c.* 1780 in Bath, for **Northumberland Buildings** on the s side is a very fine, broad and tall Adamish composition of seven houses of 1778. By *Thomas Baldwin*, his first speculative venture. Twenty-one bays wide. The middle and end houses have pediments and project slightly forward to form three three-bay pavilions. Above the first-floor centre is a festooned frieze, continued to the sides as a band of Pompeiian scrolls, and above this are large paterae. For the first time in Bath in a consistent terrace the attic is brought forward as an extra storey to maximize space. The result is top-heavy.

The simple E **side** of Queen Square (Nos. 1–5), six substantial five-bay houses stepping downhill, matches the initial houses of Wood Street. The doorways are treated individually with especially elaborate Baroque designs at Nos. 2–3 [80], probably commissioned by Richard, Earl Tylney of Castlemain and Wanstead House, Essex, the original ratepayer for both. These have grotesque Pan figure masks, swags, foliate pendants, egg-and-dart enrichment and open pediments. At Nos.

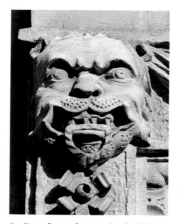

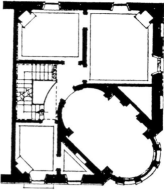

80. No. 2 Queen Square, detail of the Baroque doorcase

81. No. 41 Gay Street, by John Wood the Elder (1734–6). Plan by Walter Ison

1–2 and 4 the first-floor window sills, lowered in the C19, have been raised and glazing bars restored.

A house by the elder *Wood* forms the NE angle of Queen Square: **No. 41 Gay Street** [81], built in 1734–6 for Richard Marchant, a rich Quaker. Wood's severity disappears here, and a heavy but cheerful Gibbsian–Palladian detailing takes its place. The walls, it is true, are quite plain, but at the corner the façade is diagonal with an applied semicircular bay. The ground-floor windows have heavy Gibbs surrounds, the first floor with pairs of even heavier intermittently blocked pairs of Ionic columns, and the attic storey is plain. The doorcase in Gay Street is Ionic and the arched entrance has a grotesque mask keystone. The plan is ingenious, with a diagonally placed centre room of surprisingly modest dimensions in which the semicircle of the bay, flanked by fluted Corinthian columns and commanding a view over Queen Square, is answered by a semicircle at the back. The bay on the first floor has a Venetian window with fluted Ionic pilasters and a curved pedimented doorway at the back also with fluted Ionic pilasters and eggand-dart decoration. The chimneypiece has a matching Ionic order. The interior ground-floor treatment is similar but a little less spectacular. To the N of this ground-floor room, tucked into the small triangular space created by the main room, is a charming powder cabinet with a shell niche containing a marble basin. All other rooms in the house are orthogonal but continue the diagonal theme with corner fireplaces. Centred on plan against the N wall of the house is a good staircase, three turned balusters per tread. Despite the plaque, there is no evidence that the younger Wood (nor the elder) lived here, even for a short period.

In the centre of Queen Square is a formal **garden** containing a tall obelisk in honour of Frederick, Prince of Wales set up in 1738 by Beau

Nash. Originally it rose from a circular pool and was 70 ft (21 metres) high but it was damaged in a gale in 1815 and truncated. The trees are, of course, a picturesque addition; the greenery in the square was originally kept low, arranged as four parterres enclosed by espaliered limes and elms. Initially, stone balustrading surrounded the garden, replaced in the 1770s by railings. The present iron railings are of 1978.

Of the streets leading into Queen Square, **Old King Street**, at the NE corner running E, laid out as part of *Wood*'s development, is necessitated chiefly by symmetry of layout. Before continuing the main architectural sequence, a short out-and-back detour enables us to see, at the E end, the site of **Barton House**, a C17 or possibly earlier manor house. Incorporated in the C19 into Jolly & Sons' department store (*see* Walk 4, p. 159), it was rebuilt to its present, irregular and gabled form incorporating some of the flanking walls, in two stages: by *J. Elkington Gill*, 1869, *Browne & Gill*, 1885 (the two N gables). *C. E. Davis* added the half-timbered oriel, s gable, in 1888. **Barton Buildings** off to the N was developed in the 1760s by *Wood the Younger*, on the site of Barton House farmyard. This is the first use in Bath of the ramped string course and cornice as a device for linking houses that step uphill (*see* Topic box, p. 27). At its extreme N end to the w is a simple weatherboarded extension to the rear of No. 34 Gay Street, by *H. J. Garland*, 1882. This was William Friese Greene's photographic studio (*see* Topic box, p. 126). Returning to Old King Street, on the SE corner is Philips Auction Rooms (now **Bonhams**), by *Reginald S. Redwood*, 1962. The front is Neo-Greek Revival and the return elevation, plain except for two rows of close-set small rectangular windows, has later painted decoration with inscriptions from the Magna Carta.

Now to the N, **Gay Street** (named after Robert Gay). It is the work of the elder *Wood* of 1735–40 as far as George Street, continued to the same design by the younger *Wood* after 1755 to form the principal approach to the Circus. The elder Wood designed a uniform elevation relating to the E side of Queen Square, i.e. three-storey, plain, with string course and cornice. The houses of Gay Street climb the hill, and each breaks the string course and cornice as it steps up above its neighbour. The interiors were left to the ingenuity of the builders; these consequently differ considerably, and plastering takes the place of wood panelling.

Opposite on the w side, a little further up, the side elevation of No. 2 Gay Street facing s towards Queen's Parade Place has blind windows and a pediment sitting on blind balustrading. This is to a design of 1870 by *C. E. Davis* as No. 1 was demolished to form a road to Royal Victoria Park (*see* Walk 10, p. 236). The façade, in the C18 style of Gay Street, is remarkably polite and contextual for this High Victorian architect. In Queen's Parade Place at the rear of No. 24 Queen Square are a pair of sedan chair attendants' lodges, square on plan, with Gibbs surrounds and bold keystones. Most of the sills in Gay Street were lowered in the C19; the sills to No. 5 on the w side have been raised and the glazing bars

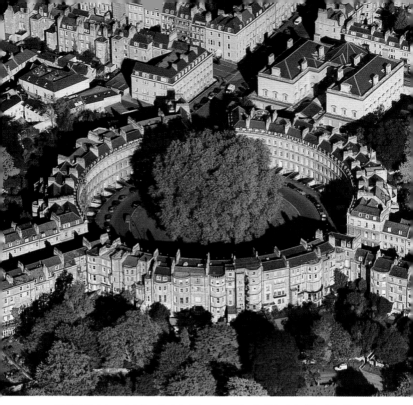

82. The Circus, aerial view, by John Wood the Elder, built by John Wood the Younger (1755–67)

restored. Again the doorways are as usual with pediments or cornices on Ionic demi-columns or brackets. Further up on the w side, No. 8 is very different, obviously an individual job for the first leaseholder, Prince Hoare, the sculptor. Corinthian pilasters on the ground floor and first floor frame the centre of the house and leave only narrow 'background' strips on the left and right. Above the ground-floor windows are garlands. The pediment over the upper middle window runs on into the architrave of the side windows. One is here – and in a few other places – led to believe that some people got tired of the Woods' chastity. Mrs Piozzi, formerly Mrs Esther Thrale, one of Dr Johnson's circle, resided here from 1784 until her death in 1821. The doorway to No. 17 is Ionic with a mask.

Gay Street runs straight into the **Circus** [82], or the King's Circus as it was originally called. The foundation stone was laid in 1754 and it is the most monumental of the elder *Wood*'s works, even more so if one remembers that the old plane trees which are now more immense than the buildings did not exist and were not projected. The sloping site was levelled and the circular piazza simply paved with stone setts with a covered reservoir in the centre and no greenery. Planting and a lawn

were introduced by 1829. Wood lived to see the foundation stone laid, but his son *John Wood the Younger* carried out the work, granting leases for the sw segment of the Circus 1755–67, the SE 1762–6, and the N 1764–6.

Wood's architectural conception is original and powerful. The plan is very simple. Only three streets enter the Circus. They are placed at even distances and, because none of the streets which enter it are opposite one another, the Circus has a static, absolute and enclosed character. Perhaps this quiet reflective mood was not what Wood had in mind when first he thought of providing a circus for, as he put it, 'the exhibition of sports' (*see* Introduction, p. 19). A circus so closed to the outer world is something very different from the French equivalent where aligned streets provide views through the whole, such as Louis XIV's Place des Victoires. Moreover, the architecture is designed so as to close the circle yet more tightly. The uninterrupted architraves are like the hoops of a barrel. The Circus has one architectural motif only, and this is relentlessly carried through on all sides – without accents of height or relief – a triumph of Wood's single-mindedness. The system is easily described: coupled columns in three orders, Roman Doric, Ionic, Corinthian, framing rectangular windows without architraves, and then a parapet with later oval piercings, crowned with giant acorn finials (an explicit Druidic reference: *see* below). The frieze of the Doric entablature is decorated with triglyphs alternating with 525 carved emblems including serpents, nautical devices and the arts and sciences [83]. Their derivations are various: most relate to a folio of no particular iconographic significance, *A Collection of Emblemes* by George Wither published in 1635; others show fables, Masonic devices and occupations (perhaps of the original lessees) and some, of military trophies, are from the designs for Jones's palace at Whitehall (*see* below). Many carvings and enrichments were replaced in the 1950s (*see* Introduction, p. 47). The second and third entablatures have plain

83. The Circus, detail of the Doric frieze

friezes. Linking the second-floor Corinthian capitals are carvings of garlands and female masks. The sustained depth of relief of the whole composition was something new for Bath. In the C19 the first-floor windows were lengthened; the glazing bars, also restored in the 1950s (the first such scheme in Bath) are incorrect and too thin for the 1750s–60s. But the Circus retains most of its splendour.

The Circus represents a fusion of Wood's long-held preoccupation with the grandeur of Imperial Roman architecture and his wild fantasies of an ancient native British civilization led by Druids, described in the *Essay* of 1749 (*see* Introduction, p. 18). Tobias Smollett, in the character of Matthew Bramble in *The Expedition of Humphrey Clinker* (1771), perceived the Circus as the Colosseum turned inside out; the anonymous *Critical Observations on the Buildings and Improvements of London* (1771) similarly deduced that the three superimposed orders derive from the Colosseum; and John Soane illustrated the comparison – disparagingly – in 1809. Wood's building is circular, not elliptical like the Colosseum, and it has been suggested that Wood was influenced by contemporary small circular models of the Colosseum. But Wood possessed William Kent's *Designs of Inigo Jones*, vol. 1 (1727) which illustrated a proposed new Whitehall Palace, *c.* 1638, with an elaborately treated circular courtyard. He was familiar too with Jones's theatrical reconstruction of Stonehenge, together with William Stukeley's *Stonehenge* (1740) which asserts that the megalithic circle had given Jones the idea for the Whitehall enclosure. To Wood the circle was perfect: 'the works of the Divine Architect . . . tend to a circular form' (*Origin of Building*, 1741). In his *Essay* Wood imagined that this concept passed by divine revelation first to the Jews, then to the Druids. Wood deduced that the first arch-Druid was none other than the legendary King Bladud who, having established Bath, applied this knowledge, constructing the stone circles at nearby Stanton Drew – the precedent, according to Wood, of Stonehenge. Built into one of Stanton Drew's circles, he supposed, was a Druid 'college', enclosing an area 'as spacious as the squares generally made in our modern cities'. Significantly too, in *Choir Gaure, Vulgarly called Stone-henge on Salisbury Plain, described, restored and explained* (1747) Wood measures the diameter of Stonehenge as 312 ft (95 metres), while the Circus encloses 318 ft (97 metres).

There are thirty-three houses in all, ten in the N segment, eleven in the sw, and twelve in the se (the numbering is 1–30 as three houses have side entrances). For privacy the houses are set back from the pavement by wide areas. William Pitt the Elder (1708–78), Lord Chatham, M.P. for Bath, 1757–66, was one of the first leaseholders and his celebrity helped ensure the scheme's success. He maintained, but probably seldom stayed at, No. 7, his sister No. 8, and his aunt, Lady Stanhope, No. 6 in the sw segment. The plan of No. 8 is handed (the front door, on the 'wrong' side) and these were originally interconnected. Internally the houses are not at all uniform, and much ingenuity was displayed in

planning rooms in different numbers and of different shapes and sizes. Several have excellent decorated interiors. No. 9* has a groin-vaulted entrance hall with an arched opening which in the staircase hall beyond is set in a coffered niche. The staircase is lit by a large Venetian window. Behind the staircase a delightful little octagonal room with a coved ceiling has a canted bay window as does the main rear ground-floor room. The front ground-floor room, which is nearly square, also has a deeply coved ceiling. Above, the drawing room has a good stucco ceiling. No. 10 has a Siena marble fireplace from Beckford's Tower (*see* Excursions, p. 271). No. 11 has a large, plain colonnaded garden building to the rear with round-arched openings. The painter Thomas Gainsborough (1727–88) rented No. 17 for eight years until 1774.

Of the other streets that lead into the Circus, Bennett Street to the E (*see* Walk 4, p. 163), which was built later, clearly does not form an over-ture to this principal building of the Woods' Bath. But in the case of **Brock Street**, leading from the Circus to the w, we have an understated prelude to the younger Wood's masterpiece. Having obtained land by an indenture of 1754 for the E end, the younger *Wood*, who named the street after the family he married into, granted leases 1763–70 for six houses on the N and five on the s. In 1766 he acquired a further 19 acres (7.7 ha.) in order to build the Royal Crescent at the w end. Brock Street was then lengthened to link with this intended development. Flanking the start of Brock Street is a splendid pair of Doric porches to two Circus houses, Nos. 1 and 36 Brock Street. Immediately evident after this however is the modest scale and lack of ornament. The general rule is plain Venetian windows on the first floor and on the s side, the ground floor also. Many houses on the s side have aedicular pedi-mented Ionic porches; others have been altered. Nos. 8–9 have a C19 three-storey porch extension. Most of the houses have standard terrace plans, but Nos. 6–7 on the s side have interesting dovetailed plans giving No. 6 (where the younger Wood was a tenant in 1765) a wide frontage overlooking the Gravel Walk (*see* p. 151) and No. 7 a double-width front to Brock Street. **Margaret's Buildings** off Brock Street on the N side is an intimate paved street of shops that served the sur-rounding houses. No. 16 has a neat rectangular projecting shopfront of *c.* 1830 with glazing bars, a central doorway and lions' heads to the pilasters. Further w on Brock Street, N side, a semicircular archway, originally Gothic, between Nos. 20–21 has a tripartite window above (the sidelights are blind), with coupled Ionic columns supporting an entablature and pediment. All this is based on Hadrian's Arch in Athens, illustrated by Stuart and Revett in the *Antiquities of Athens*, 1762, a copy of which Wood owned. It led to Margaret Chapel, hidden behind houses and destroyed in the Second World War. Designed by the

*Where lived William Ainslie, developer of Ainslie's Belvedere (*see* Walk 5, p. 175).

Illustrious Residents of the Royal Crescent

The distinguished academic, George Saintsbury (1845–1933) lived at No. 1a, 1918–33. The Princesse de Lamballe (1749–92), friend and lady in waiting to Queen Marie Antoinette, lodged at No. 1 in 1786 and the Duke of York (1763–1827) took it briefly in 1796 before moving to No. 16. The poet Christopher Anstey (1724–1805) lived at No. 4 (not No. 5 as the plaque states) but later moved to Marlborough Buildings. The eccentric and ill-tempered adventurer, Philip Thicknesse (1719–92) bought No. 8 in 1768; Vicomte Jean Baptiste du Barré (1749–78) leased it in 1778 to hold card parties but quarrelled with his partner over gambling profits and died in a duel on Claverton Down. Admiral Sir William Hargood (1762–1839), a captain in the Battle of Trafalgar, retired to No. 9 in 1834; he is buried in Bath Abbey. Edward Bulwer-Lytton (1803–73), Baron Lytton, novelist, dramatist and M.P. lived at No. 9 for a year. Elizabeth Linley (1754–92) eloped from No. 11 with Richard Brinsley Sheridan in 1772. Dr John Haygarth (1740–1827), a pioneer in medicine of isolation, ventilation and cleanliness, lived at No. 15 for two years. Sir Francis Burdett (1770–1844), reformer and M.P. for Westminster for thirty years, lived at No. 16, 1814–22. No. 17 was home for many years to Sir Isaac Pitman (1813–97). Here he wrote *Stenographic Soundhand* (1837) explaining his system of shorthand based on phonetics.

younger *Wood c*. 1773 in the Gothick style. No. 16, s side, has a fanciful Georgian Gothick porch with cluster columns, rare for Bath.

Originally Brock Street seemed to lead nowhere, and indeed did before the Royal Crescent was built. The experience in walking along Brock Street is that to the very last moment one can have no conception of the splendour to come. All one sees is the far end of the Royal Crescent at an angle. The shock of surprise in arriving at the corner is one of the strangest and most pleasurable that town planning has to offer anywhere. It is tempting to say that this understatement was intentional and to do so would place the scheme firmly within the English landscape garden tradition. This must however be doubted and, like most Bath development, is more likely the accident of site, topography and circumstance. Whether under different conditions the architect would have connected the Circus with the Royal Crescent axially is uncertain, though the *Gentleman's Magazine*, describing laying the foundation stone of the Circus in 1754, stated that the connecting streets would be 'each terminated with a fine building'.

The **Royal Crescent** [84] was built in 1767–75 by *John Wood the Younger*. It is a large half-ellipse facing down a grassy slope, nowadays into the fine and varied trees of Royal Victoria Park (*see* Walk 10, p. 236),

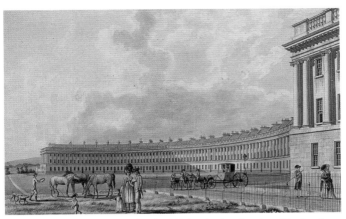

84. *The Crescent at Bath*. Watercolour by T. Malton Jun (1777), a view of the Royal Crescent from the south east

originally just into fields. Yet, even so, the conception of an open composition was something new in town planning.

The elder Wood conceived his town developments as essentially urban and inward-looking; they turned their backs on the countryside beyond. The concept of uniting a terrace of town houses with a classical palace frontage continues in the Royal Crescent, but for the first time with the character of a country house, so that every resident overlooked a rural prospect. When plate glass became available towards the mid C19, the Victorians intensified this feeling of contact with the exterior by lowering the first-floor window sills (*see* topic box, p. 30).

Although construction began thirteen years after the elder Wood's death, the idea may be his. Here there are Druidic allusions in the name, the shape of the new moon, associated with pagan worship which according to Wood in his *Essay* took place further up the hill on Lansdown. Yet the plan form is not a crescent; it is a half-ellipse, that is a half-Colosseum. As with Prior Park, compared in his *Essay* with an amphitheatre (*see* Major Buildings, p. 94), the Royal Crescent theatrically embraces its elevated site, overlooking, like a vast stage set, the landscape beyond. Yet the Royal Crescent with its extended arrangement of giant columns is an even more explicit reminder of theatre. One possible source that has so far been overlooked is the colonnade enclosing the auditorium of Palladio's crescent-shaped Teatro Olimpico which Wood knew from his copy of *Architecture de Palladio* (1740). This Palladio based on his own reconstruction of the Roman theatre, also known to Wood. The crescent moon and theatre design are linked by Alberti in his *Ten Books on Architecture*, also owned by Wood, where he comments that theatres take 'the shape of a moon in its decrease'. The united classical palace frontage of the Royal Crescent thus continues the tradition of Queen Square, but here fused with theatre themes and

Druidic reference. The crescent shape is so particular to its site and its symbolism so unique to its architect that it was to have relatively few English successors (*see* Introduction, p. 20–21). It is the classical palace theme that was to be the Woods' lasting influence, used throughout the country by architects concerned with large-scale civic developments, most notably by Baldwin at Bathwick and the Adams in Edinburgh (*see* Walk 6, p. 176).

If the elder Wood's involvement in the idea is speculative, the execution of the project and its details are undoubtedly those of the younger Wood. Devoid of Druidic iconography, the Royal Crescent has a completely plain ground floor, and giant Ionic engaged three-quarter columns on the first and second storeys. The entablature has a moulded architrave, plain frieze and modillioned cornice, and a balustrade above. It is right that no emphasis on window or door pediments is allowed; 114 columns so closely set and so uniformly carried through are majestic, they are splendid. The only accents are subtle: coupled columns at the ends and around the central bay, where the first-floor window is arched instead of rectangular.

The monumental semi-ellipse comprises thirty houses, built by individuals or collaborating tradesmen, three bays wide, except Nos. 14–17 in the centre and No. 30 on the end, which are four. Each of the two end houses, 540 ft (165 metres) apart, have five-bay return fronts. Sixteen-foot (5 metre) front areas, a broad pavement and a roadway paved with setts, constructed in sections by each leaseholder, separate the houses from the great lawn. The overall geometric layout would have been set out with templates (*see* Introduction, p. 28). No. 1, E end, was built first as a model for all the other houses to follow. The subleases contained standard clauses to ensure high standards and strict conformity with John Wood's elevation. These specified that the building shall not 'at any time or times afterwards be ever altered or varied'. Also, the builder shall 'cleanse and hone down the stonework on the outside' so that 'the whole building may be of one colour'. The resulting original uniformity contrasts with the haphazard c20–c21 streetscape with randomly cleaned façades. Behind the front façade of unbroken uniformity they have a diversity of internal arrangement, evident externally in the utilitarian, frequently angular, rear facades.

Of **individual houses**, several deserve mention to exemplify different plan forms or for their fine interiors. Others built for letting have plainer stock decoration.

Going E–W, adjoining the E end of the Royal Crescent is a modest two-storey house built contemporaneously by the lessor of the land, Sir Benet Garrard, as a farmhouse and offices, now No. 1a. Major Bernard Cayzer bought in 1967 No. 1 (completed 1769, built for Thomas Brock, Wood's co-lessee), and presented it to the Bath Preservation Trust as a museum, opened 1970, after scrupulous restoration by *Philip Jebb*. The

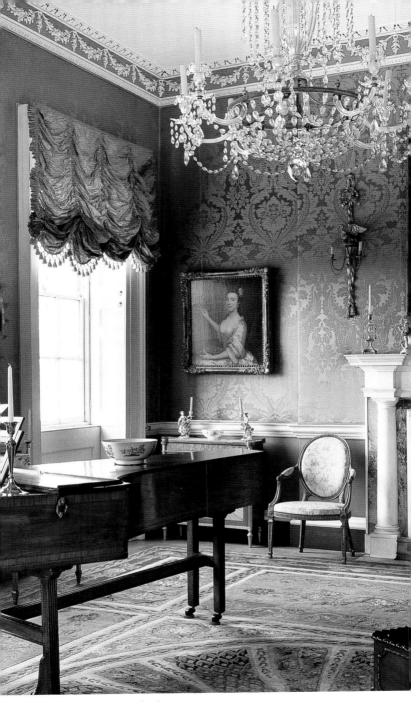

85. No. 1 Royal Crescent, Drawing Room

window sills were raised to the original level, uniquely in the Royal Crescent as the conservation policy is now to retain the C19 alterations. The entrance is on the return elevation, with a hall leading w to the dining room, E to the library, both plastered with flat sunk panels. Beyond, separated by an archway, an inner hall has a wooden staircase; the walls have been painted in a period manner with 'masonry joints' to resemble ashlar. The first-floor layout is similar: w, the drawing room with damask-covered walls [85], and E, a bedroom. The reduced friezes throughout are typically late C18. No. 2 was bombed in 1942 and restored by *Hugh Roberts & Davies* in 1948. The first-floor front room to No. 5 has an exquisite ceiling influenced by Adam, with interlaced festoons of husks and honeysuckle and foliate decoration. The corresponding ceiling to No. 12 has a great circle of radiating husk strings connected by husk festoons with ribbon bows. Nos. 15–16 are the **Royal Crescent Hotel**, restored by *William Bertram & Fell*, 1979 and further refurbished by *William Bertram & Fell* and interior designer *Rupert Lord*, 1996–7. No. 15 has an apsidal transverse hall with an elegant continuous curving cantilevered staircase with C19 cast-iron balusters, replacements for the C18 balusters. The first-floor front room has a deep foliated frieze and fine plasterwork ceiling of earlier Palladian manner divided into geometrical panels with birds with freestanding necks and wings. No. 16 is the hotel entrance. A large hall with a chequerwork floor and fireplace, suitable for sedan chairs, leads to a rectangular inner staircase hall lit by Venetian windows and containing a cantilevered staircase around an open well, with two half-landings between each floor.

Observable from the hotel rear are a group of interesting **mews** elevations facing the gardens (for the street frontages, *see* Walk 10, p. 240). The late C18 coach house to No. 12 has a pedimented centre set forward and with V-jointed rustication, with a blind semicircular arched recess. Nos. 13–18 were all converted or rebuilt for the hotel during 1983–98 by *William Bertram & Fell*. No. 13 has an C18 temple front; a pedimented centre breaks slightly forward with a tetrastyle colonnade of Ionic columns *in antis*. The mews to No. 14, by *Hayward & Wooster*, 1877, also has a temple front but with diagonal Roman Ionic volutes and balustraded parapet, reflecting Victorian sensitivity in extending building in a matching classical style. To the rear of Nos. 15–16, the Neoclassical Dower House, 1985–6, contains a restaurant, bedrooms and a double-apsidal inner hall with a cantilevered stone staircase. The garden buildings to Nos. 17–18 (the Bath House) are the hotel's health facility, converted by *William Bertram & Fell* and *Ted Brewster*, 1998. No. 17 is by *James Wilson*, 1843, two storey, five bays, with slightly projecting end pavilions and three monumental round-headed centre openings and a pierced balustrade over the cornice (*see* also Walk 10, p. 240). No. 18, late C18 or early C19, is Gothick with three pointed windows. It now contains a swimming pool. No. 19 has an excellent two-storeyed garden mews elevation by *Thomas Baldwin*, *c.* 1790.

Slightly projecting end pavilions each have at ground floor a round-headed window in a semicircular arched recess with a heavy projecting keystone and rectangular first-floor windows flanked by half-pilasters with Prince of Wales' feathers as capitals. The pavilions flank a loggia of Ionic columns and terminal half-columns. The top moulding of the entablature is continued across the pavilions as a sill course to the upper windows. Above the cornice is a blind wall (lower than the wings), with three rectangular panels containing garlands with central rams' heads, and a balustraded parapet over.

Returning to the Royal Crescent houses, No. 17 was rebuilt in 1949 by *H. Roberts & Davies* after war damage. The notorious yellow front door to No. 22 caused listed building enforcement and a public enquiry in 1971–2, which the owners won. The end house, No. 30 has fine rococo plasterwork ceilings to the principal ground- and first-floor rooms. The stairwell was altered in the early C20.

Return to the town centre down the path running s from the w end of Brock Street, and at once E along the Gravel Walk, laid out in 1771, linking Queen Square with the Royal Crescent and, since its opening in 1830, part of Royal Victoria Park. To the N are the tall ashlar rear façades of Brock Street and the Circus. The town garden to No. 4 the Circus, intended to be seen principally from the house, was restored to its Georgian 1760s layout after excavation by Bath Archaeological Trust in 1985–6 and opened 1990. Within the radial plot it has two wedge-shape side flower beds returning at the end to form a rectangular gravelled centre containing three flower beds, two circular and one oval. This arrangement remained essentially unchanged until 1836–7 when the garden was turfed.

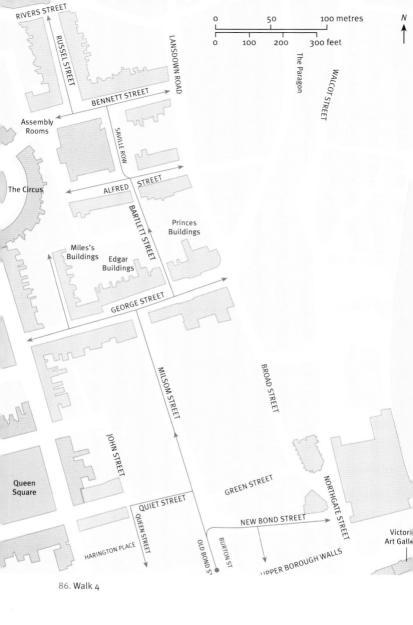

86. Walk 4

Milsom Street to the Upper Town

The Walk climbs gently N from the N extremity of the medieval city to the residential upper town E of the Circus, via commercial Georgian Bath with its rich and entertaining ensemble of added shopfronts, one of the city's prominent features. Only a selection of shopfronts is described, but after the walk the observant reader should be able to identify and date others unaided.

N of Upper Borough Walls are two parallel N–S streets forming an island block: Burton Street and, to the W, the specially attractive, paved and exclusively pedestrian **Old Bond Street**. All one composition, on the W side, *c.* 1760–9, the houses have bland elevations typical of 1760s Bath: straight cornice, pediment, straight cornice, with Venetian windows on the E. Here are excellent **shopfronts**, including several of the C20. On the E side, *c.* 1780, Nos. 7–8 have two magnificent double bow fronts of *c.* 1800 with serpentine entablatures and typical Regency reeded pilasters with lions' heads [88]. The glazing bars to No. 7 have been removed. On the W side, No. 14, of 1955, is Neo-Georgian with a large, double bow in mahogany by *E. F. Tew*. Nos. 16–17, of 1982, have two projecting bays with Tuscan columns supporting heavy pediments, by *Kenneth Boyd*. The confident and refined Neo-Georgian Nos. 18–19, by *Whinney, Son & Austen Hall*, 1932, were for Bath Gas Company. Wrought-iron brackets support a lantern over the doorway. On the N end façade on the E side, the royal coat of arms is made of *Coade* stone. The marble putto in the niche was part of the Melfort Cross in the Cross Bath, dismantled in 1783 (*see* Major Buildings, p. 83), and acquired by a perfumer whose house this was. A further island block extended N but was demolished in the early C19 to open out the street.

The line of Old Bond Street continues into Milsom Street. To the E here is **New Bond Street**, built to a design of *John Palmer* between 1805 and 1824. Its formation is not explicit in the Improvement Act of 1789 but contemporaries describe it as one of the new streets the Act created. It replaced a narrow alley, Frog Lane, part of the medieval suburb outside the North Gate. The N side, rebuilt *en bloc* in 1805, was set back considerably. It is a terrace of five and six bays, separated by plain pilasters and with ramped cornices, of which the six-bay divisions are two three-bay houses. New Bond Street was built for high status shopping (for example, the Corporation refused to allow the opening of a butcher's

shop in 1830). There are several elegant **shopfronts**. On the s side, Nos. 7–9 were rebuilt behind existing façades by *Alec French Partnership*, 1980–3 (*see* also Walk 2, p. 129). No. 12, by *A. J. Taylor*, 1906, was built as a jeweller's [89], with large sheets of curved glass flanking two entrance lobbies. Opposite, No. 19 of 1922, by *A. J. Taylor*, is an elegantly plain shopfront in black and white marble with a recessed lobby and curved glass, bronze-framed windows. Typically mid-c19, No. 21 has bold architraves with geometric enrichment. The glazing is arcaded with tapered bars with segmental heads.

Returning to Milsom Street and a few metres N, **Quiet Street** runs w. According to the elder Wood, it was 'so named from the meek temper of a washerwoman, espoused to one of the builders'. It exhibits architecture from four periods: mid and late Georgian, Regency, and Victorian. Nos. 7–11 on the s side, the former **Auction Market and Bazaar** [87], of 1824–5, attributed to *Goodridge*, was originally a combination of shops, houses, exhibition space and bazaar. It has nine bays with a three-bay centre. This has rusticated piers on the ground floor, below a segmental arch containing three windows and a fanlight, flanked by round-headed semicircular niches containing sculpted figures of Commerce and Genius by *Lucius Gahagan*. The centre of the parapet is broken and stepped back, with a statue, all of which is a quotation from the Choragic Monument of Thrasyllus, first illustrated by Stuart and Revett in the *Antiquities of Athens*, 1787 edition. The large and impressive central room on the first floor was built for exhibitions, meetings and public lectures. Grecian and somewhat Soane-like, it is triple-square on plan with three shallow-domed ceilings, each with a glazed lantern, separated by segmental arches with Greek key decoration. A large tripartite window to the rear corresponds to that at the front.

In 1871 the street was widened and the N side cut back and given a new façade by *C.E. Davis*, large four-storey with debased classical detail. The w façade of No. 1 **John Street**, which faces directly into Wood Street, was built *c.* 1840. Three upper floors each have triple round-headed windows flanked by broad panelled pilasters. The Treasury Bank inserted the arcaded shopfront, co-ordinated with the building above, in 1858. Queen Street, off on the s side opposite, retains its original Pennant setts. Nos. 2–3 and Nos. 11–11a are a group of c18 double shopfronts with separate doorways, modest, but among the earliest in Bath. The eight flat-fronted, small-pane oriel windows have no fascias for lettering and presumably originally had hanging signs (banned in Bath from 1766). No. 9 is bowed. Nos. 11–11a were originally a rather grand town house, of more pretension than the others in the street. Baldwin held the leases. Off Queen Street to the w, in **Harington Place**, Harington House is Neo-Grecian 'workrooms' of 1900 by *F. W. Gardiner*. We now return to Milsom Street.

Milsom Street was laid out from 1761 on Corporation land to con-

87. The Bazaar, Quiet Street, attributed to Henry Edmund Goodridge (1824–5)

nect the lower heart of old Bath with the growing upper town. John Wood's map of 1735 shows that this was the last major area that was undeveloped and so it remained for almost thirty years. Daniel Milsom, a schoolmaster and member of the Corporation, leased land in 1746 (renewed 1753), and his son Charles finally undertook the development jointly with the Corporation. Charles was to lay out the ground and make a common sewer and would collect the profits for thirty-five years. Thereafter the title and all profits reverted to the Corporation. Plans and elevations were agreed in 1761 and the first buildings and road were complete in 1768. The houses with their top cornice climb up step after step, with bland elevations similar to (and of course, predating) those of the w side of Old Bond Street (*see* above). The designer is not recorded. *Thomas Jelly* is known to have been concerned with the development, and *Palmer* was at this time in partnership with Jelly; Milsom's 1753 lease plans were drawn by *Robert Smith*, probably the churchwarden of Walcot whose design for the new parish church was chosen over that of John Wood in 1740. Smith was perhaps at least responsible for the original termination of the Old Bond Street–Burton Street island block which had an out-of-date Baroque elevation similar to what we know of Smith's Walcot church.

Milsom Street immediately became a favoured residential area. (General Tilney in Jane Austen's *Northanger Abbey* lived here.) Upmarket retailers soon moved in, and it remains the city's pre-eminent shopping street. From the C19 Milsom Street also acquired a quasi-civic function as the focus of street celebrations on national occasions. The **shopfronts** were accordingly sumptuous and those that remain form a remarkably rich collection. Initially all the houses had railed basement areas, but already by 1782 the top two on the w side had

Classical shopfronts (mid C18–early C19) have an entablature incorporating a shutter slot supported by columns or pilasters, or simply by the window and door frames. The shop windows are of simple geometric form (flat-fronted, bow-fronted, splay-ended or rectangular-projecting). Glazing is in crown glass, initially small panes, increasing in size throughout the period, with larger sheets of cylinder glass from *c.* 1832. With the general use of plate glass after 1845 the glazing bars of many early shopfronts were replaced by plate glass in vertical sheets with mullions and transoms. Such Victorian alterations are of interest in themselves. Below is a stall riser of stone, often with a grille to light and ventilate the basement. Alternatively, the undersill railings may be full-width, common outside the city walls until *c.* 1900 where Georgian terrace houses were converted to shops and the front projects over the area. The undersill railings were frequently covered over later and remain concealed. **Late Victorian and Edwardian** shopfronts gained lightness and elegance, characteristically by means of a sweep of curved plate glass in large sheets to windows to the side, or either side, of a deep entrance lobby. The lobby ceiling is usually panelled, sometimes mirrored, and the floor, mosaic, often with cut-glass fanlights over the doors. The window size is maximized with lowered sills, raised window heads and minimal architraves. Round glazing bars of hardwood, often in the form of thin colonnettes with small capitals, cover the vertical junctions between the panes. A projecting entablature indicates an integral roller-blind box behind the fascia, a common feature for jewellers at this period. A number of interesting interwar **Art Deco** shopfronts were designed, using geometric forms and sometimes new materials such as chrome and 'Vitrolite' (black glass), though few survive; there are many Classical Revival **Neo-Georgian** shopfronts of this date. After 1945 most new shopfronts were uninspired and mediocre. Contextual designs in **Georgian** and **Victorian/Edwardian Revival** style became usual from the 1980s, and the local authority issued design guidelines in the 1990s. There are many variations to the typical characteristics described.

inserted shopfronts – despite restrictions in the leases to the contrary. By 1840 only No. 13 was unconverted.

On the E side on the N corner of Green Street, No. 47 is 1780s by *Thomas Baldwin*; by 1791 it had become a bank. The Ionic order runs through the first and second floors. Baldwin's rusticated ground floor was restored by *Herbert W. Matthews*, architect for Capital and Counties Bank in 1908, replacing C19 shopfronts. It incorporates No. 2

88. Shopfront, No. 7
Old Bond Street

89. Shopfront, No. 12
New Bond Street

88. Shopfront, No. 7
Old Bond Street

89. Shopfront, No. 12
New Bond Street

Green Street on the return elevation, previously a gabled house, rebuilt in a conforming style in two phases for Lloyds Bank: 1930 (ground floor) and 1959 (above). Next, to the N, No. 46 has an individual and quite different façade with touches of Baroque, by *T. B. Silcock & S. S. Reay* of 1900, who had offices here. Behind lies the most fashionable and elegant of Bath's proprietary chapels, the **Octagon** by *Timothy Lightoler* [90], 1766–7, entered through a covered passage. The octagon shape was occasionally adopted in later C18 English church design, especially by the Methodists – Wesley himself favoured it – because it was ideal for preaching, the listeners being nearer to the pulpit than in a rectangular plan.* Built with funds raised by subscription, it was promoted by a banker, William Street, on the site of his garden in partnership with the Rev. Dr Dechair. The chapel is a spacious room 39 ft (12 metres) in diameter, contained – because it could not normally be seen – within a plain and windowless rectangular building, with a

*Others include: Thomas Ivory's Octagon Chapel, Colegate, Norwich, 1754; William Thomas's Surrey Chapel, Southwark, 1782–3; and George Dance's Gothic Micheldever Church, Hampshire, 1808–10.

The Octagon Chapel was essentially comfortable, pleasant and commodious and frequently served as a concert hall. Its fine Snetzler organ was inaugurated in October 1767 with a performance of Handel's *Messiah* and an organ concerto, the latter played by the chapel's resident organist for many years, the astronomer and composer Sir William Herschel (*see* also Walk 11, p. 252).

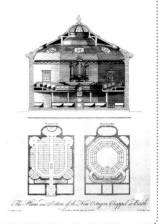

90. The Octagon Chapel, Milsom Street, by Timothy Lightoler (1766–7), plans and section

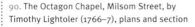

gallery on eight unfluted Ionic stone columns. The gallery fronts have added C20 plaster decoration. An entablature with a festoon frieze terminates the walls, over which rises a shallow octagonal dome with delicate light plasterwork, strings of husks and a circular window in each facet. Above is a smaller coved ceiling with a drum, decorated with swags, and a saucer-shaped lantern. It had on the ground level recesses in the corners (partly remaining), two with fireplaces, for invalids. The sanctuary has an excellent wrought-iron chancel screen with scrolls and foliate decoration. A chapel until 1895, it then became an antiques showroom and was converted into the Royal Photographic Society premises by the City Architect *Roy Worskett* in 1978–9, which it remained until 2000.

On the w side, No. 3 has a shopfront of 1911 by *C. B. Oliver*, with large console brackets supporting the fascia with delicately carved ornament; Art Nouveau door handle. The façade to No. 43 opposite has painted lettering advertising an early C19 circulating library and reading room, which incorporated a state lottery office.

N of here, one section of Milsom Street on the E side remained undeveloped longer, where the parishes of SS Peter and Paul and St James had bought land in 1735 for a poorhouse. The site was eventually developed as **Somersetshire Buildings** [91], five grand houses built as a speculation by *Baldwin*, 1781–3, now Nos. 37–42. Baldwin's position as City Architect enabled him to depart from the uniform street elevation in favour of an altogether different scale and splendour. The grand composition carries on the palace façade principle of the N side of Queen

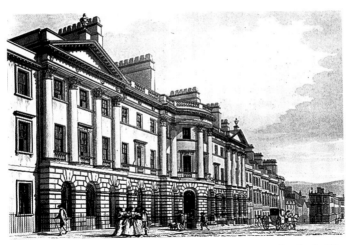

91. *Somersetshire Buildings in Milsom Street, Bath.* Aquatint by T. Malton Jun (1788)

Square, with giant order centre and end stress, though in a position where the distance is lacking to appreciate the seventeen-bay façade. It has a ground floor with rustication and arched windows and doorways. Giant attached Corinthian columns give side and middle accents and the wide centre house has in addition a segmental bowed front; the projecting end pavilions have pediments. The first-floor windows have balustrading below, and above the centre windows are panels with rams' heads and festoons; lion-mask frieze to the main entablature. No. 42 has a red granite ground-floor front for the Bristol and West Banking Company by *A. S. Goodridge*, 1892. The first-floor balustrading was restored and inserted balconies removed in 1937 by *G. A. Coombe* and *F. N. Waller* of the *Prudential Insurance Estate Department*, on advice given to the Corporation by *Mowbray A. Green*. No. 41 was restored from a Victorian commercial front to form the entrance to Shire's Yard in 1988 (*see* Walk 2, p. 133). The ground-floor front room of No. 39, the centre house, has one of the finest and most delicate plaster ceilings of its date in Bath. Husk and drapery festoons, rams' heads, paterae, foliage and ribbons decorate a large circular panel. This was Bath and Somersetshire Bank *c.* 1783–93, when it failed, and Stuckey's Bank from 1859; it is now the NatWest Bank. The ground floors of Nos. 37 and 38 were restored to the C18 design in 1960 (*see* also Introduction, p. 24).

On the w side, Nos. 7–14 are **Jolly's** department store. It was opened by James Jolly in 1831, initially in No. 12 as The Bath Emporium, an exclusive establishment selling fine silks, furs and ribbons from Paris. Most of the shopfronts are partially C19, unified in appearance during refurbishment in 1994–5, but retaining much Victorian character. Nos. 7–8 have a cornice supported on palm leaf corbels from a shopfront by

W. J. Willcox, 1907. Nos. 11–13 are Jolly's centrepiece, the most extravagant shopfront in Bath, by *C. E. Davis*, 1879, colonnaded, with stone, polished granite, bronze and mahogany, decorative lettering cut deeply into granite stall risers, Art Nouveau fascia lettering and bronze cartouches, *c.* 1900 [92]. Peacock friezes, leaded clerestory windows and strapwork in the ground-floor interior, exposed and repaired in the 1990s, recall the very formal etiquette of polite shopping in Bath that lasted into the 1950s. The peacock decoration was never finished as the artist died mid-project. The first-floor rooms overlooking the street retain vestiges of their original character as domestic drawing rooms, with an assortment of chimneypieces, one original C18 with Siena marble, the others C19. Extensions to the rear for the department store are toplit.

Continuing N, C19 façade lettering to No. 35, E side, indicates a Brush Manufactory. Further N on the E side, No. 32 has an elegant front by *Silcock & Reay*, 1902, with mirrored soffit, an elaborate brass and cylindrical ebony pull handle with turned brass ends and working rollerblind box. Still further N, W side, No. 17 had a shopfront with a pair of double fluted Corinthian columns, *c.* 1840, which was rebuilt and extended across to No. 18 in the C20 to form a dignified six-bay colonnade, possibly reusing the existing columns.

At the top a pair of **bank buildings** in the Italian palazzo style form the N corners of Milsom Street. No. 24 on the E corner, dated 1865, was built for the National Provincial Bank by *Wilson & Willcox*, extended and altered in 1884 by *Wilson, Willcox & Wilson*. Baroque in feel: a red granite bolection doorcase marks the corner entrance; the ground floor is rusticated and vermiculated; the upper floors have giant attached fluted Corinthian columns, the attic storey, double balustrading and pediments. On the W corner No. 23, of 1873–5, was won in competition by *G. M. Silley*. Rusticated ground storey with round-arched windows, full entablature, and fluted Ionic giant pilasters over with a dentil

bracket cornice. Attic cornice above with lions' heads in line with the pilasters. The s three bays to Milsom Street are an extension to a design by *Silley* of 1890. The date stone of 1902 refers to later internal alterations.

We now enter **George Street**, which runs E–W. This was lengthened to the E when Milsom Street was laid out, with Edgar Buildings and Princes Buildings forming the N side (*see* below). From the time that Milsom Street turned commercial, gentry did their shopping here. Advertising in 1846, for example, were Green and Gandy, 'woollen draper and tailor, funerals furnished', William Hick's 'china, glass, lamp and papier machee showrooms' at No. 7, and 'Pooley, chemist and druggist' at No. 8, and in 1854 a 'tea dealer and grocer, wax and tallow chandler' at No. 10 and a 'snuff and tobacco warehouse' at No. 3 York Buildings.

Turning W, the buildings on the s side are of mixed dates. Nos. 2–3 are *c.* 1760 with a shopfront by *Wilson, Willcox & Wilson*, 1874, reusing five large-scale fluted Corinthian columns, *c.* 1840, salvaged from No. 1 George Street when the bank was built (*see* above). Nos. 4–7 is a modest three-storey terrace, *c.* 1800 with later shopfronts cut into the first floor. The shopfront to No. 6 is by *C. J. Calvert*, 1909, based on an unexecuted design by Spackman & Son, 1908. Nos. 8–12, mid-C18, are part of *John Wood* the Elder's Gay Street development (*see* Walk 3, p. 141). The shopfront to No. 9 by *F. W. Gardiner*, 1887, was restored in 1987–8 by *William Bertram & Fell* and the undersill railings uncovered using evidence of an early photograph. No. 11 has an exceptional front of 1909 by *Spackman & Son*, curved, with curvilinear glazing bars, bevelled glass to the clerestory and fanlight, and a mirrored soffit. A magnificent and very wide door continues the curvilinear theme. Nos. 12–12b at the w end corner have shopfronts with flanking stone pilasters by *H. Spackman*, 1889; part of this same design, No. 12 has a tall plate-glass front with cast-iron colonettes and cresting. Still at this date (and despite little clearance) it has undersill railings to light and ventilate the basement.

A specially handsome feature of the N side of George Street at this w end (and many other streets of Bath) is a wide pavement raised high above the street, here with sturdy late C19 cast-iron railings. Off this section running N is **Miles's Buildings**, a peaceful Pennant-stone-paved enclave by *Wood the Younger*, who disposed of the plots in 1766–8. The buildings are on the E side only; Nos. 3–4 have first-floor Venetian windows, No. 3 with original Gothick glazing bars. Most doorways have architraves and hoods on consoles. Further E on the N side of George Street are **Edgar Buildings**, nine houses conceived as part of the Milsom Street development built on Corporation leases of 1761 to John Ford, mason, and Samuel Sainsbury, tiler. Raised on a level pavement, the houses at each end project slightly and the pedimented centre effectively terminates the view from Milsom Street. No. 3 has a sturdy Tuscan shopfront of 1934 by *Taylor & Fare*. At No. 4 lived Selina, Countess of Huntingdon and at Nos. 5–6, the painter William Hoare.

Continuing E on the N side, **Princes Buildings**, built on land leased from the Corporation, 1764–5, are of the standard *Jelly* type, and named after the developer, Prince Hoare the sculptor, William's brother, who lived at No. 5. Each alternate first-floor window is pedimented. No. 6 has a good shopfront by *Graham Finch*, 1992 in Victorian style.

On the S side at the E end is the long even façade of the **Royal York Hotel** (originally York Buildings), 1755–9 by *Wood the Younger*. It has a slightly projecting seven-bay centre and six-bay wings. The ground-floor windows are plain; above a platband, the first-floor windows have architraves, cornices and a continuous linking sill, the second-floor windows, architraves. It opened as a coaching inn in 1769, with a yard and stables to the rear; stagecoaches started here every day for London. Princess Victoria stayed in 1830 when she opened Victoria Park, as did the famous German architect, Karl Friedrich Schinkel, on his tour of Britain. As the inscription indicates, its continuation W housed the Post Office, until the 1920s one was built (*see* Walk 2, [75]).

Between Edgar Buildings and Princes Buildings, the Pennant-paved **Bartlett Street** climbs N. On the E side is a mid-C19 two-storey building with debased classical detailing and attic windows with segmental pediments. Next N, on the E and W sides is a purpose-built former department store of Evans & Owens with tall continuous shop frontages with Corinthian pilasters by *Browne & Gill*, 1882. The W side is two-storeyed with a pedimented entrance with a terracotta archway, and paired first-floor windows with panelled pilasters. *Browne & Gill* extended the E side to the rear for new showrooms in 1885 and rebuilt the front in 1892; three storeys and two sets of three bays separated by quoins; the upper windows have eared surrounds, the centre, cornices and scrollwork.

Bartlett Street connects with the **Assembly Rooms** by *Wood the Younger* (*see* Major Buildings, p. 88) and the surrounding related streets, Alfred Street, Bennett Street and Russel Street, all to a general layout by *Wood the Younger* but built by various speculative builders. The Assembly Rooms and streets were built simultaneously as part of one plan from 1769. The one real failure of these, and the Assembly Rooms in particular, is that despite being adjacent to the Circus they are quite unrelated to the elder Wood's masterpiece (*see* Walk 3, p. 142). Here one feels an absence of planning. The house elevations are standard with slight variation by individual builders, mostly three windows wide, with a basement, three principal storeys and a mansard attic. Ground-floor windows are plain; the upper surrounds have architraves and the first-floor windows (which have been lowered throughout), cornices in addition. A first-floor platband, modillioned cornice and parapet unite the terraces.

Alfred Street, built between 1768 and 1776, flanks the Assembly Rooms' S side. The SE range of seven houses is a symmetrical group (Nos. 1–7), the middle and ends set slightly forward and with a central

pediment. The controversial C18 historian, Catherine Macaulay (1731–91) lived at No. 2, E end, from 1774, where she finished her *History of England*. The young (Sir) Thomas Lawrence, the portrait painter (1769–1830) lived here in 1780–7, when he was taught by Thomas Barker (*see* Walk 5, p. 167). No. 14 has an unusually elaborate doorway with pendants of flowers and festoons in the frieze and a bust of King Alfred over. Unusual too is the C19 ironwork: an overthrow lampholder, two conical snuffers for extinguishing the link boys' torches that lit the way for sedan chairs at night, and a windlass for lowering objects into the basement area. William Harbutt invented Plasticine in 1897 in the basement of No. 15 (*see* also Walk 7, p. 203). (From here the rear view of the Circus illustrates the individuality of each house behind the uniform front façade and the cheaper-built faceted back façade). **Saville Row**, late C18, connecting Alfred Street with Bennett Street, is a small-scale alley, notable for its surviving C19 shopfronts.

Bennett Street was built in 1770–6. No. 19 retains a wrought-iron overthrow; Admiral Arthur Phillip (1738–1814), first Governor of New South Wales, retired here in 1806. He is buried in Bathampton churchyard. No. 22 was part of the Bath Eye Infirmary from 1811 to 1948. **Russel Street** off the N side was built 1770–6 on land leased from Sir Peter Rivers Gay. Nearest Bennett Street on the w side, the houses have unmoulded Venetian windows on the first floor. The fenestration of these houses shows a reaction against the Palladian orthodoxy that was besetting Bath building by this date. Russel Street is terminated to the s by the Assembly Rooms, and closed at the top by a canted bay window as a *point de vue* in Rivers Street (*see* Walk 10, p. 243).

Walk 5

St James's Square to the Upper Crescents

Climbing the steep slope of Lansdown, the Walk visits the splendid early Regency terraces, crescents and houses of post-Wood Bath, stacked up the hill and with soaring views. If the Elder Wood's Bath was essentially urban, and if mid-C19 Bath, with the rise of the villa, saw itself as a city with rural tendencies, then the developments in this walk are transitional. They build on the precedent of the Younger Wood's Royal Crescent and point towards values of landscape and the Picturesque (*see* Introduction, p. 33).

We start in **St James's Square**, the most complete Georgian square in Bath, exuding quiet taste and charm, a short walk N of the Royal Crescent up Marlborough Street from the SW or St James's Street from the SE.* In 1790 Sir Peter Rivers Gay leased the land (by then, partly gardens to the Royal Crescent) to four craftsmen, who commissioned the architect, *John Palmer*. To maintain quality, the lease specified that building costs should be at least ten thousand pounds. Work was complete by 1793. The precedent was Queen Square, here elongated into a N–S rectangle, but with the variation of four diagonally set approach streets: St James's Street, Marlborough Street, Great Bedford Street from the NE, and Park Street from the NW. The principal ranges are the N and s, Nos. 16–22 and Nos. 38–45, level along the contour, with a central pediment over three bays with giant unfluted Corinthian pilasters and bow-fronted end pavilions. The central first-floor window under the pediment and on each pavilion has a semicircular head; a moulded band course runs over these windows. The E and W sides, Nos. 23–37 and Nos. 1–15, step up the rising site. They are plain, except for the central and end houses, which have rusticated ground storeys and, at first floor, unfluted composite pilasters supporting a plain frieze with a pediment over the middle window; the central houses also have crowning three-bay pediments. The writer Walter Savage Landor lived at No. 35 in 1846–52. The central railings were restored in the 1990s.

*An opening on the E side of St James's Street leads to **St James's Place**, a quiet, intimate paved backwater, originally with additional houses, and part of the St James's development from 1790. The later pedimented entrance, with an elaborately carved tympanum and glazed shopping arcade of same date behind, is an exceptional survival of Victorian retail architecture, *c.* 1880, with ranks of wrought-iron bars on cast-iron brackets and butcher's hooks.

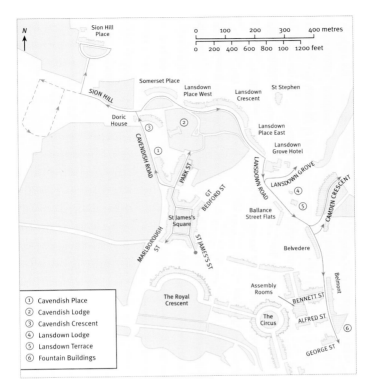

Park Street, running diagonally off the NW corner, and then steeply uphill N, is part of an incomplete extension of the whole development, eventually taken over by *John Pinch the Elder*. The lower end, Nos. 1–18, W side, and Nos. 28–42, E side, are by *Palmer c.* 1790–3, and Nos. 19–24, W side, and Nos. 25–27 on the incomplete E side, are by *Pinch*, from 1808. The later houses are quite grand, each with full-height nine-over-nine first-floor sashes. Nos. 19 and 27, opposite each other, break slightly forwards. No. 19 has a rusticated ground storey and No. 27 a large segmental bow to the garden and each has a finely carved frieze over the first-floor centre window. The street, formerly terminated at the top by All Saints Chapel (*see* below, p. 173), was intended to be continued NW.

Park Place and Nos. 1–3 Cavendish Place run the short distance W from near the S end of Park Street to connect with the taller houses in the main section of the terrace called **Cavendish Place**, both by *Pinch the Elder*. The scale is skilfully modulated, each house increasing in size until the wide, curving front of the wedge-shaped corner house, No. 3, is reached. Nos. 4–13 Cavendish Place run N up **Cavendish Road**,

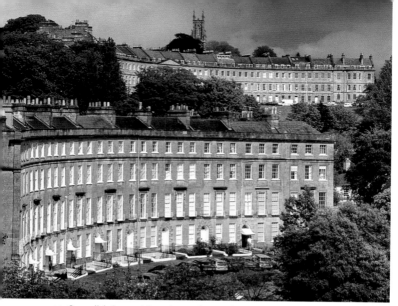

94. Cavendish Crescent from the south west, by John Pinch the Elder (1815–30)

stepping uphill and facing w across the High Common. Built in 1808–16, it is one of the most distinguished early C19 terraces. Work was well under way by 1810, when an agreement to supply water notes, 'already built several houses and building several more'. The range continues the Palladian tradition of Bath, with V-jointed rustication to the ground storey with rusticated round-headed door openings [95] and a *piano nobile*, but the details now draw on Adam and Baldwin. The first-floor windows are very tall and the middle window is accented with an entablature on narrow reeded pilasters with long, slender console-capitals. There is strong horizontal emphasis with a Pompeiian-scroll platband just below the second-floor windows and main cornice below the attic storey. These all ramp up successively to the next house, to give a cohesion that the Woods' climbing terraces never achieved. This is not a palace façade: the architecture is astylar and there are no accents to the middle or end. The only weakness is that the N end appears to stop in mid-flight. Especially notable iron- and lead-work, with overthrows, iron balconies, verandas, delicate fanlights and sidelights. Nos. 6–9 were gutted by incendiary bombs in 1942 and rebuilt by *Mowbray Green & Partners*, 1949.

Next, N, on Cavendish Road is **Cavendish Villa**, a house of *c*. 1779, refronted with an early C19 bow. A pair of semi-detached villas called **Winifred's Dale** follows, by *Pinch the Elder*, *c*. 1810. These are early examples of semi-detached villas on the NW slopes of the city, with segmental bows and a curved Doric double porch in between.

Next is **Cavendish Lodge**, Neo-Georgian apartments by *William*

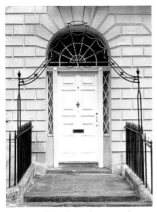

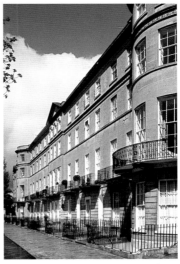

95. Cavendish Place, doorcase, by John Pinch the Elder (1808–16)

96. Sion Hill Place from the south east, by John Pinch the Elder (c.1817–20)

Bertram & Fell, 1996, the tenth planning application to be made for this sensitive site. It is of two storeys plus attic, H-shaped in plan with an applied Doric portico. A pair of lodges flanks the entrance, each with an open pediment, bullseye windows and ribbon decoration. The scheme is well detailed and the style and scale are acceptable but the ostentation, formal axial approach and Cotswold dry-walling-effect stone are unsympathetic to the neighbourhood's quiet, Picturesque Regency buildings.

Cavendish Crescent is a short, late crescent of 1815–30 [94], by *Pinch the Elder*, for William Broom, a speculating builder, who in 1815 was living at No. 3 and who was bankrupt in 1825. Following the contours along the edge of the High Common, the eleven houses are four-storeyed, three windows wide, with no central feature and somewhat austere except for cornices on long consoles over the middle first-floor windows. Sir William Holburne lived at No. 10, 1829–74, where he housed his collection (*see* Walk 6, p. 183).

Opposite its w end, still on Cavendish Road, is the temple-like **Doric House**, an important and uncompromisingly severe Grecian building built for Thomas Barker, the painter, by Soane's protégé, *Joseph Michael Gandy*, probably completed by 1805 (a first design of just one storey was shown at the Royal Academy in 1803). The elevation to Cavendish Road is remarkable. Two storeys above a substantial plinth, both of them recessed behind superimposed column-screens. The ground-floor façade is windowless and plain except for a platband, with four detached primitive unfluted Doric columns and engaged antae. These

have unconventional concave capitals and large abaci and support an entablature with a modillion cornice. Above, an attic storey has a superimposed colonnade of very short columns, with sash windows to the central bays, supporting an entablature and parapet with stylized acroteria. The entablatures return along a pedimented s elevation, with a tripartite ground-floor window and a single window above. Despite the absence of triglyphs and metopes in the frieze, the effect is intended to be Greek Doric, and the blind wall fronted by a colonnade recalls temples in southern Italy and Sicily, such as the Olympieion at Agrigento. Overlaying this is something of an archaeological joke, for the double tier of columns, proportioned as they are, refer to the two-storey interior of a Greek temple, interpreted here on an exterior. N of the main temple block is a doorway flanked by Doric columns. It leads to an entrance hall lit by an elliptical skylight, containing a pretty curving staircase with a fragile iron railing, remarkably dainty after the forbidding exterior. Behind the closed wall lies the very unusual principal room, a double cube 32 ft (10 metres) long. The room was Barker's showcase, for the E wall has a giant painting of 1826 by *Barker* of the massacre of the inhabitants of Scio (Chios) by the Turks in 1822 when twenty-five thousand were slain, executed in fresco on wet plaster. It was perhaps inspired by Delacroix's painting of 1824 of the same modern Greek subject. An attached block to the w contains a pear-shaped dining room. A continuation of the house on the N side, extended with a second storey in red sandstone with Bath stone dressings of 1822, was damaged by bombing and badly rebuilt *c.* 1952 as a separate property (No. 1 Sion Hill).

Sion Hill climbs steeply w; shortly in the s side wall, an exceptionally severe Greek Revival doorcase to a demolished house. On the same side now follow several late C18 and early C19 houses. Sion House, No. 8, is a three-storey villa, *c.* 1805, probably by *John Pinch the Elder*, with a full-height bow with balconettes to the garden front. Nos. 11–14 are a terrace of *c.* 1795–1800, plain, each house two windows wide, with the taller and grander three-bay No. 15 added in 1810–15 by a Mr *Williams*, builder. They have later C19 two- and three-storey additions, built to contain bathrooms and porches, and repositioned original Tuscan doorcases. Most have full-height segmental bows to the rear, showing that by this date the garden aspect became more important than the public face.

An optional excursion of ⅓ m. (500 metres) completes the loop of **Sion Hill**, which turns s after a further 90 yd. (100 metres). On the sw corner is a finely detailed early C19 Greek Revival villa, the central windows with shallow segmental arched recesses and good ironwork balconies; acroteria are carved into the attic quoins. Turning s downhill, on the E side, **Sion Cottage** (No. 23), *c.* 1760, is Gothick style with a castellated parapet. Canted bays with paired windows, trefoil-headed at first floor, originally leaded, and terminal buttresses with sunk quatrefoil

panels and obelisk finials. A central porch, altered *c.* 1800, has matching pilasters and finials. The road now turns E and on the N side, **Gothic Cottage**, No. 27, a pretty *cottage orné* of 1797, is unusual for its eclectic mix of Gothick and classical, and its Flemish bond brick construction. A later hip-roofed lean-to runs across the entire front. James Dredge, engineer and designer of the Victoria Bridge, lived here in the mid C19. The loop continues E, then N, with miscellaneous C19 villas of limited interest; Rose Cottage, No. 33, is Tudor style, *c.* 1840. We now rejoin the main section of Sion Hill and return to the E.

Opposite, on the N side, is an outstanding Regency-style cast-iron **entrance screen** and **railings** to Ernest Cook's embellishment of Summerhill, Sion Hill Place (*see* below), by *Axford & Smith*, Bath builders, 1932: sheer pastiche, but of the very highest order. Gate piers, with Greek key bases, anthemia and gadrooned urns support gates with spears, large and small oval panels and anthemia. Behind, **South Lodge** is a competent Neoclassical design, also by *Axford & Smith*, and of the same date: cubic, two-storey, three bays wide, round-headed ground-floor windows. The main E façade has attached Tuscan columns to the ground floor and attached Ionic angle columns to the first floor; the centre window is blind.

Immediately E of the railings to South Lodge, rusticated gate piers give access to a park-like avenue running N, leading to the secluded and distinguished **Sion Hill Place** [96]. Simple and elegant, by *John Pinch the Elder*, *c.* 1817–20, the nine four-storey houses are one of the latest palace-fronted terraces in Bath and, on this remote site, the northernmost of the urban set pieces. A Bath painter, William Cowell Hayes, built the first houses, Nos. 1–4, and Daniel Aust, builder of Walcot, constructed the central house, No. 5 and perhaps others. No. 5 is of three bays, pedimented, and breaks slightly forward. On either side, three two-bay houses terminated by three-bay end houses, correspondingly projecting, with big segmental bows. The ground floor has banded rustication with voussoirs over rectangular window and round-headed door openings. Upper storeys very restrained with window openings entirely unmoulded, full-height on the first floor.

Nos. 1–2 Sion Hill Place were substantially altered in the C20 by Ernest Cook, grandson of the travel agent Thomas Cook, and benefactor of the Assembly Rooms (*see* Major Buildings, p. 88). He occupied No. 9, then Nos. 1–2. Using *Axford & Smith*, in 1934–6 he remodelled their interiors and extended the accommodation W to form picture galleries on two floors 50 ft (15 metres) by 33 ft (10 metres). On to this addition was grafted a façade of *c.* 1738 by *John Wood the Elder*, which Cook salvaged from Nos. 24–25 High Street, Chippenham, Wiltshire. This gratifying curiosity, since 1956 part of Kingswood School, is now only accessible through private grounds 55 yd. (50 metres) s of Sion Hill Place. The façade cladding has seven bays and a three-bay centre. The ground floor has chamfered rustication. The tall upper floor has paired

Corinthian columns in the centre, with a wider arched centre opening forming an implied Venetian window. On either side are Corinthian pilasters with pedimented windows. The first-floor windows rise from blind balustrades. Between the capitals a frieze ornately carved with masks and festoons. Modillion cornice, carrying a pediment with pineapple finials, parapet with balustrading, interrupted by the pediment. This important work of Wood is unusually peripatetic, having probably been moved not once but twice. It is believed to have been designed for Bowden Hill, Wiltshire in 1738, but on the owner's death the unfinished house was sold to a Chippenham clothier, Thomas Figgins, and re-erected there between 1749 and 1777. Stylistically it resembles Wood's designs for the Exchange at Bristol. Just to the w on this picturesque hilltop situation was a late c18 house by *John Eveleigh*, among the earliest seats on the city's Nw fringes but burnt in 1912; the balustraded terrace remains. Built for the affluent physician Caleb Hillier Parry, whose many pursuits included breeding Merino sheep, and financial involvement in Eveleigh's Camden Crescent (*see* p. 174).

To the N, set discreetly inside the old kitchen garden walls, **Kingswood Day Preparatory School** [97], by *Feilden Clegg Design*, 1991–5, cuts into the hillside with a stepped section. Service accommodation forms the N wall and classrooms are paired along the front elevation, opening on to terraces for summer. Between, a toplit linear 'street' has double-height library and reception spaces. At the E end is a toplit assembly space. Sloping ceilings modulate the scale internally and exposed timber, white-painted masonry and bright colours suggest fun and learning. The walls are load-bearing brickwork; the zinc-clad roof, timber with laminated bowstring trusses.

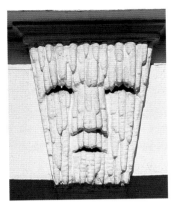

98. Somerset Place, icicle-mask key-
stone, by John Eveleigh (begun 1790)

99. Camden Crescent, elephant key-
stone, by John Eveleigh (c. 1787–8)

97. Kingswood Day Preparatory School, by Feilden Clegg Design (1991–5)

Returning to Sion Hill, retracing our steps E and ascending the steps
on the NE corner of Cavendish Road, we come now to the *pièce de résis-
tance*, an almost unbroken line of magnificently sited, sinuous crescents
that follow the contour: Somerset Place, Lansdown Place West,
Lansdown Crescent and Lansdown Place East. First is **Somerset Place**,
Bath's most unusual crescent of sixteen houses above Cavendish
Crescent. Started by *John Eveleigh* in 1790, it was abandoned for finan-
cial reasons and only resumed *c.* 1820; the W wing has only five houses
though cellars were built for two more. The central symmetrical pair,
Nos. 10–11, dominate, with a big six-bay broken segmental pediment.
The tympanum is carved with paterae and swags caught up by pegs,
and reverse curves to the tympanum in the broken section meet to form
a pedestal with a vase finial. The first floor has a central arched niche
with an open pediment. The paired doors have Gibbs surrounds and
icicle keystone masks [98] and cornices on consoles that terminate in
carved leaves. These houses were built first as a semi-detached pair;
they step slightly forward, and are not curved in plan like the wings. The
flanking houses are simpler, three storeys, three bays; the E wing
descends downhill, managing the slope with a tilted platband and cor-
nice. The doorcases are rusticated and have cornices on consoles, some
with unusual acanthus leaf keystones. Nos. 5–7 and 10–13 were gutted by
incendiaries in 1942 and rebuilt for student hostels by *Hugh D. Roberts*,
1950–60s.

Somerset Place is followed immediately by **Lansdown Crescent**
(1789–93), a segment of twenty houses forming almost one-third of a
circle, together with its convex flanking ranges, **Lansdown Place West**
(No. 8 bombed and rebuilt by *Mowbray Green*, 1948) and **Lansdown**

Place East (1792–5), which step up towards the main crescent. *John Palmer* designed them for Charles Spackman, coachbuilder and developer, and they were built by various speculating builders, some of whom were ruined by the bank failures of 1793. The convex-concave-convex plan is remarkable. The convex wings are separated from the crescent centre by carriageways to the mews, but the effect is of one continuous form snaking along the hillside. The architectural treatment of Lansdown Crescent is less superb than the earlier, more formal spaces in Bath. The pedimented four-pilaster Ionic centre with a wider space and a Venetian window in the middle is weak, as are the two bows at the ends, set just one bay in from the angle. But with its elevated position, its superb view over Bath, its fine overthrows and lamps (restored in the 1970s) and its patinated stonework, magical at dusk, the crescent has unrivalled presence. Historically, the crescent in winter would have floated, seemingly on clouds, above a pall of blue smoke from thousands of lodging-house chimneys. The details are simple (cost was crucial): ground-floor rustication, continuous first-floor sills (windows at the end houses extending down to the platband), a Vitruvian scroll string course above the first floor, and an entablature with a plain frieze, modillioned cornice and balustraded parapet.

Lansdown Crescent's most illustrious resident was William Beckford, who made No. 20 his home after leaving Fonthill in 1822 (following brief residence at No. 66 Great Pulteney Street) until his death in 1844.* The front door, to the lane on the side, opens into a prestigious entrance hall (with a dwarf footman in Beckford's time). The original Palmer staircase rises only to the first floor; a secondary staircase gives access to all floors. Beckford also acquired No. 1 Lansdown Place West across the lane, and linked the two by a bridge. It was probably designed by *Henry Edmund Goodridge*, who was building Lansdown Tower for Beckford in 1825–6 (*see* Excursions, p. 271). This housed part of his library. When Beckford sold No. 1 in 1832 he retained the bridge. It sits on a semi-elliptical arch and has horizontal mouldings that coincide with those above the first floor of No. 20, and three windows with eared architraves. Above the balustraded parapet with panelled dies are four green-oxidized copper aloes in gadrooned urns. Beckford also purchased a strip of fields and downland to the rear and created an idyllic landscape garden, stretching up one mile (1.6 km.) to Lansdown Tower on the brow of the hill. In the garden to the rear is a small domed Islamic pavilion. In 1836 he purchased No. 19 and *Goodridge* carried out alterations and amalgamated it with No. 20.

*Compared with the Royal Crescent, relatively few famous names are linked with this, more private, hillside retreat. The astronomer and meteorologist Henry Lawson (1774–1855) lived at No. 7, and built an observatory on the roof. Several houses were schools early on; in 1809, No. 3 was Miss Fossiter's Seminary for Young Ladies, No. 10 Miss Coobar's British Boarding School, No. 20 Miss Habershon's School for Young Ladies.

Palmer's staircase balustrading was removed, and the staircase encased in an inclined tunnel, said by Beckford to exclude draughts, but perhaps to avoid the gaze of servants. It is lined with bands at intervals from dado to dado, giving the effect of arches in perspective. On the ground floor is another library, by *Goodridge*. This handsome room has arched recesses with mahogany bookcases on the inner walls, divided by yellow scagliola pilasters.[*]

Below Lansdown Crescent stood **All Saints**, architect *Palmer*, a large Gothick proprietary chapel built in 1794 by local residents. It was destroyed in the Second World War. Continuing E, Nos. 5–9 **Lansdown Place East**, bombed and rebuilt in facsimile by *A. J. Taylor & Partners*, 1946. From here across the road we can overlook, downhill to the s, the handsome plain **Hope House** (originally Rock House), 1790 by *Palmer*, two-storeyed with large segmental bows on the garden fronts to s and w. During the C20 it became part of Bath High (now Royal High) School, and has many consequent alterations and extensions. Its E side fronts on to Lansdown Road; the unusual doorcase matches that of No. 1 Lansdown Place East (and also No. 16 Brock Street – *see* Walk 3, p. 146), with reeded edges and a flattened segmental roof supported by thin plain columns.

We now descend to the s down **Lansdown Road**. Opposite, at the junction with Lansdown Grove (NE corner), the **Lansdown Grove Hotel** is a house of 1770, enlarged as a hotel *c.* 1860, further altered 1913, and forming now a confused jumble. The original part, altered, has a three-bay pedimented centre and canted bays to either side. To the E a single-storey lounge extension by *A. J. Taylor*, dated 1913. Set well back and high up on the slope is a further block, by *T. B. Silcock*, 1891–2, of no interest. A few metres to the E in **Lansdown Grove** is a mid- or late C18 loggia in Batty Langley Gothick, with quatrefoil-section columns, foliate capitals, and a parapet with moulded coping and pierced quatrefoils. Originally free-standing; now incorporated into the s side of **Barcote House**, by *William Bertram & Fell*, 1987. The N side of this single-storey house has an amusing Lutyensesque entrance with an arched opening set in a stylized Dutch gable façade surmounted by diagonal chimneystacks.

Further down on the E side, set back, is **Lansdown Lodge**, a detached mid-C18 mansion, enlarged in 1835: two storeys, five bays, a pediment over the three-bay central portion, quoins. Next, E side, is **Lansdown Terrace**, three mid-C18 houses with early C19 alterations, set back behind long gardens. On the w side are the **Ballance Street Flats**, council housing designed by the City Architect and Planning Officer, *Dr Howard Stutchbury*, 1969–73. On a conspicuous site visible from around the city, the prominent corridor-access block fronting the road, built of

[*]Opposite this point in the grass to the s are clearly visible bomb craters of 1942.

reconstituted Bath stone, juts out horizontally against the contour so that its s end rises far higher than the surrounding buildings. The upper walls are slate-hung, a fashion of the later 1960s and influenced by Darbourne & Darke's recent housing in London, forming, with the roof, sham mansards. In a less sensitive setting their design would be considered acceptable and of its time. They occupy a so-called slum clearance area: 137 houses of 1773–83 that could have been refurbished were demolished. This visual disaster was notoriously an apogee of the 'Sack of Bath' (*see* Introduction, p. 47), and described in the eponymous book of 1973 as 'ugly, intrusive and tasteless; out of character and scale and harmony . . . perhaps the most detested new addition to the Bath scene.' Their construction helped stem the tide of urban destruction by planners, not just in Bath but nationally.

Soon on the NE side, Ye Olde Farm House, originally of 1753, was rebuilt as a pub by *F. W. Gardiner* in Jacobethan style in 1892, with leaded coloured glass in stone transom and mullioned windows and mock half-timbering on the first floor. Immediately E, a short out-and-back excursion to Camden Crescent completes the tour of the upper crescents. First, in Camden Row, is an early C19 pedimented Greek Revival watchman's lodge, now part of the crescent ensemble. The terrace called **Camden Place**, stepping uphill, leads to **Camden Crescent**, a large fragmentary composition of *c.* 1787–8, designed by *John Eveleigh*, with a magnificent prospect over the E side of Bath. Many plots were leased by two Bath physicians, Caleb Hillier Parry (*see* p. 170) and John Symons, to *John Morgan*, carpenter and *Mark Ffowles*, plasterer. The crescent remains unfinished and asymmetrical. The scheme was originally planned to have thirty-two houses, twenty-two forming the crescent, the remainder, flanking wings. Only eighteen houses of the crescent and the whole sw wing, Camden Place, survive; the crescent has only four houses NE of the pedimented centre. But even in its truncated state it is splendid; the substantial vaulted sub-structure supporting the roadway at the s end is reminiscent of Roman structures, and emphasizes the massive nature of this undertaking on so steep a site. The purely Palladian detail must have been already outdated when built. The centre and completed sw end have a rusticated base and giant engaged three-quarter Corinthian columns, the centre committing the solecism of having five columns, i.e. an even number of bays. The wings have matching Corinthian pilasters. The ground rises towards the centre, and the windows step up in groups of three, while the platband and entablature tilt, parallel with the slope, as at Somerset Place (*see* p. 171 above). The centre is pedimented and in the tympanum is the coat of arms of Charles Pratt, first Earl of Camden, Recorder of Bath from 1759 and Lord Chancellor, 1766. The doorway keystones bear his crest, an elephant's head [99]. A landslide at the NE end destroyed several houses under construction and the isolated end house remained a picturesque ruin for some years before being demolished.

Returning to Lansdown Road, just below Camden Place is **Ainslie's Belvedere**, E side, set back at an angle. First laid out *c*. 1760; the datestone of 1806 to Nos. 2–3 may indicate a later phase. Nos. 3–5 are C20 reconstructions.

Resuming the descent of Lansdown Road, we now leave behind the once semi-rural upper developments and re-enter urban Bath. **Belvedere**, late C18, steps uphill and on the w side sits on one of the raised pavements that are a feature of the upper town. Several have unmoulded Venetian windows, and the doorways, either flat entablatures on consoles or pediments. No. 34, E side, has a conserved sphinx sculpture on the parapet. **Belvedere Villas**, also E side, is a terrace of four three-storey, two-bay houses in Baldwin's manner, late C18, with pedimented end bays that break slightly forward and have fluted pilasters with waterleaf capitals. Attic storey and doorcases added in 1868. Nos. 1–2 Belvedere, a little lower down, w side, are big, three storeys, haphazard in appearance with a bow.

Yet lower down, **Oxford Row** on the w side, *c*. 1775, was possibly designed and certainly developed by *Thomas Warr Atwood*, forming a return elevation to Alfred Street and Bennett Street. Standard Palladian designs of the period: doors with straight cornices on consoles, a platband above the ground floor, first-floor windows with architraves, now chamfered and lengthened, and straight cornices above.

Opposite, E side, **Belmont**, 1768–73, is an impressive row of twenty similar houses on a raised pavement, with the larger rooms at the back overlooking the prospect. Tuscan doorcases; the first-floor windows now mostly chamfered and lengthened, leaving a vestige of once continuous sills. No. 1, on the downhill end, has a late C18, single-storey entrance vestibule, an architectural gem by *Thomas Baldwin*. It has a serpentine façade on a rusticated plinth, a round-headed entrance with niches either side and festoon panels above, flanked by double thin fluted pilasters with long console brackets, supporting a plain frieze and cornice. No. 1 was the office from 1840 to 1978 of the architects James Wilson, later Wilson & Willcox and others.

Finally, **Fountain Buildings**, *c*. 1775, two five-bay houses, incorporating in addition a fine five-bay mansion of *c*. 1730–40 (originally Fountain House), restored by *Carter Hughes Partnership*, 1985–7. The stone is now somewhat eroded; the pedimented centre bay has a wide rusticated arched doorway and a Venetian window over. A cistern once on the site supplied the upper part of the old city; this was commemorated by a fountain of 1860, now demolished. No. 1 was the office of the architect George Phillips Manners (*see* Introduction, p. 37). At the foot of Fountain Buildings, we reach the corner of George Street, the edge of the city centre, and the closure of the loop over the hill of this Walk.

Pulteney Bridge
to Bathwick

The Walk starts at Pulteney Bridge (*see* Major Buildings, p. 81), the gateway E across the Avon to the Bathwick estate, one of the most impressive of all Neoclassical urban set pieces in Britain. Only a fragment was completed, the central axis of an immense planned development of streets and circuses. The project was instigated in the late C18 by Sir William Johnstone Pulteney, first on behalf of his heiress wife, Frances Johnstone Pulteney then, after her death in 1782, on behalf of their daughter, Henrietta Laura Pulteney, Countess of Bath (*see* Introduction, p. 23). The scheme, the design of *Thomas Baldwin*, represents a departure from the standard Palladian style of John Wood's successors towards the new and fashionable Neoclassical style of Robert Adam – axial, geometric and large scale. The dates of the Baldwin development run from 1788 to *c.* 1820. Later building is by *John Pinch the Elder*, who endorsed drawings on leases as early as 1797.

Baldwin's composition of Bathwick, as built, can be described in a few words. The short Argyle Street connects Pulteney Bridge with a diagonally placed square, Laura Place, and its continuation E, Great Pulteney Street, forms the backbone of the New Town [100]. Unlike earlier Bath developments that hug the contours, the streets were raised on extensive vaults above the meadows that once sloped down to the river, to form a level surface for the monumental layout. The houses

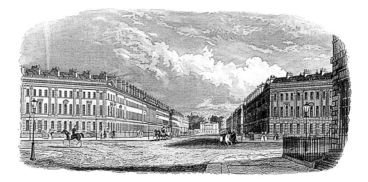

100. Great Pulteney Street, view towards Holburne Museum from Laura Place, engraving. Engraving by F. Curtis (*c.* 1835)

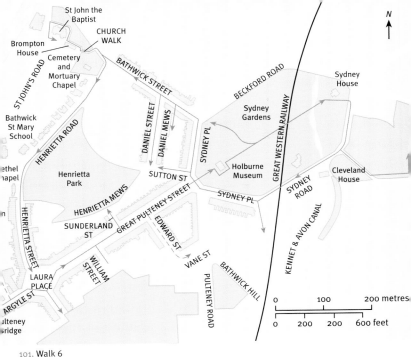

101. Walk 6

themselves are built up on basements and, except at the higher E end, sub-basements. Great Pulteney Street, with short stub streets off, fragments of the intended development now leading nowhere, runs into Sydney Gardens, a very large elongated hexagon. In the *point-de-vue* lies the Holburne Museum, originally Sydney House. Of the terraces meant to surround the gardens, only the two western diagonals, Sydney Place, were built.

Now for the details. **Argyle Street**, running E from Pulteney Bridge, is a unified composition and sets the scene for Great Pulteney Street. The S side has pedimented end pavilions and the N side divides into two blocks by Grove Street, the end houses of each projecting as pavilions. The rear elevation to No. 17 (viewed from the river, down steps to the S side) has been restored as in Thomas Hearne's watercolour, 'Bath from Spring Gardens' of 1790. This was a shopping or commercial street from the outset. The **shopfronts** are remarkable. On the S side at the W end, No. 16, late C18, has a deep bow front with a central entrance and radiating fanlights. No. 9, the Boater pub, already a pub of the Bath Brewery Co. in 1809, is similar but the central entrance is now a window. No. 8 has been Hale's Chemist since *c.* 1828; its perfect Greek Revival shopfront of that date has fluted Ionic columns and large panes set in tapering glazing bars [102]. Queen Charlotte's coat of arms in *Coade* stone now sits above. Many early fittings. Opposite, No. 6

102. No. 8 Argyle
Street, shopfront
(*c.* 1828)

(N side) has another good early–mid-C19 double shopfront with
Corinthian columns. At No. 5, beyond Grove Street to the w, George
Gregory, Bookseller from 1886 to 1916, published Mowbray Green's
book in 1904 (*see* Further Reading). A blind window to the E side in
Grove Street has an amusing *trompe l'œil*, 1993–4, by *Faulkner &
Richards* under the *David Brain Partnership*, representing the original
bookshop.

An optional out-and-back excursion of ⅓ mile (600 metres) N into
Grove Street has some interest. On the w side, the site of Eveleigh
House was John Eveleigh's yard and wharf where building materials for
the New Town were delivered. Next, **Caxton Court**, a brewery convert-
ed to flats by *Gerrard, Taylor, Hind* in the 1980s. No. 4, E side, the **Rising
Sun**, of 1788, was a pub from at least 1854. Next, a terrace of 1887–9 by
Browne & Gill, built of machine-cut, random-sized ashlar: Nos. 7–8 has
mullioned windows; Nos. 9–10, a pair of houses and Nos. 11–15, three-
storey tenements, have characteristic chamfered windows and diago-
nally set moulded brick chimneystacks. To the N is the former **New
Prison** [103], 1772–3. Pulteney built this because the access to Pulteney
Bridge from the E required the demolition of St Mary's Church, whose
tower housed the City prison (*see* Walk 2, p. 128). Pulteney commis-
sioned *Robert Adam*, but *Thomas Atwood* took over. The building is
from outside like any Palladian mansion. Gaols built soon after, espe-
cially those by Dance and William Blackburn, had much more visual
rhetoric of security. It has five bays, the middle three recessed, a rusti-
cated ground floor, and above this windows alternately pedimented
and without pediment. The ground floor, originally behind a forecourt,
is raised above a basement in this once flood-prone area. Its exposure
now spoils the proportions. Petty offenders were held in four ground-
floor rooms (the rusticated storey), debtors on the floor above. The sec-
ond floor had a debtor's common room and the attic, a workshop
where debtors made items for sale. The rear court was formed in 1780,
in which Palmer erected a felon's block of solitary cells in 1801, now

demolished. The building became a police barracks, 1850–1903, when the prisoners transferred to Twerton Gaol, built in 1842 (*see* Excursions, p. 292), and was converted to housing in 1971 by *John Bull & Associates*. Beyond, w side, the diminutive **Bethel Chapel** by *Alan Crozier-Cole*, 1972, has a correctly detailed open pediment. Further N, E side, **Bathwick St Mary School**, 1841 by *John Pinch the Younger*, is Tudor style, with mullioned windows and octagonal chimneys. Later additions probably of 1868.

Argyle Chapel, by *H. E. Goodridge*, 1821, has a Greek Ionic portico *in antis* and pediment, influenced by Wilkins' Freemasons' Hall (*see* Walk 1, p. 105). The tall central door was originally a window, with doors either side. The upper parts were insensitively altered in 1862 by *Hickes & Isaac*. The original chapel, by *Baldwin*, 1788–9, was set back behind a courtyard; it was enlarged, 1804, and Goodridge's scheme extended it again, forward to the street. The Rev. William Jay (1769–1853), celebrated for delivering 1,000 sermons before age 21, preached here for 63 years.

To the E, **Laura Place** joins four streets on its diagonals, characteristic of later C18 Bath (cf. the angled approach to St James's Square, *see* Walk 5, p. 165). On the w side is a *Penfold* hexagonal pillar box, the standard type from 1866 to 1879. The central fountain basin is of 1877 by *A. S. Goodridge*; the present fountain is 1977. **Connaught Mansions** on the N side, with a C20 arched porch, were the Pulteney Hotel, one of Bath's principal hotels. Originally Stead's Private Hotel from 1866 at Nos. 1–2 Great Pulteney Street, it extended progressively into Laura

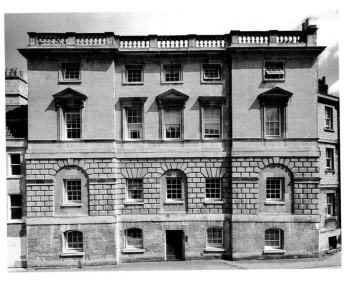

103. New Prison, Grove Street, by Thomas Atwood (1772–3)

Place, Great Pulteney Street (Nos. 3–4, 1903, Nos. 5–7, 1913) and Henrietta Street (No. 37, 1904, No. 36, 1915). Prince Arthur, Duke of Connaught (1850–1942), third son of Queen Victoria, stayed there. Admiralty offices from 1942, they were converted to flats by *Gamble, Cook & Warner* in 1978. The front doors and entrance bridges were removed by 1914.

The houses in the side streets, Henrietta Street off to the N (*see* p. 191) and the unfinished stub of **Johnstone Street** to the s, are much plainer, with arched ground-floor windows, except for the end houses which return to Laura Place. No. 1 Johnstone Street, E side, was built in 1794, the w side, 1794–1801, and the remaining E side, *c.* 1805. The change in level from the unfinished end down to the Recreation Ground, s, illustrates dramatically the height of this man-made structure.*

Great Pulteney Street is one of Bath's great architectural set pieces and among Britain's finest formal streets [100]; cf. Adam's Portland Place, London, 1773–94 and Craig's George Street, Edinburgh, begun 1767. It is 1,100 ft long and 100 ft wide (335 by 30 metres). The layout is monumental and the terraces are designed to look like palaces, so that the whole is greater than the sum of the parts. If the architectural details are spread somewhat thinly, the façades of this speculative street development are cleverly designed to provide maximum architectural incident through economy of means, vistas terminating with pediments, pavilions and giant fluted Corinthian pilasters.

The houses are standard town houses of three storeys and three bays with attics set in mansard roofs and rusticated ground floors. The windows are typically double square, six-over-six panes, with thin late C18 glazing bars. A restoration programme, 1955–70s, replaced the Victorian plate glass, but for the most part the new glazing bars were inserted into the heavier Victorian sashes with thick meeting-rails and horns. Several wrought-iron scrolled overthrows with urn finials and lampholders remain, and a pair of trellised standards at No. 59. At the time of writing plans exist to restore the missing overthrows. The rooms are well lit, with relatively low first-floor window sills; few have been lowered further.

Construction proceeded E from Laura Place. The N **side** consists of two ranges divided by the incomplete stub of Sunderland Street, creating symmetry, or rather duality. Each has a centre of eleven bays of giant pilasters, with half-pilasters at the ends – a motif beloved by Baldwin – and a platband of Vitruvian scrolls. Projecting three-bay pedimented pavilions flank the centre, each with an arched first-floor middle window with an entablature on long thin console brackets, and swags and paterae in the frieze. These are flanked in turn by a plain

*On the s side of the Recreation Ground is the visually intrusive **Sports Centre**, designed by the *City Architect's Department* with *Sir Hugh Casson* as consultant architect, 1972: concrete framed, reconstituted stone infill, metal roof fascia, curtain walling to the entrance on the s side.

fifteen-bay terrace terminated by a five-bay composition accented by double giant pilasters each side, a centre pedimented window with double console brackets. Finally, at the extremities, matching projecting pavilions. The end house, No. 20 (for sale unfinished following the builder's bankruptcy in 1794) has a good Greek Revival doorcase on Sunderland Street, *c.* 1830; the door and fanlight are original, moved forward. No. 21, opposite, has a rather grand porch by *Baldwin*, with slim half-round columns with waterleaf capitals. Sunderland Street, now merely the length of one house, was to have led to a vast square called Frances Square, on the site of Henrietta Park (*see* below) where the original ground level is again evident. From here the terrace rear can be inspected. Most houses have C19 extensions; a few retain early cantilevered bathroom extensions of timber studwork, lathe and render supported on cast-iron brackets. No. 14 (Carfax Hotel) has a coach house with a battlemented parapet and quatrefoil windows. No. 13 has a matching replica, *c.* 1990.

The s **side** has three ranges separated by William Street and, further E, Edward Street. The centre range, slightly taller than its neighbours (and the only range retaining balustrading) is the grandest. The rusticated ground floor has arched openings, giving the impression of arcading. A nine-bay centre and three-bay end pavilions have pilasters, the centre (No. 59) a five-bay pediment bearing the Duke of Cleveland's arms in the tympanum. This was meant to close the view from the unbuilt street to the N. Good ironwork balcony below. No. 53, Duke's Hotel (now joined with No. 54) has a good double bow on the return to Edward Street, s, with an elegant Adamesque fanlight in between. The w **range** is simpler, with pedimented end pavilions and some decorative pilasters. No. 57 has a late C19 cast-iron balcony. The E **range** is similar but the pediments, balustrades and parapets have been removed. (**William Street** leads only to the Recreation Ground; the charming wooden **ticket boxes** with ogee crested roofs, *c.* 1895). **Edward Street** is plainer than Great Pulteney Street; the first-floor windows above each doorway have pediments.

An optional out and back excursion of 220 yd. (200 metres) s into Edward Street passes No. 5, E side, former Duchy of Cornwall offices, the Prince of Wales's feathers carved over the door. No. 10's ground floor has an eccentric late Arts and Crafts bay window with leadlights by *J. Howard & Son, Builder* of 1920 for F. E. Weatherley, songwriter. No. 11, *c.* 1800, big shallow segmental bays, a Doric porch, and wrought-iron lampholders. The return to Vane Street, s, has a substantial mid-C19 cast-iron veranda. The big, later style continues in Vane Street, by *Pinch the Elder*.

The houses were essentially speculative, e.g. No. 26 Great Pulteney Street's building lease of 1791 is to Thomas Chiltern, plumber. The **interiors** are therefore relatively plain, with off-the-shelf components –

Famous Residents around Great Pulteney Street

When completed, Great Pulteney Street was at once the most fashionable address in Bath. Part of Jane Austen's *Northanger Abbey* is set there, while Peach's *Historic Houses in Bath and their Associations* (1884) reads like pages from British and European history. **Exiled monarchs and pretenders**: Charles V of France lived at No. 11 in 1831; Louis XVIII of France (1755–1824), as an exiled claimant, stayed in 1813 at No. 72; Napoleon III (1808–73) stayed for six weeks in 1846 at the Sydney Hotel, now the Holburne Museum, and after 1871 often at No. 55. **Native royalty**: Mrs Fitzherbert (1756–1837), mistress of the Prince of Wales, later George IV, stayed at No. 27 in 1788–9; Queen Charlotte, consort of George III, on her visit to Bath in 1817 and her son, Duke of Clarence, later William IV, resided in Sydney Place at Nos. 93 and 103 respectively. **Retired commanders**: General Napier (1782–1853), conqueror of Sind, India, at No. 9, 1836–8; Admiral Alexander Hood, Viscount Bridport (1727–1819), retired to No. 34 Great Pulteney Street, where he died; Admiral Lord Howe (1726–99), commander at the Battle of Ushant ('the Glorious First of June') 1794, frequently stayed at No. 71 towards the end of his life to take the waters; a few years after Lord Nelson's death, Emma Hamilton (1765–1815) lived for a time at No. 6 Edward Street. **Politicians**: William Wilberforce (1759–1833), leader of the campaign to abolish slavery, stayed at No. 36 in 1802 and 1805, and Pitt the Younger (1759–1806) stayed at No. 15 Johnstone Street in 1802. **The arts and sciences**: Edward Bulwer-Lytton (1803–73), novelist, dramatist and M.P., frequently stayed at No. 2, then Stead's Hotel, from 1867; No. 6 was Thomas Baldwin's own home from 1791 to 1794, when bankruptcy forced its sale; William Smith (1769–1839), father of geology, dictated his famous table of strata at No. 29 which was owned by his friend Rev. J. Townsend; No. 66 was William Beckford's first home after leaving Fonthill in 1822; Hannah More (1745–1833), philanthropist and educationalist, lived at No. 76 from 1792 to 1802; Moses Pickwick, landlord of the White Hart Inn, Stall Street, whose name Dickens adopted for his famous character, lived at No. 8 Henrietta Street, 1864–9.

delicate cast-metal fanlights, plaster cornices, plain square balusters with cast metalwork details to half-landings, and chimneypieces of pine and composition mouldings. The interiors are nonetheless good-sized and well proportioned, of a scale and elegance suitable for the London grandees who rented houses for the season. The entrance hall floors are of Bath stone flags with diamond-shaped Purbeck marble inserts. They have cantilevered stone staircases, except those at the E end, completed in wood after the onset of economic difficulties in the 1790s.

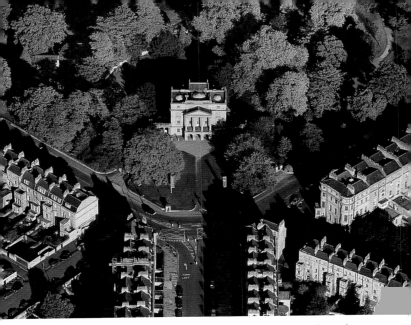

104. Holburne Museum and Sydney Gardens, by Charles Harcourt Masters (1796–7), aerial view

At the E end of Great Pulteney Street, forming its closure, is the **Holburne Museum** [104]. Originally known as Sydney House, the building was also the central element of Sydney Gardens beyond, one of Bath's C18 pleasure gardens (*see* Introduction, p. 32). Sydney House was thus a Janus building – looking in two directions at once – presenting a formal urban, civic face and an informal face towards the landscape. The latter face has now disappeared and the building is much altered. It has five bays, with rusticated ground floor and a bold Corinthian portico with pediment – just like a country mansion.

Thomas Baldwin initially designed Sydney House and Gardens in 1794, but his pupil *Charles Harcourt Masters* built both to a modified design. The building, 1796–7, contained coffee, tea and card rooms for those using the Gardens, with a ballroom on the first floor above them, and a public house in the basement – the Sydney Tap – for chairmen, coachmen and other servants who were not allowed in the Gardens. It had originally three storeys, with the portico and rusticated ground storey as now, but with projecting wings either side. In 1836 *John Pinch the Younger* added an attic storey when it became a hotel, but by the 1840s the Gardens were losing their popularity, and Sydney Hotel became first a hydropathic establishment, then Bath Proprietary College, 1853–80. Trustees of the William Holburne art collection purchased it in 1911 (*see* also Walk 5, p. 167 and Walk 11, p. 255), and *Sir Reginald Blomfield* reduced the four stories to three to form lofty galleries and replaced the wings by a colonnade either side of the façade. The museum finally opened to the public in 1916.

The impressive façade is square and static. A rusticated ground-floor arched loggia has projecting keystones and a frieze with vases and festoons between triglyphs over the piers. Springing from this is a bold projecting pedimented portico with three bays of giant Corinthian columns. The first-floor windows have pediments on thin pilasters and consoles. Originally there were five square windows to the second floor, infilled by Blomfield when the first and second floors were combined, and medallions with swags now decorate the wings above the first-floor windows to add his indispensable touch of the French *Dixhuitième*. Pinch's attic storey has a plain cornice, now finished by a parapet with blind balustrading over the central section, flanked by brackets and four vase finials. Blomfield added all this for emphasis and height. Each side of the building he also added single-storey Doric colonnades with rusticated end piers, supporting an entablature with a triglyph frieze and balustrading above with pedestals over the columns and a vase finial over the end pier. Internally, the main, first-floor gallery has big windows and a magnificent vista down Great Pulteney Street; the second-floor gallery is windowless and toplit. The Holburne Museum is now enclosed by railings (restored in 2000) and flanked by a charming pair of **watchboxes**, built 1830s. Each face has a pair of Tuscan pilasters and coved recesses, and an entablature with a triglyph frieze. These are among the best parish lookout posts to survive anywhere. Cf. Norfolk Crescent (*see* Walk 11, p. 253).

The building's rear formed one end of the pleasure garden's central axis and was a focus for concerts and other attractions. Across the width of the building there was a conservatory with large sash windows at first-floor level, supported on Doric columns forming a deep loggia of three wide bays at ground level. From the middle bay at first-floor level projected a canopied segmental orchestra stand, supported on Corinthian columns, with a panel at ground level for transparencies. The building further embraced the garden with curved wings of wooden supper boxes extending from either side for private entertaining, from where the concerts could be viewed. None of this, nor the building's relationship with the garden, remains, for Blomfield added an uninteresting rear extension and staircase enclosure.

Sydney Gardens beyond, laid out by *Harcourt Masters*, opened in 1795, funded by shares of £100. *The New Bath Guide* for 1801 described 'waterfalls, stone and thatched pavilions, alcoves, a sham castle, bowling greens, swings, a labyrinth, a fine Merlin swing, a grotto of antique appearance, and four thatched umbrellas as a shelter from rains'. Events here included public breakfasts, evening promenades, gala nights and illuminations, all accompanied by music. The original features have all but disappeared, but the central axis (continuing the line of Great Pulteney Street) and several interesting later garden structures remain. At the NW entrance is a domed **ticket kiosk** by *A. J. Taylor* of 1914. SE of this is an ashlar Italianate **gardener's lodge** with

105. Kennet & Avon Canal, Sydney Gardens, Chinoiserie cast- and wrought-iron foot-bridges (1800)

projecting eaves, *c.* 1835, by *Edward Davis*. SE again are cast-iron **gentle-men's public lavatories**, *c.* 1910 made by *Star Works*, Birmingham, an unusual survival of a once common type. Joining the main axis and turning E, on the N side, is **Minerva's Temple** by *A. J. Taylor*, built to promote Bath at the Empire Exhibition, Crystal Palace, Sydenham in 1911. It was re-erected here in 1913–14 to commemorate the Bath Historical Pageant at Royal Victoria Park in 1909, which included a wooden replica of the Temple of Sulis Minerva (*see* p. 5). Despite this tenuous connection it is interesting as a reused exhibition building, showing the enduring appeal of Bath's classical origins. Four Corinthian columns support an entablature and large pediment, the tympanum carved with female figures supporting a wreath surround-ing the head of Sulis. Further E, the **Great Western Railway** cut through in 1836–41 (*see* Major Buildings, p. 92). The stone bridge across, *c.* 1840 by *I. K. Brunel*, is skewed with a flat elliptical arch and pierced balustrading. The cast-iron footbridge to the S is *c.* 1865 and the retain-ing wall, *c.* 1840, is a bold backdrop to the crowd-pulling spectacle of early locomotives. Approximately 22 ft (7 metres) high with cornice and frieze, the lower part has a concave batter, plinth and piers. Again E is the **Kennet & Avon Canal** by *John Rennie*, excavated 1799–1810. The two delicate chinoiserie cast- and wrought-iron **footbridges**, dated 1800, were made at Coalbrookdale [105]. Flanking Sydney Gardens, the stone road bridges over the canal, also *c.* 1800, by *John Rennie*, are drilled to resemble tufa and carved with masks of Old Father Thames (N) and Sabrina, goddess of the River Severn (S), beneath swags. Cleveland House (*see* below) closes the exceedingly picturesque view across a

succession of bridges to the s. Terminating the central axis of Sydney Gardens to the E is a semicircular **exedra**, with Ionic columns and pilasters to the flanking walls. Designed by *Baldwin*, 1795, with curved wings and surmounted by statues, it was rebuilt as part of **Sydney House**, beyond to the E, 1835–6, probably by *Pinch the Younger*, and again substantially rebuilt without the wings by the city authority in 1938. Sydney Gardens became a municipal park in 1909, when it lost its relationship with the former Sydney Hotel to the w.

Entering **Sydney Road** from the exit beside the exedra, 100 yd. (90 metres) s is the entrance drive to the **Bath Spa Hotel**. This vast Greek Revival mansion consists of two two-storey blocks connected by a sturdy Greek Doric colonnade. The s block was built 1835, possibly by *John Pinch the Younger,* for Colonel, later General, Augustus Andrews. It was originally called Vellore, after the Indian Garrison town. Projecting centre; ground floor with wide banded pilasters and tripartite windows with pilaster-mullions, flanking a porch with paired fluted Doric columns. The first floor has angle pilasters, eared architraves and balconies with robust cast-ironwork with diagonals and anthemia. The entrance hall has a key-pattern frieze and Soanian shallow-domed ceiling. The similar N block and colonnade were added in 1878 by *Wilson, Willcox & Wilson*. In 1912 it became the Bath Hydropathic Company Hotel, later a nurses' home. *Alain Bouvier Associates* converted it for Trusthouse Forte in 1989, adding a nine-bay, five-storey wing, in an inappropriate, skimpy 1770s Palladian style. The classical Arcadian grounds have a pedimented Greek Doric temple and romantic tufa stone grotto, both *c.* 1835.

Straddling the canal, 50 yd. (45 metres) w down Sydney Road is a remarkable Georgian office building, **Cleveland House**, originally Canal House, by *Pinch the Elder*, 1817–20. This was purpose built by the Duke of Cleveland, owner of the Bathwick Estate, as the headquarters of the Kennet & Avon Canal Company and let until 1851 to the company, when the Great Western Railway bought it and the headquarters moved to Paddington. This is among the most refined and important buildings connected with canals. Two storey, five windows wide; the ground floor has banded rustication, and round-headed openings, the first-floor windows have architraves and cornices on consoles; the central window is pedimented. The interior has a 20 ft (6 metre)-high boardroom, ante-rooms, secure storage areas and twin entrances. At the rear is a crossover point for horses towing barges, where the towpath changes sides.

Opposite, N side, **Ravenswell** and **Lonsdale** (now Sydney Gardens Hotel), 1853 possibly by *Goodridge* and built by *John Vaughan*, asymmetrical, Picturesque Italianate paired villas with eclectic historicist details. The entrance is at the base of a tower set in the corner of two wings. Opposite, s side, **Kennet House**, *c.* 1840, has a Gothic porch, hoodmoulds and steeply pitched pierced bargeboards and finials

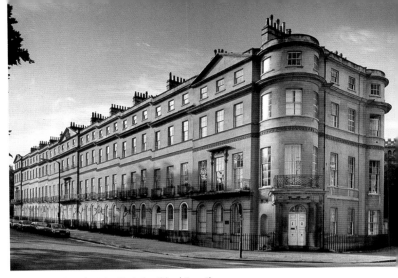

106. Sydney Place, by John Pinch the Elder (1804–8)

(cf. Edward Davis's Park Farm House [139], Royal Victoria Park, *see* Walk 10, p. 238). Next, **Kildare**, a mid-c19 Tudorbethan house, originally symmetrical, showing the influence of G. P. Manners' St Catherine's Hospital, Beau Street (*see* p. 114).

Finally in Sydney Road, 100 yd. (90 metres) s, **Sydney Place** (formerly New Sydney Place), one of only two completed sides intended to surround Sydney Gardens [106]. It was a speculation of 1804–8 designed by *John Pinch the Elder*, built by the contractor, *James Goodridge*. The terrace of eleven houses is the most beautiful of Bath's c19 buildings. Completed in one phase, with stone from one quarry, and built storey by storey (unlike Bath practice hitherto, plot by plot), the design, workmanship and uniformity of colour are flawless. Four storeys, with the attic brought forward, the scale large and the elevation rather severe. Pinch's refinement here was in the handling of the sloping site. Unlike at earlier Bath houses that step up staccato-like, breaking the cornice and string course, Pinch ramps all the horizontals: ground-floor impost moulding, first-floor string course, second-floor Pompeiian scrollwork frieze and sill course, main cornice below the attic and attic cornice. This device, though not invented by Pinch (*see* Topic Box, p. 27), is applied here with much greater elegance than previously, and relates each house to the next; the architecture flows and has continuity, a unity heightened through no emphasis to the central windows. Moreover, each corner has an applied semicircular bay, a device that very successfully turns the corner and, with the bands of horizontal decoration wrapping around like belts, provides a remarkable unity. What is less successful is that the centre and end houses have pediments and break forward as pavilions to form a palace front, inappropriate

on the sloping site. The general arrangement with full attic was otherwise unremarkable, carrying on the tradition of Baldwin's work at Northumberland Buildings (*see* Walk 3, p. 139). Pinch also uses Baldwin's device from Great Pulteney Street of round-headed openings to form a ground-floor arcade. The doors are Adam style with delicate metal fanlights and trellised side lights, and the end houses, Nos. 93, E, and 103, W, have projecting corner Doric porches. On top of the porch to No. 93 is a charming Chinoiserie conservatory, cobweb fanlights and a tented roof with small pendant bells at the eaves. The porches and conservatory were afterthoughts and not included in Pinch's plans submitted to Lord Darlington. Most ironwork is original, with elegant serpentine lamp overthrows, railings and balconies, which the leases specified be painted light green, so as to blend with the view of Sydney Gardens. The interiors are well planned, conventional, with fine stone staircases and impressive scale. The first-floor drawing rooms are square with 14-ft (4.2-metre) ceiling heights and, for the first time in Bath, windows that extend down to the skirting boards. The ground-floor front rooms have coved end walls and concave doors. The return garden wall of No. 93 into Sydney Mews is the most architectural freestanding wall in Bath, fifteen bays of blind arched recesses and coved niches, with a balustraded and pedimented three bay middle and balustraded end pavilions. In the garden is an orangery.

Returning past the Holburne Museum, with a fine prospect back along Great Pulteney Street, **Sydney Place** continues N, the other completed wing of the elongated hexagon around Sydney Gardens. The terrace is separated from Great Pulteney Street by the short **Sutton Street**, containing the Pulteney Arms by *Baldwin*, operating as an inn in 1796. The palace-fronted E side of Sydney Place is by *Baldwin*, 1792–6. The centre and end houses break slightly forward under pediments, the centre emphasized with four bays and containing two houses with paired doorways and windows decorated with pilasters and an entablature with swags. Less obvious is that each centre house has three bays, stealing a bay from the intermediate wings. The doorways have semicircular heads and vermiculated, rusticated quoins and the middle first-floor windows to each pavilion and those above the doors are decorated. Jane Austen lived at No. 4, 1801–5.

The walk can end here, or the NW part of the Bathwick Estate can now be explored. Around the corner to the NW is **Bathwick Street** and, N side, the **Crown Inn** by *Browne & Gill*, 1899, Tudorbethan style with gables, mullioned windows and rangework. In **Daniel Mews**, through the carriageway opening opposite, are coach houses built in 1804 to serve Nos. 10–12 Sydney Place. Next turning off Bathwick Street, **Daniel Street**, was named after Daniel Pulteney, grandfather of Henrietta Laura Pulteney. It began with three houses, Nos. 35–37 (s end) by *Baldwin* to leases of 1792. Baldwin's bankruptcy halted work on the street, and the remainder was designed by *Pinch the Elder* in 1810 as

modest two-bay town houses of good scale and well-related openings. Each has a round-headed doorway with a rectangular blind window above. The lower windows are set in round-headed recesses and are wider than those of the second floor, but have margins so that the narrower window is implied in the glazing bars. Nos. 4 and 21 retain lampholders, Nos. 8–9, fire insurance plaques. James Goodridge, aged 75, builder of Sydney Place (*see* above), father of H. E. Goodridge, was living at No. 18 in 1841; earlier, from 1818 to 1825 he owned and occupied the NW corner house, No. 36 Bathwick Street (one of a terrace of three with Nos. 37–38). No. 36a Daniel Street was the mews. Back in Bathwick Street, the houses on the N side are by *Baldwin*, 1788–92, as part of the Bathwick Estate scheme. Nos. 9–10 are replica infill, 2000–1, by *Beresford-Smith & Partners*. Nos. 1–8 have tripartite first-floor windows with pilaster strips and consoles supporting a frieze with swags and a pediment. They step slightly uphill with ramped string courses, the device later used by Pinch.

We now arrive at the centre of old **Bathwick Village**. In 1781 it had a population of 150, living on an irregular street of 45 houses, with Bathwick Mill and a broadcloth factory near the river. Nothing of the old village remains, except, adjoining No. 1 Bathwick Street, **Bathwick House**, which incorporates an earlier building, probably Bathwick Manor House. It retains a good C17 mullioned window in the front basement (not visible from outside). As remodelled and extended to the rear *c.* 1800, presumably by *Pinch the Elder*, the house is three-storeyed, five windows wide (three only at second floor) and has a Greek Doric doorcase. Window surrounds of plain dressed ashlar, formerly projecting but now tooled off and chamfered. Attached to the NW, **Rochfort Place** is a terrace of four late houses by *Pinch the Elder*, built around the time Cleveland Bridge opened in 1827 (*see* Walk 9, p. 230). Of a distinctly larger scale with large first-floor windows, they are comparable with elevations designed by Pinch elsewhere on the Bathwick Estate. Immediately NW is **Pinch's Folly**, a surprising C19 Baroque Revival archway, on the site of *John Pinch the Younger*'s builder's yard, but possibly erected by his son, *William Pinch*. It has a serpentine pediment and side wings flanked by large scroll brackets. The keystone is carved with the arms of Powlett, Duke of Cleveland in 1864, and Lowther, husband and wife who married in 1815.

We now have a 220 yd. (200 metre) out-and-back excursion along an alleyway through gate piers opposite, SW side, marked Church Walk. This quiet backwater away from the heavy traffic leads past a charming **cemetery** to the W. Nearby stood the decayed old St Mary Bathwick church, demolished by Pinch the Elder in 1818 when he built the new church at the foot of Bathwick Hill (*see* Walk 7, p. 192). In the cemetery to the S is a Gothick former **mortuary chapel**, now a picturesque ruin, which *Pinch* built from reused stone from the old church. The chapel has a three-stage tower with angle buttresses

107. Bridgemead, St John's Road, by Feilden Clegg Design (1989–92)

and pierced quatrefoil tracery. John Pinch, his wife, his architect son, and another son, Charles, are all buried in the graveyard.

Next, the church of **St John the Baptist**, originally built in 1861–2 by *C. E. Giles* in E.E. style, with a low N porch-tower, barely attached and suggestive of an Italian campanile. *Sir Arthur Blomfield* in 1869–71 enlarged it to seat 600, adding an octagonal upper storey and spire to the tower and a new nave and chancel in High Victorian Gothic with bands of alternating stone, s of the older building. The additions, vigorously simple and bold in scale, overwhelm the older building. Along the s elevation, windows, with simple tracery and rose windows above, alternate with buttresses. Inside, *Blomfield* punched through the s wall of Giles's nave, which became the N aisle. *Sir Ninian Comper* decorated the ornate rood screen in the nave in 1923. The charming small baptistery at the w end, of 1879, has a mosaic floor and flat panelled and painted ceiling, also perhaps added by *Comper*. The stained glass in the sanctuary and w window as well as the decoration of the sanctuary arch are by *Bell & Almond* and the windows of the nave and baptistery are by *Clayton & Bell*.

Next to St John's in **St John's Road** to the s, *J. Elkington Gill* built an Elizabethan-style choir room and Sunday schoolroom, 1873, which *Browne & Gill* extended in 1881. Behind is the former rectory, **Brompton House**, now a hotel. Three storeys, five windows wide, pre-1755 and altered late C18, it was purchased in 1873 and repaired by *J. Elkington Gill*, and given to the parish as the vicarage. *Browne & Gill* added a poorly designed extension in 1885.

Opposite on the w side facing the River Avon, **Bridgemead** Nursing and Residential Home and Day Centre for the Frail Elderly, 1989–92,

by *Feilden Clegg Design*, is organized around the idea of progressive privacy [107]. A corresponding hierarchy of scale ranges from a double-height hall and conservatory set between two blocks angled to a wedge-shape, through semi-private shared spaces, to the residents' own rooms. The building is clad in blockwork, with loggias and brises-soleil in white-coated steel. Partly built over the flood plain, it is raised on columns on the riverside.

Returning E to Bathwick Street, turning SE and then SW into **Henrietta Road**, affords another glimpse of the ruined Mortuary Chapel. 55 yd. (50 metres) further, also NW side, is **Pulteney Villa**, flats and a maisonette, 2000–1 by *Tektus Architects*, admirably sympathetic to their setting, like semi-detached stuccoed Regency villas. **Henrietta Villas**, beyond, is an assortment of comfortable detached and semi-detached suburban houses, *c.* 1840, with small walled gardens, reflecting the privacy and seclusion sought at this period. The road curves s around Henrietta Park on the E side, once part of Bathwick meadows. Capt. Forester, owner of the Bathwick Estate, offered the ground as a public park in 1896–7, coinciding with Queen Victoria's Diamond Jubilee.

Henrietta Road, continuing as **Henrietta Street**, here merges into Baldwin's planned New Town. On the E side, Nos. 20–35 have leases dated 1788–97; Nos. 6–19, w side, 1797, and Nos. 1–5, the w side return to Laura Place, are dated 1789. From 1797, building is by *Pinch the Elder*. The terraces are considerably plainer than the main thoroughfare of Great Pulteney Street. The ground storeys have round-headed windows set in plain elevations, except for simple impost moulding, string course and continuous sills and cornices, which step up in pairs of houses. Two semi-elliptical archways at Nos. 25–26 and Nos. 22–23 on the E side, inscribed with the name **Laura Chapel**, mark the former location to the rear of an elegant elliptical building accommodating 1,000, designed by *Baldwin* in 1790. Completed in 1795, it was demolished, *c.* 1920. Pinch the Younger was living at No. 21 in 1837. No. 7 was the architect's office of H. E. Goodridge and his son A. S. Goodridge.

The s end of Henrietta Street rejoins Laura Place.

Bathwick Hill and the Kennet & Avon Canal

The walk ascends Bathwick Hill, 1 m. (1.6 km), following the early C19 shift from town living to semi-rural idyll, from terrace to Picturesque Regency villa. First are those by *John Pinch the Elder*, surveyor to the Bathwick Estate, then, on the upper slopes, an exceptional group of houses by his successor, *Henry Edmund Goodridge*. The descent, with rewarding views of Bath across open fields, concludes along the Kennet & Avon Canal, with its notable survivals of canal-based industry.

We start at **St Mary the Virgin**, Raby Place [108], Bath's finest Georgian Gothic church, intended as a focus of the incomplete Bathwick New Town. In Perp Gothic and bristling with pinnacles, it was designed by *John Pinch* from 1810 and built by *Walter Harris*, 1817–20, mainly through privately raised loans at a cost of more than £14,000.

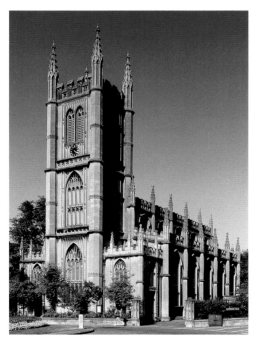

108. St Mary the Virgin, Raby Place, by John Pinch the Elder (designed 1810, built 1817–20)

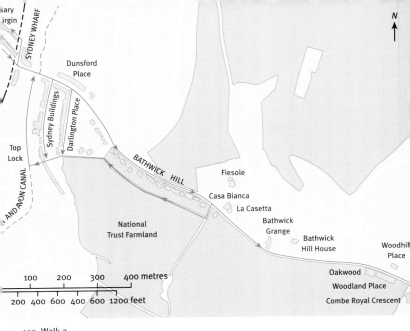

109. Walk 7

(As a large-scale, archaeologically-leaning Gothic church it is rare for pre-1818; the closest parallel – Scotland apart, specifically Edinburgh – is William Brooks's St Thomas, Dudley, Staffordshire, 1815–18. St Mary's influenced St Luke, Chelsea, by James Savage, 1820–4.) It replaced old Bathwick church (*see* Walk 6, p. 189); the original font is in the s porch. Pinch modelled the w tower on the Somerset churches, in particular St John the Baptist, Batheaston. These characteristically have angle buttresses, polygonal pinnacles, pierced battlements and an octagonal corner stair-tower. Pinch's buttresses – of the tower and the rest of the church – are unorthodox, large and octagonal like stair-turrets, perhaps derived from the much grander Abbey. The tower has three stages divided by quatrefoil friezes, with twin windows in the belfry. The choir vestry, attached s side, now the **church hall**, is by *Deacon*, 1906, with a plain extension by *F. W. Beresford Smith*, 1966.

The **interior** is high and spacious, built as a preaching house, with nave, aisles and clerestory, with Perp tracery in the tall aisle windows, the lower clerestory windows with thin four-centred heads. The columns are very tall and thin, of standard Somerset section (four hollows). There are raked galleries on three sides, with no arcade arches, but a flat timber lintel running through. The ribbed coved ceiling is intact, but the wall plaster has been removed and the stonework exposed with ugly pointing. Pinch designed a chancel, but only built an angled apse. Despite the e-facing orientation, all the pews initially faced

w, towards a great three-deck pulpit, their backs to the altar table. The orientation was reversed when the box pews were replaced in 1866 with lower pews.

George Edmund Street, one of the country's leading church architects, finally built the **chancel**, 1873–5, soon after he began building the nave of Bristol cathedral in 1868. It is Street's only building in Bath, and one of his last completed works; he died the week they cleared the scaffolding. In early C14 Dec style, the chancel is somewhat at odds with Pinch's Perp. *Clayton & Bell* decorated the chancel and nave to *Street's* design in 1881 and 1886 respectively, a blaze of medieval colour. Except for a fresco of the Annunciation in the chancel arch, this was over-painted when *Charles Deacon* (using *Hems of Exeter*) panelled the chancel and **baptistery** in 1906–10. Deacon's work is a rich blend of Gothic, Art Nouveau and Arts and Crafts; his **font** is pink alabaster. *Sydney Gambier Parry* in 1896 converted the Sanctuary into the **Lady Chapel**, lining the walls with green marble and pink alabaster.

The furnishings include: **chancel altar table**: an early design, 1886, by *Sydney Gambier Parry*, carved by *Earp* of London, with quatrefoils and diapering. The reredos (heightened and regilded, 1956) incorporates as wings a four-section C15–C16 Netherlandish polyptych **panel painting** from the studio of *Colijn de Coter*, purchased 1882. – Brass eagle **lectern**: by *Street*, executed by *Thomas Potter & Son*, 1875. – **Fixed metalwork**: all executed by *Singer's* of Frome. The Lady Chapel screen: 11 ft (3.3 metres) with much scrollwork in rolled brass, madonna lilies modelled in copper, an arcade of brass palm branches and copper rosettes. Baptistery gates: a fine and highly individual design by *Deacon*, with roses, madonna lilies and palm branches, unusually (for England) made of iron and German silver. – **Organ**: by *Willis*, installed in 1878, rebuilt 1932, by *Hill, Norman & Beard*. – **Adoration of the Child**: altar painting by *Benjamin Barker* (*see* also p. 200). Originally in Pinch's apse, it now hangs high up against the w nave wall. – **Fresco** on the w wall outside the baptistery, 1906, executed by *Hemming*. – **Stained glass**. *Clayton & Bell* executed the E and the Lady Chapel windows. The latter E window is adapted from details of the altarpiece in St Bavon Cathedral, Ghent, painted by Hubert and John van Eyck, 1420–32. The s window depicts the Blessed Virgin standing alone in a garden of roses and lilies, with the holy dove, moon and star. The N and s chancel windows are later. The baptistery window is by *Powell & Powell*.

Now Bathwick Hill. First, **Raby Place** [110], N side, an elegant terrace of eighteen two-bay houses on a sloping site by *Pinch the Elder*, 1818–25, originally called Church Street (as carved on No. 17). The attic storey is brought forward, i.e. without a dormer storey, lending greater scale, though the terrace is modest compared with his more substantial works. Pinch's characteristic ramped cornice (*see* Introduction, p. 27), unifies the terrace and imparts a vivacity not found in Bath's early climbing terraces. The first-floor windows have cornices on consoles.

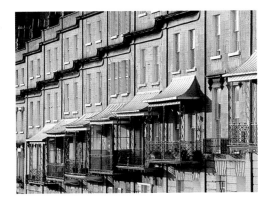

110. Raby Place by John Pinch the Elder (1818–25)

Plain pilasters separate the houses and give vertical emphasis. Many have C19 external features: pretty ironwork balconies with tented canopies, blind boxes, insurance marks, front doors with implied centre divisions and double knockers. No. 18, slightly stepped back, is later, built *c.* 1841 over the Great Western Railway tunnel, seen from the rear in **Sydney Wharf**, E end. Off Sydney Wharf, behind Raby Place, Nos. 2–3 and 5–6 **Raby Mews** are stables and coach houses by *Pinch*, 1823–5, with simple garden fronts. Returning to Bathwick Hill, opposite, s side, original railings enclose the communal garden, with stone piers capped with acroteria carved with anthemia; the cast-iron gate, disused, has four splendid, big anthemia.

Across Sydney Wharf, **The Moorings**, a retirement complex by *Keith & Lois Berney*, 1996–8, imitates its Georgian neighbours but with sadly incorrect classical detailing. The development's pleasant wharf side regenerates this section of the canal. Opposite, s side, **Bathwick Terrace** is an incomplete terrace of three houses, facing w at an angle to Bathwick Hill, attributed to *John Pinch the Elder*, *c.* 1825. It has three bays with flanking pavilions and unfluted angle pilasters, and an end elevation splayed to the street with giant angle pilasters and a pair of Ionic columns supporting a pediment. Next E, **George's Place** is a rank of shops, 1822–3, with altered shopfronts; strip pilasters with carved heads around doorways. The adjacent car showrooms, 1972–3 by *B. S. Associates*, replaced a Victorian police station.

Continuing uphill, across the **canal bridge**, *c.* 1800 by *John Rennie*, is **George Street**, w side, a terrace of small two-storey two-bay houses. Nos. 9–12, *c.* 1815, are cottagey with wide eight-over-eight sashes; better proportioned, Nos. 1–8, *c.* 1820, are by *Pinch*. Dividing George Street, **Sydney Buildings**, leading s, is an informal street of small two- and three-storey terraces, w side, backing on to the canal. The out-and-back excursion of 440 yd. (400 metres) is worth while, along the raised pavement, E side, built *c.* 1820 to overlook the development with views beyond, a late – and very high – example of this traditional Bath

promenade. On the E side are ordered, panelled gatepiers and, steeply uphill, the imposing rear façades of Darlington Place (*see* below). The NW end house, No. 1, *c.* 1830, is perhaps by *Goodridge*, unusual in small domestic architecture for its finely executed Greek Revival front, recessed in the centre with broad banded ground-floor pilasters and stone balustraded first-floor balcony. The adjacent terrace of five houses, Nos. 12–16, two-storey with platband, by *Browne & Gill*, 1881–2, replaced wharf buildings when canal activity declined. This included animal feed and builder's merchants, coal carriers, Stothert's ironmongery warehouse and an ice house. One of the more notable survivals is the **Malthouse**, mid-C19, converted to offices in 1972 by *Marshman Warren Taylor*. The site occupies part of a wharf which Pinch the Elder leased for supplying building materials. The Malthouse has a timber structure with cast-iron columns; adjacent is a square kiln with a pyramidal roof and weatherboarded vent. Nos. 21–22, formerly one dwelling, early C19 with a late C19 lean-to wing, was a substantial late Georgian house engulfed by development around the canal and its associated activities. No. 23, early C19 with C20 alterations, was a ticket office for the Kennet & Avon Canal. (For S of here, *see* below.)

Returning to Bathwick Hill, **Miles House**, N side, is a former rectory, plain mid-C19 Italianate. Stepping uphill, N side, **Dunsford Place**, by *Pinch the Elder*, fifteen two-bay houses with Greek key ironwork balconies, gracefully accommodate the angle of the road with slight concavity. Opposite, Darlington Place, a separate street leading S off Bathwick Hill, contains **Adelaide Place**, NW end, a semi-detached pair of villas with Neo-Grecian incised decoration between. **Darlington Place**, W side, 1812–39, have unassuming façades with porches. Nos. 1–8, by *Pinch the Elder*, are larger houses of 1824; the W elevations are best, overlooking gardens and the view. No. 9, with a delicate canopied porch, is 1812; the remainder, miscellaneous and later. No. 11 has the only coach house; Gothic windows. Next on Bathwick Hill, **St Patrick's Court**, 1966, by *Hugh Roberts & Partners*, an ugly development of twenty-five flats that step uneasily uphill, having learned nothing from Pinch.

Opposite, N side, raised above the road, are two pairs of large **semi-detached houses**, Nos. 39–40, then Nos. 36–37, 1827, by *Pinch the Elder*. Symmetrical, bow-fronted, the ground floor rusticated, plain pilasters at first floor, Greek Revival Ionic doorcases. These alternate with large villas, No. 38, **Baysfield House**, and No. 35, **Lomond House**, the latter 1839, probably by *John Pinch the Younger*. They are three-bay, the centre slightly projecting, with Grecian Doric doorcases forming a balcony above with crisp ironwork. Lomond House has immense brackets on the parapet. **Sion Place**, S side, is another small-scale (incomplete) terrace by *Pinch the Elder*, 1826, stepped downhill, the houses separated by vertical panelled pilasters.

Uphill from Sion Place is a sequence of individual **villas** (*see* Introduction, p. 33), designed or approved by *Pinch the Elder* as surveyor to the Bathwick Estate. Unlike the *cottages ornés* of contemporary pattern books, however, these are hardly Picturesque. They are neat regularly spaced boxes, perhaps representing more the financial expediency of plot-by-plot development than satisfying a demand for a wholly different, quasi-rural aesthetic. (There were few consistently Picturesque suburban developments in the 1820s; Nash's Park Villages, Regent's Park, London stand out by virtue of scarcity.) The deeds usually depict front elevations, though only a handful carries Pinch's signature or initials. The façades are generally plain, two storey, three bays, elegant with shallow modulation, some with the individual builder's naïve embellishments. Several garden fronts, viewable later on the descent (*see* below), are more exuberant, reflecting a new-found enjoyment of gardening and connection with the outside. Dates given below refer to leases; most have later alterations, noted where significant.

No. 1, **Bathwick Lodge**, 1825, originally five bays, was extended, 1840, including a segmental barrel-vaulted room. No. 2, **Cumberland Villa**, 1824 (the lease, as No. 6, **Willow House**, 1828, signed *J. Pinch & Sons, Architects*) has small flanking wings with symmetrical 'front' and 'back' doors giving the appearance of two houses. No. 3 has fanciful, outdated Batty Langley-style Gothick detail over the door; Nos. 4–5, **Devonshire Lodge** and **Cornwall Lodge** (all 1825), each have a swept balustraded centre. No. 7 is 1825, Nos. 8–9, **Mendip Lodge** and **Spa Villa**, 1820. *Pinch the Elder* built No. 9 as an octagon, the garden side projecting over two storeys with shallow-pedimented Greek Revival front and pilasters at ground floor. In 1877 *Gill & Browne* demolished the two canted sides to the garden and added extensions either side of the original projection, squaring the house off to the garden, while retaining the original, unaltered garden front as a centrepiece. No. 10 has a delightfully original Neo-Greek garden elevation, giant Ionic half-pilasters flanking a slightly projecting centre, with a bowed Ionic porch. No. 15, **White Lodge**, has a two-storey Tuscan front porch and elegant double-bowed garden front. A mid-C19 w extension formerly contained a coach house. Nos. 17–19 are 1810. No. 17, **Heron Lodge**, has a projecting former coach house. The home of Charles Edward Davis 1898–1902, No. 18 has mid-C19 symmetrical single-storey pavilion wings and an interconnecting front link with, over the door, bold Greek key decoration and a large urn. *Silcock & Reay* added a two-storey extension to No. 20 in 1897, Jacobean style, gabled with mullioned windows. No. 23, 1817, has fine Grecian detailing. The chimneys form a raised parapet with pierced stonework; the semicircular bay to the garden has trellised ironwork. Opposite, the pretty Tudoresque **Priory Lodge**, *c.* 1840, served a house, Bathwick Priory, demolished.

We now approach on the steep upper slopes a remarkable series of Picturesque Italianate villas, built in the 1830s–40s by *Henry Edmund*

Goodridge and others. First, an asymmetrical semi-detached pair on the N side, **Casa Bianca** and **La Casetta** [111], built as a speculation by Goodridge *c.* 1846. These are the most rustic and literally Italianate of the group, with rugged pantiles, chimneys as campaniles and the obligatory tower *alla Toscana*, designed to be seen from Fiesole above (*see* below). Paved terraces, loggias, and balustrades dissolve the boundary between house and garden.

To the N side, up a shaded drive, is **Fiesole** [112] (after the hill town near Florence), 1846–8, by *Goodridge*, his home until shortly before his death in 1864, now a Youth Hostel. All the ingredients of the Italianate villa are here – projecting eaves, loggias, tower and asymmetrical plan. The result however is formulaic, heavy-handed and lacking charm (cf. his crazy scheme of the same date to extend the base of Beckford's Tower). The entrance hall has a cantilevered staircase with Greek Revival ironwork balustrades [113] derived from L. N. Cottingham's *Ornamental Metalworkers' Directory* of 1823. At the top of the stairs a stucco panel depicts the architect and his wife in profile over cherubs engaged in stonemasonry, painting, music and gardening. Other interiors are entirely conventional.

Opposite, s side, **Claverton Lodge** is large, very austere to the street, now apartments, with origins of *c.* 1820 evident on the garden elevation. *J. M. Brydon* altered the house in 1896, adding a porch, top floor and roof with pedimented dormers. The Rev. Francis Kilvert (1793–1863), uncle of the diarist of the same name, lived here, 1837–63, running a gentlemen's boarding school here from 1841 until his death.

Next uphill on the N side is *Goodridge*'s earlier home, Montebello, now **Bathwick Grange**, 1829, built to house his growing collection of Italian paintings, some of which he had acquired from Beckford. Large, not pretty and not explicitly Italianate like Goodridge's later villas, it is

111. Casa Bianca and La Casetta, Bathwick Hill, by Henry Edmund Goodridge (1846)

112. Fiesole, Bathwick Hill, by Henry Edmund Goodridge (1846–8)

113. Fiesole, Bathwick Hill, staircase balustrade detail

nonetheless an important contribution to the genre. (cf. the asymmetrical, Picturesque layout of Thomas Hope's Deepdene, Surrey.) A shaded carriage drive through dense shrubbery and trees hugs the perimeter to provide an illusion of great distance and a sense of expectation. The house is asymmetrical with a round-arched colonnade and dominated by a very tall Italianate campanile, the upper two stories of which are inaccessible, emphasizing its purely visual *raison d'être*. An octagonal corner tower, now reduced in height, derives from the Tower of the Winds, Athens. The ashlar construction is superb. A large octagonal-ended conservatory, now demolished, projected from the house at right angles, now replaced with an extension of 1998, by *Bennett Diugiewicz & Date*. The delightful lodge was added after Goodridge sold the house in 1848.

Adjacent, N side, and set in an elevated position is **Bathwick Hill House**, probably by *Goodridge*, in severest Greek Revival style, presumably designed before 1829 when he visited Italy and converted to the Picturesque. Again, the drive, flanked by piers supporting stone vases set within a battered retaining wall, hugs the perimeter of the site. Strict regularity in plan and crisp, finely jointed ashlar construction give the house a monolithic appearance. The s façade recedes in the centre to form the garden entrance with two Corinthian columns derived from the Tower of the Winds. The ground- and first-floor windows either side are each set in a single panel, shallow-recessed on the ground floor and deeply set back above. The E and w façades are slightly set back behind implied corner pilasters and entablature that are void of enrichment and reduced to abstraction. From the garden, the view of Montebello's (Bathwick Grange's) campanile with countryside beyond gives an Italian flavour. E of the house *William Bertram & Fell* incorporated the remains of a C19 gazebo into a swimming pool structure, 1981–2.

Opposite on the s side of the hill is the garden wall to **Oakwood**, originally Smallcombe Villa [114]. This is an unusual survival in Bath of a large Regency garden with water features, laid out by the landscape painter *Benjamin Barker*, brother of the better-known Thomas Barker (*see* Walk 5, p. 167). Barker bought the land in 1814 jointly with his brother-in-law, the flower painter James Hewlett. The antiquary and topographer John Britton recorded in his *Autobiography* (1856) that 'at this delectable retreat I spent many happy hours, in company with some of the Bath "Worthies". Springs feed a chain of four small ashlar-lined lakes linked by cascades. An Italianate fountain and stone bridge with pierced balustrades are *c*.1835. (Queen Charlotte visited the garden in 1817.) The house is at the top corner, unusually on to the road, but oriented towards the garden away from noise and prying eyes. It incorporates a simple villa of square plan built by Barker, but is mainly interesting for alterations and extensions built after 1833 by *Edward Davis*, a pupil of Sir John Soane. The result is an early example of Picturesque Italianate asymmetry, with the characteristic shallow-pitch roofs and deeply projecting eaves, campanile, loggia and French windows opening directly on to terraces. Davis added a wing in two sections N of Barker's house. The w section contains a dining room and main bedroom, with a projecting bay at ground floor and a tripartite loggia above (now glazed). The E section uphill contained an art gallery with Venetian window, servants' quarters, a kitchen, stables at the top corner and a coach house with a shouldered-arch opening. Behind and axial to the coach house is a Tuscan watchtower with a shallow-pitched lead roof and projecting eaves. A single-storey flat roof articulated the two sections of the new wing, but *Gill & Browne* added a storey to this in 1879 to provide additional servants' accommodation. *Brydon* added a vestibule to the main entrance in 1896. Internally Davis's architectural

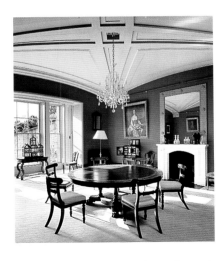

114. Oakwood, Bathwick Hill, altered and extended by Edward Davis (1833)

115. Oakwood, Bathwick Hill, dining room (private house)

details are in the manner of Soane. A stone entrance staircase descends into an ashlar-faced rusticated hall with segmental arches, flush reeded skirtings, recessed architraves and incised linear ornament. The dining room has a Soanian shallow groin-vaulted starfish ceiling [115]. *Brydon* added a further wing on the s garden front in 1896 in Jacobean style, with mullioned and transomed windows lighting an immense drawing room with an inglenook fireplace. General Booth bought the property in 1928 as a nursing home for the Salvation Army's retired officers and in 1992–3 it was reconverted to a house by *Forsyth Chartered Architects*, when the servants' quarters were converted into apartments, **Bathwick Tower**, with the coach house as entrance.

Adjacent, E, **Woodland Place**, six attached houses of 1826, is a specu-lation by *Goodridge*. Stepping uphill in pairs, they are linked villas rather than a terrace, with gatepiers, front gardens, porches and double frontages. The details are Greek Revival including sarcophagus gatepost capitals, and acroteria with incised decoration on the end corners. Comfortable, substantial and affording privacy, the houses have no aspiration to the grand palace-fronted formal character of Bath's C18 houses. The principal rooms are at the rear, with rural views, the city at a distance. With tall sashes that slide into the soffit, they open on to ironwork balconies with bold anthemia from Cottingham's *Ornamental Metalworkers' Directory*. No. 1 has an elegant elliptical staircase. No. 6, where Goodridge's builder father, James, lived, retains a C19 garden layout of paths and a stone plunge pool.

Woodhill Place opposite, also by *Goodridge*, is a pair of semi-detached villas with a recessed centre and first-floor Doric loggia. A combination of Greek Revival and Italianate, these represent the further progression of late Georgian suburban housing. Above the E ground-floor window is a big sunburst relief carving with a central

116. Kennet & Avon Canal, Somerset Coal Company Wharf (1814)

head of Apollo [1]. Goodridge was living there in 1829. Uphill again, s side, **Combe Royal Crescent** by *David Brain Partnership*, built 2001–2, three terrace houses crisply detailed in Pinch's manner with a touch of Soane: banded ground floor, panelled pilasters, windows in arched recesses to first floor, and ironwork. Finally, at the top, same side, **Combe Royal** is a substantial and complete detached house set in grounds, Jacobean Revival style with Dutch gables, designed 1855, replacing a building of 1814–15, a former school.

To the NE is the University (*see* Excursions, p. 278). Returning down Bathwick Hill to Casa Bianca, a gap opposite opens on to **National Trust farmland**, purchased under the skyline scheme (*see* Introduction, p. 47).* The footpath downhill to the w follows the rear façades of the Pinch villas (*see* above) with a magnificent **panorama** of Bath. To the rear of Nos. 2–4 Bathwick Hill are two houses, **Hawkshead** and **Wingfield House**, enclosed by a wall, 1989–90, by *Hadfield Oatley*, single storey, projecting eaves, corner glazing and chain rainwater drips. Further down, No. 22 **Darlington Place**, is by *Keith Bradley* of *Feilden Clegg Design*, 1996–7. Linear with a monopitch, two storeys and a small angled wing, the house presents to the street a plain ashlar façade, punctuated by a clerestory and 'hole-in-the-wall' entrance. Inside, a raised threshold platform overlooks the living spaces, single-volume one end, split-level the other. Timber balconies, columns and trellises modulate the garden elevation.

*The footpath ahead leads to Smallcombe Chapel and cemetery (*see* Excursions, p. 285).

Further down is Sydney Buildings. Opposite, a Neoclassical, locally manufactured cast-iron lamppost, *c.* 1830, has 'Parish of Bathwick, *Stothert*' on the base. s, Nos. 30–38, **Sydney Parade**, is a small but dignified terrace, 1820s, by *Pinch the Elder*, with banded ground-floor rustication, platband and continuous sill band. Between Nos. 29–30 the path joins the **Kennet & Avon Canal** towpath, across a small iron footbridge by *Stothert* adjacent to the **top lock** of Widcombe Locks. Here are various canal structures: a Gothic **lock keeper's cottage** and the ornamental **chimney**, thought to be of a former pumping station to replenish water lost through the locks.

An optional out-and-back excursion of 1,300 yd. (1,200 metres) explores the canal's extremity as it meets the River Avon. Past, in sequence, Second Lock, Abbey View Lock, Wash House Lock, and another iron footbridge by Stothert, is Bath Deep Lock, the deepest in Britain. Here the canal joins the River Avon, where across Claverton Street is Thimble Mill, another **pumping station**, now a restaurant.

55 yd. (50 metres) N along the towpath on the E side is the **Somerset Coal Company Wharf** [116]. The related warehouse was completed in 1814, within five years of the canal's opening, and handled coal from the Somerset coalfield transported via the Somersetshire Coal Canal and the Kennet & Avon Canal. It was converted to offices by *Edward Nash Architects*, *c.* 1989. It also has a stabling block. 55 yd. (50 metres) further is the Malthouse (*see* above, p. 196). 165 yd. (150 metres) further N the walk concludes at Bathwick Hill.

Time and energy permitting, exploration of the Kennet & Avon Canal can be extended by a pleasant towpath walk – 3 m. (4 km.) out-and-back – through open countryside to **Bathampton** and the ancient and picturesque George Inn. Along the towpath from Bathwick Hill through Sydney Gardens (*see* Walk 6), the canal swings eastward parallel with the Great Western Railway cutting. Below, **Hampton Row**, a terrace of artisan houses, 1817–19, by *Pinch the Elder*. Shortly to the N are views to Camden Crescent and the rear façades of Grosvenor Place (*see* Walk 9, p. 233). Past **Candy's Bridge**, on the opposite bank, on the site of a 1970s housing estate, stood a flour mill, used from 1900 as the factory of Harbutt's Plasticine. A charming and diminutive terrace of canal cottages fronts the towpath. At the junction with the road, the **George Inn**, C17 with C14 origins, has been a pub since 1840. Belonging stylistically to the s tip of the Cotswolds, Bathampton village is strictly beyond the present scope. However, through the village up **Bathampton Lane**, 550 yd. (500 metres) W of the George, a group of Regency villas is an outlier of Bath. From here either return to the city continuing W along the busy but uneventful main road; 550 yd. (500 metres) further on, N side, **Hampton House** has a Greek Revival doorway; **views** over the E side of the city; alternatively, walk back 150 yd. (140 metres) and return to the canal down Meadow Lane running N and return w to Bath.

Walk 8

South to Widcombe and Lyncombe

The Walk explores how *John Wood the Elder* and others made fashionable the inaccessible E fringe, between the medieval city and the river, with the construction of streets, promenades and, later, the railway. Then s across the river to Widcombe, a perfect and rewarding ensemble of church, principal house, dovecote and old cottages: seemingly rural, yet just 1 m. (1.5 km) from our starting point. We return to the city in a loop via Lyncombe, once a place of spas and pleasure gardens, with vestiges too of Ralph Allen's stone mining industry, the key to the building of Bath.

Orange Grove to the Station

Beginning on the N side of the Abbey facing Orange Grove, the **Rebecca Fountain** (1859, erected 1861 by Bath Temperance Association) is a white marble statue and basin with arcaded piers, like a church font. Its plinth is inscribed, 'water is best'. Until the Dissolution, **Orange Grove** was the 'litten' or churchyard of the Bath Priory. In 1572 it became a

117. Orange Grove, detail from Gilmore's map (1692–4)

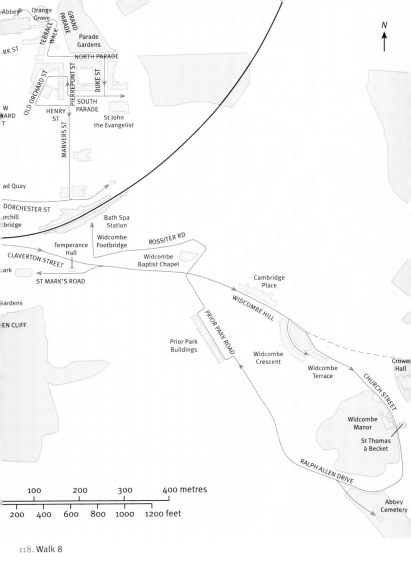

118. Walk 8

public open space for recreations including bowling and, from the early C18, a fashionable shopping area. It was laid out in the late C17 [117], and relandscaped in the 1730s, with gravel walks, formal planting, and a privy at the NE corner. The name was adopted and Beau Nash erected the **Obelisk** after the Prince of Orange's visit to take the waters in 1734. With later C18 competition from the upper town, the area declined into picturesque decay until the late C19, when *Charles Edward Davis*, City Architect, improved it during Bath's brief resurgence as a spa town. The **Terrace** on the s side, now a curious Late Victorian contribution to

119. Empire Hotel by Charles Edward Davis (1899–1901). Photograph (early C20)

Bath, was a plain row built 1705–8 along the boundary dividing the Colthursts' land from the land N of it given to the Corporation (*see* Major Buildings, p. 56). In 1895–7 *Davis* gave them a uniform appearance with eleven gables with bargeboards, shell hoods to absolutely all the first-floor windows and an angle tower. (For the Police Station, *see* Walk 2, p. 124.)

On the NE corner, the former **Empire Hotel** [119] is an unbelievably pompous piece of architecture, by *Davis*, 1899–1901. It is five-storeyed and adds for good measure two storeys in the roof and a yet higher angle-tower, once higher still.* Moreover in the roof there are side by side a large Loire style gable and two small Norman-Shavian tile-hung gables, originally with escalloped architraves capped by finials, removed, along with numerous balconies, by the Admiralty who requisitioned the building in 1939. The Avon front is in the same frolicsome spirit. What can have gone on in the mind of the designing architect? Yet, this is a worthy survival of a grand and confident turn-of-the-century hotel, a building of its time, and Bath's only major survivor (*see* Introduction, p. 39). The elegant glazed wrought- and cast-iron entrance canopies are by *A. J. Taylor*, 1907. Saved from possible demolition in 1995–6, when *PRP Architects* converted the upper part into retirement flats (the conservatory on the S façade is of the same date). *Davis*'s **Grand Parade** to the E, part of the scheme, created a wide road into Orange Grove from Pulteney Bridge to the N (*see* Introduction, p. 39).

Orange Grove continues S with **Terrace Walk**, originally with luxury

*The developer, Mr Alfred Holland, in putting his proposals to the Corporation wrote that he was 'taking it for granted that there are no restrictions as to height'.

Empire Hotel

The ground-floor public rooms, now bars and restaurants, are remarkably little altered, with heavy classical relief decoration, the orders varying from room to room: hall (with French château-style fireplace), *table d'hôte* room, supplementary dining room, reading room, drawing room, smoking room and billiard room. The first floor had a dozen or so suites with private sitting rooms, some with bathrooms, and the upper floors had bedrooms (over 100 in all) with common bathrooms; the top floor was for guests' servants. The bathrooms had patented toilets of porcelain set in wood, each pan marked 'closet of the century'. The basement included a dormitory for sixteen female staff (no male staff lived in). A single lift served all floors and a grand open-well stair, ground to fifth.

shops, a coffee house and public rooms. Its angle was dictated by the medieval wall, the foundations now buried beneath the road. The Lower Assembly Rooms, or Harrison's Rooms, once so important to Bath's development, stood at the N end on the E side, built against the exterior of the medieval wall in 1709, rebuilt by *George Underwood* in 1824 to house the Bath Royal Literary and Scientific Institution. The building was regrettably demolished in 1933 to widen the main road and the remaining triangular site between the road and Terrace Walk was also excavated to form underground public lavatories. The site is

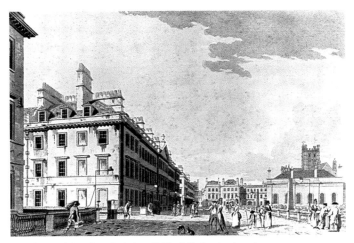

120. *The North Parade at Bath.* Aquatint by T. Malton Jun (1779)

now empty except for a **fountain**, 1859, by *Pieroni*, removed here from Stall Street in 1989.

The existing houses at the N end are *c.* 1728, refronted late C18. No. 8 was James Leake's Bookshop and Circulating Library, John Wood the Elder's publisher and, according to Defoe, one of the finest booksellers in Europe. A little S, at the junction with York Street stood Thayer's Buildings and Long Room (later 'Wiltshire's') by *Wood*, opened 1730. These were demolished when York Street was formed in 1805–10, to improve access to the Lower Rooms after the Upper Assembly Rooms opened and the area had declined. No. 2, **Bridgwater House**, opened as Parade Coffee House in 1750, became Crowbrow's India House, purveyors of 'works of art, antiques, curios'. The doorcase carries a broken pediment on Ionic demi-columns and the upper windows have architraves. The elevation is altered. No. 1, probably by *John Wood the Elder*, was built as a shop with house attached, in 1748–50. It has the only surviving stone **shopfront** of C18 Bath: four Ionic half-columns, three arches, the middle one depressed and wider, heads carved on the keystones, and in the spandrels leaf-carving curiously reminiscent of English Perp traditions. The glazing bars are not original. It became Eldridge Pope's The Huntsman pub in 1906. The range running E–W, S of Terrace Walk, is the W end of North Parade – *see* below. The end house, No. 1, which meets the return to North Parade Buildings (*see* Walk 1, p. 106), has a canted front area wall built off the medieval city wall's foundations (*see* Introduction, p. 12).

To the E, **Parade Gardens**, never built up from its riverside level, in the C17 was an orchard. A water mill, Monks Mill, stood to the N. Harrison's Walk, a gravelled extension NE of his Assembly Rooms, occupied part of the site in the early 1700s. From the 1730s it became a

121. *The South Parade at Bath.* Watercolour by T. Malton Jun (1775)

garden associated with the Parades (*see* below), known as St James's Triangle, designed by *Wood the Elder*. Davis's **colonnade** supporting Grand Parade, with Italianate balustrading, now forms the gardens' NW boundary. This continues s with the road scheme's retaining wall and a further colonnade. The domed Doric kiosk, lamp standards and vases along the entire length are 1930s. The central circular lawn and surrounding paths, laid out by *Mowbray Green & Hollier*, part of the same project, recall Wood's original formal plan. The Parade Gardens have on their s side the N front of Wood's next major enterprise after Queen Square. **North and South Parades** [120, 121] with Pierrepont Street (w) and Duke Street (E) are one composition, a great square block laid out by *John Wood the Elder* in 1738 and built in 1740–8. This was to be part of his projected Royal Forum for Bath which was to have extended to the s (*see* Introduction, p. 16). The long ranges have projecting ends and centres and central pediments, North Parade, Duke and Pierrepont Streets with twenty-five bays (3–7–5–7–3), South Parade twenty-nine bays (3–7–3–3–3–7–3). The Corporation initially objected to the project – access was difficult and the sloping land to the river seemingly unsuitable – but with Beau Nash's help Wood became 'absolute contractor' for the ground in 1739. Costly foundations up to 18 ft (5.5 metres) high were required to form level terraces. Wood's plan, described in his *Essay*, was for a palace treatment to the centre N and s ranges, like Queen Square, with giant Corinthian columns and pilasters, but Wood's tenant developers insisted upon cheaper, plainer façades. The orders here are simply implied by the proportioning of the elevation. Decoration was limited to a platband, a continuous first-floor sill, and surrounds to the upper windows with straight cornices to the first-floor windows, and a modillioned cornice. The doorways have straight hoods on brackets or pediments on demi-columns or console brackets. Indiscriminate alteration to windows and removal of balustrading, the continuous sill and other features further heightened their severity. Some houses have a bow to the staircase in the centre of the back elevation, for sedan chairs.

The shaded **North Parade** (originally Grand Parade) was intended as a summer promenade. The centre house is five bays wide, with a bigger doorway than its neighbours'. The front saloon on the upper floor ran the whole width of the house. In the garden of No. 14 (E end on the riverside) is **Delia's Grotto**, a small, pedimented folly, vermiculated with an arched alcove, Palladian style in the manner of Kent. It may be a structure that originally stood in Harrison's Walk in 1734.* **Duke Street** running s, paved with flagstones (the widest pavement in Bath),

*North Parade was extended across the river with **North Parade Bridge**, 1835–6, by *W. Tierney Clark*, engineer. The original structure was cast iron with rusticated ashlar piers, one enclosing a staircase to the riverside, another, formerly a toll collector's residence. *F. R. Sisson*, City Engineer, clad the span in ashlar in 1936–7. The bridge continues as a viaduct to the E, with two **lodges**, 1835–6, in Jacobethan style with well-preserved strapwork.

122. St John the Evangelist, South Parade, by Charles Francis Hansom (1861–3)

has on its E side a further range of houses backing on to the river. (Interestingly, no major Bath development ever had a principal riverside aspect.) No. 1 was Pinch the Younger's office in 1829. Intended for autumn and winter promenading overlooking the intended Royal Forum, **South Parade** was started 1743; plots were still being assigned in 1749. Malton's view of 1775 shows front area balustrades, urns at the parapet corners, and an obelisk finial over the central pediment. Only No. 1 retains stone balustrading to the parapet. A ferry at the E end was a picturesque departure point for pleasure trips to Spring Gardens across the river (*see* Introduction, p. 32).

Facing Wood's South Parade, **St John the Evangelist** (R.C.), 1861–3, by *Charles Francis Hansom* [122], is demonstrative proof of how intensely the Gothicists hated the Georgian of Bath, but also can be seen as a signal of mid-C19 Roman Catholic confidence. The exterior is rock-faced, with dressed stone only around openings, a further defiance of the local ashlar tradition. Hansom considered it one of his best works. He added in 1867 the lofty w tower and 222 ft (68 metre) spire and spirelets. In confident late C13–early C14 Dec style, the building reflects Pugin's principles of honesty and severity laid down in his *The True Principles of Pointed or Christian Architecture* (1841): small stones to enhance scale, roof fairly steeply pitched, decoration functional – splayed moulds to throw off rainwater, structurally useful pinnacles. On the N side, the lean-to aisle, and gabled transept, baptistery and porch make the church 'one mass of gables' as *The Builder* put it. The result, however, tends to blandness and lacks the sinuous intensity that perhaps the zealous Pugin himself might have achieved here. The N aisle and large presbytery to the s of the church were destroyed by bombing in 1942, and rebuilt, the latter to a new design, by *Alec French Partnership* in the 1950s. The interior is architecturally somewhat thin, and the original polychrome painted scheme does not survive intact. What does survive is the very elaborate architectural and figure carving, all by *Thomas Earp* of London, and a complete set of High Victorian Catholic church furnishings. It has a w end narthex, with baptistery and altar to St Benedict. It has an ambitious aisled nave with clerestory running as a screen across the transepts, and broad polygonal apse with side apses, and circular polished Devonshire marble piers with elaborate foliated capitals. – **High altar**. Polished marble and alabaster, by *Earp* of London, flanked on right by Blessed Sacraments and on left by Lady Altars and pulpit. The Lady Chapel altar came from the (still surviving) previous R.C. church in Corn Street, Bath. – **Chancel screen** of iron, the most ornate feature, by *John Hardman Powell* of *Hardman & Co.* of Birmingham. – **Organ** by *Walker of Brandon*, from the University of Hull. – **Baptistery**. Contains relics of St Justina within a shrine designed by *Edward Hansom*, 1871. – **Stained glass** by *Hardman & Co.* Damaged in 1942. The apse windows of 1863, the earliest. Quite good and glowing in the aisle rose windows, under transverse gables.

Returning w to Pierrepont Street and a little N, we now make a short loop into a pleasant backwater, through an opening on the w side, **St James's Portico**, by *Wood the Elder*, c. 1745. Four Tuscan columns at ground level support the building above, maintaining the integrity of the Pierrepont Street façade, while forming a link to an existing street, **Pierrepont Place**, behind. Here, No. 1, c. 1730, was the home in the 1760s of Dr Thomas Linley, director of music at the Assembly Rooms; his daughter was the singer, Elizabeth Anne Linley. The doorway has Ionic pilasters, pulvinated frieze, and later pineapple finials. Inside, the best plasterwork of that moment at Bath (acanthus foliage, busts of the four

In its day this was the most important theatre outside London, especially for the period 1790–1805 before the new theatre opened in Beauford Square (*see* Walk 11, p. 257). John Palmer M. P., originator of the mail coach system, managed the theatre and held the first Royal Patent ever granted to a provincial theatre. The actress Sarah Siddons performed here 1778–82. The theatre closed in 1805. Garrick and Kemble also performed here.

seasons, a Baroque shell niche with a head, also a good wooden fireplace with an open pediment).

The continuation s, **Old Orchard Street**, has on the e side the original Theatre Royal, now **Masonic Hall**, which received a Royal Licence in 1767; is the most important theatre outside London. Built in 1750 by *Thomas Jelly* and altered and extended by *John Palmer* in 1775, the exterior is undistinguished, the interior gutted, except for remnants of stage boxes. The building became a Roman Catholic chapel in 1809, then, when St John the Evangelist was built (*see* above), *J. Elkington Gill* converted it into a Freemasons' hall in 1866. No. 21 was home of the architect Charles Harcourt Masters; he exhibited a model of Bath here in 1789–90. Manvers Hall, w side, dated 1853, was a Roman Catholic school until 1868, now chapel. The adjacent car park, s, has fragmentary remains of the C4 **town wall**, repaired and rebuilt in medieval times (*see* Introduction, p. 12). This 65 ft (20 metre) section survived the 1760s' general demolition of the walls.

Old Orchard Street meets New Orchard Street, running w with **Northwick House**, s side, 1962 by *E. Norman-Bailey & Partners*, the first of Bath's stone-clad nonentities of this period, replacing early C18 houses. In **Henry Street**, the continuation e, the **Swedenborgian Church** ('New Church') is by *Henry Underwood*, 1844, still in a remarkably pure Grecian. Pedimented portico of four three-quarter Ionic columns, plain angle pilasters and a splayed doorway set in a rusticated base. Its best-known worshipper was Isaac Pitman, inventor of the shorthand system named after him. It is now offices. Attached, e side, **Blenheim House** is the minister's house – same date, style and architect.

At the NE corner of Henry Street, Pierrepont House and adjacent, N in Pierrepont Street, Kingston House, *c.* 1808, form part of the projected, but never completed, Kingston Square. On the s corner, Nos. 1–2 **Manvers Street** (Pierrepont Street's continuation s), two houses of *c.* 1845, possibly by *Underwood*, in severe Greek Revival style, a type rare in Bath but much commoner in Bristol and Cheltenham. *A. J. Taylor* linked them to Blenheim House with a single-storey extension,

1924–5, and *Gerrard Taylor Hind* converted them to a bank, 1975. On the
E side, a little S, the nondescript, reconstituted stone, Central Police
Headquarters, by *J. G. Wilkinson*, chief planning officer, Bath City
Corporation, 1962, replaced that in Orange Grove. On the W side,
Nos. 5–12 are an ambitious but dull High Victorian **terrace** by *Hickes &
Isaac*, 1869, with vestiges of classical detailing, surrounds, a column
separating paired first-floor windows and a ground-floor bay.

On the E side, the Gothic Revival **Manvers Street Baptist Church**,
1871–2, by *Wilson & Willcox*, the Institute and Sunday School extension,
by *Silcock & Reay*, 1907. It has a simple, single-gabled W front, of
squared rock-faced Bath stone with freestone dressings and a small,
open NW corner tower with a continuous arcade of horseshoe arches
and a conical roof. This is based on early French models (cf. the
Cistercian church at Pontigny near Auxerre and Notre-Dame-
la-Grande, Poitiers). The interior has galleries with nave and aisles,
boarded roof and apsidal E end spanned by a lofty stone arch. Next S,
No. 20 is a crisply detailed and proportioned office building, by *T. P.
Bennett & Son*, 1972, with pre-cast concrete cladding divided into bays,
an abstracted, faint echo of a Georgian terrace. Then **Bayntun's
Bookshop and Bindery** by *F. W. Gardiner*, 1901, originally the Post
Office sorting office, and externally unaltered. It has big, arched
ground-floor openings, first-floor mullioned and transomed windows,
four gables and nice rainwater hoppers and original pairs of gates and
railings – a bold and convinced statement, conceding nothing to the
Georgian tradition. *Mowbray Green & Hollier* converted it in 1938.
Ahead is the **station** (*see* Major Buildings, p. 92). On the opposite N cor-
ners, two rounded hotel façades, late 1840s, originally the Royal and
Argyle hotels, make a formal entrance to Manvers Street and the city
centre, laid out in accordance with the Great Western Railway Act, 1835
(*see* Introduction, p. 40). At least the W building, the **Argyle Hotel**, is
probably by *H. E. Goodridge*, Surveyor for this area to the Great Western
Railway. Between a solid podium and heavy attic storey, giant Ionic
columns and pilasters very effectively turn the corner and give each
façade equal importance. The tripartite first-floor windows are like the
Bazaar (*see* Walk 4, [87]), but the fanlight is blind; there are sarcopha-
gal forms, anthemia and wreaths along the ground-floor frieze. The E
building is a little later; it is still a hotel. **Ralph Allen House**, possibly by
Underwood, closing Railway Place running E, is a small, distinctive
building *c.* 1840; broad band-rusticated pilasters articulate its three
bays.

w from outside the station along **Dorchester Street**, N side, are five
telephone kiosks by *Sir Giles Gilbert Scott*, of the later, smaller (and
once more numerous) type K6, designed in 1935. 220 yd. (200 metres)
further w, s side, is the **Electric Light Station**, by *W. J. Willcox*, 1897,
Bath's first power station, closed 1966. The associated offices and show-
rooms, w, by *W. A. Williams*, 1931–2, are a good Neoclassical design with

123. The Forum (former cinema) by W.H. Watkins & E. Morgan Willmott, interior Art Deco wall decoration (1933–4)

band-rusticated ground floor and double Doric giant order columns and pilasters above. With a big, rounded quadrant elevation, the return to the river has equal architectural treatment. Threatened with demolition at the time of writing. 80 yd. (75 metres) to the NW – an out-and-back excursion – at the junction of St James's Parade and Somerset Street, the **Forum** cinema, by *W. H. Watkins & E. Morgan Willmott*, 1933–4, has an exceptionally complete Art Deco interior [123]. Steel-framed and stone-clad, the façade is Neoclassical in deference to the *genius loci*, with a curved corner entrance and four giant Corinthian three-quarter columns. The foyers have concealed lighting, chromed handrails, walnut and ebonized doors and a first-floor mirror. The 2,000-seat fan-shaped auditorium has a cantilevered balcony, concealed lighting, figured classical friezes and an elaborate candelabra. Cinema use ceased in 1968; celebrated orchestras and light entertainers also performed there in its heyday. Bath Christian Trust refurbished it from 1989 as Bath City Church.

Dorchester Street meets **Broad Quay**. On the N side, **Carpenter House** and **Quay House**, offices by *Russell Diplock Associates*, 1971, and *Gerrard, Taylor & Partners*, 1973–5, respectively, were converted to student accommodation, 2001–2. From here is a view S across the river to the hillside **Calton Gardens**, a private development of low-rise housing by *Marshman Warren Taylor*, 1969–70. The design tries to reflect the linearity of Georgian terraces but in reality has a damaging impact on the landscape. To accommodate the scheme, 381 houses were demolished, 304 of them pre-1875, in 1968, under plans by the City Architect and Planning Officer, *Dr Howard Stutchbury* (architectural advisor, *Sir Hugh Casson*).*

*A sequence of early industrial buildings begins 220 yd. (200 metres) to the w across the river – *see* Excursions, [149].

On Broad Quay, **Churchill Bridge** and, to the E, **Churchill Footbridge**, single spans in concrete, opened 1964–6. They replaced the Old Bridge, which stood between the two, aligned with the South Gate. Rebuilt in 1304, this had a small chapel mid span and a tower with a portcullis on the s side. Enlarged in 1754 and 1847, it was demolished in 1964 as a flood control measure. E of the footbridge is the **Skew Railway Bridge**, first built by *Brunel* in 1840, in timber with a central pier. The two spans were rebuilt in 1878 with wrought-iron lattice girders (strengthened with steel in the 1960s). This continues w as a **viaduct** by *Brunel*. Castellated, with a pair of half-octagonal towers, offset with arrow slits and Tudoresque arched openings and centre mullioned windows, all facing towards the city – perhaps distant echoes of the medieval gate, demolished in 1755, and the Old Bridge. Five chamfered arches with four-centred heads and two-stage buttresses each side.

South of the River Avon

Across the Churchill Footbridge, under the viaduct and E along Claverton Street on the s side, **Temperance Hall** adjoins St Mark's Road. Dated 1847, this handsome little building is pedimented, with Doric pilasters and a full entablature. It is now First Church of Christ Scientist. 110 yd. (100 metres) along St Mark's Road, running sharply w (an optional out-and-back excursion), **St Mark** by *G. P. Manners*, 1830–2, a Commissioners' church (*see* Introduction, p. 35). Perpendicular Gothic Revival, battlemented and pinnacled, the w tower rather in the Somerset manner. The polygonal chancel by *Thomas Ames* of *Wilson & Willcox*, 1883. The fittings are removed but the stone pulpit is *in situ*. Redundant, it became Widcombe Community Centre in 1975, with partitioned aisles. Claverton Street continues E to **Widcombe Parade**, s side, late C18. Originally twelve houses; the first four carefully rebuilt in facsimile by *Aaron Evans Associates*, 1990–1. **Claverton Buildings** and **Sussex Place**, N side, are *c.* 1800, much altered.

Now Widcombe Hill. First, s side, is the **Church Room and Institute**, an amateur but not amateurish design by the *Rev. W. T. H. Wilson*, 1882, converted with an inserted mezzanine for the Natural Theatre Company by *Aaron Evans Associates*, 1997. Local masonry students carved the corbels around the entrance, depicting characters from the company's ensemble, the cone head, the Georgian fop and the nanny. **St Matthew**, Cambridge Place, Widcombe, 1846–7 by *Manners & Gill*, is dull, in the Dec style, but prominently sited with a s tower carrying a 150 ft (45 metre) broach spire, visible across the city. Its 1,250 seats (500 free) provided for the early C19 growth of Widcombe. The stone reredos is by *Charles Edward Davis, c.* 1870. The interior is now subdivided. Next, s side, **Clarendon Villas**, by *Hickes & Isaac*, 1869–76, is a modest terrace with no pretension to the street and sold itself snobbishly as villas. Opposite, on the N side, **Cambridge Place**, by *Pinch*

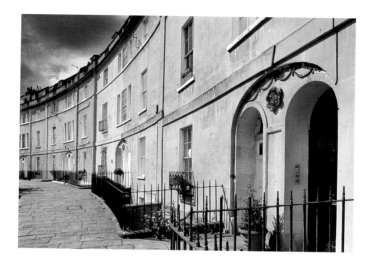

the Elder, c. 1825, are four detached and (Nos. 1–2) semi-detached, three-bay villas, raised above street level. Nos. 1–2 with parapets, the remainder, eaves. The central windows are blind except at Nos. 3 and 6. The wall of No. 7 has an early C19 water trough in a Gothic niche.

A little uphill, s side, Widcombe Crescent with Widcombe Terrace is one of Bath's most attractive and Picturesque minor ensembles. **Widcombe Crescent** [124], *c.* 1805, fourteen houses by *Harcourt Masters* (whose name appears in several leases), has an unpretentious plain façade, reflecting the growing introspection of Bath housing styles at this time, with no central feature. By placing the staircase to the front, the rear principal rooms face picturesque views of Beechen Cliff (*see* Excursions, p. 263). The central houses, five pairs, have entrances within charming shallow-arched recesses decorated with a floral boss and ribboned festoons. To the E, **Widcombe Terrace** [125], six tucked-away houses by *Harcourt Masters, c.* 1805, relates to the crescent with an elegant double segmental-bowed w front with parapet urns. The unusual back-to-front arrangement has a finely articulated principal rear elevation influenced by Robert Adam, modest in size yet architecturally very grand, with a Vitruvian scroll frieze. It faces expansive sw views across the valley to Lyncombe hill. A paved terrace separates the gardens from the houses. The street frontage to Church Street (*see* below) is very plain.

An optional and somewhat strenuous out-and-back excursion – 685 yd. (625 metres) each way – now climbs steeply up Widcombe Hill. On the s side, behind an enclosing wall, **Aquila** is a house by *David Hadfield*, 1997, single storeyed with a Japanese flavour and pyramidal top lighting. On the N side, behind rusticated gateposts with pineapples,

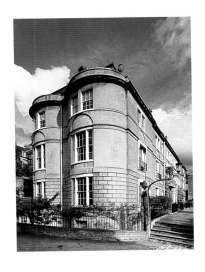

Widcombe Hill House, late C18, is one of the earliest suburban villas in the area. **Crowe Hall**, s side, a very grand mansion built for Brigadier Crowe, stands behind tall, banded ashlar gatepiers surmounted by vases with pineapple leaves and swags. Originally built in 1742 and 1780, the house was rebuilt *c.* 1805, and continuously remodelled, particularly by an Italophile owner, *c.* 1871, who was responsible for much of the interior. After a serious fire in 1926 *Axford & Smith* completely rebuilt the w front in sympathetic style. The entrance front has a giant Ionic tetrastyle portico with coffered soffit. The bold classical detailing to blind flanking bays may well be post-fire. The interior has lavish classical decoration. Large central hall with coved and domed ceiling supported on Doric columns, forming a screen to each long side. Grand staircase, post-fire, other rooms Adamish detail, some re-set. The house stands in extensive terraced gardens, mostly 1870s, with a late 1930s terrace pool. 1880s garden loggia at w end. The statuary and Italianate ornament are mostly C20. The grotto below the s terrace is possibly of 1742. The coach house, late C18, pedimented with an *œil de bœuf* window, became two dwellings in 1987. Further up are **Macaulay Buildings**, 1819–30, named after the developer. Three pairs of semi-detached villas with bow fronts face Widcombe Hill; off the hill, a range of attached pairs of villas, oddly isolated in this semi-rural setting, command fine prospects over the Prior Park estate and Lyncombe Vale. A **parish boundary marker**, dated 1827, erected by Bath Turnpike Trust (engineer, 1826–36, *John Loudon McAdam*), signifies Widcombe Hill's important road link, connecting the city with Bradford-on-Avon and Trowbridge. The outward excursion ends here, with westerly views to 'Bath's Fiesole' (*see* Walk 7, p. 198), and s over the city.

Returning downhill, shortly before Church Street, Nos. 1–5

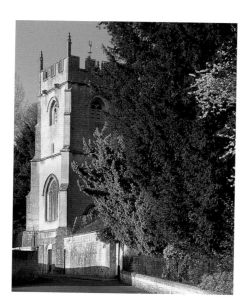

Widcombe Hill have façades of *c.* 1800. Entering **Church Street**, the rear of No. 5 reveals itself as a village house of *c.* 1700, with fine original mullioned windows, which was extended a century later to front the hill: a sign of the changes in Bath house building over the course of the C18 and the replacement by standard Palladian tastes of local vernacular traditions. No. 1, s side, **Somerset House**, early C19, one of an unequal pair with No. 2, has a powerfully austere Greek Revival porch. This served as Widcombe vicarage. A little further, N side, Nos. 11–12 are *c.* 1700 with mullioned windows. Next, s side, the mid-C19 **Widcombe Lodge** occupies the site of the earlier Yew Cottage, possibly incorporating earlier fragments. Straight ahead, on the hillside beyond, is a stunning view of Prior Park (*see* Major Buildings, p. 126).

St Thomas à Becket [126], built by Prior Cantlow, 1490–8, on the site of a Norman chapel, is thus earlier than the Priory Church. The w tower is plain, of two stages, with battlements and pinnacles and a carved shuttle and mitre, arms of the Priory of Bath, high up on the E-facing wall. The nave is embattled and Perp; the pierced chancel parapet is from *C. E. Davis*'s restoration of 1860–1. At this time also the chancel E window was restored, having been blocked-in in 1746. The s chapel is screened off from the chancel by complex C19 tracery. – **Reredos**, by *F. Bligh Bond*, 1914. – **Screen**. Finely carved oak, together with linenfold wainscot to walls, 1913. – **Font**. Fine early C18 bowl supported by three cherubs, gadrooned base. Over chancel arch painted **royal arms** dated 1660. – **Stained glass**, by *Lavers & Barraud*, 1861. Curious for depicting shrubs, plants and flowers, but no human figures. – **Monument**. Of the many, the oldest (tower, s side) is to Jane Gay, 1610.

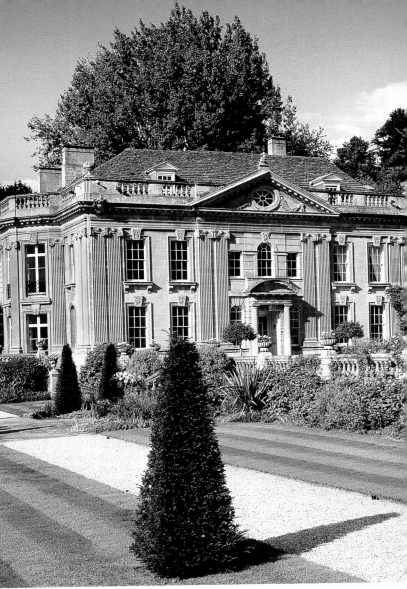

127. Widcombe Manor from the south west (late c17)

Widcombe Manor* is late c17 [127], built for a Bristol businessman, Scarborough Chapman, and altered in 1726–7, with a new principal s façade, giving its present appearance. This work was carried out by his grandson, Philip Bennet II, later M.P. for Bath, 1741–7. It is an elegant if

*The actual manorial site is in Lyncombe – *see* Excursions, p. 286.

provincial design, not in the local tradition, and by an unknown architect, perhaps *Nathaniel Ireson* of Wincanton (Philip Bennet was Lord of the Manor of nearby Maperton). Set behind a forecourt, the warm, honey-coloured **main front** is decidedly Baroque. It has seven bays and two storeys. Giant fluted Ionic pilasters are coupled at the angles and as framing to a pedimented three-bay centre; garlands and an oval window in the pediment. The Doric doorcase – flanked by arched windows – has a triglyph frieze and segmental pediment. Three individual first-floor windows make up into something like a low Venetian window. The side windows have architraves with grotesque mask keystones and, at first floor, sills supported on consoles. The entablature has a pulvinated frieze, modillioned cornice and a high parapet; behind is a hipped stone-tiled roof. In 1840 *James Wilson* of *Wilson & Willcox* built the remarkably sensitive **west elevation**, with a canted bay, and fluted Ionic giant pilasters to match the s front. Plain C19 service extensions to the N. The **interior** has a low, panelled hall with bolection mouldings, a good staircase with twisted balusters, and a first-floor landing with groin-vaulted side bays, which the then owner, author Horace Annesley Vachell, made into a library in the 1920s. The main w room has the canted bay.

The forecourt has a two-stage bronze **fountain**. This is said to be Venetian of the late C16, brought from one of the Grimani palaces of Venice by the previous owner, Sir John Roper Wright, and repositioned for Vachell by *Rolfe & Peto* in 1928. Four turtles support the base, which bears the Medici arms; satyrs surround the lower bowl; above, a cherub rides a seahorse. w of the house is a C19 gravel walk running 75 yd. (70 metres) N–s at the head of an extensive **garden**, restored in the 1990s. At the s end of the walk is a small **summerhouse** by *Didier Bertrand* with an C18 façade, moved to its present location from Fairford, Gloucestershire, *c.* 1961. The arched centre has rusticated Doric columns and, each side, an oculus with four keystones. Primitive blocks instead of triglyphs in the frieze may allude to Vitruvian beam-end theory. Below the gravel walk *Rolfe & Peto* added two lower terraces divided at centre by a double staircase, and a sunken garden, *c.* 1930. At the w extremity is a lake with an C18 rustic three-tier cascade, originally with a Neptune statue. Beyond this is an early C18 mount, 20 ft. (6 metres) high, with a spiral path to its summit.

On the s side of the church is a two-storey **garden house**, attributed to *Richard Jones.** Square in plan, the ground floor has a three-arched loggia with engaged Doric columns; single Ionic columns flank the windows to the upper floor. A little s on Church Street, E side, are the former stables and service block, mid-C18 and C19, converted in the C20

*Jones, Ralph Allen's clerk of works, referring in his *Life* to the High Street Guildhall (*see* p. 76), compares it with 'my drawings of the other piece at Widcombe, done for one Squire Bennet'. The two structures are indeed similar.

to a house, Manor Farm (now renamed **Widcombe House**). In front is a handsome C18 octagonal **dovecote** with a cupola and set in the E garden wall facing inwards is an C18 grotto. The garden, and possibly the house conversion, were by *Rolfe & Peto* in 1929.

Church Street to the s meets **Ralph Allen Drive**, the former private drive to Prior Park (*see* Major Buildings, p. 94). Acquired by the city in 1921, this became a broad public road in a scheme to provide work for the unemployed. **Lower Lodge** on the corner, by *Wood the Elder*, has a Venetian window and quoins.* Opposite, **Bath Abbey Cemetery**, 1843–4, by the celebrated gardener and horticulturist *John Claudius Loudon*, is one of three (his best, most intact and last), laid out according to his scientific and hygienic design and management principles. The entrance gateway, in free Gothic, is probably by *Manners*. A long rising drive leads to the cemetery's heart, divided and sub-divided by roads, walks and paths. The **mortuary chapel**, dominating the cemetery, is by *Manners*, 1844 (originally projected to have cloister wings). Boldly Neo-Norman with deep modelling and vigorous decoration, it is one of SE Bath's prominent incidents, with a square w tower and pyramidal spire. Numerous fine Greek Revival tombs commemorate illustrious Bath residents. At the top of the Carriage Road, the Crimean monument, by *Samuel Rogers*, 1856, a Greek Revival Pennant obelisk, unusually mentions 'other ranks' as well as officers. On the s border, Samuel Maxwell Hinds, late speaker of the House of Assembly, Barbados, by *Reeves*, 1847, is based on the Choragic Monument of Lysicrates. Adjacent, the Williams memorial, by *White*, *c.* 1848, is a miniature Greek Revival temple with four paired sets of fluted columns, containing a draped urn flanked by an angel and a female mourner. One inscription commemorates Henry Williams 'who by accidentally falling off the West India Docks in a dense London fog was unfortunately drowned' in 1853. At the N end is John Lambe, *c.* 1865, formerly of HMS *Phoenix*, fittingly, a column supported by two cable-moulded bands and a rising phoenix.

Descending Ralph Allen Drive into **Prior Park Road**, off to the s is the area of Lyncombe, once a place of pleasure gardens (*see* Introduction, p. 32 and Excursions, p. 286). **Ashley Lodge** is a pretty mid-C19 Regency villa fronting the road on the s side. On the N side, an early **mill** later associated with Wood's 'Lower Town' for Ralph Allen, has a good Venetian window (now a car dealership). Next, same side, are two semi-detached pairs of picturesque Tudor **villas** dated 1843, Nos. 69 and 71, Oriel Villa and Oriel House and Nos. 61 and 63, Baliol House and Baliol Lodge. They have all the ingredients: asymmetrical plans, gables with copings and finials, steep roofs, grouped chimneys, mullioned and transomed windows, dripmoulds, gabled tower porches and oriel bay windows. A series of modest but pretty pairs of semi-detached

*Another, similar lodge is at the top of Ralph Allen Drive.

late Regency **villas**, *c.* 1830–40, follows. Behind rises the impressive Coliseum-like curved rear of Widcombe Crescent.

Further down, w side, **Prior Park Buildings**, by *Pinch the Elder*, is a good, later Georgian, palace-fronted terrace begun in 1820. Deceptively monumental, with a pedimented centre and end pavilions set up on a bank separated from the road by a channelled millstream. Several doorways have original fanlights with projecting lanterns. At right angles beyond, **Prior Park Cottages**, same date, rise very steeply uphill. The lane beside No. 2, **Good Hope** (early C19 with a Gothick front) leads, out-and-back, to **Millbrook School**, by *C. B. Oliver*, 1902, now residential. Conventional Tudoresque, but the centre has individual Arts and Crafts detail – a hood with a wrought-iron bell, off-centre rainwater hopper, and a delicate cupola.

Finally, on Prior Park Road, **Ralph Allen Cottages**, by *Wood the Elder*, *c.* 1737, which housed Allen's stonemasons. These small Palladian workers' dwellings – very early examples of their type – were part of Allen's extensive quarrying business, built close to the wharf where stone, brought down from the quarries by railway (*see* Topic Box, p. 17), was shipped. The interiors have stone spiral staircases. *Hugh Roberts, Graham & Stollar* restored them in 1983**.** The **White Hart** pub, opposite, was part of this former industrial landscape.

Directly N, off Claverton Street and overlooking a lock of the Kennet & Avon Canal, **Widcombe Baptist Chapel**, formerly Ebenezer Chapel, dated 1820 (opened 1822), has six bays of pointed windows with intersecting glazing bars (best seen on the N side), battlements and a pyramidal roof painted with religious messages, originally in 1903. The large square hall, galleried with slender Batty Langley-style cluster columns, was originally entered from the N with the platform and reading desk at the s end. The layout was reversed and an entrance extension, s side, added, *c.* 1980. The large Jacobean-style Sunday School and offices, E side, by *Silcock & Reay*, have plaques dated 1910.

W along Rossiter Road, **Widcombe Footbridge** over the River Avon, a single-span wrought-iron lattice girder construction by *T. E. M. Marsh*, 1877, replaced a double bow-string wooden arch bridge of 1863 by *Hickes & Isaac*. This collapsed in 1877, with eight deaths, when crowds of excursionists arriving by train were heading to the Bath & West of England Society centenary show at Holloway Farm. We return to the city centre across the bridge and under the railway to the station.

Walcot and the London Road

Walk 9 follows the ancient suburb of Walcot (*see* Introduction, p. 4), N of the North Gate, still a bustling district of trades and crafts practised here since the Roman Empire. Until the C19 it was the main route into the city. Uncertainty cast by Colin Buchanan's C20 hated road tunnel scheme (*see* Introduction, p. 46) sustained the area's somewhat unconventional character – 'Bath's Montmartre'. An extension to the walk follows late Georgian ribbon development along the London Road to the lively community of Larkhall.

Walcot Street to Cleveland Bridge

At the s end of **Walcot Street**, the **Hilton Hotel** by *Snailum, Le Fevre & Quick*, 1972, is the most reviled building in Bath. The tall slab block is visible across the city but particularly affects the view of Robert Adam's Pulteney Bridge from the s. The fenestration was obviously designed with some idea of keeping-in-keeping, and a terrace at the back relates to the river. Together with the adjacent multi-storey car park, it formed part of the Buchanan traffic plan. Sir Hugh Casson approved the plans, but later regretted this decision. Opposite, on the N side of **Saracen Street** running w are three shops by *MWT Architects*, late 1980s, with bold double-height arched openings. Further N on Walcot Street, w side, Nos. 27–33, a terrace of *c.* 1840, have good **shopfronts**. The shop fascia to No. 27, 1896, spans a former carriage entrance. No. 29 has an elaborate shopfront with carved frieze and brackets, by *R. Turner*, 1890, framing older glazing. Those to Nos. 31–33 are 1875. A much older building attached to the rear has a C17 moulded stone single-light window opening on to the steps to the side. These climb steeply to the tranquil **Broad Street Place**. This is bounded by the upper level of the Saracen Street shops, pleasantly small scale on this elevation, and on the N side by the **YMCA Hostel and Club** by *F. W. Beresford-Smith & Partners*, 1972. The YMCA front to Walcot Street sits above street level on segmental arches and the upper walls are slate-hung to give the impression of a mansard roof, a fashionable device at that time (cf. Ballance Street Flats, p. 173).

Opposite, E side, was the site of the Beast Market. Its N boundary is the **Corn Market** by *Manners & Gill*, 1855. Entered through a narrow, two-window-wide classical building, it is a very simple long and narrow hall raised on arches, now suffering from ground settlement. Edward III

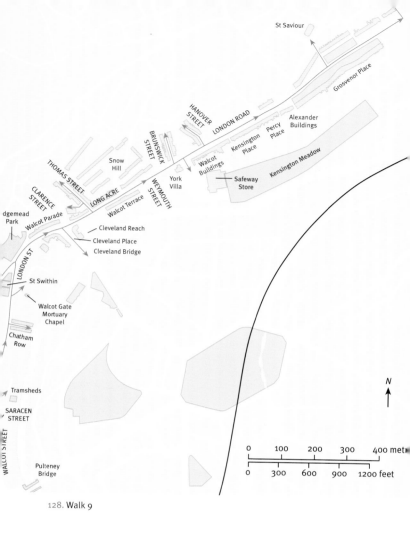

128. Walk 9

granted a charter giving the right to hold a market in the High Street in 1371 and the cattle market moved to the area in the early 1800s. Next, off to the E, in **Beehive Yard** (so called because honey bees were found in a vaulted cellar from the C18) is **Bath Electric Tramways Depot**, a brick-clad building by *Harper & Harper* and *G. Hopkins & Sons*, engineers, 1903. Popularly known as the Tramsheds, the building housed, besides trams, an associated boiler house, electricity generator, foundry and workshops; the complex closed in 1939. *BBA Architects* in 2000–2 inserted into the brick shell four and five storeys of new accommodation. Together with a mid-C19 brass and iron foundry building at the end of Beehive Yard this created a complex of apartments, offices, a restaurant, new workshops for local tradesmen and a social services building.

Continuing N on Walcot Street, No. 66, *c.* 1740, has pedimented first-floor windows; the shopfront, *c.* 1790. Inside, the dog-leg staircase has a wide mahogany handrail and turned balusters. Nos. 68–70 are early C18, probably originally gabled. Nos. 72–82 is an irregular terrace, *c.* 1800, with added mid- to late C19 single-storey projecting shopfronts. Opposite, w side, a steep, four-stage, late C18 flight of **steps** (which we do not climb) ascend to Bladud Buildings, 1755–62, high up going s, and their continuation N, the Paragon (*see* Walk 10, p. 245). Next to the steps is **Ladymead Fountain** by *C. E. Davis*, 1860, Romanesque style in contrasting materials: ashlar, red sandstone, polished pink and grey granite columns with foliate capitals. Nearby was the Cornwell, an ancient conduit blocked off in 1849 because of cholera scares. **Bladud Buildings** is unusual, having a rear elevation similar to the front, with entablature, surrounds, pediments and cornices. When built, they would have directly overlooked the river. The **Paragon**, perched on a precipitous retaining wall with mews below, forms a huge man-made cliff dominating the remainder of Walcot Street's E side, dramatically emphasizing the confidence of Georgian building development.

Returning to the E side, No. 88 and **St Michael's Church House**, one building by *Wallace Gill*, 1904 – two gables and Jacobean-style windows – has attractive Arts and Crafts detail. A large recessed arch contains the entrance and the doorcase has fine and delicate lettering in the frieze. A bold, raised carving of St George slaying the dragon stands between a broad swan-neck pediment. No. 92, the former **Red House Bakery** by *A. J. Taylor*, 1903, built of random and machine-cut ashlar, is a symmetrical seven-window range with mullioned and transomed first-floor windows. Nos. 94–106 are a terrace of shops with accommodation over by *C. E. Davis*, 1883 (behind the uniform façade Nos. 94–96 are earlier C19). Stylistically eclectic, the seven bays of mullioned and transomed windows have alternating straight and pedimented cornices, and a classical entablature above. Stone pilasters with scalloped console capitals divide the shopfronts. No. 108 is an C18 house set back from the road, extended forward in 1905 with an interesting single-storey Arts and Crafts style **shop**

129. Arts and Crafts style shop, Walcot Street, by Silcock & Reay for the builders Hayward & Wooster (1905)

[129] by *Silcock & Reay* for the builders Hayward & Wooster, indicated by the original elegant brass lettering. Light and airy with large mullioned and transomed windows, the little building has a bold classical entablature. The old house belonged to Robert Southey's aunt, Mrs Tyler.

Next, the **Penitentiary Chapel** (to Ladymead House, *see* below), by *Manners*, 1845, replaced houses used until 1824 as an isolation hospital to treat venereal diseases. It is a bold design with a heavy platband, a continuous sill course, and five tall first-floor windows with blind balustraded aprons, architraves and cornices. Smaller circular windows between the bays and deeply chamfered ground-floor windows are later additions. The N façade has a big bow and banded rustication. **Ladymead House**, No. 112, became a female penitentiary in 1805. Externally appearing C19, it incorporates remains of a late C17 house. Nos. 114–116, **Cornwell Buildings** is a delightful symmetrical pair of shops, *c.* 1800, restored 1989–90. The fronts are concave like a miniature crescent, with small panes, concave reeded door pilasters and rosettes. Off E down towards the river, **Chatham Row** (after William Pitt, first Earl of Chatham and originally called Pitt Street), *c.* 1767, is standard Palladian with a Venetian window on each end. Pinch the Elder was living at No. 12 in 1800. Scheduled for demolition, No. 12 was ignited in 1967 by the local authority for fire testing.

Walcot Street N of here was formerly called Cornwall Street. The **Bell Hotel**, No. 103, W side, is mentioned in council minutes of 1753. Nos. 124–126, E side, were the Ice and Cold Storage Company by *F. W. Gardiner*, 1899: first-floor Venetian windows and bold Corinthian pilasters at ground floor. The building, however, has earlier origins: set back on the s side is a protruding bay of an early C18 range with eared surround at first floor. Facing, on the W side, Nos. 109–119 is a small-scale mid-C18 terrace with naïve Venetian windows and Gothick glazing. In **St Swithin's Yard** opposite, E side, are the Tudor-style **St Swithin's Schools**, by *Browne & Gill*, 1899–1901. *BBA Architects* converted the building to housing in 2000–1. The development includes a convincing street frontage, Nos. 130–138, informal Neo-Georgian infill with repro shopfronts. In **Walcot Gate** off to the E is part of **Walcot Cemetery** (*see* below). The former **Mortuary Chapel**, by *James Wilson*, 1842, is rather crudely detailed Neo-Norman, cruciform in plan. Walcot Street concludes with No. 146 (formerly No. 18 Cornwall Street), a rebuilding of 1900 with a Dutch gable and good carved shopfront by *F. W. Gardiner*, built of 'best Combe Down stone, sound red deal and Bristol Plate Glass'.

The road now becomes London Street. N of the junction with the Paragon running SW (*see* Walk 11) is **Hedgemead Park**, on which stood 175 houses, destroyed by a landslip in 1881. At the head of the junction, **St Swithin**, by *Jelly & Palmer* [130], is Bath's only remaining classical-style parish church, built 1777–80, extended E to its present six-bay size by two further bays in 1788. The central square W tower, circular drum

with arched openings, and octagonal spire (dismantled and rebuilt in the early 1990s) were finished by 1790. All round the exterior are giant Roman Ionic pilasters, unusual for an C18 church (cf. All Saints, Oxford, but this has a prominent attic above the order). Each bay has two tiers of windows, segment-headed and round-headed, and a string course at gallery level. The w doorway is in the base of the tower, but the access is managed in a rather feeble way, with shapeless lobbies either side that cut across the lower parts of the giant pilasters, giving access to the galleries. Inside, three widely spaced giant Ionic columns stand on each side of the nave. The galleries were cut back behind them following structural damage during the landslip. *W. J. Willcox* added a shallow sanctuary corbelled out on the Walcot Street elevation in 1891. At the same time, under the influence of the Evangelical Revival, the pulpit was brought forward to its present position. – **Font**. Arts and Crafts, 1901. – **Stained glass**. In 1942 the E window was shattered; its replacement maintains the same theme, the Ascension. Walcot church itself is depicted at the feet of Christ. – Innumerable **monuments**, including one to the architect John Palmer, d.1817. Urns in particular are many. – Jerry Peirce, d.1768, with an excellent, lively profile portrait. – Paul Bertrand d.1755, also a portrait in a medallion. – The novelist Fanny

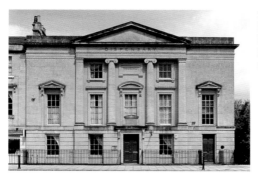

Burney (Countess d'Arblay) d.1840, not of artistic interest. Notables buried here include the painter William Hoare d.1792, Bath poet and editor of the *The New Bath Guide*, Christopher Anstey d.1805, and Jane Austen's father the Rev. George Austen d.1805. George Austen, one time curate of the parish, and William Wilberforce were both married in the church. s of the church, the **cemetery entrance**, with a vaulted mausoleum under, is by *James Wilson*, 1840, in a gloomy style with two short towers and extinguished torches as the chief ornament.

Walcot Street merges into **London Street**. Nos. 1–13 were rebuilt in 1901–2 in uniform Georgian style with ramped cornice and platband, by *H. W. Matthews*; the Hat and Feather, No. 14, next corner, same date and architect. Off to the SE, in **Nelson Place** are C19 weavers' workshops with extensive first-floor glazing. On the s side is the rear of Nos. 4–6 St Swithin's Place, simple late C18 terraced houses, vestiges of a type once common, representing the merging of urban and vernacular. Next on London Street, in Nelson Place East, is **Walcot Methodist Chapel**, 1815–16, by the *Rev. William Jenkins* of London. Classical style, it has a two-storeyed five-bay front with round-headed windows on both levels, and a Greek Doric porch of two pairs of columns. The three-bay pediment raised above the entablature on the attic, strictly incorrect, is a device found elsewhere in Bath (*see* Walk 3, p. 137 and Walk 11, p. 253), though the building generally is more Methodist-looking than a Bath architect would have made it. Jenkins was a minister-turned-architect and had already built Methodist chapels in Sheffield, 1804, Canterbury, 1811, Darlington, 1812, and elsewhere. The interior gallery is U-shaped. – **Organ**. Built in 1771 for the Assembly Rooms, it went to Walcot in 1818. The minister's residence, on the w side, is a handsome three-bay Grecian house with a Tuscan doorway and banded rustication. **Walcot Parade** opposite, N side, *c.* 1770, has the tallest raised pavement in Bath. It is a picturesque, slightly concave terrace, the houses all Palladian but varying in width and height and evidently erected by various builders without reference to a single architect's composition. Built on sloping ground, they had river views and were fashionable.

Cleveland Terrace on the s side (Nos. 4 and 6 with shopfronts of

1832) curves into the wedge-shaped **Cleveland Place**, off to the SE. There is a similar curving flank into London Road on the E side. This is all a development by *Goodridge*, c. 1827–30, laid out to provide a worthy approach to Cleveland Bridge (*see* below), the N entrance to the Bathwick Estate (*see* Walk 6, p. 176). These are among the finest Greek Revival buildings in the city. The ground floors have banded rustication. No. 9 **Cleveland Place West**, SW side, intended as the central house, has tripartite windows, wreath decoration and an incised Greek key between slightly projecting flanking wall panels, with further incised decoration. No. 7 and its opposite counterpart in **Cleveland Place East**, NE side, have giant pilasters, also with tripartite windows, pedimented at first floor. Goodridge's partiality for ironwork is evident here: good continuous balconettes with palmettes at Nos. 5–6 Cleveland Place West, balconies at Nos. 7–10 (and opposite at Nos. 4–5 Cleveland Place East). The end house, No. 4 Cleveland Place West, is c. 1860, but interesting because the Ionic column and other fragments in the garden (visible from the pavement) are from *Wood*'s St Mary's Chapel, removed here when demolished in 1875 (*see* Topic box, p. 138).

The return of Cleveland Place East into London Road has a particularly delicate and refined elevation: at first floor, three bays of tripartite windows with panelled pilasters, set within arched recesses, the centre windows blind, and wreath decoration in the attic storey. A later addition to Cleveland Place East is the **Dispensary** of 1845, a charitable institution where medical advice was given and medicines dispensed. It has a good late classical front, five bays, a rusticated ground storey, giant Ionic columns *in antis* supporting a pediment over the middle three bays [131]. The square ground-floor plan [132], projecting to the rear, had an ingenious in-out circulation pattern. Waiting rooms either side of the central entrance had benches with each row attached alternately to the opposite wall to ensure a strict zig-zag queueing system. A physician's and surgeon's room occupied the far corners with in- and out-doors and a common toplit dispensing room

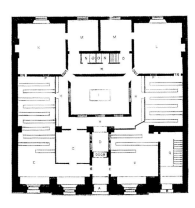

132. Plan of the Eastern Dispensary, *The Builder* (1849)

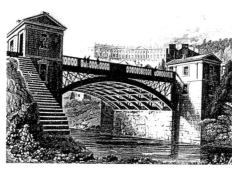

133. *The New Bridge, Bathwick*, a view of Cleveland Bridge with Camden Crescent. Steel engraving by F. P. Hay (1829) from a drawing by T. H. Shepherd

134. Cleveland Bridge, by Goodridge (1827), detail of ironwork

in the centre connecting with the exit. Around 1912 all the buildings on the dispensary side were colleges and pharmacies connected with the medical profession.*

At the SE end of Cleveland Place is *Goodridge*'s **Cleveland Bridge** of 1827 [133, 134], built for the Duke of Cleveland on the site of an ancient ferry crossing. It is one of the finest late Georgian bridges in Greek Revival style, combining the antique with expressive use of new materials. It has a single 100 ft (30 metre) span in parallel segmental cast-iron arches springing from stone piers, with heavy iron railings and four handsome Greek Doric prostyle lodges with porticoes taken from Stuart and Revett's *Antiquities of Athens*. The contractor was *William Hazeldine*, a Shrewsbury ironmaster who worked with Telford. It was reconstructed in 1928, and repaired and strengthened by *Dorothea Restoration* in 1992.

The Walk can conveniently terminate here. Alternatively, London Road, with long rows of late terraces, can be followed for a further ¾ mile (1 km.).

*Cleveland Reach on the riverbank to the NE is an energy-efficient development of flats and maisonettes by *Feilden Clegg Design*, *c.* 1980, with a monopitch roof and extensive glazing on the SE elevation, for solar gain.

London Road

The street, still a tiresome traffic artery, was once busy with horse-drawn vehicles – mail coaches, phaetons, curricles and Wiltshire's Flying Wagons – plying to and from the capital or making short pleasure trips out to the countryside. The houses, large-size and briefly fashionable, were the cause of many bankruptcies at the tail end of Bath's Georgian prosperity.

First, N side, **Anglo Terrace**, by *R. Wilkins & Sons,* builders, Bristol, 1893, workers' housing for the Anglo-Bavarian Brewery: ugly, two-storey with debased detailing; a wagon entry (the inscription, Burdalls Yard, later) leads to vaulted cellars at the rear. Adjoining E, the **King William IV** public house, *c.* 1830, has bowed small-paned windows on to **Thomas Street**. This rises steeply N with late C18 terraces at the lower end and, W side, the humble three-bay front of **Thomas Street Chapel**, 1830, which provided a Nonconformist place of worship within the expanding edge of the town; now flats. Terraces of the 1830s continue the street N. W off Thomas Street, in Clarence Street, is a C19 **malthouse**, large, three-storeyed with small segmental windows, now offices.

The S side of London Road continues with **Walcot Terrace**, late C18; No. 7 was the architect Thomas Baldwin's office, 1803–13. No. 9 was the **Bath Ear and Eye Infirmary**, dated 1837, with a curious narrow prostyle Ionic porch with a bust of Aesculapius (the Greco-Roman god of medicine) above the cornice. The original half-glazed double doors have amber margins. One of the many medical businesses grouped around Cleveland Place, it functioned as an early 'drop-in centre' for the poor, regardless of residence, though home attendance was only available within Bath. By the 1920s W. F. Dolman was trading here as cabinet-maker and undertaker.

Opposite, N side, **Long Acre** was an early C19 terrace; the centre section became Vesey's Coach Factory, then *Mowbray A. Green* rebuilt it as Bath Technical Institute in 1910. Four storeys, symmetrical ten-window front, with metal windows. Next on the S side, **Walcot Buildings**. Nos. 1–7 and Nos. 12–26 are late C18, Nos. 8–11, later and lower. Many have C19 **shopfronts** (for dating these, *see* Topic box, p. 156). No. 17 was the National and Provincial Bank, the small-paned bowed shopfront by *Mowbray A. Green*, 1926: oak-panelled doors, Tuscan columns. S off Walcot Buildings, **Weymouth Street** is a humble row of 1792–4, with paired windows to reduce window tax; further down is an early C19 oast house, part of a brewery.

On the N side, **Snow Hill**, a housing estate for Bath City Council by *Terence Snailum* of *Snailum, Huggins & Le Fevre,* 1954–61. Notoriously intrusive with green copper roofs visible across Bath, it replaced a hillside of small C18 terraces and narrow streets, but was at the time a model of slum clearance redevelopment. Long parallel blocks of flats are set along the contours, with one stepping uphill 'for contrast' and a point block for 'focus'. Ashlar-faced and set among informal retaining

walls, it is a Scandinavian interpretation of Bath's classicism. The middle two blocks, four storey on rubble plinths, were built 1954–6. The twelve-storey block, Berkeley House, 1955–7, repeats the form of the London County Council's point blocks at Alton East. The upper terrace has ground-floor flats with two tiers of maisonettes above, entered by means of prominent external staircases. The lowest terrace fronting London Road has five storeys and an adjoining church hall to the w.

Then follows a somewhat scattered and sparse stretch. Set back on the s side, an c18 **workhouse**, later Walcot Poorhouse, rebuilt 1828; it became Sutcliffe Industrial Schools in 1848: Tudor style, battlemented parapet and porch, and a large blind quatrefoil dated 1848. Two c18 wings remain at the rear. It is now commercial premises known as Sutcliffe House. Next e is Fortt, Hatt and Billings' furniture **depository**, steel framed with a Greek Revival front of 1926, by *A. J. Taylor*. The **Porter Butt** pub next door first appeared in the Bath Directory in 1800. It had a first-floor assembly room and there is a stone barrel finial above the parapet. **York Villa**, a large late c18 house at right angles to London Road facing e, possesses a remarkably large ballroom with a coved ceiling in a wing at the back. The entrance doorway has a dentil cornice and Corinthian quarter-columns with unusual and very delicate garland decoration to the shafts. It was a residence of Frederick Augustus, Duke of York, second son of George III. Opposite, off London Road to the n, the w side of **Brunswick Street** is a remarkably intact early c19 artisan terrace stepping steeply uphill: houses one window wide, two storeys. Set back to the s beyond York Villa is a supermarket by *Atkins, Walters & Webster*, 1999–2000. The development established the river frontage (mostly lacking in Bath), which was landscaped and made accessible. Refreshingly contemporary, the building uses a mixture of traditional and new materials, including stone, zinc roofing and aluminium rainscreen cladding. A curved canopy, like an aircraft wing, runs the length of the front, supported on canted columns and struts, broken by the entrance with high-tech glazing. A little e on London Road, again off to the n, **Hanover Street**, w side, late c18, has some remaining ten-over-ten-pane sash windows to basements. The w side is slightly later; Nos. 7–8 have Regency doorways with blocks and roundels to the upper corners.

Then the road gathers strength once again, with **Kensington Place**, a long frontage of *c.* 1795 by *Palmer*. Between Nos. 5 and 6 is the pedimented façade of the former **Kensington Chapel**, opened for service in 1795 (closed 1929), a proprietary chapel to augment St Swithin's. The design is quite original, one of Palmer's best. The rusticated ground storey has three windows. In the plain wall face above, widely spaced pairs of pilasters frame each of three tall, arched corresponding windows. These are set upon a deep continuous sill on consoles. The pilasters support a cornice that returns at the windows to form a

springing for the archivolts. This architectural arrangement has the pleasing ambiguity of reading, alternatively, as three linked Venetian windows, the outer compartments of which are blank. Nos. 5–6 both have recessed porches with flat segmental arches giving access to side entrances. The chapel, formerly galleried and with three fireplaces, still has its panelled reredos. It now has an inserted floor and is a warehouse. The only other accent to Kensington Place is at No. 16: a three-bay pediment and chamfered ground-floor rustication. The first floor has a Regency canopied balcony with French windows. The houses here still have conventional pedimented doorcases with Tuscan demi-columns or pilasters. One feels that by 1800 the erection of such long terraces at Bath had become a routine and that architects devoted much less thought to them now than the Woods had done. Nos. 1–3, bomb damaged, were reconstructed by *Mowbray Green & Hollier* in 1946–7.

Now three more terraces. **Percy Place** on the s side is irregular with houses of early, mid- and later C18; No. 4 was the home of the Rev. William Jay (*see* Walk 6, p. 179). Opposite, n side, **Worcester Terrace**, of *c.* 1813–16, is quite distinguished, with crisply executed fronts and little alteration. **Alexander Buildings**, s side, is a neat, early C19 range with long first-floor windows. Then, on the n side, **Beaufort House**, not visible from the street, set back behind tall gatepiers with small Soanian caps. Of *c.* 1800 with later additions. Symmetrical, seven windows wide with large, full-height segmental bays and a balustraded parapet. The rear range is **Beaufort Lodge**, seen from St Saviour's Road, which joins London Road as a fork. It has a clock at first floor with a black iron dial. In the angle of the two roads is a **tollhouse**, *c.* 1820–30, marking the start of the Grosvenor turnpike, the real beginning of the great road to London. It is now part of a block of shops known as **Balustrade**.

On the s side is the bowed w end of **Grosvenor Place**, designed by *John Eveleigh*, started in 1791, a long terrace of forty-one houses and a hotel with a gently convex centre, screening Grosvenor Gardens, one of the Vauxhalls or pleasure gardens of Bath (*see* Introduction, p. 32). It extends most of the remaining length of this walk and can be visited now or on one's return to Bath, but it will be described here in entirety for convenience. It is the only completed part of an immense intended scheme of 143 houses. Following his bankruptcy, Eveleigh sold his share in the project, the gardens were abandoned soon after 1810, and the hotel and many houses were still unfinished in 1819.

Forming the middle of the terrace, the hotel, No. 23, is gaily ornate and somewhat vulgar, almost Baroque [135]. The ground floor has vermiculated rustication, and arched windows with bearded icicle man keystones. Above are seven giant attached Ionic columns, forming an even number of bays as at Camden Crescent (*see* Walk 5, p. 174). It will be noticed that one of these columns stands wilfully over the top of a doorway. This mannerism is surely deliberate. The shafts are decorated with bands of garlands, the lower band left uncarved when money ran

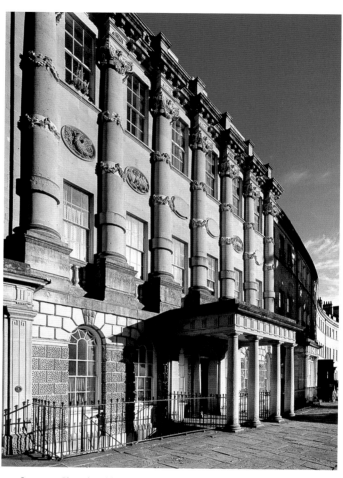

135. Grosvenor Place, hotel façade by John Eveleigh (started 1791)

out. Above the first-floor windows are oval plaques with reliefs of animals; three of the six plaques also uncarved. Only the columns have a full entablature, but the modillioned cornice breaks back across the bays. Above is a balustraded parapet. The central doorway, with its later four-column Doric porch, was originally designed as an arched entrance to the pleasure gardens. The terraces swell forward to meet the hotel, and these flanks are punctuated by three houses that step slightly forward as pavilions, one to the left and two to the right. The plan is orientated towards the view with the staircase at the front and a large first-floor drawing room overlooking the gardens to the s. No. 13 is exceptional, five bays, Ionic doorcase, good ironwork and stair hall across two bays. Projecting porches to several houses are early C19

Greek Revival additions. Singling out one or two, No. 3 has Soanian pilasters, a triglyph frieze and vermiculated plinth and No. 20, a good set-back Doric doorcase.

On the N side, **Beaufort West** is another late C18 terrace. At its E end, **St Saviour's Way** leads, out and back, to **St Saviour**, St Saviour's Road, 1829–32, a Commissioners' church [28], probably by *Pinch the Younger* to the elder *Pinch*'s design. The plan approved in 1824 was Doric, the building is Gothic. It cost £10,600 and seated 1,096. *C. E. Davis* added the chancel in 1882. It is in the Somerset Gothic of the early C19 and modelled on St Mary, Bathwick [108]. Neo-Perp w tower with octagonal buttresses, pinnacles and parapet. Tall Perp windows. The broad galleried interior, now sub-divided to form a church hall, has tall, thin piers, and plaster tiercon vaults. The chancel however is fan-vaulted. – Gothic **reredos** by *J. D. Sedding*, 1886, carved by *Harry Hems*, marble and stone, immensely rich in its Dec decoration and carvings. – Octagonal oak **pulpit** and octagonal stone **font**, late C19. – The late C19 pews were removed *c.* 2000; the gallery **pews** are original. – **Organ**. By *Sweetland*, *c.* 1882, richly painted. – **Monuments**. Many tablets. Frances Pottinger, d.1842, by *Reeves*. The usual two allegorical females, but they now stand left and right of a Gothic panelled tomb-chest.

Facing the church are **mews** to Beaufort East, the next terrace after Beaufort West. The coach houses to Nos. 5 and 9 have quatrefoils and castellated parapets to the garden. **Beaufort East**, *c.* 1790, still with Tuscan doorcases, is set high and back from London Road. Flanking the E end, **Beaufort Place** running N, has a Regency period terrace of pretty, painted artisans' cottages, several with original porches and trellis-work. At their s end, **Lambridge Mews** runs E. The coach house and coachman's cottage to No. 10, *c.* 1800, is Gothick style to the garden, with quatrefoil windows and battlements. Returning to London Road and continuing E, **Lambridge** is a row of Regency villas set back behind gardens. Nos. 1–11 are attached and yet of individual design. Nos. 12–13, **Barn Close** and **Cedar Lodge**, are semi-detached, each a symmetrical seven-window range with full-height segmental bays, rusticated ground storeys and gadrooned urns on the parapet. No. 13 has a fine cast-iron veranda with lead ornaments and trellised supports. Dr Joseph Channing Pearce and his museum of 22,000 fossils occupied No. 15, **Montague House**, in the late C18.

Between Nos. 13 and 14, Lambridge Street, then Upper Lambridge Street, leads into the centre of **Larkhall** village and **Larkhall Inn**. Originally a house of mid-C18 origins, it became a pub with attached stabling and brewery. Its location on the old Gloucester Road made it an important staging post for mail coaches.

Walk 10

Victoria Park
to the Paragon

Leaving behind the bustle of the town, Royal Victoria Park is one of Britain's earliest public parks, and contains rewarding architectural and sculptural features, some with remarkable provenance. Climbing a little N, we return to the city centre in a broad arc that follows several intact Georgian developments and takes in the Building of Bath Museum.

We begin just w of Gay Street in **Royal Avenue**, at the Rivers Gate leading into Royal Victoria Park. The **war memorial** of 1923 is by *Sir Reginald Blomfield* (one of three architects to the Imperial War Graves Commission, together with Lutyens and Sir Herbert Baker). His Cross of Sacrifice design, erected at many military cemeteries and memorials across the world, forms the centrepiece. The design – flanking rustication, cornice and bronze lions – relates to, and forms a group with, the **Rivers Gate**, Soanian piers and arches to former gates of 1830 by *Edward Davis*, with later modifications. The classical *Coade* stone lions on top, reputedly bronzed originally, 1833, came from the Freemasons' Hall in York Street (*see* Walk 1, p. 105). **Royal Avenue** leads N then w through the park. Parallel, and hugging the rear of Gay Street, the Circus and Brock

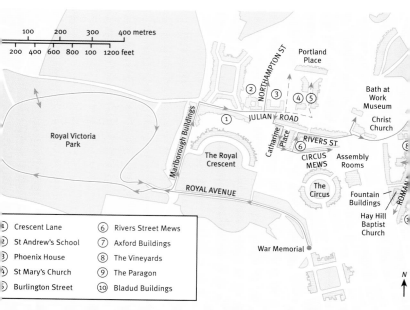

137. Royal Victoria Park, Victoria Gate by Edward Davis (1830)

138. *Plan of Victoria Park*. Drawing by Edward Davis (1829)

Street, is the **Gravel Walk**, laid out in accordance with the building leases of those properties, but now part of the park (*see* Walk 3, p. 151).

The 46 acre (19 ha.) **Royal Victoria Park** was designed in 1829 by *Edward Davis*, just three years after his return from Soane's office in London [138]. It is a remarkably early British public park, substantially predating John Claudius Loudon's Derby Arboretum (1839), and Joseph Paxton's People's Park (1843–7) at Birkenhead.

Entering **Royal Avenue** just beyond the Rivers Gate on the w side is a C19 Italian Carrara marble **vase** with putti and garlands, from Villa Grimani, Stra-Padua, donated in 1910. A few metres further, **Royal Victoria Park Pavilion**, 1997, by *C. G. Davies*, timber clad around a steel structure, with projecting eaves and a deck to the s and an exposed pine roof inside. Opposite, a **pedestal** with wreath decoration, once bearing an urn, is standard C18 production from Bath mason's yards. Royal Avenue now swings w and on the N side, the **Kemble Vase**, mid-C19, donated by the sculptor *S. S. V. Pieroni* (*see* also Walk 8, p. 206), is an outrageously large basin showing the capabilities of Bath stone.

Royal Victoria Park

Its history is meticulously documented in Frederick Hanham's later *Manual for the Park* (1857) which records the species planted, and in the Park Committee's Annual Reports, albeit in a self-congratulatory tone. 'The Committee disclaim any participation in that just meed of praise so liberally bestowed – it belongs to Mr. Edward Davis, Architect, who so tastefully laid it out, and to him exclusively. He it was, who has in this instance, so happily blended the luxuriance of nature with the classic proportions of art, as to render the Park at once an ornament to his native city, and a lasting memorial to his own fame.' The idea was initially instigated by a group of local businessmen to improve the Crescent Fields, land s of the Royal Crescent belonging to Lady Rivers, though it was decided to extend the plan to include the larger Common Fields to the w to provide sufficient land for ornamental plantations, walks and drives. The park is thus in two halves separated by Marlborough Lane (*see* below). Work started by January 1830 employing nearly 200 men. The Duchess of Kent and her daughter Princess Victoria officially opened the park on 28 October 1830, hence the name Royal Victoria Park.

Opposite, s side, is an elaborate C18 solid **urn** with serpents. Further on the s side, the **bandstand**, *c.* 1887 by *Charles Edward Davis*, has a very interesting parabolic roof for sound reflection, continuous with the walls.* Flanking the bandstand are a pair of Cararra marble **vases**, a gift of Napoleon Bonaparte to the Empress Josephine 1805, set within Portland stone **aedicules**, brought from France after the Peninsular War by Col. Page and bequeathed in 1874. They are possibly to the design of *Percier & Fontaine*. The bandstand is centred on the Royal Crescent to the N. In between is the 6 ft-(1.8 metre)-high **ha-ha wall**, running E-W, *c.* 1774–7. With a rough masonry finish in keeping with the Arcadian character of the pastureland on which it bordered, it kept livestock at a respectable distance from the Royal Crescent, while retaining them in view.

Continuing w through the entrance to Marlborough Lane, the **Victoria Gate**, 1830, by *Edward Davis*, a pendant to his Rivers Gate, is a pair of severely trabeated, primitive Greek Revival triumphal arches [137]. It recalls the severe pilaster strips and simple raised central attic to the w front of the church of St John, Bethnal Green in London, on which Davis was involved in his last months at Soane's office. The

*Cf. H. Heathcote-Statham's design for an orchestra platform illustrating his paper, 'Architecture practically considered in relation to music', RIBA, 1872.

139. Royal Victoria Park, Park Farm House, a *cottage orné* by Edward Davis ('being built' 1831)

adjacent **Park Farm House** [139], a *cottage orné* – i.e. not related to real agriculture – was 'being built' in 1831. It is a charming asymmetrical, Picturesque gabled composition, with splendid bargeboards, tall octagonal Tudoresque chimneys, oriels and hoodmoulds. The centrepiece now of the entrance is the **Victoria Column**, actually a crisp triangular obelisk with a corresponding tri-axial base with guarding recumbent lions, set within a circular balustrade, dated 1837, by *G. P. Manners.*

This larger part of the park to the w was an 'immense plantation' of more than 25,000 evergreens, forest trees and shrubs which 'belted the whole meadow' from the lower end of Marlborough Buildings. A carriage drive and gravel walk were built through this plantation, with shrubberies on both sides along the South Walk and on the North Walk along the upper boundary. These formed 'agreeable drives' and 'shady promenades', while a fish pond with an encircling gravel walk created a central feature. Davis's plan followed the principles of landscape design described in many current books, including Humphry Repton's *Fragments on the Theory and Practice of Landscape Gardening* (1816), John Claudius Loudon's *Hints on the Formation of Gardens and Pleasure Grounds* (1812), and Loudon's popular *Encyclopaedia of Gardening* (1823). *William McAdam* became involved from 1835 and he supervised, without payment, the improvement and maintenance of the drives until 1843.

The Walk now makes a clockwise circuit of the 'carriage drive'. To the w, the ornamental lake was enlarged to a serpentine form in the 1870s with a rustic bridge by *Edward Milner*; the lake was restored, 1996. Across the w side of the lake, the Neoclassical **Victoria Vase**, dated 1880, celebrated the half-centenary of the park's opening. Continuing w and then N we come to the **Botanical Gardens**, laid out 1887, with its maze of paths and massed flower beds. These were to display the increased number of foreign plants and flowering shrubs introduced by that time. On the N side the **Temple of Minerva**, built by the Corporation of Bath as a pavilion at the 1924 British Empire Exhibition at Wembley, and re-erected here in 1926, when the botanical gardens were extended E. It has a three-bay colonnade with double columns. The s parapet has 'Aqua Sulis' in pierced letters (giving the impression of Jacobean strapwork), the E parapet, 'City of Bath.'* From the adjacent N entrance of the Botanical Gardens, the **Great Dell** opposite has a remarkably classical **Shakespeare Monument** in the form of a Roman altar, by *C. E. Davis*, erected in 1864 on the 300th anniversary of Shakespeare's birth. Just NE is a colossal piece of public sculpture in Bath stone, of rare size, a giant bearded bust of Jupiter, 1835–8 by *John Osborne*. The stepped 19 ft-(6 metre)-high plinth was designed in 1861 by *James Wilson*, carved by *H. Treasure*. The circuit is now completed along the N and E sides, the only further feature of interest being the enormous rear façades of Marlborough Buildings that bound the E side.

Returning to Marlborough Lane and heading N uphill, the long terrace of **Marlborough Buildings** brings urban Bath to an abrupt end. The development, on the w side only, was promoted by a tiler, plasterer and a statuary mason on land obtained in 1787. The houses are plain with unadorned arched doorways, a characteristic motif of the ending C18, except for the much more elaborate central trio, Nos. 13–15. They mark the end of the vista from Brock Street across the front of the Royal Crescent. Their central first-floor windows have pediments set in shallow arches with decorative panels either side (cf. Nos. 28–30 Green Park by Palmer – *see* Walk 11, p. 251). The larger rooms, at the back, overlook the view, with the staircase to the front. Originally identical, many at the N end have C19 bathroom and porch excrescences: Nos. 17–18, porches by *Hayward & Wooster*, 1885–7; Nos. 22 and 27, porches by *F. W. Gardiner*, 1905 and 1910; No. 25, a full-height extension with a French mansard roof by *W. E. Tovey*, builders, 1885.

On the E side of Marlborough Lane are the irregular rear façades of the Royal Crescent. Turning E at the top, in **Crescent Lane** are several good **coach houses** (for the garden elevations, *see* Walk 3, p. 150). No. 17, 1843 by *James Wilson*, has a yard flanked by two-storey wings, each with an open pediment to the gable-end on heavy paired brackets. No. 15,

*Cf. the Temple of Minerva, Sydney Gardens (*see* Walk 6, p. 185), another transplanted exhibition pavilion commissioned as part of an export drive.

140. St Andrew's School, Julian Road, interior, by Nealon Tanner Partnership (1991)

part of the Royal Crescent Hotel's Neoclassical Dower House, 1985–6, by *William Bertram & Fell*, is big scale with rustication, a rounded centre expressing a staircase, and flanking pavilions with blind arches; it incorporates C18 gatepiers. No. 14, *c.* 1773, has two-storey wings flanking a narrower recessed centre with a small yard.

Bounding the N side, **Julian Road** sits approximately on the line of a Roman road. At the W end the Church of **St Andrew** is by *Hugh D. Roberts*, 1961–4, simple, dignified with a square side tower open at the top. The chancel has abstract stained-glass panels. The exterior reuses rubble from old St Andrew, which once occupied the adjacent large, forlorn green triangular space to the S. By *George Gilbert Scott*, Gothic Revival, 1869–73, it had a spire of 1878, at 220 ft (67 metres) once the tallest landmark in Bath. It was bombed in 1942 and finally demolished *c.* 1960; the footprint of its foundations is visible in the grass during a hot summer. Adjoining the new church, E, the delightful single-storey **St Andrew's School** by *Nealon Tanner Partnership* [140], 1991, presents to the road a heavy, protective rubble base pierced by porthole windows. A contrasting, colourful steel-frame structure supports the roof, pierced by playful metal vents.

W of the school, **Phoenix House** is a block of forty-three housing units for Bath City Council by *Hugh D. Roberts*, 1951–3. The building, in six sections, is ashlar-faced on a rubble plinth, now altered with pitched roofs. The E and W blocks have communal internal staircases, the Julian Road frontage, balcony access with two-storey maisonettes for maximum southerly aspect. Between the school and Phoenix House,

Northampton Street off to the N was developed on land (known as Buttsway since Tudor times) bought by the Pulteney Estate in 1791. *Baldwin* prepared designs but *Pinch the Elder* took over the scheme in the 1790s; there were seventeen houses by 1800. Nos. 7–8 were rebuilt in replica by *Oakwood Homes*, completed 1998. The steeply sloping upper section, **Northampton Buildings**, was built cheaply by *Thomas Scott* in 1820–6 to designs of *G. P. Manners*, his only speculative housing scheme.

There is now an optional out-and-back excursion further E along Julian Road to St Mary (R.C.) and Burlington Street and Portland Place, the only streets of several built after 1780 N of Julian Road to have architectural merit. The ambitious and unfinished **Our Lady Help of Christians (St Mary's Roman Catholic) Church**, 1879–81 by *Dunn & Hansom*, is in Gothic Revival style, externally lower and more spread-out looking than Puginian. Nave and s aisle of five bays, chancel and s chapel of three narrower bays. The interior has marvellously delicate sculpture with birds and flowers, and angels along the aisle arcade. The superb Italian marble **reredos** is by *Signor Leonardo*. – **Stained glass** by *Hardman.* The church was restored *c.* 1950 following bomb damage.

E of the church, sloping N, **Burlington Street**, *c.* 1786 by *Palmer*, steps uphill. **Portland Place** on a raised terrace across the top N side forms with Burlington Street a T-shape. By *John Eveleigh*, 1786, it is a uniform range of ten houses, well proportioned and of considerable severity, with a plain platband above the ground floor, continuous upper window sills and a strong cornice. The pedimented three-bay centre of the centre house projects forward. The composition is spoilt by Nos. 6–8, where an attic storey was added by *C. E. Davis* in 1875. A high pavement with continuous steps extends the whole length, with a central double ramp for sedan chairs, with a stone obelisk each side. (Further E still along Julian Road are **Lampard's Buildings**, ziggurat flats, 1960, by *City of Bath Architects and Planning Department*.)

Return w along Julian Road, and s and at once E into Rivers Street, of which more below. **Catharine Place** off to the s by *John Wood the Younger*, *c.* 1777–84, is especially attractive in its intimacy, with a pleas-ant secluded central garden (railings restored, 1990s). No. 19, s side, has Gothic glazing to the Venetian first-floor window. No. 1, E side, was rebuilt in 1946 after war damage and No. 17, s side, rebuilt behind the façade in 1948. At the s end off to the E, **Circus Mews**, N side, were originally late C18 stables and coach houses with accommodation over, serving the Circus. The mews, grouped around courtyards with throughways from the street, were almost completely recon-structed using modern materials by *MWT Architects*, 1986–95. On the s side ten new houses by *Edward Nash Partnership*, 1995. Those on the street frontage take the typical plan of a three-storey terraced house, but are split-level front and back and are entered off the half-landing of the stair. Houses in the courtyard have a spiral stair rising through three

flights around a structural column. Although the street retains little historic fabric, these dense small-scale developments collectively form a successful piece of urban repair. Returning N up **Rivers Street Mews**, E of Catharine Place, where, E side, **Rivers Cottage** and **Rivers Street Mews** are a late C18 or early C19 cottage and former stables surrounding a courtyard. These modest structures are the best surviving Georgian mews in the city.

Rivers Street, running E, is a picturesque, meandering Georgian street, for some time the northernmost boundary of the built-up area. *John Wood the Younger* developed it on land purchased from the Rivers Estate (owned by Sir Peter Rivers Gay) in the late 1760s. A number of Bath builders implemented Wood's overall design from the 1770s. By 1779 Wood had disposed of twenty-three plots; Nos. 1–15 are later and lower than the rest on the N side (Nos. 5–7 with simple Venetian first-floor windows); Nos. 48–50, S side (including the Chequers pub since at least 1833) are small early C19. The W end suffered bomb damage: Nos. 1–2, 3, 5 and 7 were reconstructed in the late 1940s by *Mowbray Green & Partners* and others. The earlier houses are standard Palladian, mostly with plain Tuscan doorways; a semicircular enriched doorway with fanlight to No. 18. No. 39 was the architect George Phillips Manners' house; his mentor Harcourt Masters also lodged there. No. 36 is later infill. No. 35 has a first-floor plaster ceiling in the style of *Daniel Fowles*, one of the principal builders in this area. (For Russel Street off to the S, *see* Walk 4, p. 163.)

At the end of Rivers Street is **Christ Church** Julian Road, 1798 by *John Palmer*, the first instance in England of a free church erected primarily for working-class families and servants unable to afford pew rents. It was also the first bigger Neo-Gothic church in Bath, though still Gothic only in a vague way, with wide nave and aisles like a classical church. The simplicity of design and detailing reflect its charitable status. The W tower is plain, with porches of two bays' width spreading to either side. The battlemented parapet, octagonal turrets and pinnacles are by *Wallace Gill*, 1908. Inside, tall quatrefoil piers support galleries. The ground floor accommodated 800 non-fee-paying worshippers, with chargeable places up in the galleries to help pay costs. Small quatrefoil windows lit the lower level, now segment-headed rectangular. The apsidal chancel with nine lancet windows was inserted, 1865–6 by *J. Elkington Gill*. *Manners & Gill* and the succeeding practices made numerous other alterations and additions to c. 1945. – **War memorial** by *Mowbray Green*, 1920. – **Stained glass**, two in the S gallery by *A. O. Hemming*, 1890; two in the W gallery by *James Powell & Sons*.

Behind the church, the schoolrooms of the former **Christchurch Infants' School** by *Browne & Gill*, 1894, are raised above an arcaded covered playground (cf. the Cornmarket, Walcot, *see* Walk 9, p. 223). The adjacent Tudor style **Christchurch Cottages** are by *Fuller & Gingell*, 1856. Set further back, the **Museum of Bath at Work** occupies a

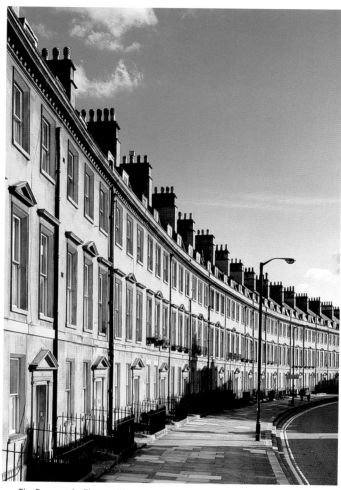

141. The Paragon, by Thomas Warr Atwood (1768–75)

rare example of a former **Royal Tennis Court**, built in 1777 by *Richard Scrase*. The plain rubble exterior has nine bays of clerestory windows, originally extending lower. It became a brewery in 1825, when two floors were inserted, and a museum in 1969. E of Christ Church, N side, behind a raised pavement, Nos. 1–4 **Montpelier**, 1770–6, have first-floor Venetian windows and wrought-iron balconies, a modillion cornice and parapet.

Across Lansdown Road, **Guinea Lane** descends steeply E and N. On the S side, the former **Catholic Apostolic (Irvingite) Church**, 1841 by *G. P. Manners*, is Norman Revival style, skilfully designed on a cramped

site. A segmental apse to the chancel, lower than the nave, has scallop-capital engaged columns set in round-arched window reveals. Irving was a cult London preacher and it was used by the Irvingites until the 1860s, when it became St Mary's (R.C.) church hall and the Kingdom Hall of Jehovah's Witness in 1976. Adjacent downhill, **Walcot Schools**, 1840, by *James Wilson*, is a boldly detailed, powerful building of irregular plan, with a commanding presence of huge scale for its modest triangular site. On a basement plinth that increases in height with the slope, two tall storeys are treated as a giant, deeply recessed arcade of seven bays. The end bays break forward with quoins and long corbel brackets and, with similar returns, function as corner towers. Within the bays are narrow flat-arched ground-floor windows with cornices and consoles over, and round-arched marginal glazed windows above. The schools once accommodated 1,000 children.

Opposite the end of Guinea Lane, E side, extending S is the immense terrace made up of Axford Buildings, The Paragon and Bladud Buildings (*see* below). **Axford Buildings**, sixteen terraced houses, 1767–73 by *Joseph Axford*, stonemason, are numbered with, and continuous with, The Paragon. Nos. 28–32 were rebuilt after destruction in 1942. The twenty-one **Paragon** houses of 1768–75 [141] were built on land leased from the Corporation, to plans by *Thomas Warr Atwood*. They have a slightly concave form, though they only follow the existing road line and contour and are not deliberately designed as a crescent. The standard elevations for buildings on Corporation property, three storeys, pediment over the middle first-floor window with good classical detail and fine scale. The first-floor sills were all lowered as required under lease renewal in 1870 (*see* Introduction, p. 30). To the rear they sit on massive foundations (*see* Walk 9, p. 225 and Introduction, p. 28), and are planned with the larger rooms here overlooking the extensive prospect.

Extending down the **W side** on a raised pavement above the street is the **Vineyards**, so called from those that covered the slope until *c.* 1730. The picturesque miscellany of styles and scales is unusual for Bath. Several houses have old insurance marks. At the extreme N end, the **Star Inn**, first licensed as a pub in 1760, was formerly two houses, Nos. 22–23. No. 23, N, has a complete mid-C19 fitted interior by *Gaskell & Chambers*, including bar, oak panelling and numbered rooms, compulsory when licensing laws required all rooms to be numbered and listed for their purpose. Additional storey by *A. J. Taylor*, 1948. No. 22 was reconstructed in 1928, by *W. A. Williams*, with a lobby, staircase and lounge with matching oak-panelled interior. No. 20 is a five-bay detached Palladian villa, *c.* 1765, pedimented with an oculus in the tympanum and pedestals for acroterial ornaments. Nos. 18–19 have Baroque keystones and provincial (i.e. smaller, flatter) Gibbs surrounds, and pedimented first-floor windows with pulvinated friezes. Nos. 16–17 were originally one house. No. 15 has quoins, Gibbs surrounds and

142. The Countess of Huntingdon's Chapel, the Vineyards (1765)

second-floor Venetian window, and old render to the ground floor, typically lined out in courses. No. 14 has a bow front, No. 13, quoins, a third-floor Venetian window and a crude Tuscan pedimented doorcase, and typical later Victorian window reveals.

The **Countess of Huntingdon's Chapel** [142] was built in 1765 for Selina Hastings, Countess of Huntingdon, a prominent figure in the Evangelical movement, 'to protect the residents from the evils of Bath society'. It also gave preaching opportunities to her personal chaplain, George Whitefield, the celebrated Calvinistic Methodist. The architect is uncertain. The exceedingly pretty little villa façade is that of the Countess's own house from 1765 until her death in 1791. The chapel itself is at the back. It is one of the first efforts in the Gothick style at Bath, and the first connected with ecclesiastical architecture. The front is embattled and has a canted bay window with single-storey flanking wings that return both sides in the same style. The windows have ogee-heads separated by engaged cluster columns in the manner of Batty Langley, the centre is given a kind of tripartite window also with ogee-heads. The windows on the sides and at the back are larger, round-arched, and provided with intersected tracery, perhaps at a slightly later date. The chapel is aisleless with a flat ceiling. Horace Walpole in 1766 called it 'very neat, with true Gothic windows' and added: 'yet I am not converted'. Last used for worship in 1981; acquired by Bath Preservation Trust, restored by *Aaron Evans Associates* and fitted out as the **Building of Bath Museum** by *Michael Brawne & Associates*, 1984–8, as a unique museum essential to understanding Bath's Georgian development.

To the s, the **Countess of Huntingdon's Schools**, by *Manners*, 1842, with mullioned and transomed windows with hoodmoulds, were formerly the Sunday School to the chapel, now the interiors section of the Building of Bath Museum.

s of the chapel the Vineyards conclude with a range of simple houses, *c.* 1765–70. No. 9 has late C18 flower baskets and an early C19 Gothick footscraper; No. 8, an early style of architrave door surround with very heavy consoles, Nos. 1–5, Venetian windows, the arches to Nos. 3–5 blocked. On the s corner of the pedestrian **Hay Hill** off to the w, **Hay Hill House**, 1870 by *C. E. Davis*, is tall, four storeys in a quirky classicism with banded ground storey and a rounded corner on the acute return to Hay Hill, where the block continues, very plain, as **Agincourt House**. **Hay Hill Baptist Church**, set on the raised pavement that continues from the Vineyards, is a craggy, buttressed Gothic chapel with a rock-faced gabled front, 1869–70 by *Wilson & Willcox* (cf. Manvers Street Baptist Church, *see* Walk 8, p. 213). *Carter Hughes Partnership* converted the interior in 1985–6, inserting a new floor at balcony level.

Back on the E side, **Bladud Buildings**, 1755–62, probably by *Thomas Jelly* or *Thomas Warr Atwood*, was the first of the three great terraces here. Again the design is prescribed but, very unusually, the front elevation is repeated on the rear (*see* Walk 9, p. 225). The centre house, No. 8, is pedimented and projects slightly. Bladud Buildings links with the Paragon over a flight of late C18 steps that descend to Walcot Street (again, *see* Walk 9, p. 225). Fronting the steps are three handsome late C19 cast-iron ornamented bollards. The doorways are mostly pedimented Tuscan; Nos. 9 and 15, taller, Corinthian. Nos. 1–8 have projecting C19 shopfronts. Over the two right-hand bays of No. 6 is an early C19 full-height segmental bow with reeded mullions. No. 3 in 1871 was occupied by Gustav Horstmann, 'inventor, maker and patentee of the perpetual self-winding clock', founder of Horstmann Engineering, continued today as one of Bath's most important companies.

South-West of the City Centre

This is an excursion w of the medieval city through **Kingsmead** (*see* Introduction, p. 17) to the extremity of the considerable Georgian extension westward, starting and finishing in Kingsmead Square just w of the West Gate (*see* Walk 1, p. 115). Despite having been heavily bombed in 1942, with subsequent clearance, some principal features remain, including the early and delightful Beauford Square.

Kingsmead Square, begun in 1727, was developed on land called Kingis Mead belonging to St John's Hospital. It was one of the first planned developments in Bath, contemporary with John Wood's Queen Square (*see* Walk 3, p. 135) and the first outside the city walls. Permission to demolish the neglected s **side**, Nos. 5–10, by *John Strahan* of Bristol, damaged in the war, was refused in 1969 (an early sign of the arrest of postwar demolition) and they were restored in 1974–6 by

143. Rosewell House, Kingsmead Square, detail of Atlantis figure (1735)

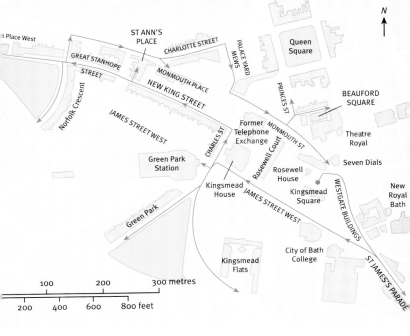

Map labels:

N

ST ANN'S PLACE

CHARLOTTE STREET

PALACE YARD MEWS

Queen Square

1 Place West

GREAT STANHOPE STREET

MONMOUTH PLACE

NEW KING STREET

PRINCES ST

BEAUFORD SQUARE

Norfolk Crescent

JAMES STREET WEST

CHARLES ST

Former Telephone Exchange

MONMOUTH ST

Theatre Royal

Seven Dials

Green Park Station

Rosewell Court

Rosewell House

Kingsmead House

JAMES STREET WEST

Kingsmead Square

WESTGATE BUILDINGS

New Royal Bath

Green Park

City of Bath College

Kingsmead Flats

ST JAMES'S PARADE

100 200 300 metres

200 400 600 800 feet

144. Walk 11

David Brain & Stollar. Thick-section glazing bars replaced plate glass and new stone windows and doors replaced c19 shopfronts. The square now contains inappropriate street furniture. At its w end lies the most ornate house in Bath, No. 14, **Rosewell House** (originally Londonderry House), built for Thomas Rosewell. The architect was probably *Nathaniel Ireson* of Wincanton, Somerset, who developed parts of the square in the 1730s and who still worked in provincial Baroque. It bears the date 1735. It is thus later than Wood's Queen Square, yet is still entirely and unashamedly Baroque, with German–Flemish influence. It has five bays, three storeys and a hipped roof. There are angle pilasters and pilasters flanking the middle bay. The windows to the left and right have heavy and very complex frames and keystones with busts. Yet they are nothing compared with those of the centre bay, above the simple doorway with Ionic columns and a pediment (now flanked by inserted shopfronts). The first-floor window has bearded termini Atlantes to the left and right, their chests bulging forward [143]. On the floor above are the most fantastical grisly curves and gambols and garlands. *Wood*'s judgement in his *Essay on Bath* was 'nothing save ornaments without taste'. A heavy side elevation faces **Kingsmead Street**, right (otherwise mostly lost to bombing). Inside, the entrance hall has full-height raised panelling and, in the stair hall beyond, an excellent wooden staircase with three balusters per tread, the centre ones barley-sugar twisted, the outer turned, and ramped dado panelling. The first-floor landing has a Doric doorcase with triglyphs.

145. Nos. 39–40 St James's Parade, double doorcase perhaps by John Eveleigh (*c.* 1768)

E of the square is the site of the medieval West Gate. In Westgate Buildings, running s, the (former) **Co-operative Wholesale Society Building**, 1932–4 (w side) by *L. G. Ekins*, is Neoclassical with a pedimented centre and flanking pavilions with giant fluted Ionic pilasters. Adjoining to the s, **Westgate Buildings**, originally *c.* 1760–71, follow the curve of the medieval city walls. Nos. 13–14 are the only c18 survivors. Nos. 11–12 were rebuilt after war damage in 1951 by *Tew, Pope & Oliver*. Opposite to the s, at the junction of James Street West and St James's Parade, **City of Bath College**, 1957–63 [33] by *Sir Frederick Gibberd* is dominated by a large general-purpose block to the front with a raised projecting lecture theatre and pentagonal assembly hall expressed as free-standing sculptural forms. The scale and form are utterly alien to its context.

Continuing s, **St James's Parade** (originally Thomas Street) of *c.* 1768 is a development by *Thomas Jelly*, *Henry Fisher* and *Richard Jones*, for which they obtained approval in 1765 to demolish the medieval walls next to the Ambry gardens. The design is probably that of *Jelly & Palmer*, though it closely resembles work by the younger Wood in Brock Street, Miles's Buildings and Rivers Street (*see* Walks 3, 4 and 10, pp. 145, 161 and 241). It used to be a private, broad paved walk enclosed by bollards. The first-floor windows are Venetian, some with Gothick glazing bars. The pedimented doorcases have various orders – Tuscan, Doric, Corinthian, and, at No. 19, sw side, Ionic. On the NE side, Nos. 39–40 (which may be by *John Eveleigh*) share a notable doorcase: three columns with Tower of the Winds capitals support an entablature with a festooned frieze and a large pediment [145]. Over the doorway of No. 33 is a bust of Athena, goddess of wisdom. Nos. 41–43 were rebuilt in replica in 1964.

Returning to the N end of St James's Parade, we now make an excursion to the western extremity of the Georgian city, first W into **James Street West**. Most of *Strahan*'s streets near here, i.e. Kingsmead Street, Monmouth Street, Avon Street, were obliterated in the Second World War, and replaced by some of Bath's most barbaric developments. No. 3, a late 1930s Neoclassical fragment on the corner of Milk Street, the old **Employment Exchange** by the *Office of Works*, is scarred by shrapnel. It is a poignant reminder of what Bath looked like after the Blitz. On the N side is **Rosewell Court** (1961), an insensitive estate of council dwellings by *Hugh Roberts* (a former mayor). A five-storey block of deck-access maisonettes with balconies faces the street, a similar block of nine storeys is at right angles behind and a five-storey block of walk-up flats fronts Monmouth Street to the N. Beyond to the W is the hostile eight-storey social security office, **Kingsmead House**, 1964–5, by *W. S. Frost*, senior architect for the *Ministry of Public Building and Works*. s along Green Park Road, on the left are **Kingsmead Flats**, a 1930s estate of local authority housing, replacing slums demolished in 1932. Refurbished by *Feilden Clegg Design* in 1992 after extensive consultation with the tenants. The upper access decks became private balconies, common open staircases were enclosed and many ground-floor units given gardens. A new community facility was built in the central courtyard, which was extensively landscaped.

Opposite, the wedge-shaped green open space has on its W side a great terrace, **Green Park** (formerly Buildings), by *John Palmer*, originally enclosed also by a converging E range, now demolished, which met at the N apex with Seymour Street, also by *Palmer*. This too has gone, the W side for Green Park Station in 1869, the E side *c*. 1950, following bomb damage. Nos. 31–40 are of 1792–6 (cf. St James's Square, *see* Walk 5, p. 164), continued at Nos. 20–30 on a taller, grander scale, *c*. 1790–1805, probably also by *Palmer* (cf. Nos. 28–30 with the central feature of Marlborough Buildings – *see* Walk 10, p. 240). Their style and that of Norfolk Crescent further W (*see* below) is indicative of the new Late Georgian developments – longer, slimmer windows, iron balconies, verandas and overthrows. The arched doorways have sidelights and good fanlights. No. 40 has a good Tuscan doorcase with an open pediment.

Green Park Station [29], Queen Square Station until 1951, was built in 1868–9 at a cost of £15,625 by the Midland Railway for services to Bristol and the north, and was also used from 1874 by the Somerset and Dorset Joint Railway Company. Here an effort is made to impose Georgian conformity even on a station façade. The architect of the station building was *J. H. Sanders* and the builder, *Mr Humphreys* of Derby. The polite elevation to the city has two storeys with a rusticated ground floor with six first-floor Ionic columns and pilasters to flanking pavilions, with a glazed ornamental cast-iron porte-cochère. The train shed, a forthright design with much delicate detailing by *J. S. Crossley*,

chief engineer of the Midland Railway (builder, *Andrew Handyside* of Derby), has a 65 ft (20 metre) central cast- and wrought-iron vaulted glazed roof with small trusses over the wood-floored platforms to either side. Both buildings are indeed creditable though they clash where they meet, little effort having been made to bring the two together. The last train ran in 1966. Bath City Council purchased the station in 1974 and *Stride Treglown Partnership* restored it in 1982–4 at the expense of Sainsburys, a trade-off for permission to build the adjacent superstore. The station is now regenerated: the booking hall is a brasserie with a public meeting room upstairs; shops flank the s platform and the former tracks serve as a car park and farmers' market.

A little to the N reached up Charles Street, running W, **New King Street** was built in 1764–70 by various tradesmen, including *John Ford*, mason, with *Jelly*, s side, and *James Coleman*, carpenter, N side. The **Christadelphian Hall** on the N side is a diminutive building dated 1880. The houses are plain but generous, one and two bays wide (No. 25, three), broadly consistent with variations of detail. Building was in small sections marked by straight joints. The N side has pedimented Tuscan doorcases. No. 55, NE end, was a symmetrical composition with its demolished neighbour, as the blind former centre bay indicates. Nos. 7–9 are rebuilt in replica. No. 19 was the home of the astronomer and musician William Herschel, friend of Haydn, and is now a museum of the Bath Preservation Trust. From here he discovered the planet Uranus in 1781. The interior illustrates a typically modest C18 Bath dwelling – basement kitchen, ground-floor dining room, first-floor drawing

room. Near the w end of New King Street is **St Ann's Place**, *c.* 1765, restored by *Aaron Evans Associates* in 1987, a Pennant-paved court of two-storey ashlar-faced artisan houses with continuous timber ground-floor lintels. The doorways have simple hoods. Through a gap in the N end is the rear of No. 9 Monmouth Place; mullioned windows indicate late C17 origins that belie its late C18 front façade. The two-bay houses of **Great Stanhope Street** follow w, again with pedimented Tuscan doorcases. Most of the N side was rebuilt in facsimile by *Design & Planning Associates*, 1983. No. 24 on the s side has interesting alterations by *Edward Davis*, *c.* 1830, in the manner of Sir John Soane. The porch has a shallow pediment, a Greek key frieze and reduced flanking pilasters with incised decoration and anthemia [146]. The swept ironwork to the balcony is derived from Soane's house at No. 13 Lincoln's Inn Fields, London.

Yet further w and terminating Georgian Bath in that direction is **Norfolk Crescent**, a very grand conception of eighteen houses with a radius of 420 ft (128 metres), built from 1792 by an attorney, Richard Bowsher, working with two craftsmen-builders. It was the centrepiece of an intended large development which was to have included a further street entering at right angles to the centre. The project was hit by the financial crisis of 1793, and only nine houses were completed by 1810, the remainder not until some years later. The houses are four storeys high and three bays wide with arched ground-floor windows and doorways. The middle three and the end houses break slightly forward to form pavilions, each with a giant Ionic order of plain pilasters and a detached pediment above the attic storey. The finely proportioned elevations suggest that the architect was *Palmer* and the joinery and elegant first-floor iron balconies and verandas with Greek key decoration suggest the finishing hand of the elder *Pinch*, by this time a bankrupt whose affairs were in the hands of Bowsher. Nos. 7 and 14 have wrought-iron lamp standards identical to Pinch's New Sydney Place. Nos. 1–7 at the N end, bombed in 1942, were rebuilt in 1958 for Bath City Council by *E. F. Tew*. The rear does not attempt a Georgian reconstruction. A charming stone circular **watchbox**, *c.* 1810, pilasters and a frieze with paterae, stands at the NE corner. Perhaps this is an interpretation of the Choragic Monument of Lysicrates in Athens. The pair at the Holburne Museum (*see* Walk 6, p. 182) are the only others in Bath. On the N side of the greenery, **Nelson Place West**, *c.* 1815, is built to a design related to Norfolk Crescent but of smaller scale. It remained unfinished for over 150 years, until *Marshman Warren Taylor* in 1973 added a w pavilion to match the E end, as part of an otherwise undistinguished development of twenty-four flats extending w in an abstracted Georgian style.

We now return to the city centre. Walking N up Nile Street, E along Upper Bristol Road for 170 yd. (150 metres) and a few steps out and back brings you into **Monmouth Place** (the right-hand fork), which was on

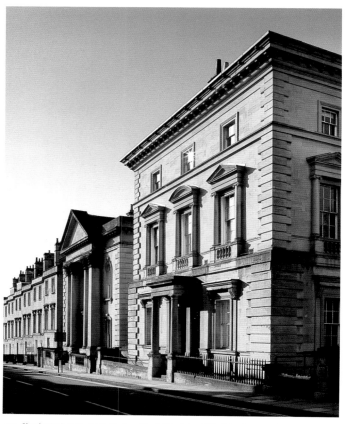

147. Charlotte Street: Bath Savings Bank (Register Office) by George Alexander (1841), the Moravian Chapel by James Wilson (1844–5) and, beyond, a terrace by George Phillips Manners (1839–40)

the important carriage route from Bath to Bristol. The **King's Arms** public house, on the s side, has a late c18 front with the royal coat of arms and a central carriage archway with large panelled spiked doors. Returning out of Monmouth Place, the left-hand fork is **Charlotte Street**, a new road of 1839–40 connecting the NW corner of Queen Square and the Upper Bristol Road, named after Lady Charlotte Rivers, wife of the lord of the manor of Walcot. It was laid out by *G. P. Manners* as City Architect, who at the same time also built the nine three-storey houses on the N side, the next after Northampton Street (*see* Walk 10, p. 240) of Manners' street frontages. Still at this date they have ramped platband and cornice in the manner of Pinch (*see* Topic box, p. 27) to accommodate the slope. The mid-c19 ashlar terrace with canted bays opposite (s side) makes an interesting contrast.

On the N side, is the former **Moravian Chapel**, no longer with any of the humility of the C18 Moravians. By *James Wilson*, 1844–5, in Roman Revival style. The large assertive façade on its restricted site has giant Corinthian columns *in antis* with petalled capitals derived from the Temple of Vesta, Tivoli. The heavy portico and rounded windows have a touch of English Baroque (cf. Vanbrugh's Eastbury Park, Dorset). The building cost £2,700, containing also the minister's house, schoolrooms and a chapel keeper's residence. From 1907 the Church of Christ Scientist, since *c.* 1990 offices known as Charlotte House. Next, No. 12 the **Register Office** [147] was built as the Bath Savings Bank by the London architect *George Alexander* in 1841 in Barry's Neo-Italian-High-Renaissance, the Reform Club style, derived from the Palazzo Farnese, Rome. Isolated on its site and symmetrical, just three bays wide on both principal elevations, this delightful little palazzo is perhaps the first bank building in this style in Britain. Standing on balustraded plinths, the windows of the *piano nobile* have Ionic columnar aedicules and alternating pediments. Big rusticated quoins, a heavy overhanging cornice and a Tuscan porch. It housed the Holburne Museum of Art, 1893–1916, municipal offices until 1940. Opposite, S side, **Elim Pentecostal Chapel** (formerly Percy Chapel and Congregational Church) by *Goodridge & Son*, 1854, has a spreading Lombardic Romanesque façade, with rich repetitive decoration and a blind arcade at ground floor. Two short corner towers carry Italianate roofs, and in the middle is a rose window. A large decagonal lantern 40 ft (12 metres) in diameter – *à la* Parma or Cremona – supported by Purbeck columns each only 1 ft (0.3 metre) thick encloses the main space, which is polygonal and galleried with the altar facing W (now spoilt by a false ceiling). Particularly significant was its early air-handling system by *Haden's* of Trowbridge.

Further E on the S side, **Queen Square House** is an office development of 1990 by *Nicholas Magniac* with *William Bertram* as consultant. The scheme extends a handsome single-bay coachman's house with a clever balancing pavilion in matching style and returns S into **Palace Yard Mews**, with a two-bay link to mews-style buildings and an arch with an attic over. A pleasant and sensitive infill, it is also somewhat pretentious and its absence of domestic use is all too obvious. Moreover, the authenticity of the pastiche is let down by alien dormers and ashlar laid with too thick joints.

At the S end of Palace Yard Mews is **St Paul's Place** and **Holy Trinity Church** of 1872–4 by *Wilson, Willcox & Wilson*. It replaced St Mary's Chapel to the E, by *Wood*, 1732–4, demolished 1870. The new church was dedicated to St Paul until 1957 when it replaced *John Lowder's* demolished Holy Trinity in James Street West of 1820–2, gutted by bombs in 1942. The W front, gabled with heavy arcading to the narthex and with lancets above, is E.E. The same architects added a smaller gabled N aisle in 1880–1 (converted for a parish hall in 1953–4 by *Hugh*

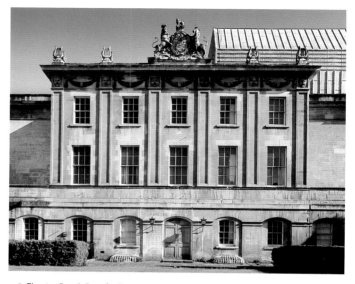

148. Theatre Royal, Beauford Square, façade, by George Dance the Younger carried out by the architect John Palmer (1802–5)

Roberts), forming a terribly unsatisfactory asymmetrical façade. Otherwise, the building is derived from C13 French Gothic architecture as practised by G. E. Street and fashionable in the 1860s: cf. John Loughborough Pearson's St Peter at Vauxhall, London. The bold s side is buttressed. More advanced for the 1870s is the long, continuous roofline and semicircular E end enclosing a barn-like interior with no distinction between nave and chancel except for the windows.

We now cross **Charles Street**, with a terrace on the w side of *c.* 1770, continued sympathetically at Nos. 28–30 by *H. J. Garland*, surveyor in 1892. On the opposite, E corner of **Charles Street** is the former **Telephone Exchange** of 1966–7 by *W. S. Frost*, for the *Ministry of Public Building and Works*. A taller extension to Charles Street to house the automatic exchange, with a slate-hung cantilevered top storey, was added in 1971–2. The slab block design is one of unbelievable perversity in this setting. Beyond in **Monmouth Street**, most remaining of interest is on the N side. The E corner block to Monmouth Street and **Princes Street** is one design, *c.* 1830–50, with original shopfronts. We now make a short out-and-back excursion into Princes Street and Beauford Square. Starting with the corner block, Princes Street is a charming enclave of small shops. No. 8 was the Beaufort Arms (now Beauford House) and has a pub front with bold Corinthian pilasters by *F. W. Gardiner*, 1903. No. 11 has an early C19 shallow-bowed shopfront. It was a forge. The bellows survive at the back of the premises and on

the roof against the sky is a large metal sign advertising 'J. Ellett Smith & Plumber'. No. 33 is mid-C18. To the w is **Beauford Square** (originally Beaufort Buildings), developed by *John Hobbs*, a Bristol sail maker and timber merchant, in the early 1730s. The architect was *Strahan*. The two-storeyed cottages have a Doric entablature with a triglyph frieze. The parapet ramps at the party wall divisions and in the centre of each house. The doorways have segmental pediments on brackets. Originally, all were three windows wide with architraves and those on the ground floor were enriched with a pulvinated frieze and cornice. To avoid window tax, several later had their windows paired with a slender central mullion (to count as one window) and most have a blocked window. Scratched on a pane to the rear of No. 16 is the couplet: 'God gave us light, and it was good, Pitt came and taxed it, damn his blood'. The circular cut-out to the blocked window of No. 15 contained a clock and was a clockmaker's premises. The N **side** was repaired in the 1980s by *Graham Stollar & Associates*. The E **side** is no longer original: No. 5 is rebuilt behind an original frontage, Nos. 2–4 and 21 are replicas of 1963–6, by *E. F. Tew* of *Tew, Pope & Oliver*. The bold spearhead railings, overthrows and gates to the square are Regency period, possibly by *George Dance the Younger*.

The intimate character of the s **side** is somewhat disturbed by the higher elevation of the **Theatre Royal** [148]. It is a design of *George Dance the Younger* carried out by the architect *John Palmer* in 1802–5 (Dance gained the commission during a visit to Bath for his 'habitual winter cough'). It has a frontispiece five bays wide with three storeys, set against a windowless rectangular block containing the auditorium and stage. The ground-floor windows stand in blank segmental arches. The principal entrance was originally in the centre, with side entrances for the pit and galleries. Above are giant pilasters, a composition which owes something to Palladianism, but here given a flat treatment with sunk panels that are almost abstract, far removed from the Palladian or even Hellenic traditions. The deep frieze has Greek masks set over each pilaster with garlands between. Restored carved lyre finials and a magnificent Hanoverian royal crest are on the top against the sky.

The theatre was burnt out in 1862; the discolouration due to the fire is still visible. The interior was rebuilt by *C. J. Phipps*, who also moved the main entrance to the Saw Close (*see* Walk 1, p. 116). The Victorian theatre has an intimate, horse-shoe-shaped plan with stalls and three tiers of balconies on a cast-iron structure, and a shallow domed ceiling. The balcony fronts of the dress circle are decorated with *trompe l'œil* panels and medallions. In 1982 *Dowton & Hurst* refurbished the building and raised the flytower. Externally, this is an obtrusive 33 ft (10 metre)-high lead-clad box, an evil necessary to the theatre's functioning.

Returning to Monmouth Street and continuing E, next is a vigorous bronze sculpture of 1997 by *Igor Ustinov* of a winged figure, named

'Hopefully', decorating the façade of the **Ustinov Studio Theatre**. Refitted by *Tektus* in 1995 for experimental performance as an adjunct to the Theatre Royal (*see* above), it has 150 seats and an end-stage, contained within an otherwise uninteresting interwar building. **St Paul's Parish Hall**, 1888–9, on the corner of St John's Place, is an amateurish design by the *Rev. Angus Clark*, constructed in squared coursed rubble with stone dressings by *J. Long & Sons,* builders. Rusticated pilasters with urns mark the corners, and the centre has a decorative curved pediment. Interior rebuilt 2004–5 as **the egg**, a children's theatre by *Haworth Tompkins*, advised by a panel of children. The intimate and fun crimson-coloured auditorium has a truncated elliptical plan. Nos. 3–5 are part of Strahan's speculative development extending from Kingsmead Square, laid out in 1727. No. 5, s side, has an early to mid-C19 shopfront with three windows with glazing bars, flanked by panelled pilasters with roundel block capitals. No. 4 has a rainwater head dated 1731 and is unusual in being brick-built. No. 3 has a mid-C19 reeded pilastered shopfront. Kingsmead Square is just ahead.

Excursions

The significant outlying buildings are grouped into five areas – central fringe, then roughly according to the compass points – and are listed more or less sequentially as they might be visited on the ground. Inevitably, the outlying areas contain a lower density of interest than the essential Walks 1–11, but individually the sites included hold considerable value. Some form convenient clusters and are in part or whole walkable.

The Central Fringe

Magistrates' Courts, North Parade Road. By *Chris Bocci*, 1987–9. Steeply pitched slate roofs respond to the adjacent La Sainte Union Convent (*see* below). The interior has a notable first-floor public waiting area, the walls clad with horizontal bands of contrasting terrazzo.

La Sainte Union Convent, Pulteney Road. By *J. Elkington Gill*, 1866–7, his largest work under his sole name. In the Tudor style used by the practice for schools and institutional buildings. Its main departure lies in the bold verticality, giving it a rather gaunt, forbidding character. *Browne & Gill* added a two-storey extension in 1880. It now houses the probation service related to the adjoining magistrates' courts.

Dolemeads Estate, Pulteney Road, designed by *Charles Robert Fortune*, the City Surveyor from 1888. On formerly low ground, originally subject to flooding, the scheme involved raising the ground level, in some places by over thirteen feet. Begun in 1901, it followed the passing of the Housing the Working Classes Act, 1890, empowering corporations to

149. Industrial Buildings, Lower Bristol Road, view from the riverside

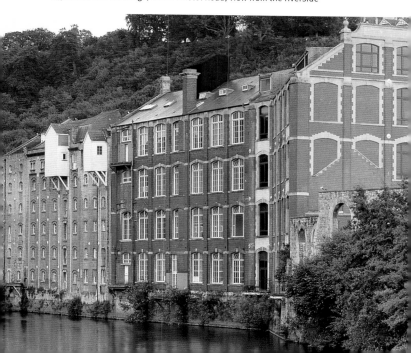

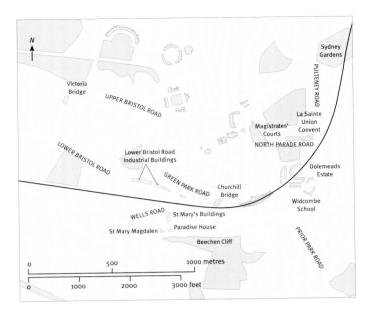

150. Excursion 1, the central fringe

replace 'insanitary' areas with new housing. This so-called 'bye-law' housing was much disparaged by Abercombie (*see* Introduction, p. 45), who cited this scheme as a prime example. Unusually, and incongruously, it is built of red brick. By 1901 seven houses in Archway Street were completed, and the following year Excelsior Street was finished, but the scheme took twenty years to complete.

Widcombe School, Pulteney Road. By *Nealon Tanner Partnership*, 1995–6. The low single-storey building presents to the busy street protective rubble stone walls with a clerestory, and a shallow-pitch stepped slate roof, pierced with amusing metal air vents. It replaced a building to the w by *Gill & Morris*, 1900, demolished except for the foundations, which still stand in the school grounds along with the bellcote.

Industrial buildings, Lower Bristol Road [149]. These are among the few survivors of the once active riverside industry, which began with the opening of the Avon Improvement in 1727 (*see* Introduction, p. 16). Starting w of Churchill Bridge (*see* Walk 8, p. 212) is **Camden Malthouse and Silo**. The early C19 malthouse has a deep gabled hoist on brackets with horizontal timber siding. *J. G. Stone* raised the E part in 1913–14, with a transverse roof. The adjoining reinforced concrete silo to the E was built by *Hayward & Wooster* in 1913. Concrete silos were considered a model for grain storage at the time. In 1986, the silo part was

151. Victoria Suspension Bridge, detail of wrought iron structure, by James Dredge (1836)

carefully converted, with cantilevered glazed additions, into offices and residences known as **Waterfront House**, by *K20 Design Company Limited*. – **Camden Mill**. By *Henry Williams* of Bristol, 1879–80, with extensions by *F. W. Gardiner*, 1892. A large rectangular former steam flour mill for the shipment of grain in, and onward distribution of flour. *Morrison & Partners* converted the building into sixteen flats and office accommodation in 1974–5. Adjoining, w, *F. W. Gardiner* designed the **Bayer Building** as a corset factory for Bayer in 1890, which he extended in 1895. Built of red brick, it has big segmental windows with stone surrounds, and chunky rock-hewn quoins and keystones to the ground floor; timber-clad jetties at high level. – Further w, the **Newark Works**, 1857, by *Thomas Fuller* were part of the famous Stothert & Pitt heavy engineering works, noted for dockside and other heavy-duty cranes, until closure in 1987. The Neoclassical ashlar façade to the road has a battered plinth of squared rock-faced stone, large iron-framed windows to the ground floor, thirteen bays of paired windows above, each framed by Tuscan pilasters, and a modillion cornice. A further three-bay storey over part, with rusticated quoins, contained offices. The building continues to the left with a further thirteen, later bays.

Victoria Bridge, Victoria Bridge Road [151]. A suspension bridge by *James Dredge*, a local engineer, completed in 1836 but named for Victoria. Like all suspension bridges of the period it uses chains of wrought-iron strips. It differs in being designed on a suspension principle that spread the load of the platform by having the suspension rods mounted at increasing angles towards the centre of the bridge. It also uses chains of diminishing cross section, tapering towards the middle of the bridge. It bears a plaque, 'Dredge Patentee Bath', and was the prototype for more than a dozen in Great Britain and overseas; but this is the only one to survive intact. Each bank has an impressive plain

ashlar arch flanked by piers, with a plain blocking course and pedimented entablature. The bridge is thus a fusion of classical masonry and innovative iron technology, a monument to the heavy engineering associated with Bath from the early C19.

Holloway

The name applies both to a long street, the old main Wells Road across the river, climbing s from Bath, and also to the area, which used to be poor and notoriously unsavoury. This was largely demolished in the late 1960s for the construction of Calton Gardens (*see* Walk 8, p. 214), but the street retains a group of interesting buildings and an C18 raised pavement higher up. On the N side No. 88, **Paradise House**, now a hotel, *c.* 1760, was formerly part of Paradise Row. It has a wide symmetrical frontage with a central staircase, and fine Palladian details, two Venetian windows with Tuscan columns, and a pedimented doorway. The gateposts have large vase finials, the lower half gadrooned. At the rear is a three-storey canted bay and a big single-storey Victorian extension with round-headed windows, polychrome voussoirs, and Ruskinian marble columns with foliate capitals. No. 90, dated 1761 and with Gothic windows, is on the site of a lepers' isolation hospital, known from before 1100. **St Mary Magdalen**, adjacent, was the hospital's chapel. It was built for Prior Cantlow of Bath, *c.* 1495, and is Bath's only pre-C16 building. Restored in 1761; *H. E. Goodridge* added the chancel and small three-stage w tower in 1823–4, but the tower arch was not cut through until 1889. The E end was rebuilt after bomb damage of 1942. The genuine Perp s porch has a canopied image niche above the entrance. The nave windows have hoodmoulds. Inside, the plain narrow nave has a restored plastered barrel vault, and more image niches – three to the N, two s. – **Monument**. Handsome tablet to Anne Biggs, d.1662, with an extremely odd, mannered top with a broken reversed scroll pediment, and high-relief carved reclining figures. The inscription is painted in white on black. – Ball-like **font** removed from Huish parish church, 1980. – **Stained glass** above the altar, *c.* 1950, by *Michael Farrar Bell*, containing C15 glass found in the rubble after bombing. **Magdalen House** at No. 92, actually off Holloway N of the church, mid-C18, was also part of the lepers' hospital. The footpath off Holloway, s side, climbs steeply to **Beechen Cliff** with a panoramic **view** of the city. Jane Austen noted in *Northanger Abbey* 'that noble hill, whose beautiful verdure and hanging coppice render it so striking an object from almost every opening in Bath'.

St Mary's Buildings, below the Holloway on Wellsway. By *Pinch the Elder*, *c.* 1820, a plain terrace rising steeply. The cornice swoops from house to house in his characteristic manner.

North and East Lansdown

These outliers are outskirts of Bath, except for Beckford's Tower, which is isolated on the downs, with scenery very different from that of the hills in the other directions from Bath, and more similar to the Wiltshire downs.

Camden Road. The houses and terraces that line the road show the considerable architectural distinction that even small houses were given until the early C19. E of Camden Crescent, **Berkeley Place**, s side, twelve mid-C19 two-storey terraced houses, have banded ground floor rustication and two-storey projecting porches. **Upper Camden Place**, formerly **Sion Row**, set back above the N side, is a picturesque assortment of late C18 and early C19 houses, some by *Eveleigh* for the attorney John Jelly. The crash of the Bath Bank of 1793 probably resulted in their completion only after 1815. Nos. 1–2 and 6–7, three-storeyed pairs, 1815, take advantage of the SE prospect, with segmental bays and French doors. **Lower Camden Place**, s side, early C19, possibly by *Pinch the Elder*, are small, two-storey with basements, separated by plain pilasters, with ground-floor banded rustication and a band course. Set back high above the road, **Camden Terrace**, N side, is a range of six early C19 houses, possibly by *Pinch the Elder*, single window width and thin reeded porches. The two slightly projecting centre houses have banded ground-floor rustication and a pediment with the arms of Charles Pratt, first Earl of Camden, in the tympanum. **Prospect Place**, N side, a long terrace of cottages. Nos. 12 and 14, a pair, formerly one house, are 1736, No. 20, 1740, refronted 1811, the interior with early C18 features, the remainder mostly *c.* 1810. Further E is **Claremont Place**, four pairs of small elegant Regency semi-detached villas of 1817, three windows wide, the centre window blind. The ground-floor windows have segmental soffits set in similarly shaped panels. The windows, including the segmental heads, have margins. The elevations, with corner pilasters and acroteria with incised decoration, show the influence of Soane. Probably by *Pinch the Elder*.

Heathfield, Mount Road. With **Mulberry House** (formerly Lonach), and **Bella Vista**, one of a group of three rather heavily detailed Italianate villas, by *James Wilson*, *c.* 1845, with shallow-pitched projecting

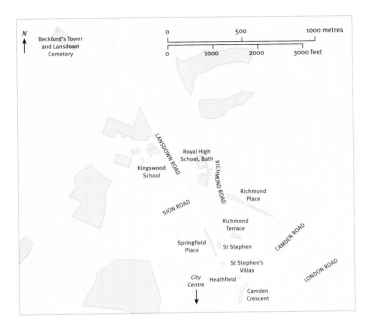

152. Excursion 2, North and East Lansdown

eaves, and at Heathfield a good Roman Doric gateway with fluted columns and a guilloche frieze with paterae.

St Stephen's Villas (originally St Swithin's Almshouses), St Stephen's Place. By *James Wilson*, 1843, in institutional Tudor-Gothic. With only six built, this fragment hardly suggests the grandeur of the original collegiate plan to build sixteen houses with clusters of huge crenellated chimneys and battlemented parapets, flanking a central chapel and hall. The houses have gables with finials and mullioned windows, and the end houses project with weathered buttresses. Completed, the scheme would have been grandly collegiate, emulating Vicar's Close, Wells. As it stands, the row is an example of the final, pre-Pugin phase of religious philanthropic design.

St Stephen, Lansdown Road. *James Wilson* built the church at a cost of £6,000 in 1840–5 to serve existing developments NE of the city, and in expectation of further growth. It is broad and somewhat Georgian in proportion, and still in the mix-and-match style of the 1830s, with lancets, but also Perp-style octagonal buttresses. The tower, similar to the w towers of Ely Cathedral (*c.* 1400) or Antwerp Cathedral (1519), is a very important visual focus on Bath's N slopes. Starting square and E.E., then at once turning octagonal, with detached big octagonal corner pinnacles connected with the octagon by traceried flying buttresses; a

153. St Stephen, stained glass E window, Lady Chapel, by Mark Angus (1983)

154. The Royal High School, Bath, Lansdown Road, by James Wilson (1856)

smaller octagon on top with pinnacles is arranged in the same way. The nave and transept are very be-pinnacled, with pierced parapets. Two-light lancet windows with cusped Y-tracery. The church faces N–S so trouble was made by the Bishop of Bath and Wells over consecrating it and for many years it acted as a chapel of ease to Walcot with the altar in a transept, to be correctly E–W oriented. The church remained unconsecrated for some forty years until 1881, after which *W. J. Willcox* built the very wide apsidal **chancel** in 1882–3, together with the vestry and organ chamber (at a cost of £3,000). The handsome painted ceiling, 1886, is by *W. J. Willcox*, executed by *H. & F. Davis*. The NE aisle was added in 1866 for the use of the Royal School, presumably by *Wilson & Willcox*, in a harsh Gothic typical of the later work of the firm and contrasting with the style of 1840. – **Stained glass**. E window, Lady Chapel by *Mark Angus*, 1983 [153], the 'Centenary', depicting St Stephen's transformation, on the bridge between life and death at the moment of martyrdom. With distorted ambiguity between pain and repose, the body rises amid red flames on a blue ground. – **Font and font cover**. Marble, florid Gothic, dated 1843. – **Transept ceiling** and **reredos**. By *Sir T. G. Jackson*, *c.* 1900, then working on the Abbey. *Slade, Smith & Winrow* converted the crypt to a parish room in 1993–4.

E of St Stephen, **Richmond Road** and **Richmond Hill**. This area has the most isolated of the early C19 terraces of Bath. 110 yd. (100 metres) from the S end of Richmond Road, E side, **Richmond Terrace**, part of Richmond Hill, 1790–1800, possibly by *Pinch the Elder*; eight houses of three storeys and three bays. Next on Richmond Road, **Richmond Lodge**, of 1814, was enlarged with a stylish addition by *Browne & Gill*, 1885, for St Stephen's vicarage; now two houses. **Northfield House**, W side, *c.* 1820, is a large two-storey, late Georgian villa that reflects the desire by this time for outward prospects and contact with the landscape. A late Greek Doric portico, with fluted columns and balustraded

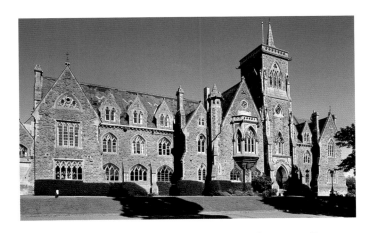

parapet, faces the garden. Extended by *F. W. Gardiner*, 1898. Entrance, *Browne & Gill*, 1894, stables, *Gill & Morris*, 1903. Proceeding N, **York Place**, E side, has a projecting Roman Doric enclosed porch with projecting cornice and parapet. 55 yd. (50 metres) further up Richmond Road, off to the E side and running E–W, **Richmond Place** is a row of small pretty artisan cottages, mostly two-storey, many rendered and colourful. No. 7, the Richmond Arms pub, has been heightened. The painted panel between the first-floor windows has the arms of the Dukes of Richmond. Opposite, **St Stephen's School** (originally Beacon Hill Schools) is of 1839 by *George Phillips Manners*, in the typical Jacobethan style used by the practice where classical or Gothic was inappropriate. A classroom wing extension by his successors, *Gill & Morris*, 1900, is interesting for the ease with which the style is repeated much later and for the continuity of projects that the practice frequently enjoyed.

Springfield Place, Lansdown Road, w of St Stephen's church. These semi-detached classical two-storey villas of *c.* 1820, with shallow pediments and acroteria, are highly characteristic of Regency suburban development in Bath, with their Greek Revival influence. No. 11 is detached.

Glen Avon, Sion Road. *James Wilson* built this eclectic, Goodridge-inspired Italianate villa in 1858–60 for his own occupation. A gabled projecting block to the right has deep eaves with a projecting centre section, a three-storey belvedere to the left, and a four-storey octagonal turret in between. The chimneystacks are gabled and machicolated. Wilson lived there until his death in 1900. It is now two dwellings.

Royal High School, Bath, Lansdown Road [154]. Entered through an ornate armorial archway, the building is by *James Wilson*, 1856. Opened as the Bath and Lansdown Proprietary College, a boys' day school

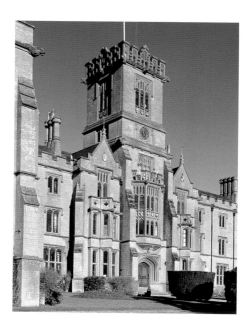

established in 1853, it soon failed due to its distance from Bath. Sold for £1,000, it became in 1863 the Royal School for Daughters of Army Officers, founded after the Crimean War. It was considerably altered and extended, 1864–6, by *M. Habershon*, with roof dormers and sub-division of the great hall; a large SE wing and sanatorium to the NW were added in 1883–4, by *M. Habershon & Fawckner*. Wilson's chosen style is C14 Gothic, appropriately scholastic, angular, with steep roofs, but handled in a remarkably uncouth way and bearing no resemblance to any conceivable medieval edifice. The centre is dual with an enormous asymmetrical porch tower and thin stair-turret crowned by a spirelet, and a broad bay with an oriel. The straight ranges left and right are not symmetrical either. Wilson's wilful eccentricities show how different his Gothic had become from Kingswood School (*see* below) in only six years. *Mowbray Green* added a big rear extension in Neo-Tudor, 1924–5. In 1939 *H. S. Goodhart-Rendel* started the **chapel**, but the school evacuated to Longleat until 1947 and it was not consecrated until 1950. In stripped Gothic style, tall oblong mullioned and transomed windows reach as square-headed dormers into the steep roof. The E window makes an interesting composition. *Tolson & Nugent* completed the design with a W entrance and W gallery over in 1960–1.

Kingswood School, Lansdown Road [155]. Designed by *James Wilson* and built by *Hayward & Wooster*, it was built for the sons of Wesleyan ministers in 1850–2. John Wesley founded a fee-paying boarding school for his supporters' children at Kingswood near Bristol in 1748. The

move to the more salubrious Lansdown followed the pattern of other older city schools. Unlike the Royal High School, which faces the road, the principal front faces s. The style here is early Tudor and the composition is symmetrical, an earlier stage in the development of Victorian architecture than the Royal High School. Still Early Victorian in feel, it draws upon well-established precedents for collegiate buildings – C. R. Cockerell's Harrow College, Middlesex (1819–20) and St David's College, Lampeter (1822–7) and, specifically, Wilson's own Queen's College, Taunton, 1843, which Kingswood closely resembles. The centre has the same prominent square tower, suggestive of Somerset Perp. Above the entrance are an oriel window and two flanking gabled bays with oriels attached which in the centre are triangular in plan. Identical ranges extend e and w, projecting at the ends. Gargoyles and rainwater heads articulate these wings and the parapets are battlemented. Internally, there is much Gothic detailing. Beyond the entrance, the staircase hall has a panelled ceiling and cast-iron balustrade. The w wing contains the old **school room**, where the whole school was taught, the master on a dais. The **dining hall** in the e wing, with a rib-vaulted ceiling with bosses and polychrome tiled floor, doubled as the chapel.* A corridor connects the two. The e half of the central building served as the private residence of the Governor (later, the Headmaster) until 1959. Grilles still exist from the original, inefficient ducted hot-air heating system. There were no hot baths until 1868, then only two (the upper body was washed twice a week, the feet once a fortnight). In 1882–3, *James Wilson & Elijah Hoole* carried out extensive alterations. They extended the hall by two bays. **Stained glass**, by *H. J. Salisbury.* They also built a big and barrack-like four-storey dormitory block projecting at a right angle at the back and, to the e of this, the **sanatorium**, a Swiss chalet with mock timber framing. This was subsumed by additions of 1908, e side, and, 1929–30, a large w wing by *Hayward & Wooster*. Wounded Belgian soldiers recuperated there in the First World War. Adjacent w, *Elijah Hoole* built a gymnasium, now the **Arts Centre**, 1891, with mock Tudor timber framing.

Also behind the main school, w side, is the **Kingswood Theatre** by *Nugent Vallis Brierley*, 1993–4, an infill that closes the fourth side of a small quadrangle. The 450-seat auditorium has a single rake of partly retractable seating, an exposed tubular steel structure and a broad lantern for natural lighting. Further w, the **Ferens Teaching Block**, 1924–6, extended 1949, by *W. A. Forsyth*,[†] is the biggest addition to the school. H-shaped, gabled with mullioned and transomed windows, its science laboratories were considered forward-looking at the time, with good standards of electrical services, lighting, ventilation and acoustics.

*Wesley's original pulpit from Kingswood is in the gallery.
†Surveyor to Salisbury Cathedral, and consultant architect to the Citadel in the Mall, Westminster, a curious Second World War fortress.

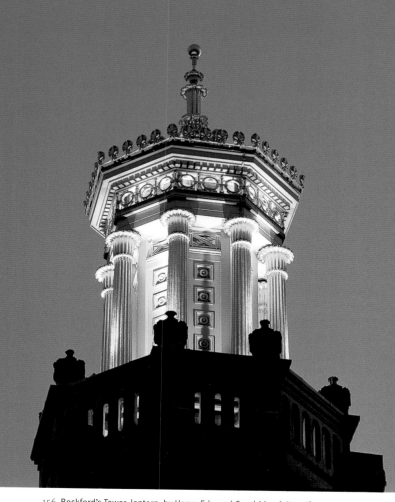

156. Beckford's Tower, lantern, by Henry Edmund Goodridge (1825–6)

W. A. Forsyth & Partners added a further three-storey, flat-roofed block in 1957–9 to the N.

SE of this, W of Wilson's main building, *W. A. Forsyth* built, in 1935, the **Posnett Library** in Domestic Revival style with a steeply pitched, hipped roof with finely crafted, pegged oak queen-strut trusses. SW of this, the **Y**-shaped **Dixon Sixth Form Centre** is by *Goldsmith & Tolson*, 1969–70.

Finally of interest, free-standing at the SE of the main building, is the **War Memorial Chapel**, by *Gunton & Gunton* of London, 1920–2, Neo-Perp with a four-bay, slightly raked nave, and apsidal chancel. – **Stained glass**. The Sower, by *Hugh Easton*, 1936.

Beckford's Tower
and Lansdown Cemetery Lansdown Road

The **Tower** was designed for William Beckford in 1825–6 as his eyrie, when in his old age he lived in Lansdown Crescent below. It was the terminating feature, a retreat which he daily visited, at the head of his idyllic landscape garden (*see* Walk 5, p. 172). Following Beckford's death in 1844 the Tower was sold in 1847 on behalf of his daughter, Susan, wife of the tenth Duke of Hamilton, for a mere £1,000. When the Duchess of Hamilton heard that the purchaser, a local publican, intended to turn it into a beer garden, she bought it back for £1,150 and donated it to the Rector of Walcot for use as a cemetery. The Bishop of Bath and Wells consecrated the ground in 1848 and the principal ground-floor room became the mortuary chapel. Beckford's tomb was then moved there from the Abbey Cemetery.

The architect of the Tower was *Henry Edmund Goodridge*, who had recently set up in practice at No. 7 Henrietta Street, appointed by Beckford perhaps because he was young and compliant. Goodridge made several designs for the tower, including a Gothic lighthouse and a Saxon tower. The final design is Greco-Roman. The building is a picturesque fusion of two elements: the tower, 154 ft (47 metres) high, in Neo-Greek manner with, at its foot, an asymmetrical Italianate one- and two-storeyed house. This has round-arched windows protected by iron lattice grilles, a triple-arched entrance loggia on the E side, a small single-storey apse to the N, and a triumphal arch campanile above the S parapet.

The surrounding graves, and the Tower's former function as a cemetery chapel, strike one as singularly appropriate. There is something bleak and sinister about the building, which penetrates into all its details. The windows for instance, although they have sill brackets and straight hoods, refrain from all mouldings and are reduced to straight blocks; equally elementary the balustrades. The severity is unique in Britain, save perhaps in the Glasgow work of 'Greek' Thomson. The tall square shaft of the first stage is two-thirds plain with small windows, terminating with a great Doric entablature with a boldly profiled cornice. The second stage, containing the belvedere, has plain square piers that form three tall rectangular openings framing deeply recessed arches. The entablature is reduced with dentils and a plinth-like parapet decorated with panels of key-fret and square corner blocks with circular bosses. The third stage is octagonal, a reference to the Tower of the Winds illustrated in the *Antiquities of Athens*. This acts as a high, perforated plinth for the crowning octagonal lantern with cast-iron columns, adapted from the Choragic Monument of Lysicrates, again illustrated in the same volume [156]. The forms are ponderously, funereally, but very freely, treated. The design is really quite ahead of its time and has much that characterizes the change from Grecian to Victorian.

The interior was originally very rich, and filled with Beckford's treasures. These included fine china in heavy carved oak coffers in the

157. Beckford's Tower, the Crimson Drawing Room. Chromolith by Willes Maddox from English's *Views of Lansdown Tower* (1844)

apsidal Scarlet Drawing Room on the ground floor, a picture collection in the first-floor Crimson Drawing Room [157], and a dazzling display of books in the Etruscan Library. Vertical circulation is by a stone spiral cantilevered stair, which continues to the Belvedere, nearly 1,000 ft (300 metres) above sea level, with magnificent panoramic views. Fifty-three wooden steps continue from the centre of the Belvedere to the cupola. Originally, warm air heated the shaft from a furnace in the basement.

Fire gutted the interior in 1931 and after years of uncertainty the chapel was declared redundant and *J. Owen Williams* converted it to a house in 1972. Finally, *Caroe & Partners* and *Mann Williams Structural Engineers* restored the tower in 1997–2000 for Bath Preservation Trust. This included stabilizing the lantern, which stood on a timber structure that had failed, and something of the richness of the interior was re-created. *Hawkes, Edwards & Cave* converted the ground floor to holiday accommodation for the Landmark Trust. The Tower is open to the public and the first floor contains a Beckford museum.

The **gateway** to the cemetery is also by *Goodridge*, elaborately Romanesque in detail, gabled with sarcophagal corners. The design incorporates an entrance screen of piers and railings that had previously enclosed Beckford's tomb. The railings, removed during the Second World War, were replaced in 2000, based on two surviving sections. **Beckford's tomb** is a pink Aberdeen granite sarcophagus. Goodridge, Sir William Holburne and the architect James Wilson are also buried in the cemetery.

East of the City and the University

Batheaston Villa, Bailbrook Lane, London Road West. Geographically strictly beyond the present scope, but with a significant place in Bath society, a large early C18 house, owned later by Sir John and Lady Miller. It has quoins of even length, window surrounds and thick glazing bars. The entrance has a four-column Ionic porch, and the s front a large bow, embattled. The ironwork is restored. It was famous for Lady Miller's weekly poetry contests in the 1770s, mentioned disparagingly in Horace Walpole's letters, and attended by celebrities who included the Bath poet Christopher Anstey, the Duchess of Northumberland, second Viscount Palmerston and Lord Carlisle. The custom was to offer an original verse to an antique vase excavated at Frascati in 1759. Lady Miller, the 'High Priestess', then crowned the winner with myrtle. In the garden is a small **rotunda**.

158. Excursion 3: East of the City

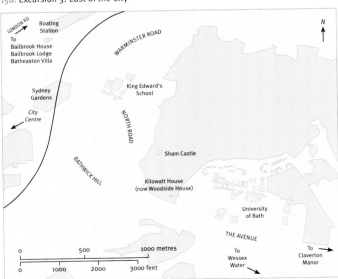

Further w in big grounds, **Bailbrook House**, London Road West, by *John Eveleigh*, for Dr Denham Skeet, doctor of law in London. Now a Conference and Training Centre. A contract with Eveleigh was drawn in 1786, drawings were being made in 1789, building began 1791, and then in 1793 Eveleigh was declared bankrupt. He left Bath, and building continued slowly. It sold to Valentine Jones for £7,035 in 1802. The ambiguity of the composition is interesting. Instead of the normal country-house layout – roughly speaking a hierarchy of main block with service wings – here are two blocks connected by a one-storeyed entrance hall. The w fronts of the blocks are identical, with giant Ionic pilasters, yet the s block is the main house and the n block a service wing with an open courtyard. Defying c18 precepts of propriety, it looks grander than it is – and is it one building or two? The link has a richly detailed pedimented doorcase, and to the left and right arched windows with garlands over. The s front of the s block has an arched rusticated projecting ground floor, forming a terrace above, with pedestals and urns. The two storeys above that have a slightly projecting centre bay and giant Ionic angle pilasters and half-pilasters disappearing into the projection.

Fine entrance hall with oval lantern, Doric e and w galleries, and broad semi-elliptical fanlights across n and s inner doors with wide sidelights. The s wing has a central hall opening directly off the single-storey entrance, and a landing at first floor, also lit by an oval lantern, with wrap-around accommodation on three sides at both levels. The hall and landing are interconnected by an elegant staircase turned at right angles to the e and side-lit, concealed behind doors like the other rooms, with semicircular ends and concave doors.

Bailbrook Lodge, Nos. 35 and 37 London Road West. On land leased in 1825 to David Aust, mason. Seven houses were intended, but only this pair were built, by *John Pinch & Son*, for sale in 1831. Three-storeyed with a raised basement. Elegant and symmetrical, with two-storey bows crowned with trellised ironwork. The ground floor has banded rustication, the first floor plain pilasters, and the rear façade incised Greek key decoration (cf. Nos. 39–40 and 36–37 Bathwick Hill, *see* Walk 7, p. 196). Now a hotel.

Boating Station on the Avon, Rockcliffe Road. *Browne & Gill* built two boating pavilions in 1887–8, gabled structures with fretwork balustraded decks and bracing brackets. *Gill & Morris* added a further pavilion for the Bath Boating Company in 1901. They remain in use.

King Edward's Junior School, North Road, by *Alec French Partnership*, 1989–90. Occupying a steep site, with the hall and dining area on the e side and two tiers of classrooms, staggered in plan to the w. The wedge-shaped open library in between is the focus to which all other spaces relate. It is lit by northlights, developed from the pitched roofs over the

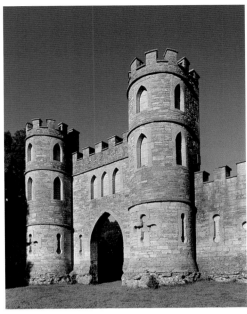

159. Sham Castle, built by Richard Jones, probably to Sanderson Miller's design (1762)

classrooms. A circular stained-glass window in the s wall is by *Ros Grimshaw*.

Sham Castle, Claverton Down, off North Road [159]. *Richard Jones* built it as an eye-catcher for Ralph Allen's townhouse in 1762. It was probably *Sanderson Miller*'s design, Miller having been approached seven years earlier (though Jones claimed that the design was his). It replaced an earlier structure, Anstey's Lodge, recorded on William Pulteney's plan of 1726. It is no more than a picturesque façade, with tall semicircular half-towers each side of an archway and square corner towers, with blind lancets, and arrow loops.

Kilowatt House, now **Woodside House**. By *Mollie Taylor* (daughter of Alfred J. Taylor) of *Alfred J. Taylor & Partners*. Built in 1935–8, on a former quarry site, for the electrical engineer Anthony Greenhill. It is Bath's only Modern Movement house. Constructed of reinforced concrete with banded metal Crittal windows and corner glazing, it has two storeys with a projecting semicircular stair tower and transformer chamber to the garden front, and flat roofs capable of being flooded for summer cooling. Permission to build was granted on condition that the exterior was painted Bath stone colour. Greenhill had a particular interest in acoustics, and his home was an experimental laboratory. On the E side is a garage and w of the staircase hall was the Power Room and, beyond, a single-storey wing that contained the main recording studio, 45 ft by 23 ft and 16 ft high (13.7 by 7 by 4.9 metres), lined with acoustic board. The sitting room doubled as Studio Number Two and

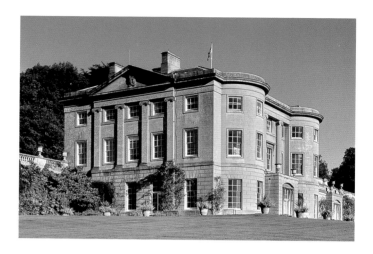

the main bedroom upstairs, with a shallow dome with concealed lighting, Studio Number Three. On the roof is a tank room that doubled as an echo chamber for mixing with the sound output of the studio apparatus. He produced 'colour music' which lit up an indoor 'cascade of glass', whereby an automatic system caused each note of the musical scale to light up a particular tint. 'Thus in a musical composition the appropriate tints are selected in rapid succession, the colours always corresponding to the pitch of the sound, and the light getting brighter as the sound got louder.' His gadgets used 150 kW of power.

Claverton Manor, The Avenue [160], by *Jeffry Wyatt* (later Wyatville), for John Vivian; now the **American Museum in Britain**. In 1819–20 a new manor house was built up on the E slope of Claverton Down to replace a Jacobean house lower down. It is a fine and elegant Palladian villa, rather old-fashioned except that the *piano nobile* has been abandoned and the most important rooms are on the ground floor, reflecting the rising interest in landscape and nature. The E front has two segmental bows and between them two giant engaged Ionic columns above an elegant tripartite porch. On the opposite side two identical Ionic columns *in antis*. The s front is more conventional, five bays with a three-bay pediment on Ionic pilasters. A large screen wall was soon after added to the N, concealing an art gallery, and another to the s, perhaps later. Inside, beyond a vestibule, is a large enclosed stair hall rising to the roof with a circular glazed lantern and a frieze of bucrania and swags. The elegant cantilevered staircase, with cast-iron balustrading of palmettes and anthemia, serves only the lower two floors. The final stage of the sequence, entry into the reception rooms (the museum is now built within the interiors), revealing the full majesty of the Avon valley, must have been a *coup de théâtre*. s of the house is a pedimented

160. Claverton Manor (The American Museum) by Jeffry Wyatt (later Wyatville) (1819–20)

161. Wessex Water Building, North Road, by Bennetts Associates (1998–2000)

coach house, intact with three large pairs of doors and on the SE side is a semicircular concave **stable block**, which presents to the formal garden the convex back wall.

Wessex Water Building, North Road [161]. *Bennetts Associates* designed the office headquarters, 1998–2000, around a commitment to environmental sustainability and as a sensitive, low-key response to the rural, steeply sloping site. The building is organized around a central spine or 'street', a wide, double-height, cool and pleasant space, naturally lit and ventilated with opening rooflights. The street cascades gently down five levels, connecting a series of office wings to the E and ancillary accommodation to the W. This basic functional diagram is modified in response to the irregular site, and the workspaces face extensive views over woods towards Salisbury plain. The cladding is glass and Bath stone, with large metal sunshades to the S. Designed to operate at about one-third of conventional consumption levels, it employs energy-saving measures including use of thermal mass, solar shading, some natural ventilation, solar panels and recycling of water. The energy used for construction was minimized by using local and recycled materials, including crushed railway sleepers for the *in situ* concrete, and reuse of excavated material. The landscape strategy reinforced the existing flora and fauna.

162. University of Bath, the campus from the south, by Robert Matthew Johnson-Marshall & Partners (1966–80)

University of Bath

The campus contains important later built projects by *Alison & Peter Smithson*, additions to the 1960s complex by *Robert Matthew Johnson-Marshall & Partners (RMJM)*, with its ordering spine of vertically separated pedestrian and vehicular circulation [162]. A further major building programme was undertaken under a **Masterplan** of 2001 by *Feilden Clegg Bradley*. The University's buildings and parts are classifiable under three heads: original megastructure, extensions and detached pavilions-in-the-park. The sequence follows a walkable clockwise circuit: the central campus, then through the landscape to additions and teaching outliers, s, and to the w additions, the n extremities, and the e side including the sports complex.

Occupying a 150-acre (60-ha.) site, formerly Norwood Playing Fields (previously Norwood Farm) donated by Bath City Council, the campus is comparable to the seven wholly new British 1960s universities (Sussex, Lancaster, Warwick, Essex, York, East Anglia, Kent/Canterbury). Its detailed history however belongs with a slightly later movement of upgrading Colleges of Advanced Technology to University status (*see* also Introduction, p. 48). Bath shares with the Seven the landscaped (or, at least, characterful) edge of town site, conceived as an antidote to the scattered, formless character of the municipal 'redbrick' universities. They attempted to integrate, or at least juxtapose, residence with teaching and research with the aim of nurturing intellectual life by directing movement and interaction, all part of a general 'Utopian' idealism about reshaping the University. The UK – and Canada – were the admiration of the world for the speed with

which these were set up, and for their immediate success in social and academic terms.

As a megastructure embodying both compactness and the possibility of expansion, with blocks latched on to a central axis, Bath's concept is similar to Arthur Erickson's Simon Fraser University, British Columbia (designed 1963). Of the British Seven, the arrangement resembles the much more complex Lancaster (by Gabriel Epstein of Bridgwater, Shepheard & Epstein). For its pedestrian deck-over-road access, it is closest to Essex (Kenneth Capon, Architects' Co-Partnership). The use of CLASP (Consortium of Local Authority Special Projects) building system aligns it with York, also by RMJM, but York had a much more college-based concept, planned around a lake. Bath's CLASP is of a special version, with coloured concrete made to look more Bath-stone-like.

RMJM published its Development Plan in 1965 (design ideas 1963–4) and phase one was completed, 1966–7, the rest by 1980. A proposed administrative and 'hotel' tower block, 'a slim finger' breaking the wooded skyline, was not built. The shaping role of the architect in deciding what the University was to be like was crucial. Here, as at some other new universities, the plan was substantially decided by just two people, the architect and the new Vice-Chancellor, Dr George Moore.

Description of the Buildings

The basic framework of RMJM's main **campus** is an extendable raised pedestrian spine running E–W (cf. also Cumbernauld New Town). The pedestrian deck is separated vertically from a central service road at ground level (unsurprisingly, *Colin Buchanan* was traffic consultant, *see* Introduction, p. 46). The aim was to foster social and intellectual inter-action: either side are the library, lecture theatres, department entrances, refectories, shops and cafés. Beyond these frontages, creating a hierarchy of front-to-rear, are further teaching spaces and, at the back, workshops and laboratories. Two tall, transverse slab blocks, residences E and administration W, enclose the spine at its centre, broadened here to form a long courtyard known as the '**Parade**', the main social space, a high-density, highly charged place. The non-collegiate character of Bath's campus comes across very strongly here by comparison with the other new universities. On the S side, the hall and refectories define a grand flight of steps, originally intended in the development plan as the principal approach. This relates the Parade to the landscape, a sunken grass amphitheatre and lake surrounded by well-maintained shrubs. On the ground the campus reads as one large building complex sitting in a green landscaped setting. This quickly became so established that subsequent additions have responded to the landscape and turned the backyard spaces into fronts, rather as Cambridge colleges did on a grander scale in the C18. The **buildings** themselves have a degree of individual presence within the restrictions of system-building, here

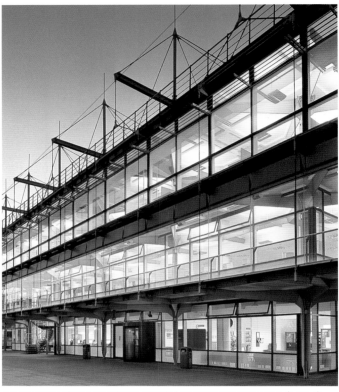

163. University of Bath, the Library, extended by Alec French Partnership (1994–6)

using a development of CLASP Mark 4, steel framing with pre-cast floor slabs, ribbed pre-cast concrete cladding panels and paving. On the SE side of the Parade, building **Two East, Electronic and Electrical Engineering**, 1969, uses extensive patent glazing.

Dominating the Parade on the N side is the **Library** [163], extended by *Alec French Partnership*, 1994–6. The original façade was demolished and the building brought forward into the Parade. This transformed the rather dated, lacklustre 1960s architecture into a fashionably lightweight tension structure, a transparent 'shop window'. Supported on a row of existing strengthened columns at roadway level, six cruciform steel masts set back behind the glazing penetrate the roof, and cantilevered diagonal arms with tension rods support the structure. Solar control was a significant design consideration. The extension overhangs the Parade level to shade the ground floor; a circulatory route around the façade at first-floor level outside the library security area distances library users from the façade, and fixed brises-soleil provide further shading.

Detached a little W of the grass amphitheatre is **UBSA** (University of

Bath Staff Association), built in two phases, in 1978–80 and 1984–5, by *Alison & Peter Smithson*. The first phase, a single storey in blockwork and concrete with a temporary roof, became a plinth for the second phase, a steel-framed, fully glazed superstructure with a deep roof fascia, a pavilion with s-facing wooded views. Adjacent, N, is a pavilion structure, **Six West, Management Training Centre**, by *Nugent Vallis Brierley*, 1990–1. Built over an existing CLASP building unable to take further loading, it is supported on an independent exposed column structure. Accessed by a ramped bridge, lecture theatres, seminar rooms, boardroom and offices sit either side of a glazed central spine. s of here is an isolated group. The **South Building** to the E, square with a courtyard, was originally the Preliminary Building opened in 1965. This was refurbished and re-clad in the 1990s by *Nick Hawkins* of *Northcroft*. Adjacent, w, the **Chemistry Teaching Building**, 2002–3, by *Quentin Fleming, Estates Department Property Services, University of Bath*, wedge-shaped in plan, is masonry- and metal-clad, with a segmental metal sheet roof and exposed flue. At the sw of the group is the **Computer Centre**, *Robert Matthew Johnson-Marshall & Partners*, 1975, plain, single storey. N of this, **One South, Chemistry Research Building**, by *Wilson Mason & Partners*, 1999, has butterfly, inward-sloping roofs and is organized internally around two parallel toplit galleried circulation spaces.

Returning now NW to the main campus spine, **Eight West**, the **School of Management**, s side, by *Nugent Vallis Brierley*, 1992–4, together with Seven and Nine West (*see* below), forms the w end of the campus as identified on the development plan. Tall vertical glazing to the imposing four-storey w front breaks the horizontality. Opposite, N side and oriented N–S, **Seven** and **Nine West**, by *de Brandt, Joyce & Partners*, are research and teaching laboratories. They read as one building but are planned as two: the Departments of Pharmacy and Pharmacology, 1994–7, N, and Chemical Engineering, 1999–2001, s. The building follows the slope, three and four storeys with a basement-level, double-height Pilot Rig Laboratory. Gleaming, heroic flue-towers and stair-towers clad with glass blocks contain the building at both ends. Bath-stone-coloured pre-cast panels express the structure of columns and floors, with storey-high windows and Bath stone infill at lower levels to harmonize with adjacent buildings. Metal cladding panels enclose the top floor and a split-level, curved roof houses mechanical plant. The internal circulation areas are brightly coloured. At the back, E side, the **Glaxo Laboratories** by *de Brandt, Joyce & Partners*, 1993–4, an annexe to Five West, the Department of Pharmacy and Pharmacology, were designed as a free-standing two-storey square pavilion, a glazed link connected to the main building. The space between was infilled, 1999. The building has a pyramidal roof clad in dark grey coated aluminium sheets with raised seams, with a witch's hat finial.

The development plan defined the N part of the University's site as

the student housing zone. The first phase, contemporary with the main campus, was **Westwood**, by *RMJM*, completed 1976, conventional straight blocks running E–W along the N boundary. *De Brandt, Joyce & Partners* broke away from this traditional hostel design at **Polden Court**, 1993–4, to the w. Containing higher standard, guest accommodation, this wraps around an E-facing landscaped courtyard split into two levels to suit the contours. Mirrored 220 yd. (200 metres) E, **Brendon Court**, 1987–90, also by *de Brandt, Joyce & Partners*, is a croissant-shaped student residential building facing w with solid, angular massing and small-pane windows derived from Lutyens's Castle Drogo. The fenestration is differently coloured for identity.

Adjacent, SW, **One West North** (built as the Second Arts Building), completed 1978–81, was the first of a series of buildings attached to the original campus by *Alison & Peter Smithson*, their chief works after the early 1970s. At least on a superficial reading, they seem to lack the fierceness and authority of their earlier works, especially the Economist Building, Westminster (1959–64), St Hilda's College, Oxford, Garden Building (1967–70) and Robin Hood Gardens, Poplar, London (1966–72). The implicit risk is that the buildings seem a bit dull by comparison. However, the Smithsons' architecture has always meant to respond to place and to human need, which in this case means the *existing* masterplan much more than the fairly uneventful terrain. In other words, the buildings read as a critique of the RMJM work (while necessarily working with it), while also implementing a Smithson philosophy of architecture that already existed. One West North and the Department of Architecture and Civil Engineering (*see* below) are significant for striving to break out of a grid pattern, towards a more humane architecture. The architects described it as 'a new piece woven onto the edge of an existing mat . . . the first of a series of tassels that are going to be needed to make that mat's terminating fringe . . . so it can lie there, on its gently sloping hillside, seemingly complete'. It is three storeys and delta-shaped in plan with a zigzag back containing teaching rooms; the staircase walls act as wind-braces to a column grid structure, a development of the grid-plan of the Smithsons' unbuilt Lucas Headquarters (1973). The delta-plan allows E and w sunlight into the building. The exterior is built of exposed *in situ* concrete, the structure being also the weather enclosure. This was a departure for the Smithsons, as the two were often expressed separately before, as with the earlier buildings mentioned above. The exterior is articulated with weathering drips and construction joints, and a thin reinforced concrete 'cornice'. The second, internal skin for thermal insulation is lined in beech plywood to reflect the winter hues of beech planting outside. Built with an economy of means, the touchable interior surfaces have higher quality finishes, with joinery in British Columbian pine. The walls read as structural or non-structural, though the circulation areas, originally blockwork, have been plastered.

Eastwood, 165 yd. (150 metres) further E, by *McDonagh Round*, was built in phases: one, 1972–3, two, 1983–4, three, 1984-5 and four, by *James McDonagh*, 1989–90. The last, **Esther Parkin Residences**, is a formal little building with an interesting classical touch. It has a central range with wings, the ground floor an open loggia with segmental and round-headed arches and rusticated voussoirs, like a semi-cloister. To the s, student residences, a large scheme by *Feilden Clegg Bradley*, 2002–3, links geometrically to its smaller neighbour, Eastwood, and mirrors its court-yards. A robust four-storey building, it is constructed of rendered masonry and vertically oriented windows, with colonnades at ground level, and a curved-profile stainless-steel roof enclosing mechanical plant.

SE of here is **Six East**, the **Department of Architecture and Civil Engineering**, by *Alison & Peter Smithson*, 1982–8, the E extremity of the main campus [164]. This idiosyncratic building is an interesting late work of the renowned architects, a development of earlier themes, for example Robin Hood Gardens, which is already a long way from, say, Hunstanton School. It is also in the Corbusian plan-as-generator tradition – the Smithsons called it 'developed from the inside outwards' – even if the results are strictly non-monumental. The materials also suggest a rejection of the machine-aesthetic of CLASP. Ordered on two overlapping grids, one orthogonal, the other angled, but frequently stepping outside these, the walls bend and crank, contrived as if enjoying the accidents of building. The resulting spaces differ in shape and size, and these differences of character provide an oddly pedagogic building with 'widely different feelings for privacy, of being safe, of being lost.' The building is ordered according to the structural, spatial and environmental demands of its parts, so that bearing walls and columns diminish in thickness as their need for load or mass diminishes. Heavy uses like engineering laboratories occupy the ground floor, exhibition space, lecture theatres, seminar rooms and principal offices are at the main deck access level, teaching rooms, above, and at the top are tall north daylit studios. Outside, a gently stepped walkway makes the transition from ground level to the pedestrian deck. The string course follows its line, said by Peter Smithson to derive from Bath terraces stepping uphill. The

walkway also recalls the stepped ramps of Italian hill towns. Bands of concrete emphasize the floor levels, and this was inspired by the bold string courses that wrap around the fortress of Sassocorvaro in the Duchy of Urbino by Francesco di Giorgio Martini. Clearly, too, the Smithsons were influenced by Giancarlo de Carlo's work at Urbino, with its sensitivity to the Italian vernacular context. The façade has infill of Bath stone, and vertical sliding aluminium windows that refer to C18 sashes; the roof is stainless steel. Inside, electrical services and lintels above doors are all exposed, the detailing rather crude, intended to withstand 'additions, subtractions and technical modifications'.

Eight East, the **Centre for Power Transmission and Motion Control**, by *Feilden Clegg Bradley*, 2000–2, on the s side of the Smithsons' building, adds a final limb to the original RMJM plan, another case of turning back into front. A linear building, it contains a large laboratory, two studios and a virtual reality and video conferencing suite. Accommodation is generally open plan to enable academic and social interaction. The cladding is partly stainless steel with horizontal joints; the remainder, crisply detailed Bath stone. Window openings are enlarged into horizontal bands or two-storey high with a finer grain of mullions and transoms set within. Bands of woven stainless steel shade the glazed entrance. To the E is the **Arts Barn**, a converted agricultural building, intended as the centre of an arts complex. The only other related building complete at the time of writing is the **Arts Theatre**, immediately sw. This was *Alison & Peter Smithson*'s final 'tassel' to the fringe of the campus fabric. The shell was built 1989–90 but not fitted out for use until the late 1990s. The exterior is a windowless blockwork box with a stainless-steel roof and fascia. The walls have ledges and pads, as if ready for other structures, or perhaps suggestive of structures previously attached, giving an archaeological sense of fragments. This encloses a single-rake rectangular auditorium with side galleries and an asymmetrical entrance lobby underneath. Lighting gantries that double as trusses fall in one direction, giving a canted section.

To the s is the **English Institute of Sport** (**South West**), a regional centre with facilities for training world-class athletes. Phase one, the **Sports Training Village**, by *Denning Male Polisano*, 1994–5, is two large steel-clad sheds with segmental roofs, containing an indoor athletics hall, fencing salle and projection room to the N (converted to these uses as part of phase two) and a 50 metre (55 yd.) swimming pool to the s. These are linked by a flat-roofed entrance and café. Phase two, by *David Morley Architects*, 2002–3, to the w and linked to phase one by a covered colonnade, contains a multi-purpose sports hall, an indoor athletics hall for jumps, throws and vaults, a hall for Dojo (a martial art), and indoor tennis courts. To the E of phase one is an indoor 100 metre (110 yd.) sprint track.

Further additions to the University are anticipated under *Feilden Clegg Bradley*'s **Masterplan**.

Smallcombe Cemetery, Horseshoe Road, Smallcombe Vale. This characterful place feels remarkably isolated for a spot so close to the city centre. It contains a **mortuary chapel** designed in 1855–6 by *Thomas Fuller* in E.E. style. The single-cell chapel of three bays has a w entrance and bellcote, stepped buttresses, and a single lancet to each bay, triple to the E end. The doorway has two orders of columns, with leaf capitals and chevron moulding. The good stained-glass E window is by *Powell*, 1895. – Adjacent, the **Nonconformist chapel**, designed by *A. S. Goodridge*, *c.* 1860–1, is octagonal, buttresses at each corner, with a projecting porch and bellcote over. Built of random squared rubble, also in E.E. style. Each face has a lancet window. Inside is a scissor-brace roof. – **Hancock Memorial** *c.* 1863, a Neoclassical Pennant-stone adaptation of a Roman altar. – **Ethel Pocock headstone**, *c.* 1924, with a bronze relief crucifixion with doves, winged seraph and kissing figures behind. It is of high quality and of explicit Christian symbolism for the period. **Memorial**, 1888. An unusual Italianate twisted barley-sugar

165. Excursion 4: Combe Down and the Southern Slopes

composite column in artificial stone with continuous ribbons set with glass mosaic on a panelled base. It supports a fluted urn. The poet A. E. Housman's family memorial is situated on high ground behind the chapel. The architect J. Elkington Gill is also buried there.

Lyncombe Hall, Lyncombe Vale Road. Built by William Chapman in the 1730s on the old manorial site. It has a tall s-facing front with six Venetian windows. On the garden wall is balustrading believed to have come from Queen Square. A C17 house, Lyncombe Farm formerly stood on the site and in the Middle Ages there were vineyards, fishponds and a granary.

Lyncombe House (now the Paragon School), Lyncombe Vale Road. A large plain five-bay house, *c.* 1740 with a later C18 porch. It had a mineral water spring believed to have curative properties and operated for a while as Lyncombe Spa, then from 1767 for a brief period as an isolation centre for smallpox inoculants.

Perrymead Roman Catholic Cemetery, Blind Lane, Perrymead Hill. Laid out in 1858 and consecrated 1862. It is adjacent to, but independent of, the Abbey Cemetery. Its planning is much more informal, less scientific. **Cemetery chapel** by *William Hill* (probably Hill of Leeds), 1859, a plain but competent Gothic Revival design with a central belfry and buttresses. **Eyre Chantry**, just N of the cemetery gates, by *C. F. Hansom*, *c.* 1860 for Count John Eyre. Small but elaborate in Geometric Frenchified Gothic, with a polygonal E end, unbroken ridge line, polygonal tower and spire. The interior is richly decorated. – **Tiles.** By *Minton.* – **Altar**, alabaster, by *Charles Hansom*, executed by *Boulton* of Cheltenham. – **Ironwork** by Hardman. – **Stained glass** by *John Hardman Powell.*

Lodge Style (formerly **St Winifred's Quarry**), built in 1909 by *Charles Voysey*, the most important C20 house in Bath and one of Voysey's most significant late buildings [166]. It was built to the requirements of

T. Sturge Cotterell, the owner of the Combe Down Quarries. Single-storey, built round a small courtyard, it is a miniature collegiate Gothic building, partly crenellated, with a defensive entrance tower and a wide gabled stone porch. Though typical of Voysey in its grouping, the Gothic details are more revivalist than he was in his younger years. The interior emphasizes warmth and enclosure, with large open hearths, oak fittings, vaulted ceilings and leaded casements.

Holy Trinity, Church Road, Combe Down. By *Goodridge*, 1832–5. In contrast to the tendency towards the more scholarly handling of Gothic materials at St Mary, Bathwick [108], St Saviour, Larkhall [28] and St Mark, Lyncombe (p. 215), Goodridge could be as fanciful and crazy as the best. It has four buttresses. The inner ones become polygonal pinnacles of a tightly fitted octagonal tower with spire. Lancet windows. *W. J. Willcox* added the aisles and extended the chancel, 1883–4, but in serious C14 Dec style, far too well mannered to compete with the tower. The original aisleless church bristles with pinnacles. The broad nave has a very flat coved plaster vault with sparse lozenge pattern of ribs brought down to small corbels. Adjacent to the E, the very grand Neo-Jacobean **Vicarage**, *c.* 1840, is boldly asymmetrical, with gables and octagonal stacks; some windows are mullioned and transomed, and others have pointed heads.

Opposite, **De Montalt Place**, dated 1729, eleven cottages designed by *Wood the Elder* and built by *Richard Jones* to house quarrymen and their families, an early instance of 'model' housing. The pedimented centre, Dial House, was for Jones, Allen's foreman, later clerk of works.

Valley Spring, Horsecombe Vale, Southstoke Road [167]. By *Peter Womersley* for his brother John, 1972. It sits in a valley, well screened from the road. Built of reddish-brown bricks, it offers no concession to regional style or materials. It is a highly eloquent linear composition of

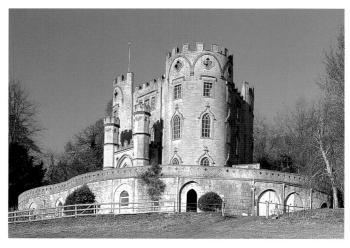

168. Midford Castle, Midford Road, after a design by John Carter (c. 1775)

four visually discrete flat-roofed elements: two two-storey blocks, the E
with a rooftop sun terrace, a tall stair-tower in between, and a w block
of one storey, originally guest accommodation. Vertical pairs of U-
shaped piers support floors and roofs, defined by horizontal timber fas-
cias, leaving glazed corners unobstructed. These accommodation units
have links glazed floor-to-ceiling that visually interconnect with the
wooded landscape setting.

Midford Castle, Midford Road [168]. Beautifully placed in wooded
grounds with a s view down to Cane Brook and Midford Brook, this is
the most eccentric of the substantial villas that surround Bath. It was
built for Henry Disney Roebuck, *c.* 1775, after a design by *John Carter* for
'a Gothic Mansion' published in the *Builder's Magazine* in 1774. It is
tower-like, three-storeyed, on an ingenious trefoil plan with semicir-
cular corners, raised on a large plinth containing the service accommo-
dation. Each floor has a lozenge-shaped hall and three rooms giving off
it with three-windowed ends. (A story, coined in 1899, said that the plan
commemorates some prodigious gambling success of Henry Roebuck and
represents the ace of clubs.) The two principal floors have pointed
windows with ogee-hoods, the upper windows, straight hoods. To give
the appearance of towers, the battlemented parapet projects upwards at
the corners as a screen wall. This is pierced with quatrefoil openings set
in blind arches like eyebrows. The interior has charming light plaster-
work, chiefly long branches with sparse leaves, attributed to *Thomas
Stocking*. The house is an early example of the unusual geometric-
shaped villas, mainly triangular and sometimes castellated, that
architects experimented with in the 1780s–90s. These include Carr's
Grimston Garth, Yorkshire (1781–6), Adam's Walkinshaw House,

Renfrewshire (1791), and Nash's Castle House, Aberystwyth for Uvedale Price (*c*. 1795).

Castellated also, the early C19 **gatehouse** (four-centred head of the archway, quatrefoils in the spandrels) and the picturesque group of **stables** and tower of the former **chapel**. This has a tower with pinnacles (and a cupola as well). In the NE part of the grounds are the ruins of a summer house known as the **priory**, a two-storeyed circular tower with a higher circular stair-turret, embattled, with quatrefoil windows. Originally, this had a nave with an apse, with ogee-headed niches. This was presumably built at the same time as the castle as it is mentioned in Collinson's *History of Somerset*, 1791. On the brow of a steep descent is a rustic **hermitage**, now restored. Collinson also mentions this.

St Martin's Hospital, Odd Down. 1836–8, built as Bath Union Work house, i.e. a workhouse. Hexagonal, containing Y-shaped wings, three storeys, in the late classical style. Following the 1834 Poor Law Amendment Act, *Sampson Kempthorne*, architect to the Poor Law Commissioners, produced model plans for execution by local architects, in this case the City Architect *Manners*. Kempthorne's first (and only other) hexagonal workhouse was at Abingdon (1835), but the ranges at Bath are longer and lower. The infirmary to the rear had 'imbeciles' on its ground floor. A new lunatic block opened in 1857 and was praised in the *Journal of the Workhouse Visiting Society*, suggesting that few lunatic wards of this standard yet existed on workhouse sites. The **chapel**, 1846, Gothic Revival E.E. style with a steeply pitched roof, is by *Manners*. It was built by *John Plass*, a former master builder and an inmate of the workhouse, who 'at the age of 78 working with much zeal and industry laid all the stone'. The detail and finishes were possibly adapted to the relatively unskilled labour to be employed.

Entry Hill Drive, Entry Hill. A group of romantically conceived Neo-Tudor villas by *Edward Davis*, 1829–36, his first recorded commission after returning to practice in Bath from Soane's office. Designs for seventeen houses were exhibited at the Royal Academy in 1828, but only five were built. They were a speculation by a local solicitor, Richard Else, who possibly occupied the houses progressively as they were finished. The approach from the old Warminster Road (now Entry Hill) is up a private road flanked by vermiculated stone piers. The first to be completed was **Entry Hill Villa**, occupied by 1829 and purchased by Charles Davis, Edward's elder brother, in 1836, followed by **Newfield Villa** (now Newfield), occupied from 1831. The next, **Granville House**, was completed by 1835; although it was again owned by Charles Davis, Edward Davis himself lived there with his wife and daughter, 1835–41. The house is symmetrical, with a recessed central entrance between projecting wings with tall Tudor chimneys and pinnacles. The name recalls the Civil War royalist general Sir Bevil Grenville, defeated and killed at the

169. Church of Our Lady and St Alphege, Oldfield Road, Oldfield Park, by Sir Giles Gilbert Scott (1927–9)

Battle of Lansdown in 1642, whose grandson erected a commemorative monument at Lansdown. Edward Davis was commissioned to restore this and in so doing removed Grenville's coat of arms and incorporated them into the wall of Granville House (a romantic motivation, reflecting the appeal of antique fragments to the historical imagination). **Entry Hill House**, the principal house, occupied by 1836, is asymmetrical with mullioned and transomed windows, an oriel window and battlemented parapets. **The Briars** was the final house, occupied by 1836.

Bloomfield Crescent (originally Cottage Crescent), Bloomfield Road. By *Charles Harcourt Masters*, *c.* 1801. The main N elevation, fronted by rural pasture with panoramic views towards the city, with centre

pediment and shallow Greek detail, has considerable ambition. But its seven houses are remarkably unpretentious in execution, a poor man's Royal Crescent. A pair of urbane, rusticated gatepiers with curious bee-hive finials, restored 1990s, leads from the street to a mews and the convex entrance elevation, decidedly rustic in rubble stone and with uneven rooflines. The depth of the houses is tiny. Some have later upper floor additions over the doorways, supported on columns.

Elm Place, Bloomfield Road, w side. An unfinished small-scale early C19 Greek Revival terrace with a three-storey middle and NE end pavilion (twenty-one houses intended, seven unbuilt). With a banded ground storey, plain giant Doric pilasters in the middle, crisp surrounds and hoods to first-floor windows. The two-storey wings are plain with a band course and continuous first-floor sills.

Church of Our Lady and St Alphege, Oldfield Road [169]. By *Sir Giles Gilbert Scott*, 1927–9 but not consecrated until 1954, a thousand years after the birth of the patron saint who had been a monk at Bath. The attached domestic-scale presbytery, E of the church, was completed 1958. One of Bath's least known post-Georgian buildings, tucked away in an uneventful late C19 suburb, it cannot fail to astonish and delight. Modelled on Santa Maria in Cosmedin, Rome, it is a severe Early Christian basilica of impressive simplicity. The **exterior** has a three-arched loggia, with sturdy columns and Byzantine capitals, and a lean-to roof with Italian tiles. The campanile, attached to the left side, is only half the planned height because of fears over foundations. Exposed stone walls and roof structure inside, with arcaded aisles and blind apsidal sanctuary, flanked by the Lady Chapel and sacristy. The column capitals have exquisite figurative carving by *W. G. Gough*, the N side, scenes from the life of Our Lady, the s side, of Alphege, and, at the w end, persons associated with the design and building of the church. Scott, designer of Liverpool's Anglican Cathedral, noted that 'it has always been one of my favourite works, my only regret is that it has not proved possible to complete the exterior by building the campanile'. The floor was 'an interesting experiment in using small pieces of linoleum in the same manner as marble'. The architect's delightful gilded pendant sunburst **light fittings** survive, disused. – **Baldacchino**. Gilded oak carved by *Stuflesser* of Ortisei and decorated by *Watts* of London. – **Organ**, by *Rushworth & Draper* of Liverpool, built in 1915 as a demonstration model, installed 1960, when the w gallery was completed.

The Western Outskirts

Twerton Gaol, Caledonian Road, by *G. P. Manners*, 1840–2. Only the Palladian-style **Governor's House** remains from this, the first prison to be completed under the 1835 Prisons Act. Now converted to apartments. Large scale, it is suitably forbidding with blocky detailing, banded rustication over all three floors and unfluted giant pilasters, the centre breaking forward. Besides the Governor, it housed the chapel, chaplain's room, surgeon, magistrates, reception rooms, kitchens and laundries. The prison, designed in principle at national level, was based around the separation of functions and persons, with the requirement of good ventilation and healthy conditions. It had a straight block to the rear as against the radial type used at Joshua Webb's Pentonville, also 1840–2, and Bath's Union Workhouse (*see* Excursions, p. 289). It housed 122 prisoners in total. The gaol closed 1878.

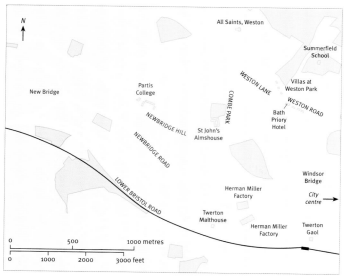

170. Excursion 5: the Western Outskirts

171. Herman Miller Factory, Locksbrook Road, by Farrell Grimshaw Partnership (1975)

Herman Miller Factory, Locksbrook Road [171], by *Farrell Grimshaw Partnership*, 1975. A furniture factory and store designed with quality, adaptability and the wellbeing of the workforce in mind. It has a large-span steel structure of simple primary and secondary beams with a hollow steel frame, clad with demountable cream-coloured glass-reinforced polyester (grp) panels with a neoprene gasket system that fits into the steel sections. Solid units, glazed units, louvres and doors are all moveable using unskilled labour. Cool and elegant, it contrasts with the more aggressive High-Tech of e.g. Team 4's Reliance Controls factory (1966) or Richard Rogers' Inmos factory, Wales (1982).

Bath Cabinet Makers' Factory (now part of Herman Miller), Lower Bristol Road. Designed by *Yorke, Rosenberg & Mardall*, 1966–7. A large single-storey factory, notable for the first use in Britain of a Mero space frame roof structure, developed in the 1940s by the German engineer *Max Mengeringhausen*. This uses two basic steel elements, short rods and patented nodes. The rods have threaded ends that screw into any of eighteen tapped holes in each machined node, to form the top and bottom booms and the linking diagonals of two-dimensional trusses. These allow large, clear spans. Rod and diameter sizes can be varied to

suit the forces to be carried. The external cladding is grey asbestos sheets and clerestory patent glazing.*

Malthouse, Lower Bristol Road, N side, opposite the disused Twerton railway station on a raised viaduct, part of Brunel's Great Western Railway. With pre-1830s origins, the building was largely rebuilt *c*. 1900. Its main architectural interest is the reinforced concrete pyramidal roof to a barley-drying kiln N of the main block, an early British example of the *Hennebique* system. The building was converted to offices by *Edward Nash Partnership*, 2000–2.

New Bridge, Newbridge Road West. Originally built 1735–6, by *John Strahan* (according to John Wood's *Essay*), with three arches; presumably executed by Ralph Allen as part of the improvement of the River Avon Navigation, 1727. Rebuilt in the late C18 with a single segmental arch spanning 90 ft (28 metres), it was widened in 1831–4 by *William Armstrong* of Bristol for the Bath Turnpike Trust, during the General Surveyorship of John Loudon McAdam. The bridge has rusticated voussoirs, the upstream abutments (visible from the high road) battered, panelled pilasters; the spandrels have circular tunnels to reduce the weight. The approaches are built up with eight round-headed arches, blocked on the downstream side (i.e. not flood arches).

Partis College, Newbridge Hill, almshouses of 1825–7, by *Samuel & Philip Flood Page* of London. The Neo-Greek composition, a large quadrangular plan open to the S, is so spacious that the college looks more like Wilkins's Haileybury College, Hertfordshire, or Downing College, Cambridge, than like almshouses and is more intact besides. The central chapel, with a tall blind attic, has a portico of six unfluted Ionic columns and a pediment. To the right and left are thirteen two-storey bays, of which the last three are accentuated. Sixteen-bay ranges to E and W also have three-bay accents on the ends. The accents are giant Doric pilasters, paired at the corners – an austere design, Bath's finest example of Greek Revival. In 1863 *George Gilbert Scott* altered the small chapel to sumptuous Gothic style, also Bath's finest High Victorian interior. It was all built and endowed under the will of the Rev. Fletcher Partis to provide homes for thirty 'decayed gentlewomen'. They had to be Anglican orphans or widows of clergymen, officers in the army or navy, professional men in law, physic or divinity, or merchants. The rule still stands today, to the exclusion of the Royal Air Force.

*Bath Cabinet Makers' earlier red brick multi-storey factory, to the N, a former malthouse of 1900 converted to an aircraft factory in the First World War, was demolished in 1994.

St John's Hospital, Combe Park Almshouse, 2002–3 by *G2 Architects* with extensive landscaping by the *New Leaf Studio*. Arranged around a courtyard with water features, the high-quality, energy efficient building of 54-units-plus-chapel, highly articulated – somewhat over worked – in Bath stone and brick, with roof terraces, bay windows, and expressive parts, is an unusual C21 example of an early building type.

All Saints Church, Weston. Other than the simple C15 Perp w tower, the church was rebuilt in 1830–2 by *John Pinch the Younger. E. Harbottle* of Exeter added the chancel and transepts in 1893, and *Mowbray A. Green* a memorial chapel in 1921. Nave and aisles. Tall lancet-like three-light windows with four-centred arches and Perp tracery. Battlements and pinnacles. Arcade of tall piers of Perp section carrying four-centred arches. The nave is broad and low with a rear gallery. Many **monuments**, including: coffin lid with foliated cross. – Arthur Sherston d. 1641, Mayor of Bath. All that remains is a frontal demi-figure, the hand on a skull. – General Joseph Smith d. 1790. Unsigned. Good hanging monument: two standing female figures left and right of a pedestal with a trophy and an urn. – **Stained glass**. Post-1893, except for the E window, *c.* 1860. The N and s chancel windows are *c.* 1902 of Morris & Co. type.

s of the church is *Thomas Baldwin*'s **tomb** [172] to Thomas Atwood, d. 1775 (*see* Major Buildings, p. 76). A pedestal, with flutes and bucrania with garlands in the frieze, the sides with roundels and wheat-ear husks, supports a splendid carved vase. Good original railings. – N of the church a **sarcophagus** of 1795 with sharply angled sides and acroteria, supported on lions' feet. Adjacent is a **tomb** to Philip Affleck, admiral of the 'White Squadron of His Majesty's fleet', 1799. It has a plaque with military trophies, columns with waterleaf capitals, pendant husks between, cable-fluted tented canopy, and an original railed surround. Another, similar, sw side, commemorates General Joseph Smith, d. 1790, this with a vase finial.

Vicarage, w of the church. A pretty villa of 1802, attributed to *Baldwin*, with the half-pilasters he so much favoured. The ground-floor windows are set in segmental panels. The doorway has a cornice supported by long thin double consoles and plain strip pilasters. Above a continuous moulded string course, the middle window has a surround and pediment, roundels and wheat-ear husks to either side. The flanking ranges step slightly forward at first floor. Half-pilasters to either side and angle pilasters both have delicately carved capitals. The cornice follows the contour.

Weston Park West, Weston Park East and **Weston Road** form a once-exclusive area of substantial Victorian villas in Italianate and other historicist styles, most now converted into large apartments. **Cranwells**

(now **Summerfield School**), Weston Park East, is a mansion set in grounds at the end of a long drive, by *Wilson & Fuller*, 1850–2. A near facsimile of Widcombe Manor, including the giant fluted Ionic pilasters, carved keystone masks – and James Wilson's own extension of 1840 (*see* Walk 8, p. 220). The Doric porch, with emblems in the frieze derived from the Circus, is the only notable variation. Exhibited at the Royal Academy in 1850, it marked the rediscovery of Bath's Georgian architecture by the mid Victorians. Built for Jerome Murch, three times mayor of Bath and a prominent member of the Park Committee (*see* Walk 10, p. 236). Also notable are a group attributable to *Manners*: **Glenfield**, Weston Park; **The Retreat** (now King Edward's Pre-Prep School), Weston Lane; the **Bath Priory Hotel**; and two asymmetrical semi-detached pairs, **Granville** and **Little Woodcote** (formerly Park House), **South Lynn** and **Herne House** (originally Ivy Cottage), all in Weston Road. This group of Gothic-Tudor-Jacobean-style houses of *c*. 1840 evokes all the Romantic tendencies that Manners first used at his additions to The Moor, Clifford, in 1827–9 with gables, some castellation, tall chimneys, oriels and casement windows with hoodmoulds. Similar but simplified, Herne House of 1833, now altered, was *Manners*' own home. The Bath Priory Hotel **interior** has Gothic doors, chimneypieces and iron balustrading. The *David Brain Partnership* built a large addition, completed 1996, alluding to Regency style. Much articulated, with projecting eaves and pretty ironwork canopies.

172. All Saints, Weston, Baldwin's tomb to Atwood (d.1775)

Further Reading

The literature on Bath is vast, and the present volume is only the latest of many **guidebooks** to the city, some of which still provide interesting architectural accounts and contemporary insights, often structured into – sometimes strenuous – walks. These include P. Egan, *Walks through Bath*, 1819, S.D. Major, *Notabilia of Bath*, 1871, R.E.M. Peach, *Rambles about Bath,* 1876, and J. Tunstall, *Rambles about Bath,* 1889. *Letters from Bath 1766-1767* by the Rev. John Penrose, 1983, ed. Brigitte Mitchell & Hubert Penrose, provides a contemporary insight into the daily round of the c18 visitor. There are also many **fictional references**, famously Tobias Smollett, *Humphrey Clinker*, 1771, and Jane Austen, *Northanger Abbey*, 1818; H.A. Vachell, *The Golden House*, 1937, although written in a dated style, is set in Bath and based around Widcombe Manor, the author's home.

For an overview of **Aquae Sulis** see Barry Cunliffe, *Roman Bath* (English Heritage), 1995. The same author's *Roman Bath Discovered* (most recent editions 1984, 2000) charts the process of discovery, from the observations of c16 antiquaries through the unearthing of architectural remains of the Temple in the late c18 and the uncovering of the Baths a hundred years later, to the dramatic exploration of the Sacred Spring and Temple Precinct in 1979–83. **Excavation reports**, essential reading for the serious scholar, also contain illuminating discussions which establish the context within which the investigations took place. The largest and most detailed, B.W. Cunliffe and Peter Davenport, *The Temple of Sulis Minerva at Bath,* vol. 1: *The Site* (Oxford University Committee for Archaeology, monograph 7), 1985, also contains the most comprehensive synthesis of knowledge up until that time and is a rewarding source for those with an enduring interest in Bath. The others can simply be listed chronologically: W.H. Knowles, 'The Roman Baths at Bath; with an account of the Excavations conducted in 1923', *Archaeologia* 75, 1926; B.W. Cunliffe, *Roman Bath* (Society of Antiquaries of London, Research Report 24), 1969; B.W. Cunliffe, 'The Roman Baths at Bath: excavations 1969–1975', *Britannia* 7, 1976; B.W. Cunliffe (ed.), *Excavations in Bath, 1950–1975* (Committee for Rescue Archaeology in Avon, Gloucestershire and Somerset, Excavation Report 110), 1979; T.F.C. Blagg, 'The Date of the Temple at Bath',

Britannia 10, 1979; B. W. Cunliffe, 'The Roman Tholos from the Sanctuary of Sulis Minerva at Bath, England', *Studia Pompeiana and Classics* 2, 1989; P. Davenport (ed.), *Archaeology in Bath 1976-1985* (Oxford University Committee for Archaeology, monograph 28), 1989, and P. A. Davenport, 'Archaeology in Bath, Excavations *1984-1989*', *BAR* British Series 284, 1999. Other more specialized studies include G. A. Kellaway (ed.), *Hot Springs of Bath* (Bath City Council), 1991, and K. Dark, 'Town or Temenos? A re-interpretation of the walled area of Aquae Sulis', *Britannia* 24, 1993.

For more general essays on Roman Bath, its development and its hinterland, the reader is directed to articles by P. Davenport in *Bath History*: 'Roman Bath and its Hinterland' (vol. 5, 1994), and 'Aquae Sulis: the origins and development of a Roman Town' (vol. 8, 2000). G. de la Bédoyère, *The Buildings of Roman Britain,* 2001, puts Bath in the national picture. Readers fascinated by the first stirrings of interest in Roman Bath should explore the wealth of antiquarian literature recording isolated objects of interest and *in situ* remains, often observed and then subsequently lost to view. Detailed works of the c18, c19 and early c20 give a glimpse of the city of the moment and the drama created by unexpected discoveries: T. Pownall, *Description of Antiquities dug up in Bath in 1790,* 1793, R. Warner, *The History of Bath*, 1801, S. Lysons, *Reliquiae Britannico-Romanae 1,* 1813, H. M. Scarth, *Aquae Solis,* 1864; also F. J. Haverfield, *Romano-British Somerset* (Victoria County History, vol. 1), 1906. For the most persistent researchers the *Proceedings of the Somerset Archaeological and Natural History Society* and its *Bath Field Club* never fail to surprise and delight with unexpected articles and notes on Roman discoveries in and around Bath.

Despite the volume of published material on the post-Roman city, there are relatively few strictly **architectural accounts**. John Wood's *A Description of Bath,* 1742–43 (2nd edn 1749, reprinted 1765 and 1969), is fundamental as an explanation of his architectural intentions. Mowbray A. Green's handsome *The Eighteenth Century Architecture* of Bath, 1904, marked the start of post-Victorian appreciation. Wartime damage, which brought its architecture once again to national attention, is described in N. Rothnie, *The Bombing of Bath: The German Air Raids of 1942,* 1983. Walter Ison, *The Georgian Buildings of Bath from 1700 to 1830,* 1948 (new edn 1980), is an unsurpassed description of all the great set pieces, dated only by the fact that lesser Georgian streets are relegated to an appendix, many of which have since been demolished, perhaps partly as a result. Nikolaus Pevsner's entry in *North Somerset and Bristol* (*The Buildings of England*), 1958, represents that particular moment between partial completion of war damage repair (the Assembly Rooms were still a ruined shell) and 1960s aggressive 'clearance' when large tracts of the city were demolished. Published **council policies** which led to this situation include P. Abercrombie,

J. Owens, and H.A. Mealand, *A Plan for Bath*, 1945, and C. Buchanan, *Bath: A Planning and Transport Study*, 1965 (Buchanan's next published report hints at eventual change: *Bath: A Study in Conservation*, 1968). The losses were recorded in Peter Coard's three-part *Vanishing Bath*, 1970–2, and the ongoing severe threat was brought to national attention in Adam Fergusson, *The Sack of Bath*, 1973 (expanded as A. Fergusson and T. Mowl, *The Sack of Bath – And After*, 1989), and 'Bath: City in Extremis' in *Architectural Review* 153, May 1973. Bath's delights were meanwhile published in 'Bath in the Eighteenth Century', a special issue of *Apollo* (November 1973).

The revaluation of the city generated a spate of publications. The most significant at the time was Charles Robertson, *Bath, an Architectural Guide*, 1975, a broad architectural description with an alphabetical gazetteer, though (like Ison) it falls short of considering the city as an economic and social, as well as architectural, entity. These aspects are exhaustively discussed in R. S. Neale, *Bath: A Social History*, 1981. Barry Cunliffe, *The City of Bath*, 1986, and Christopher Pound, *Genius of Bath: The City and its Landscape,* 1986, are less specifically architectural overviews. Of the recent literature on the Georgian era generally, there is much that puts Bath in a broader context, as in C. W. Chalklin, *Provincial Towns of Georgian England,* 1974, D. Cruickshank and N. Burton, *Life in the Georgian City*, 1990, M. Girouard, *The English Town*, 1990, and J. Ayres, *Building the Georgian City,* 1998. The fullest general account of spas can be found in P. Hembry, *The English Spa 1560–1815, a Social History*, 1990, and its continuation, P. Hembry, L.W. Cowie, and E.E. Cowie, *British Spas from 1815 to the Present, a Social History*, 1997. John Wroughton's *Tudor Bath: Life and Strife in the 'Little City' 1485–1603*, 2006, and *Stuart Bath: Life in the Forgotten City*, 2004, are accounts of the pre-Georgian city.

Detailed studies of pre- and post-Georgian architecture remain few, with Neil Jackson, *Nineteenth Century Bath Architects and Architecture*, 1991, and P. Davenport, *Medieval Bath Uncovered*, 2002. Further information on individual architects can be obtained from Howard Colvin's definitive *Biographical Dictionary of British Architects 1600-1840*, 3rd edn 1995. More, if dry, description of individual buildings is available from the DCMS schedules of listed buildings, held by the local authority and at the National Monuments Record at Swindon. **Monographs** on key individuals include B. Boyce, *The Benevolent Man: A Life of Ralph Allen of Bath*, 1967, C.E. Brownell, 'John Wood the Elder and John Wood the Younger', unpublished Ph.D. thesis, Columbia University, 1976, T. Mowl and B. Earnshaw, *John Wood: Architect of Obsession*, 1988, J. Lees-Milne, *William Beckford*, 1990, T. Mowl, *William Beckford: Composing for Mozart*, 1998. D.E. Ostergard (ed.), *William Beckford, 1760–1844: An Eye for the Magnificent*, 2001, is a lavish exhibition catalogue. S. Winchester, *The Map that Changed the World: The Tale of William Smith and the Birth of a Science*, 2001, explains the char-

acter of the area through the pioneering observations of the locally based father of geology. D. Bernhardt, 'A Victorian Practice in Bath: George Phillips Manners, John Elkington Gill, Thomas Browne, Wallace Gill, Percy Morris, Architects', unpublished Ph.D. thesis, University of Bath, 2003, uncovers rich new material from the Biggs Archive held in the City Records Office. The ongoing *Bath History* series has published several studies of individuals (as well as much besides of architectural interest). These include B. Cunliffe, 'Major Davis: Architect and Antiquarian' (vol. 1, 1986), D. McLaughlin, 'Mowbray Green and the Old Preservers' (vol. 4, 1992), J. Roote, 'Thomas Baldwin: His Public Career in Bath, 1775–1793' (vol. 5, 1994), and M. Forsyth, 'Edward Davis: Nineteenth Century Bath Architect and Pupil of Sir John Soane' (vol. 7, 1998).

For **individual buildings and groups**, K. Hylson-Smith, *Bath Abbey: A History*, 2003, is the most up to date; E. M. Hick, *The Cathedral Church of SS. Peter and Paul in the City of Bath,* 1913, is still useful, as is the relevant chapter in G. Cobb, *English Cathedrals: The Forgotten Centuries*, 1980. On the University, see Robert Matthew, Johnson-Marshall & Partners' development plan *The Proposed University of Bath. A Technological University*, Report No. 1, 1965. The Bath Preservation Trust exhibition catalogue, *Beyond Mr. Pulteney's Bridge,* 1987, is a compact but well-researched publication of documents relating to the Bathwick Estate. On Prior Park there is G. Clarke, *Prior Park, a Compleat Landscape*, 1987. For the medical background see R. Rolls, *The Hospital of the Nation*, 1988. J. Manco's publications include 'The Cross Bath' in *Bath History* (vol. 2, 1988) and *The Spirit of Care: The Eight-Hundred-Year Story of St John's Hospital, Bath,* 1998.

An immense amount has been written about the city's **history** in general, and only one or two examples can be mentioned here. J. Lees-Milne and D. Ford, *Images of Bath*, 1982, contains every known published illustration, while R. S. Neale, *Bath 1680-1850, a Social History: or, a Valley of Pleasure, Yet a Sink of Iniquity*, 1981, and P. Borsay, *The Image of Georgian Bath, 1700-2000: Towns, Heritage, and History*, 2000, are seminal social histories, the latter with an excellent bibliography. For a lighter read – about the C18 – there is Edith Sitwell's wonderfully eccentric *Bath*, 1932.

Glossary

Abacus: *see* [4F].

Acanthus: *see* [4F].

Ambulatory: aisle around the E end of a church.

Angle buttress: one set at the angle or corner of a building.

Anta: simplified pilasters, usually applied to the ends of the enclosing walls of a portico (called *in antis*).

Anthemion: *see* [4F].

Apse: semicircular or polygonal end of a space.

Arch: for types *see* [1]. *Skew arch*: spanning supports not diametrically opposed.

Architrave: *see* [4A]. Also the moulded frame of a door or window.

Ashlar: large rectangular masonry blocks wrought to even faces.

Astylar: with no columns or similar vertical features.

Atrium: a toplit covered court rising through several storeys.

Attic: small top storey within a roof. Also the storey above the main entablature of a classical façade.

Baluster: pillar or pedestal of bellied form; used together in a *balustrade*.

Barrel vault: one with a simple elongated-arched profile.

Basement: lowest, subordinate storey; hence the lowest part of a classical elevation, below the *piano nobile* (q.v.).

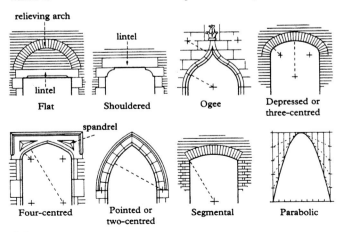

1. Arches

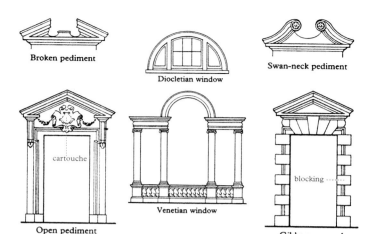

2. Classical features

Batter: intentional inward inclination of a wall face.

Bay window: one projecting from the face of a building. *Canted*: with a straight front and angled sides. *Bow window*: curved.

Bellcote: small gabled or roofed housing for a bell or bells.

Blue Lias: a kind of limestone.

Bolection moulding: *see* [5].

Bowstring bridge: with suspending arches rising above the roadway.

Box pew: one enclosed by doors and a high back.

Brise-soleil (French): a sunscreen of projecting fins or slats.

Broach spire: *see* [3].

Bucrania: ox skulls used decoratively in friezes on classical buildings.

Campanile (Italian): free-standing bell-tower.

Capital: head feature of a column or pilaster; for classical types *see* [4A].

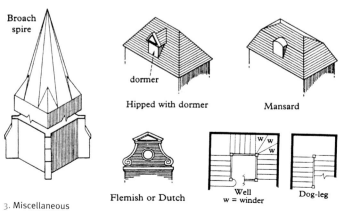

3. Miscellaneous

Cartouche: *see* [2].

Caryatids: female figures supporting an entablature.

Choir: the part of a great church where services are sung.

Clerestory: uppermost storey of an interior, pierced by windows.

Coffering: decorative arrangement of sunken panels.

Composite: classical order with capitals combining Corinthian features (*acanthus*, *see* [4]) with Ionic (*volutes*, *see* [4C]).

Console: bracket of double-curved profile.

Corinthian; **cornice**: *see* [4; 4A].

Cottage orné: artfully rustic small house.

Cove: a broad concave moulding.

Crenellated: with battlements.

Cupola: a small dome used as a crowning feature.

Dado: finishing of the lower part of an internal wall.

Decorated: English Gothic architecture, late C13 to late C14.

Dentil: *see* [4C].

Diocletian window: *see* [2].

Distyle: with two columns.

Doric: *see* [4A, 4B].

Drum: circular or polygonal stage supporting a dome.

Dutch or Flemish gable: *see* [3].

Early English: English Gothic architecture, late C12 to late C13.

Egg-and-dart: *see* [4F].

Entablature: *see* [1A].

Extrados: outer curved face of an arch or vault.

Fascia: *see* [4C, 4D]. Also a plain upper band on a shopfront.

Flying buttress: one transmitting thrust by means of an arch or half-arch.

Freestone: stone that can be cut in any direction.

Frieze: middle member of a classical entablature, *see* [4A, 4C]. Also a horizontal band of ornament.

Frontispiece: central feature linking doorway and window above it.

Gadrooning: boldly ribbed or lobed classical ornament.

Geometric: Continental Gothic architecture of the later C13 and C14.

Giant order: a classical order (q.v.) that is two or more storeys high.

Gibbs surround: *see* [2].

Greek key: *see* [4F].

Groin vault: one composed of intersecting barrel vaults (q.v.).

Guilloche: *see* [4F].

Half-timbering: non-structural decorative timberwork.

Hipped roof: *see* [3].

Hypocaust: Roman underfloor heating system.

Impost: horizontal moulding at the springing of an arch.

In antis: *see* Antae.

Ionic: *see* [4C].

Jamb: one of the vertical sides of an opening.

Jetty: a projecting upper storey on a timber-framed building.

Lancet: slender, single-light pointed-arched window.

Lantern: a windowed turret crowning a roof, tower or dome.

Light: compartment of a window divided by mullions (q.v.).

Loggia: open gallery with arches or columns.

Louvre: opening in a roof or wall to allow air to escape.

Lunette: semicircular window or panel.

4. Classical orders and enrichments

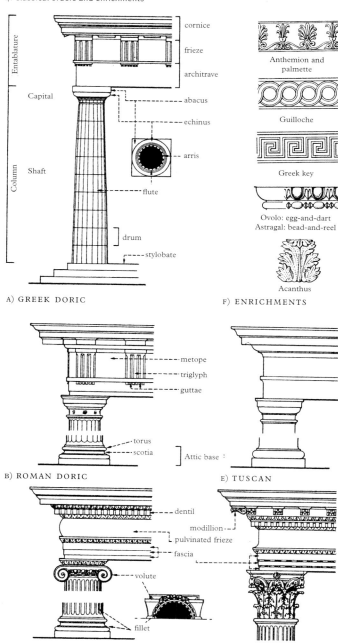

A) GREEK DORIC

cornice
frieze
architrave
Entablature
Capital
Column
Shaft
abacus
echinus
arris
flute
drum
stylobate

F) ENRICHMENTS

Anthemion and palmette

Guilloche

Greek key

Ovolo: egg-and-dart
Astragal: bead-and-reel

Acanthus

B) ROMAN DORIC

metope
triglyph
guttae
torus
scotia
Attic base

E) TUSCAN

C) IONIC

dentil
modillion
pulvinated frieze
fascia
volute
fillet

D) CORINTHIAN

Mansard roof: *see* [3].

Metope: *see* [4B].

Mezzanine: low storey between two higher ones.

Modillion: *see* [4D].

Moulding: shaped ornamental strip of continuous section.

Mullion: vertical member between window lights.

Narthex: enclosed vestibule or porch at the main entrance to a church.

Newel: central or corner post of a staircase.

Nogging: brick infilling of a timber frame.

Norman: the C11–C12 English version of the Romanesque style (q.v.).

Oculus: circular opening.

Ogee: *see* [1].

Orders (classical): for types *see* [4].

Oriel: window projecting above ground level.

Overthrow: decorative fixed arch above a gateway.

Ovolo: *see* [4F].

Palladian: following the examples and classical principles of Andrea Palladio (1508–80).

Palmette: *see* [4F].

Panelling (timber): *see* [5].

Patera: round or oval ornament in shallow relief.

Pavilion: ornamental building for occasional use; or projecting subdivision of a larger building, often at an angle or terminating a wing.

Pediment: a formalized gable, derived from that of a classical temple; also used over doors, windows, etc. For types *see* [2].

Pennant: hard sandstone often used for paving.

Perpendicular: English Gothic architecture from the late C14 to early C16.

Piano nobile (Italian): principal floor of a classical building, above a ground floor or basement and with a lesser storey overhead.

Pilaster: flat representation of a classical column in shallow relief.

Platband: flat horizontal moulding between storeys.

Portico: porch with roof and (frequently) pediment supported by a row of columns.

Postern: small gateway to the side of a larger entrance.

Presbytery: a priest's residence.

Prostyle: of a portico, with free-standing columns.

Pulvinated: of bulging profile; *see* [4C].

Quatrefoil: opening with four lobes or foils.

Queen-struts: upright paired roof-timbers, set off-centre over a tie-beam.

Quoins: *see* [6].

Raised and fielded (panelling): *see* [5].

Reeded: decorated with small parallel convex mouldings.

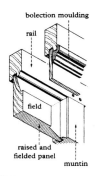

5. Panelling

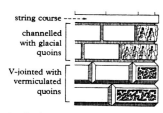

string course

channelled
with glacial
quoins

V-jointed with
vermiculated
quoins

6. Rustication

Reredos: painted and/or sculpted screen behind and above an altar.

Reveal: the inner face of a jamb or opening.

Romanesque: round-arched style of the c11 and c12.

Rustication: exaggerated treatment of masonry to give the effect of strength. Banded rustication: with only horizontal joints emphasized. For other types *see* [6].

Sacristy: room in a church used for sacred vessels and vestments.

Sanctuary: in a church, the area around the main altar.

Scagliola: composition imitating polished marble.

Setts: squared stones used for paving or flooring.

Soffit: underside of an arch, lintel, etc.

Spandrel: space between an arch and its framing rectangle, or between adjacent arches.

Splayed: angled; (of an opening) wider on one side than the other.

Sprocket: a short supporting piece.

Stallriser: the area below the window sill of a shopfront.

Stairs: for plan types *see* [3].

Strapwork: decoration like interlaced leather straps.

Stringcourse: horizontal course projecting from a wall surface.

Studwork: close-set timber uprights.

Termini: downward-tapering pedestals or pilasters, usually topped with the upper part of a human figure.

Tetrastyle: (of a portico) with four columns.

Tierceron vault: with extra decorative ribs springing from the corners of each bay.

Trabeated: having a post-and-beam structure, i.e. not arched.

Tracery: openwork pattern of masonry or timber in the upper part of an opening.

Transept: transverse portion of a church.

Trefoil: with three lobes or foils.

Triglyph: *see* [4B].

Truss: braced framework, spanning between supports.

Tunnel vault: one with a simple elongated-arched profile.

Tuscan: *see* [4E].

Tympanum: the area enclosed by an arch of pediment.

Venetian window: *see* [2].

Vermiculation: *see* [6].

Vitruvian scroll: wave-like classical ornament (*see* p. 27).

Volutes: spiral scrolls, especially on Ionic capitals (*see* [4C]).

Voussoirs: wedge-shaped stones forming an arch.

Wainscot: timber lining of a room (cf. Panelling).

Waterleaf capital: one carved with stylized flattened leaves.

Weathering: inclined, projecting surface to keep water away from the wall below.

Winder: *see* [3].

Index
of Architects, Artists, Patrons and Other Persons Mentioned

The names of architects and craftsmen working in Bath are given in *italics*.
Relevant illustrations are denoted by page numbers in *italics*.

Quin, James 67

Rauzzini, Venanzio 66
Reay, S.S. 157
Redwood, Reginald S. 141
Reeve, Mrs and sons 66
Reeve, George 66
Reeves & Sons 63, 66, 221, 235
Rennie, John 40, 185, 195
Repton, Humphry 33
Richardson, Sir Albert 89
Rivers, Lady Charlotte 238, 254
RMJM 48, *278*, 279, 281, 282
Robert of Lewes, Bishop 13, 54
Roberts, Hugh 46, 251, 255–6
Roberts, Hugh & Davies 150, 151
Roberts, Hugh, Graham & Stollar 222
Roberts, Hugh & Partners 196
Roberts, Hugh D. 45, 171, 241
Roebuck, Henry Disney 288
Rogers, Samuel 221
Rolfe Judd Partnership 49, 110
Rolfe & Peto 220, 221
Romain, Chris 58
Rome, Alan 58, 63
Rosewell, Thomas 249
Rowlandson, Thomas 31
Rudge, Roebuck 126
Rushworth & Draper 291
Russell Diplock Associates 214

Sainsbury, Samuel 161
Sainsbury, William 113
St Barbe family 64
St Blaise 97
Saintsbury, George 146
Salisbury, H.J. 269
Sanders, J.H. 38, 251
Sarum Group 63
Schenck, Frederick 79
Schinkel, Karl Friedrich 162
Scoles, A.J. 96
Scoles, J.J. 34–5, 96, 97
Scott, George Gilbert 36–7, 57, 58, 59, 62, 63, 241, 294
Scott, Sir Giles Gilbert 42, 213, 290, 291
Scott, Thomas 242
Scrase, Richard 244
Sedding, J.D. 235

Severius Emeritus, Gaius 9
Shepherd, Edward 17, 136
Shepherd, T.H. 31, *83*, *230*
Sheridan, Richard Brinsley 31, 146
Sherston, Arthur 295
Shum family 123
Sibthorp, Dr 65
Siddons, Sarah 212
Silcock, T.B. 134, 157, 173
Silcock & Reay 42, 160, 197, 213, 222, 225, 226
Sill, Joseph 6
Silley, G.M. 160, 161
Simpson, Major 42
Singer's of Frome 194
Sisson, F.R. 209
Skeet, Dr Denham 274
Skidmore of Coventry 62
Slade, Smith & Winrow 266
Smith (of Bristol) 64
Smith, General Joseph 295
Smith, Robert 155
Smith, William 182
Smithson, Alison & Peter 48–9, 278, 281, 282, *283*, 284
Smollett, Tobias 31, 144
Snailum, Terence 45, 231
Snailum, Huggins & Le Fevre 45, 114, 231
Snailum, Le Fevre & Quick 47, 223
Snetzler, John 158
Soane, Sir John 34, 144, 200, 237, 253
Society for the Protection of Ancient Buildings 43, 88–9
Spackman, Charles 172
Spackman, H. 161
Spackman & Son 161
Speed, John 11, 12, 14
Spence 79
Stanhope, Lady 144
Star Works (Birmingham) 185
Stephenson, John 97
Steuart, Brigadier-General William 66
Stocking, Thomas 288
Stollar, Graham & Associates 257
Stone, J.G. 261
Stonor, Sir Francis 75
Stothert & Pitt 40, 203

Strahan, John 19, 248, 251, 257, 258, 294
Street, George Edmund 194
Street, William 157
Stride Treglown Partnership 48, 252
Stuflesser of Ortisei 291
Stukeley, William 144
Stutchbury, Dr Howard 45, 173, 214
Sulinus, son of Brucetus 7
Sulis Minerva 5–6, 7–8
Summerson, Sir John 47
Sweetland 130, 235
Symons, John 174

Taylor, A.J. 42, 85, 115, 124, 127, 128, 129, 154, 173, 184, 185, 206, 212, 225, 232, 245
Taylor, A.J. & Partners 173, 275
Taylor, Mollie 43, 275
Taylor & Fare 161
Tektus Architects 191, 258
Tempus 62
Tew, E.F. 153, 253, 257
Tew, Pope & Oliver 250, 257
Thicknesse, Philip 146
Thomas, Archdeacon 66
Thrale, Esther 142
Tierney Clark, T. 209
Tindall, Laurence 60, 62, 70
Tolson & Nugent 268
Tompion, Thomas 70
Toms, William 97
Tovey, W.E. 240
Townsend, Rev. J. 182
Treasure, H. 240
Trim, George 118
Tunstall, J. 31
Turner, R. 223
Tyler, Mrs 226

Underwood, George Allen 34, 207
Underwood, Henry 212, 213
Ustinov, Igor 257

Vachell, Horace Annesley 220
Vaughan 57
Vaughan, John 186
Vertue, George 62
Vertue, Robert & William 54
Victoria, Queen 41, 79, 80, 162, 238
Vitellius Tancinus, Lucius 4

Vivian, John 276
Vivian & Mathieson 82
Voysey, Charles 42, 286

Wade, General George 15, 47, 63, 97, 102, 103–5
Wade, Captain William 42
Wailes of Newcastle 122
Wakeford, K., Jerram & Harris 46, 115
Walker (of Brandon) 211
Walker, A.G. 62
Walker, Anthony 95, 99, 100
Waller, F.N. 43, 159
Waller, Sir William and Lady 66
Walpole, Horace 22, 246, 273
Walsh, Lt.-Col. Robert 66
Ward & Hughes 64, 65, 112
Watkins, W.H. 42, 214
Watts (of London) 291
Watts, Peter 60
Weatherley, F.E. 181
Wentworth, Lady 66
Wesley, Charles 31
Wesley, John 268
Whaite, William 126
Whinney, Son & Austen Hall 153
White 221
Whitefield, George 246
Wilberforce, William 182, 228
Wilkins, Charles 40
Wilkins, R. & Sons 231
Wilkins, William 34, 105
Wilkinson, J.G. 213
Willcox, W.J. 128, 160, 213, 227, 266, 287
Willcox & Ames 120
William II 53
William IV 182
Williams, Mr (builder) 168
Williams, Mrs (photographer) 126
Williams, Henry (d.1853) 221
Williams, Henry (of Bristol) 262
Williams, J. Owen 272
Williams, W.A. 43, 117, 131, 213, 245
Willis 194
Willmott, E. Morgan 42, 214
Wilson, James 33, 36, 37, 41, 150, 175, 220, 226, 228, 240, 245, 254, 255, 264–5, 267, 268, 269, 272
Wilson, Rev. W.T.H. 215

Index
of Localities, Streets and Buildings

Illustrations are denoted by page numbers in *italics*. Principal descriptions are shown in **bold**.

Bath Street 23, 49, 68, 84, *109*, **110**, 126
Bath Technical Institute 231
Bath Temperance Association 204
Bath Union Workhouse 41, **289**
Bathampton 203
Bathampton Lane 203
Batheaston, church *see* St John the Baptist
Batheaston Villa 273
Bathwick 4, 10, 189
Bathwick Estate 22–4, *176–9*, 180–2, *183*, 184, *185*, 186, *187*, 188–91
Bathwick ferry 12, 32, 125, 129, 210
Bathwick Grange (Montebello) 33, **198–9**
Bathwick Hill 33, **194–5**, **196–203**
Bathwick House 189
Bathwick Mill 189
Bathwick Street 188–9
Bathwick Tower 201
Bathwick Villa 22, 32
Bayer Building 262
Bayntun's Bookshop and Bindery 42, **213**
Baysfield House 196
Bazaar 34, **154**, *155*
Bear Inn 122
Beau Nash Picture House *see* Canon Cinema
Beau Street 85, **113–14**
Beauford House 256
Beauford Square 19, 30, **256**, 257
Beaufort Arms 256
Beaufort Buildings 257
Beaufort East 235
Beaufort Hotel *see* Hilton Hotel
Beaufort House 233
Beaufort Lodge 233
Beaufort Place 235
Beaufort West 235
Beckford's Tower 34, 145, 172, *270*, 271, *272*
Beechen Cliff 263
Beehive Yard 224
Bell Hotel 226
Bella Vista 264–5
Bellot's Hospital 114, 122
Belmont 175
Belvedere Villas 175

Bennett Street 22, 145, 162, **163**
Berkeley House 232
Berkeley Place 264
Bethel Chapel 179
Bilbury Lane 11, 114
Bimbery 14, 103, 110
Bishop's Close 108
Bishop's Palace 12, 107
Black Swan Inn 133
Bladud Buildings 22, **225**, **247**
Blanchard's Tenement 107
Blenheim House 212
Bloomfield Crescent (Cottage Crescent) 290–1
Bloomfield Road 290–1
Blue Coat School 41, **118**
Boat Stall Lane 125
Boater (pub) 177
Boating Station 274
Bonhams (Philips) Auction Rooms 141
Botanical Gardens 41, **240**
Box Roman villa 9
Box Tunnel 40, 92
The Briars 290
Bridewell Lane 14, 119
Bridge Street 25, 26, **128**
Bridgemead Nursing Home 49, *190*, **191**
Bridgwater House 208
Bristol &West Banking Company 159
Broad Quay 15, 40, **214–15**
Broad Street 13, *14*, 15, **130**, *131–2*, 133–4
Broad Street Place 133–4, **223**
Brock Street 19, 31, **145–6**
Brompton House 190
Brunswick Street 22, *23*, **232**
Building of Bath Museum 246–7
Burdalls Yard 231
Burlington Street 242
Burton Street 153
butchers' market 105
Buttsway 242

Calton Gardens 46, **214**, 263
Cambridge Place 33, **215–16**
Camden Crescent 22, 27, *171*, **174–5**
Camden Malthouse and Silo 261–2
Camden Mill 262

Topic boxes

Architects: Advertising for Architectural Commissions p. 25, Architect 'Dynasties' p. 37

Building details: Windows and Glazing Bars pp. 30, 31, Grecian Ironwork p. 35, Shopfronts p. 156

Building Georgian Bath: Transporting Building Materials p. 17, Leases on the Bathwick Estate p. 24, Building on Sloping Sites p. 27

City life: Bath's Population Growth p. 16, Trains to Bath in Victorian Times p. 93, Early Photographic Studios in Bath p. 126, Music at the Octagon Chapel p. 158

Individual buildings and sites: Spa Water and the Pump Room p. 32, Manners' Restoration of the Abbey p. 57, Monuments in the Abbey p. 63, Chapel of St Mary, Chapel Row p. 138, Empire Hotel p. 207, Theatre Royal, Old Orchard Street p. 212, Royal Victoria Park p. 238

Personalities: General (later Field-Marshal) Wade (1673–1748) p. 105, Illustrious Residents of the Royal Crescent p. 146, Famous Residents around Great Pulteney Street p. 182

Roman Bath: Religious Inscriptions p. 7, Combe Down in Roman Times p. 9

Illustration Acknowledgements

Every effort has been made to contact or trace all copyright holders. The publishers will be glad to make good any errors or omissions brought to our attention in future editions.

We are grateful to the following for permission to reproduce illustrative material:

Bath Chronicle Archive: 30, 32, 42, 74, 119
Bath Reference Library/ Victoria Art Gallery: 4, 5, 46, 51, 58, 90, 91, 138
Beckford Tower Trust: 157
The Bodleian Library, University of Oxford: 58
Bridgeman Art Library / Victoria Art Gallery: 9, 10, 49, 79, 84, 121
British Museum: 7
The Builder: 132
James O. Davies: 35

English Heritage (James O. Davies): 1, 3, 6, 8, 11, 12, 13, 14, 15, 19, 20, 21, 22, 23, 24, 26, 27, 28, 29, 31, 33, 34, 38, 39, 40, 41, 43, 44, 45, 47, 48, 50, 53, 55, 59, 60, 62, 63, 66, 68, 69, 71, 72, 75, 76, 77, 80, 82, 83, 85, 87, 88, 89, 92, 94, 95, 96, 97, 98, 99, 102, 103, 104, 105, 106, 107, 108, 110, 111, 112, 113, 114, 115, 116, 122, 123, 124, 125, 126, 127, 129, 130, 131, 134, 135, 137, 139, 140, 141, 142, 143, 145, 146, 147, 148, 149, 151, 153, 154, 155, 156, 159, 160, 161, 162, 163, 166, 167, 168, 169, 171, 172
Alan Fagan: 37, 65
Ironbridge Gorge Museum Trust: 57
Walter Ison: *The Georgian Buildings of Bath*: 16, 17, 18, 52, 54, 81
Touchmedia: 2, 36, 61, 70, 78, 86, 93, 101, 109, 118, 128, 136, 144, 150, 152, 158, 165, 170
V & A Picture Library: 120